# THE ART OF
# RAY HARRYHAUSEN

# THE ART OF
# RAY HARRYHAUSEN

**RAY HARRYHAUSEN & TONY DALTON**

WITH A FOREWORD BY PETER JACKSON

BILLBOARD BOOKS

An imprint of Watson-Guptill Publications/New York

First published in the United States in 2006 by Billboard Books

An imprint of Watson-Guptill Publications
A division of VNU Business Media, Inc.
770 Broadway, New York, NY 10003

First published in Great Britain 2005 by Aurum Press Ltd.
25 Bedford Avenue, London WC1B 3AT
www.aurumpress.co.uk

Copyright © 2006 by Ray Harryhausen and Tony Dalton

Library of Congress Control Number: 2005930364
ISBN: 0-8230-8400-0

2 3 4 5 6 7 8 9 10
2006 2007 2008 2009 2010

Book design by TWO:design, London.
Photography by Andy Johnson
Printed in Singapore

**Acknowledgements**
We would like to thank all those people who have helped us to compile this volume, especially those
organisations and individuals who have kindly granted us approval to use visual materials and quotes.

The still from *King Kong* on page 72 is reproduced by kind permission of Warner Bros Entertainment Inc.

The passage from *Tyrannosaurus Rex* by Ray Bradbury is reproduced by kind permission of the author.

Charles R. Knight's mural for the La Brea Tar Pits is reproduced by kind permission of the Natural History Museum of Los Angeles County.

Charles R. Knight's drawings of dinosaurs are reproduced by kind permission of Rhoda Knight Kalt.

We would also like to thank the following for their kind assistance:

BBC Television, Alexandra Bradbury, Canal + Image UK Ltd., Columbia Pictures, DN-Images, Hammer Films, John Herron, Peter Jackson,
Gareth Knowles, National Trust for Scotland, Tim Nicholson, Turner Entertainments

All original artwork, including bronzes, as well as original storylines and creatures contained in this book, that have
not been realised as or included in past productions, are copyright © Ray Harryhausen.

*This book is dedicated to my dear wife Diana*
*and beautiful daughter Vanessa.*

# CONTENTS

*Foreword*

There's a group of people around the world, of widely differing ages and professions, who are all linked by a common thing – their love for a movie made in 1933 titled *King Kong*. Sometimes this film has changed their lives, for the impact of seeing it was so profound that it steered them towards a career in the movie business. I have no facts to back me up, but I'm certain that *King Kong* inspired more young people to become filmmakers or special-effects artists than any other film ever made.

Ray Harryhausen is in that select group of first-generation *Kong* fans, seeing it as he did at its opening run at the Grauman's Chinese Theater in 1933.

I'm probably part of the third generation. I first saw *Kong* on TV in New Zealand in 1970, and like so many people before me, I have wanted to make movies ever since. In fact the very next day, I was doing crude stop-motion with plasticine dinosaurs. My generation was the luckiest because we had not only *Kong* to inspire us, but also the wonderful series of Ray Harryhausen films, gifted to us film-fantasy lovers by the number one *Kong* fan of all.

When my *Kong*/dinosaur/stop-motion craze hit our household, my mother did the only thing she really could to help – she went to the local library to look for books on the subject, and came home with a copy of Ray's first book, *Film Fantasy Scrapbook*. That book became a fixture in our household. I would constantly renew it at the library, thumb through the pages and stare in wonder at the images – photos and drawings from films I'd never seen. This was Wellington, New Zealand, in the early seventies, and we had one TV channel and no revival picture houses.

Slowly, very slowly, I managed to see Ray's films on TV, or at the cinema. *Jason and the Argonauts*

was the first. *The Golden Voyage of Sinbad* came to the cinemas, and my dad gave me a special Christmas present that year: the new edition of Ray's book with the colour photo section from the new *Sinbad* adventure. The theatrical re-release of *The 7th Voyage of Sinbad* followed, and that became my favourite of all Ray's films. It's right up there with *Kong* on my movie appreciation chart.

All this time, my teenage years were being fuelled by a desire to do exactly what Ray Harryhausen was doing, in his fruitful collaboration with Charles Schneer – create a new world populated by new creatures, and bring them to life with the magic of stop-motion. While my school classmates were going out with girls, learning to drive, listening to music, I was the solitary kid; an only child who rushed home from school to build rubber monsters and dream of using something mystical called foam latex. At the weekends I would animate, bringing my creatures to life one frame at a time. I remember the day Elvis died, but only for one reason – it was the day I saw *Sinbad and the Eye of the Tiger*!

I was driven by a dream that one day, if I was good enough, I might become Ray's apprentice, just like he had worked with Willis O'Brien on *Mighty Joe Young*.

As the years went by, I eventually did become a filmmaker, taking the low-budget horror movie route into the industry, sneaking a little stop-motion in where I could. But the arrival of science-fiction films into mainstream cinema, led by *Star Wars*, and the computer technology that followed, meant that the fantasy genre became unpopular for a while. Ray retired … and I finally got to meet him, first as a fan who queued for hours at a London bookstore to get his auto-

graph. Like so many people who ask for my autograph today, my hands were trembling. Later we were fellow guests at a Fantasy Film Festival in Germany.

It seemed like the world of cinema had moved on from fantasy, but not for me. In 1996, whilst I was building up a computer visual effects facility in Wellington, I still wanted more than anything to make a movie just like the films that inspired me throughout my life. I wanted to make my 'Jason', or my 'Sinbad'. My partner Fran Walsh and I toiled for a while on original fantasy story ideas, before settling on the idea of adapting *The Lord of the Rings* instead. The *Lord of the Rings* is my 'Ray Harryhausen movie'. Without that life-long love of his wondrous images and storytelling it would never have been made – not by me at least.

In fact, sitting right in the middle of the first of the trilogy, *The Fellowship of the Ring*, is my 'Harryhausen scene' – the fight with the cave troll in Balin's tomb. I wanted that monster fight to contain all the gags and moments I enjoyed seeing in Ray's films: people dodging the monster, throwing rocks and spears at it, the climactic moment when the hero jumps on its back, it's all there in that scene. I was finally fulfilling a childhood dream. I never got to become Ray's apprentice – not in the literal sense – but his passion for fantastical story-telling, for taking a wondrous journey into the reaches of the imagination, fuelled me as I made *The Lord of the Rings*.

It's so important not to grow up. I've come to appreciate how the lucky people stay young at heart. I finally got to meet Ray properly and spent time with him and Diana, and he has continued to inspire me. That's exactly how I want to be when I reach his age. He has not lost his boyish

excitement and sense of fun. We can talk about *King Kong* together like two thirteen-year-olds. That passion has been captured so well in the pages of this book.

I'm so grateful to Tony Dalton for the way he has collaborated with Ray to preserve and publish this wonderful book of images, and the stories behind them. When I read *The Art of Ray Harryhausen*, it transports me back to the magical worlds that meant everything to me as I grew up. It's as if my mother's made another trip to the library! I love being able to learn new things about Ray's movies – and just as interestingly, the movies that never got made. Now our imaginations can really run wild as we're offered a glimpse into an alternate reality of the Harryhausen films that might have been.

Thank you Tony … and thank you Ray, for this treasure trove of pictures. That they have lost none of their ability to provoke wonder, in some cases fifty years after they were produced, is a testament to the true timelessness of the genre and cinema's greatest master of fantasy.

PETER JACKSON
JUNE 2005
WELLINGTON, NEW ZEALAND

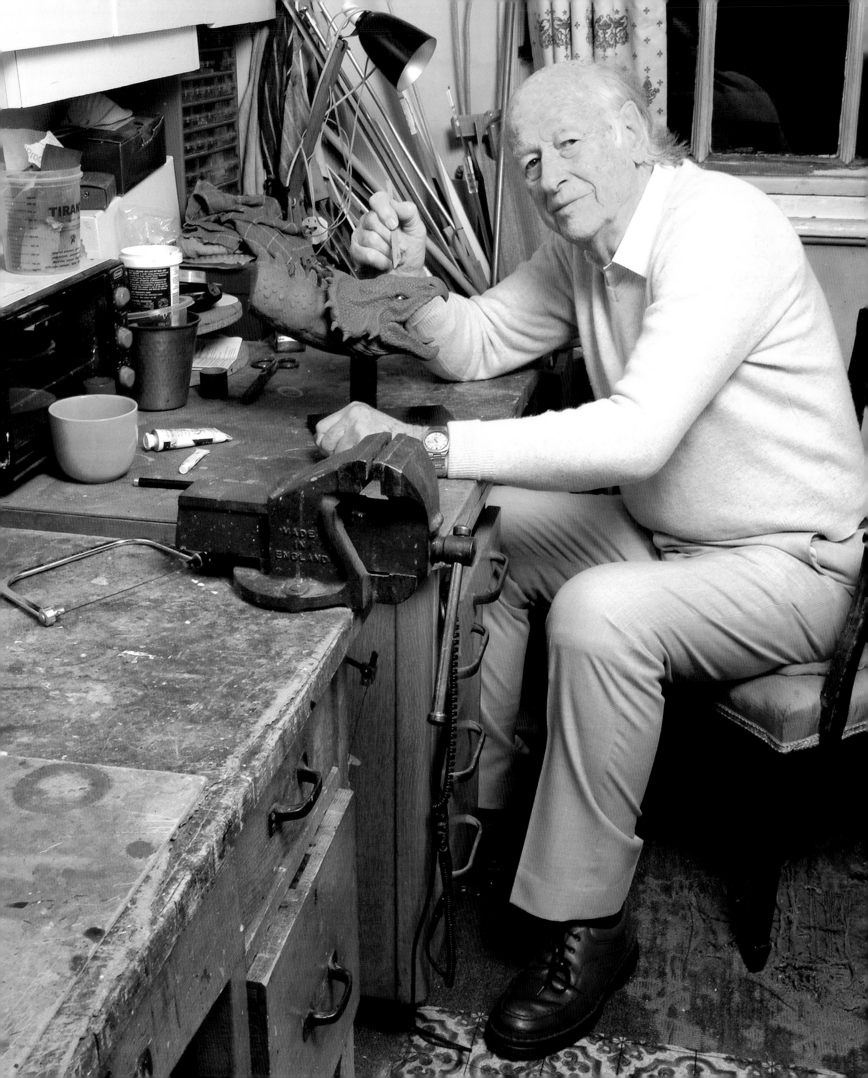

## Introduction

When tony and i collaborated on my autobiography, *An Animated Life*, in 2002, we included as many illustrations as we could. But as we dug deeper into my archive, discovering a wealth of material that even I had forgotten I had kept, it rapidly became apparent that many images would have to be omitted and that much of my artwork, in particular, could not be reproduced at a size that showed it to best advantage. Hence this book, which should be seen as a companion to the first. Unlike *An Animated Life*, it concentrates on my artwork rather than production stills of the animation process or images from the final films, and is primarily a 'gallery', which includes not only sketches, key drawings and storyboards, but also items such as clay and wax models, armatures, moulds and, of course, the final products – the models that appeared on the screen.

By focusing on the artwork, it allows the reader to follow the process by which a particular scene or sequence developed in my imagination and was visualized on paper in two dimensions long before we shot a single frame of live action or animation. It also takes readers through the various stages of developing a new creature and the situations or scenes in which I placed it, from a rough sketch to the final rubber latex model and on, in some cases, to the casting of a bronze which preserves the creature's form in perpetuity.

The structure of this book is also different from that of *An Animated Life*. As an autobiography, the latter was a chronological account of my life and my career in films. In this volume we have chosen a more thematic arrangement. While the opening chapters describe my early work and the artists who influenced it, the rest of the book is divided into chapters that are each devoted to a single subject – fairy tales, dinosaurs, aliens, legends and mythology, for example.

There is inevitably some overlap with *An Animated Life*, but we have attempted to keep it to a minimum. Above all, very few of the same illustrations appear in both books and, indeed, many of those reproduced here have never been previously published in any form. Thus, I hope that readers of *An Animated Life* will find that *The Art of Ray Harryhausen* stands on its own merits as a volume devoted to my art, and at the same time complements and expands upon its predecessor, offering new insights into how I learned to translate the beings I conceived in my imagination into the screen creatures with which everyone is so gratifyingly familiar.

Ray Harryhausen & Tony Dalton

**Left.** The inner sanctum, or the secrets of my workshop revealed. This is where I create and repair all my models and sculpt the clay or wax maquettes for my bronzes. In this photograph I am working on a clay maquette of the head of Scylla. I originally designed this creature when I was working on the unrealized *Force of the Trojans* and then revamped it for another project called *The Story of Odysseus*. Although he, or she, never reached the screen, it is some consolation that my creation may yet be immortalized in bronze.

# CHAPTER 1 SETTING THE SCENE

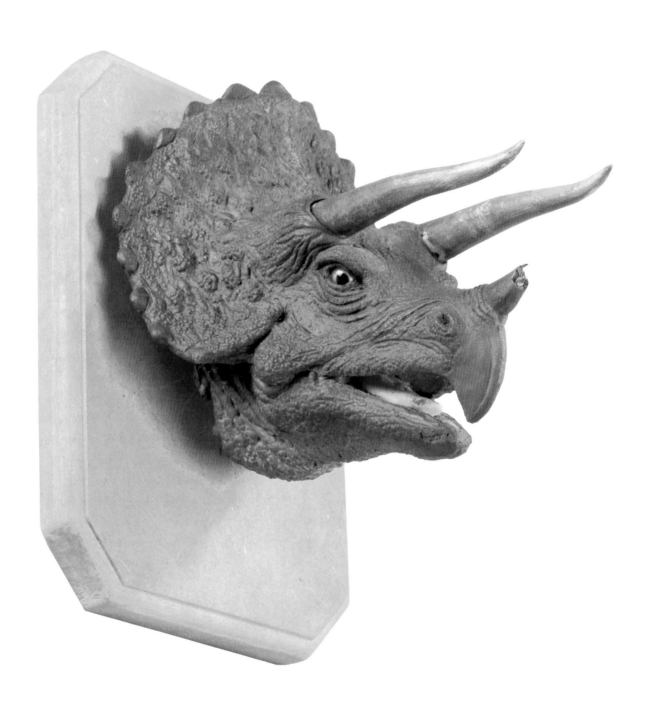

*My beauties, thought Terwilliger, my little lovelies.*
*All liquid latex, rubber sponge, ball-socketed steel articulture;*
*all night-dreamed, clay-moulded, warped and welded, riveted*
*and slapped to life by hand.*

*No bigger than my fist, half of them; the rest no larger than*
*this head they sprang from. Rubber, steel, clay, reptilian latex sheath,*
*glass eye, porcelain fang, all ambles, trundles, strides in terrible prides*
*through continents as yet unmanned, by seas as yet unsalted, a billion years*
*lost away. They do breathe. They do smite air with thunders. Oh uncanny !*

*Fuse flexible spine to sinuous neck, pivot neck to death's-head skull,*
*hinge jaw from hollow cheek, glue plastic sponge over lubricated skeleton,*
*slip snake-pebbled skin over sponge, meld seams with fire, then rear upright*
*triumphant in a world where insanity wakes but to look on madness…*
*The creator's hand glided down out of arc-light sun.*

Passages from *Tyrannosaurus Rex* by Ray Bradbury

WHAT BETTER WAY TO BEGIN THIS BOOK THAN WITH THESE PASSAGES FROM A STORY BY MY GOOD FRIEND RAY BRADBURY, written as a tribute to animators everywhere, but with specific reference to myself, hence the unusual name of Terwilliger. The story tells of a young modeller who is constructing and animating his 'little lovelies', while at the same time trying to cope with his producer, a scenario that does seem rather familiar. Ray's story describes, poetically and, up to a point, accurately, the work that goes into creating an armatured model; he also captures the passion that is shared by all animators and shows the dedication that is required to create the illusion of life on screen. The story should be dedicated to all animators, especially those working in small, dark backrooms, as most of us do.

The purpose of the next few pages is to describe the processes I follow when I put down on paper what is in my imagination and then translate it into moving images on the screen. In other words, my art.

Although I was always interested in art and this interest was encouraged by my parents, in truth it became a means to an end. The end was the bringing to life of inanimate objects, and to do that I had to master many arts. For as long as I can remember I have always wanted to create, whether drawing or modelling, so when I discovered, aged fourteen, the 'Eighth Wonder of the World' – *King Kong* (1933) – I wanted to direct my skills into making my own Kong or at least something similar. Luckily my inherent skills and interests provided the tools which would enable me to follow that path and make my own creations.

I eventually found out that the genius behind Kong, and before that *The Lost World* (1925), was someone called Willis O'Brien, or Obie as he was known to his friends. Although I knew his name I didn't get the opportunity to meet him until about 1938 or '39, when I plucked up enough courage to call him at the MGM studio where he was working on a project called *War Eagles*. He invited me over and from that day on he helped this young enthusiastic lad who was strange enough to want to animate models. I think he could see in me his successor and in those days there were few, if any, young people who knew about Obie, let alone who wanted to do what he did. More about Obie later, but I need to say here that it was he who set me on the path to utilising my talents as an artist, by advising me what I needed to do and where, on

occasions, I was going wrong. Without that assistance I think I would have had a far more difficult path to follow in becoming a professional animator.

Well before I had met Obie I had experimented with drawing, modelling and animation. Although all of these accomplishments play a vital role in successful screen visualization it is the last technique that allowed the creatures in *The Lost World* and *Kong* to achieve the semblance of life. For those of you who don't know the process of three-dimensional stop-motion animation, to give it the correct title, let me explain, as simply as I can, what it involves. An armatured model (an articulated metal skeleton covered in latex rubber) is photographed a frame at a time, with the animator making fractional adjustments to its position in between successive frames. When the resulting film is run through a projector at normal speed it seems as though the model is living. If you are photographing with 16mm film stock, which I used when I was experimenting, then the projector shows 24 frames per second. For 35mm film stock the speed would usually be 16 frames per second for silent films and 24 per second for sound. Basically this means that the animator has to change the position of the model 24 times to produce one second of 35mm footage. When Obie filmed his 1925 version of *The Lost World* it would have been silent, which meant that he had only to shoot between 16 and 20 frames of film to make a second of movement. However, when it came to shooting *King Kong*, which had a soundtrack and would be projected at 24 frames per second, another 4 to 8 frames were required for each second of screen-time, so inevitably the animation took longer. As these numbers make clear, all animation is time-consuming and patience is essential, but when you see the results of your labours it is dramatically rewarding. When the exposed film stock arrives back from the laboratories after being processed, the excitement of seeing a model move is impossible to imagine. That excitement never left me, even up to the last frame of film on my last feature.

However, before I get too far into animation, which is basically not what this book is about, I need to describe the preliminary processes and the subsidiary skills that have to be mastered before the model is even placed on the animation table and a single frame of film is shot. Very early on I found that the first stage was to learn how to draw the creatures I hoped to animate, to capture

**Previous page.** Latex with an internal metal armature. 6 ½" (h) x 6½" (d) x 5"(w). c.1965. The head of the triceratops that featured in *One Million Years BC*. Because the rest of his armature was used for a subsequent creature, possibly the styracosaurus in *The Valley of Gwangi*, I decided to mount his head as a trophy, as Count Zaroff did with his prized game in *The Most Dangerous Game* (1932).

them in a two-dimensional medium. Although I liked to draw, some of my earliest attempts were out of proportion. So I attended art classes at the Manual Arts High School and it was there that I encountered an arts teacher called Swankowski. I remember that he caused a bit of a stir by having models pose nude for the art class. This wasn't the usual practice in those days and the school authorities, as well as some of the parents, were a little shocked. The men who posed always wore a thong to cover their modesty but the women were usually completely naked. Those art classes were always so popular!

I thought Swankowski was a good teacher; he certainly gave my class one of the best pieces of advice I ever heard about art: 'If you can draw the human figure, in any position, you can draw anything.' He was also apt to say, 'Take a look see', meaning that too many people look but don't see. Swankowski also taught me to draw relatively quickly. He did this by allowing us a ten-minute period during which we would have to sketch a posed figure. At the end of those ten minutes the class would all move around so everyone had a different angle on the figure and we would begin again. It was good training for me to have to think quickly even though I never found it easy to sketch or draw rapidly. Some people have a natural talent for capturing a likeness quickly and easily, but I always found it a laborious task. Obie was the opposite; he could produce an acceptable sketch in minutes.

To brush up my techniques I later attended an institution in Los Angeles that I remember being called the Arts Center, although the name might be incorrect. There I learned portraiture in classes given by Stanley Reckless, a name I could never forget. The Arts Center had a number of different classes covering all forms of art and so I also took classes with another teacher in life drawing. This training, together with the courses in film editing, art direction and photography which I later took in night classes at the University of Southern California (USC), provided me with the core skills that would allow me to translate the images in my imagination on to the screen, but I continued to take every opportunity to develop my talents further.

After the war, while I was waiting to get out of the armed forces, I attended night classes at the famous Art Students League in New York for about six months, where I was influenced by the work of an artist called Bridgeman. He had written several books on anatomy and was hugely influenced by Michelangelo's dynamic figures. He had passed away by the time I took the course but our teacher used his books for a guide, and I always admired Bridgeman's methods of drawing the human figures. As at the Manual High, we had life classes to study anatomy and a model was provided once a week. They were usually ex-chorus girls who posed nude and were often slightly – how shall I put it? – plump. The only thing they would never take off was their silk stockings. Our teacher always

said that he didn't want us to draw the perfect figure, he wanted us to see people who were a little stout; in other words, not idealized. This presumably explained why they never took off their stockings.

When I returned to Los Angeles in late 1945, after the war and a trip to Yucatan and Mexico City, I again attended the Arts Center in L.A. for more night classes in live drawing and sculpture. It was at about this time that I produced a fired clay model of a reclining female nude, with no head and arms. I made it as an exercise in sculpting the human torso and I still have it to this day. For the truth is that, although drawing would play a vital part in my work, I always preferred sculpting; it was usually so much more satisfying. Some of my favourite pieces of sculpture are Michelangelo's unfinished series of stone figures, now in the Galleria dell' Accademia in Florence, which portray prisoners or slaves seemingly emerging from the rock. It is the fact that they are unfinished that gives them their aura of excitement and mystery and their fascinating dynamism.

All these classes, along with the books on anatomy and muscle structure that I studied, strengthened my understanding of the musculature of both humans and animals. When it came to animals, whether still living or long since dead, I was hugely influenced by Charles Knight's depictions of muscle structure in his paintings of dinosaurs. I learned that an understanding of the muscular development of an animal is essential if you are to render it on paper or, later, in three-dimensional form. Knight had published some wonderful books on how muscles sit on the bone and these helped me to visualize how to bring an animal 'alive' in as realistic manner as possible. I was also influenced by the illustrators of the *Tarzan* books, which were exciting to look at and read. The illustrations showing the movements of the muscles of both the humans and the jungle creatures were so effective and powerful – effects that I strove to achieve in my own drawings and sketches.

Because I knew I wanted to create creatures, not only dinosaurs but other beings that would bear a greater or lesser resemblance to living creatures of various kinds, I studied the movements of animals; watching all their actions and moods was essential to understanding their makeup. It was never enough to study them in books, I had to see as many facets of their lives as possible. I would therefore go off to my local zoo to watch the animals and see how they moved, ate, played, listened and looked at us humans. I noticed that many animals shared our human characteristics, resemblances that I would commit to memory and which would later be invaluable when I stood at the animation table confronting a model that awaited my life-giving touch.

When I began making features I continued to go off to zoos. For example, I visited the aquarium at Long Beach while I was making *It Came From Beneath the Sea* and watched the octopuses, to see

how they moved, how they curled up their tentacles and how the bag hung horizontally or down rather than up, as a lot of people imagine it does. On another occasion, when I was about to begin production on *Sinbad and the Eye of the Tiger*, I went to London Zoo to study the tigers; I noted how they walked and crouched and ensured that my sabre-toothed tiger in the film replicated those movements. I also visited the Natural History Museum in London to look at the bones on display. Bones, if available, have always helped me to visualize structure and to get details in proportion.

When I met Obie for the first time and saw all the artwork for *War Eagles*, I realized that projects were first visualized by means of large key drawings that depicted the crucial scenes in the screenplay. Initially, they helped to sell new ideas to producers and, once a film was in production, showed the technicians and actors what the scenes were intended to look like. So I began producing my own. They were usually drawings measuring eighteen by twelve inches. The first step in creating a key drawing was to roughly sketch out various ideas for a creature and a scene in which it would feature, slowly trying to establish what might work. With some creatures this can take longer than with others because I was always looking for something original, and it might need to go through several metamorphoses before I achieved a result that satisfied me. The next stage was to sketch out an idea of the composition onto tracing paper. This might feature the creature on its own or sometimes with a background. I would transfer the outlines from the tracing paper onto a three-ply Strathmore card. I then produced the finished drawing employing a technique that I had learned from Obie. Using a piece of cotton wool I would cover the entire area with powdered charcoal and then pick out the highlights with an eraser. When I had the highlights I would fill in the dark areas and lines with a dark Wolf pencil. This was my usual method of executing my key drawings but there was one exception, the three drawings I did for *Valley of the Mist*. These were all hard-pencil drawings, the technique for which I learned at the L.A. Arts Center.

Once I had produced my key drawings and the screenplay had been agreed by the producer, the screenwriter and, sometimes, the director, I was then faced with the tasks of designing and constructing what I had portrayed on paper and of making the scenes that I had rehearsed in my imagination work on the screen. This is where it gets tricky. Everything up until then had been on paper but now, with writers, directors and my producer breathing down my neck, I had to put their money where my mouth was.

When it came to constructing the models I was unable to find anybody to make either the armatures or the final latex covering. So I had to make them myself. Starting with the armatures, I did construct some of them in their entirety, although my father machined most of them following my specifications.

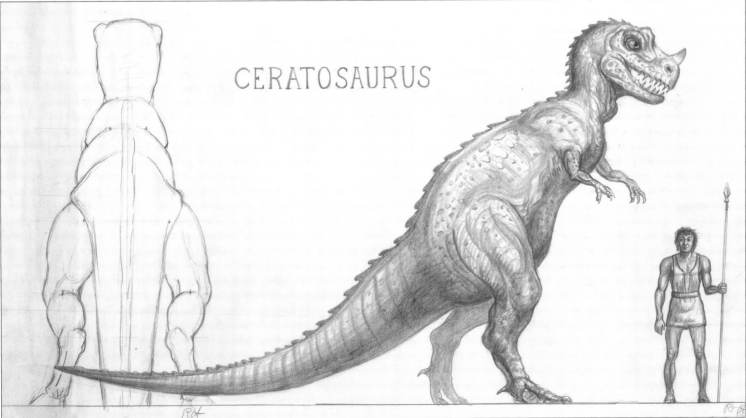

CERATOSAURUS

**Top.** Charcoal and pencil on art paper. 11½" x 7½". c.1952. Very rough sketches for what would become *The Beast From 20,000 Fathoms*. I was feeling my way to what I felt was the correct balance, and even sketching in a rough idea of the basic armature points.

**Bottom.** Pencil on paper. 30" x 14". c.1965. A comparison drawing for the ceratosaurus for *One Million Years BC*. He was designed to be somewhat plumper than he would eventually appear because I had to allow for shrinkage during the latex cooking process. .

**Right.** Charcoal and pencil on illustration board. 19" x 12½". c.1961. The Hall of Zeus. One of the key drawings I executed for *Jason and the Argonauts*. This scene didn't appear in the final film, for which it was changed to the temple of Hera. In the next chapter you will see some of the influences for this drawing.

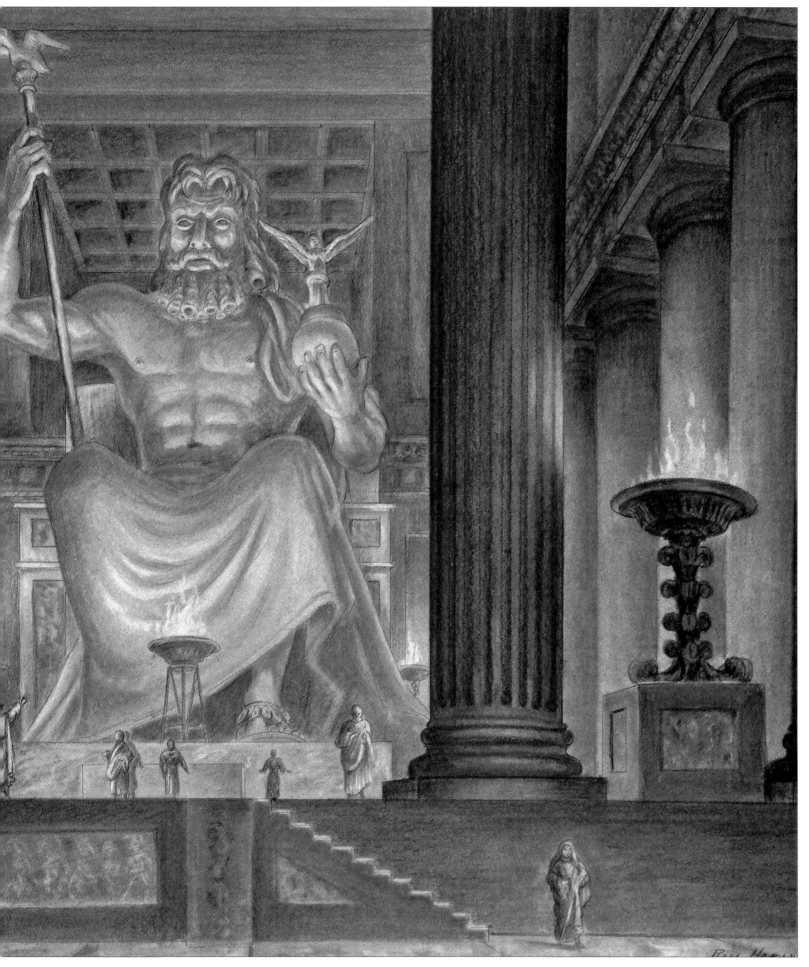

Obie usually had a team of technicians to do this, paid for by the studio. I didn't have that luxury and had to learn the mechanics of armature construction by trial and error. Armatures are works of art in their own right: they not only have to be designed to 'fit' perfectly inside the model, they also have to be articulated in such a way that each section is capable of being manipulated to produce the movements you require from that particular creature.

There are several methods of constructing the latex exterior for stop-motion models. I generally use one of the two most common procedures. The construction of my models has changed over the years as I switched from the use of the 'build-up' method to what I call the 'casting' method, although I have used both on occasion. For my earliest models, for example the creature in *The Beast From 20,000 Fathoms*, I employed the build-up method. I would begin the process by glueing layers of sponge rubber on to the metal armature and then, using a pair of scissors, I would shape the basic contours of the body. The muscles were then built up with cotton wool and more sponge rubber. In the case of the Beast, the skin was made by a combination of techniques. For its belly, I first of all made a cast of the stomach section of an alligator hide, obtained from a taxidermist, and I then made a clay model of the rest of the skin and made a cast of that. From the two casts I made a combined mould into which I poured liquid latex, which produced a thin 'skin'. The tail was cast separately. This 'skin' was then stretched over the sponge covered armature and secured with rubber cement.

I employed the build-up method for a number of years while occasionally using the casting method for a few models, including the Ymir in *20 Million Miles to Earth*. But as successive projects went into production I found myself employing the casting method more and more, and by the time of *One Million Years BC* I had almost completely changed over. The casting process began with a wax or clay model, from which I made a plaster mould. Then I would fix the armature securely in the mould, making sure it was central, before filling the mould with liquid latex, finally baking it in my kitchen oven. When it came out, I would clean it up and paint it. It sounds so simple when put into a few lines but I can tell you it was slow, painful and sometimes very frustrating, especially if the latex 'fell' in the oven and it came out like a limp noodle.

It wasn't that I preferred one method to the other, I still don't. I had learned the process of producing these models by means of the 'build-up' method but then I discovered that I could get extremely good results with casting, if I spent time ensuring the texture of the skin was realistically detailed. Texturing the skin with scales and wrinkles and other characteristics was apt to take a lot of time, although I love working on the minute detail because it provides the creature with character and depth. Time constraints meant I was sometimes forced to employ other artists to make the clay models, although they were all based on my designs. When they were completed I would usually add some of my own final details before I cast the model.

There were some creations that needed other methods of construction – for example, the skeletons in *The 7th Voyage of Sinbad* and *Jason and the Argonauts*. It's very difficult to hide a skeleton within a skeleton so, for those 'little lovelies', the armature had to be made very thin to allow me to build up the bone structure directly onto the armature. The structure was painstakingly built up with cotton dipped in a latex rubber solution, thus giving me the desired bare skeletal bones.

When I had my final armatured latex figure I was then faced with the job of finishing it off. This involved painting it and adding some of the features. In my early model-making days there were very few paints available that would adhere to rubber and not crack or flake. So, just as I was forced to make my own models, I had to make my own paints. Occasionally, I used rubber tyre paint while on other occasions I mixed Japan paint (called *Ground in Japan*) with rubber cement to get the correct colour and a consistency that would prevent cracking or flaking. When I was making my later models it was considerably easier as there were paints that had been specifically produced to work on plastic and rubber. Everything becomes easier if you wait long enough!

Then there were the teeth, tusks and eyes. Sometimes I made teeth or tusks out of metal, or made a mould and cast them in plastic, and sometimes I would use real teeth from a monkey skull or something similar. As for the eyes, depending on the creature, these were obtained either from doll-makers or from taxidermists.

Of course I also had to teach myself a huge variety of other trades that I needed to master if I wanted to be a model animator. I had to learn to paint backgrounds, build miniature sets, make mattes (a technique of optically combining two separately photographed scenes into one picture), match foregrounds and colour, develop what would become Dynamation (a process by which the performances of animated models and the human actors could be co-ordinated) and, last but by no means least, solve all those unexpected problems that would inevitably arise in front of the camera either during the live action or when I came to the animation phase. Nowadays, when a production is faced with a problem on set, or during the final stages of effects, there is usually a wide range of technicians available to put their heads together and come up with a solution. When I was working, right up to the final picture, I was usually on my own and had to solve those problems myself and as quickly as possible because – you've guessed it – time was money. There were many occasions when I had to create something out of nothing at the eleventh hour. For example, on *Jason and the Argonauts* I was faced with the challenge of producing the steaming ichor, or fluid, from Talos' ankle. I had no idea, in the planning stages, how I would achieve this; it was only on the animation table that I came up with the idea of using cellophane on a revolving disc lit by a red light – and it worked!

When it came to animating the giant crab in *Mysterious Island* I was confronted with a problem that I had known would arise when I began the designs, but that I simply hadn't figured out how I would solve. When animating, all models must be secured to the animation table. Usually this is done with pins fitted into the base of the model (usually the feet), which fit through holes in the table and are then secured underneath to prevent unnecessary movement. However, the legs of the crab were sharply pointed so that would not work in this case. In the end I solved the problem by drilling tiny holes in the tips of the legs, through which I fixed thin wires which ran down through the animation table and were secured below. Imagine the time it took, unhooking those wires and fixing them again each time I wanted to move one or more of the crab's legs! Another problem, this time totally unforeseen, arose on *The Valley of Gwangi*. I had meticulously planned for a real fifteen-foot elephant to perform in the bullring in the scenes before Gwangi appears, but when it came to the day, what did we get? A six-foot elephant. So, overnight, I had to rethink and redesign all the shots that involved the elephant. The only way I could do it was to animate the model elephant I had already designed for the fight with Gwangi, which in the end cost a lot of extra time.

A different kind of problem would sometimes arise on location when we were filming live-action footage that would later have to be combined with stop-motion animation. Although I always did a recce of each location in advance, there were sometimes difficulties that only became apparent once we were ready to begin live-action shooting. For example, I might have identified a location that seemed perfect for the scene that I had in mind, only to discover, once the cast and the crew were on site, that there was some feature, perhaps a rock formation, that prevented me shooting it exactly how I would have liked from an animator's point of view. It was no good just carrying on regardless, because that might leave me with an insoluble problem later on at the animation stage. Nor could the crew be moved elsewhere at short notice. So I would have to improvise a solution on the spur of the moment and change the shooting plan accordingly.

At the planning stage it was not always possible to visualize exactly how something was going to be done, and sometimes I knew that I was going to have a problem when I got to the animation table but would simply push the issue to the back of my mind and say to myself, 'I'll think about that tomorrow.' This is not something that most technicians are able to do today because of the vast

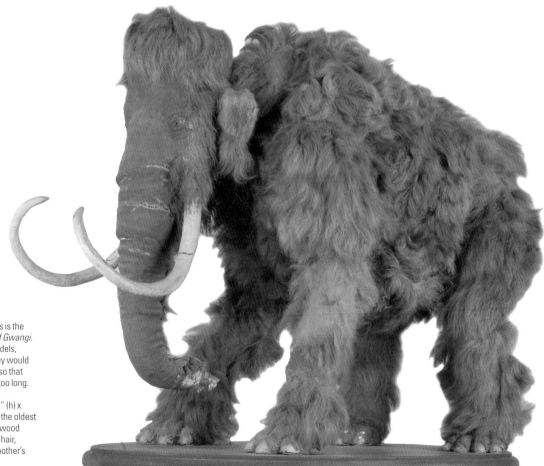

**Top.** Solid latex body. 13″ (h) x 22″ (d) x 7″ (w). c.1968. This is the solid, non-armatured, model for Gwangi for *The Valley of Gwangi*. I would often, although not always, make spare solid models, which would serve to see that I had the design right. They would also be used as 'stand-ins' whilst I was lighting a scene so that the armature model wasn't exposed to the hot lights for too long.

**Bottom.** Latex body with an internal metal armature. 13½″ (h) x 18½″ (d) x 8½″ (w). c.1938. My original woolly mammoth, the oldest of all my working models. The tusks are made of carved wood and painted to resemble ivory; the fur was Siberian goat hair, obtained from a taxidermist, and the trunk is one of my mother's old silk stockings.

amounts of money involved; but I was working in a dark backroom with nobody else to ask, and I was confident that when it came to the crunch I would come up with a solution. It has to be said there are one or two of those 'solutions' that I am not particularly proud of, but I have no intention of telling readers which they were.

Miniature set building was another skill I had to learn early on, during my amateur days. I had read somewhere that Obie had cut his palm trees, complete with branches and leaves, out of metal so that they wouldn't move when he was animating the models within those sets. For my early experiments I decided to follow his example, so I used scissors to cut my palm leaves out of very thin copper sheets and then attached them to trunks made out of papier mâché or plaster. These miniature trees were extremely detailed and took me so long to make that I saved them for re-use – the same trees and flora appeared several times in *Evolution of the World*, *How to Build a Bridge*, *Guadalcanal* and, sometimes, in the Fairy Tales. This was my miniature props department, all stored in my dad's garage.

In these early days I also painted most of my own backgrounds, although on occasions a friend of mine who was interested in my work and had a talent for painting produced some for me. The very earliest of my amateur subjects, which I shot out in the open, had backgrounds painted on canvas or cardboard, which could be seen flapping in the breeze – never a good thing when you are animating. Another drawback to shooting in the open air is that the sun, and thus the shadows it creates, moves round as the animation progresses – an effect that is, of course, greatly exaggerated by the stop-motion process. But these were minor hiccups which taught me useful lessons (such as never shoot in the open) and I soon began to improve my techniques, gradually learning to follow the methods used by the feature film people, albeit on a much smaller scale.

An animator often has to master some unexpected skills. For example, when I started to make *The 7th Voyage of Sinbad*, which was going to involve much swordplay between the hero and my animated skeletons, I realized that I would have to learn the art of fencing. So I enrolled for a course at the Faulkner Fencing School on Sunset Boulevard. I must confess that I enjoyed it, but I had to give it up when I threw my hip joint out. What we artists suffer for our art!

Of course, the final and most difficult part of my art is the animation itself, which brings me back to where I began this introductory chapter. I always tried to instil character into my creations and to express that character through their movements. In order to achieve that I had to observe how the character of animals and humans was expressed through movement and then translate those observations into action when I manipulated my models. This kind of insight can come from studying an animal in a zoo, watching someone walking down the road or simply noticing how other artists have achieved an effect in a statue, a painting or an illustration in a book. I look at such things, make a mental note and then store it away. Sometimes such observations did not bear fruit for years; but sooner or later they would seem to be just what was required to bring a particular creature to life or to make a particular scene work and, through a process that is mysterious even to me, they would materialise again in the movements of my models. That's the way I see it. Of course, there are limits to how much character you can put into a creature. Joe in *Mighty Joe Young* was a gorilla and so I could give him human traits; a dinosaur is much more difficult, but he still needs a character to make him work for the audience.

In this chapter I have tried to outline just some of the skills that I had to master in order to bring my creatures to life on the screen. Today, it is all done by banks of computers which create the animated images of dinosaurs, spaceships or whatever that are then combined with the background or live-action plate. Although I had to combine the movements of my models with those of the human actors on my own live-action plates, I also had many other 'tricks' to perform: I had to be a carpenter, a metal worker, a matte artist – in fact an odd-job man. I had to master whatever was required to make it all come together.

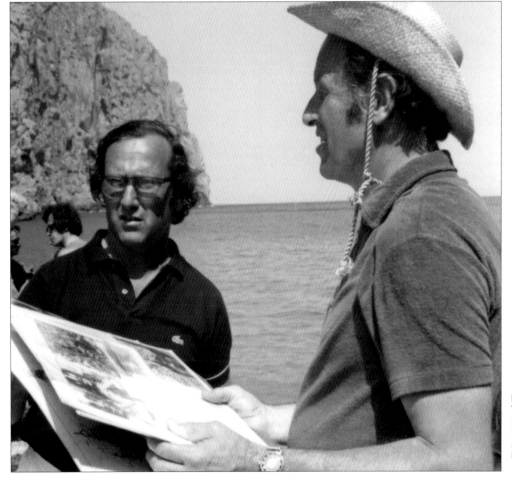

**Left.** Charles and myself on location in 1972 at the beach in Torrentes de Pareis in Majorca, Spain for *The Golden Voyage of Sinbad*. We are discussing what is required for the next shot and I am showing him my sketches for how I saw the scene. As with all locations there is of course an element of compromise, which is probably what we were discussing.

**Above.** Charcoal and pencil on illustration board. 19" x 12½". c.1961.
Key drawing for the Phineus and the Harpies sequence in *Jason
and the Argonauts*. This is one of my favourite drawings for the
film and shows the influences of Gustave Doré and, to an extent,
John Martin.

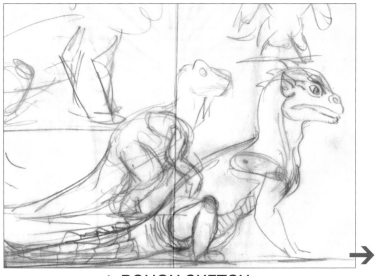

1. ROUGH SKETCH

2. TRACING

5. STORYBOARD

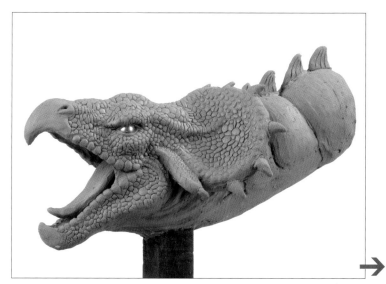

6. CLAY MODEL

9. MOULD

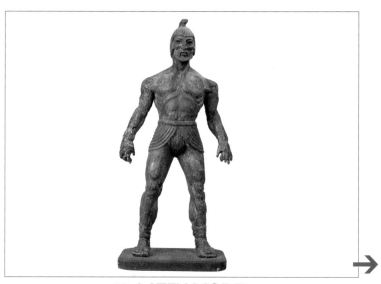

10. LATEX MODEL

3. KEY DRAWING

4. COMPARISON DRAWING

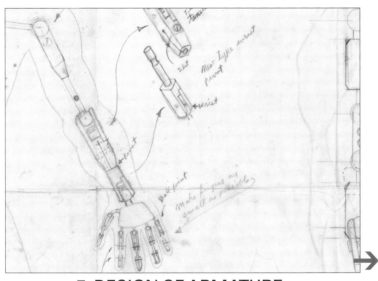

7. DESIGN OF ARMATURE

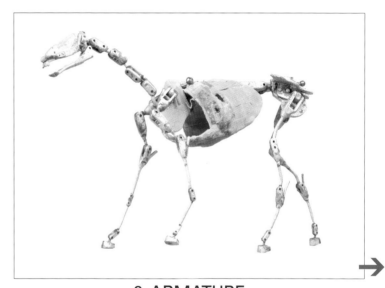

8. ARMATURE

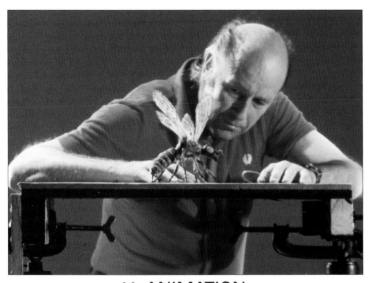

11. ANIMATION

# CHAPTER 2    INFLUENCES & INSPIRATION

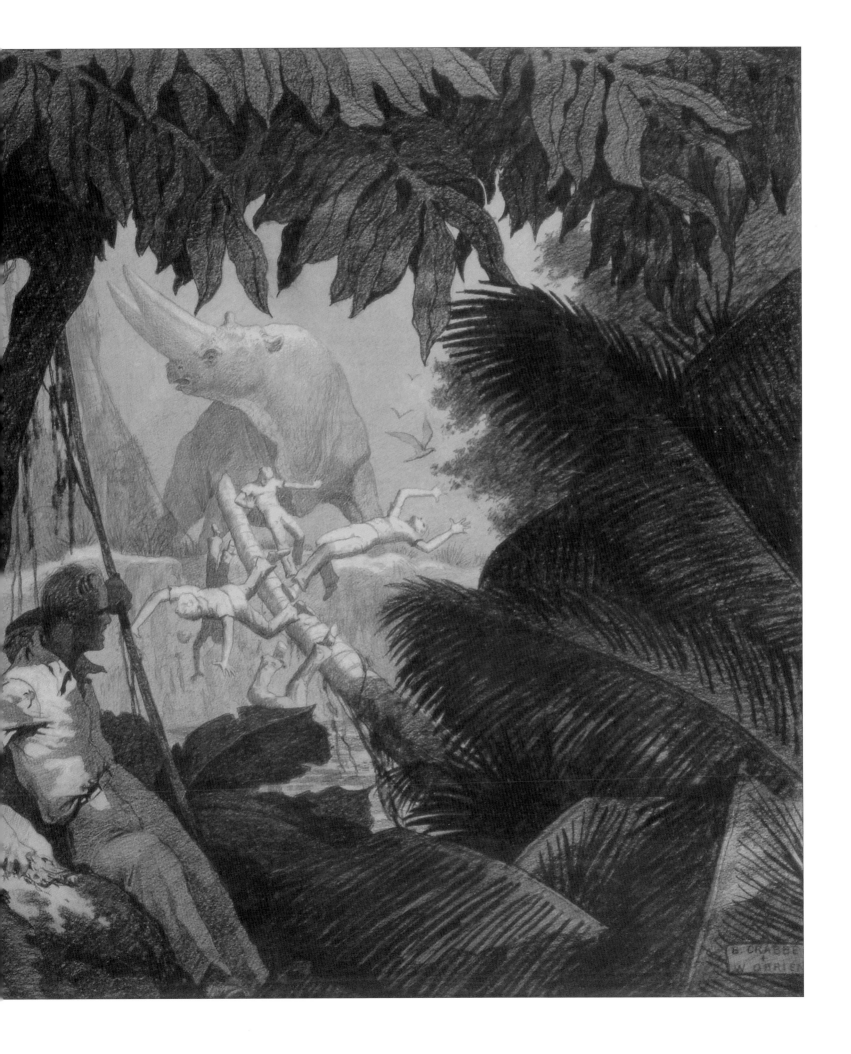

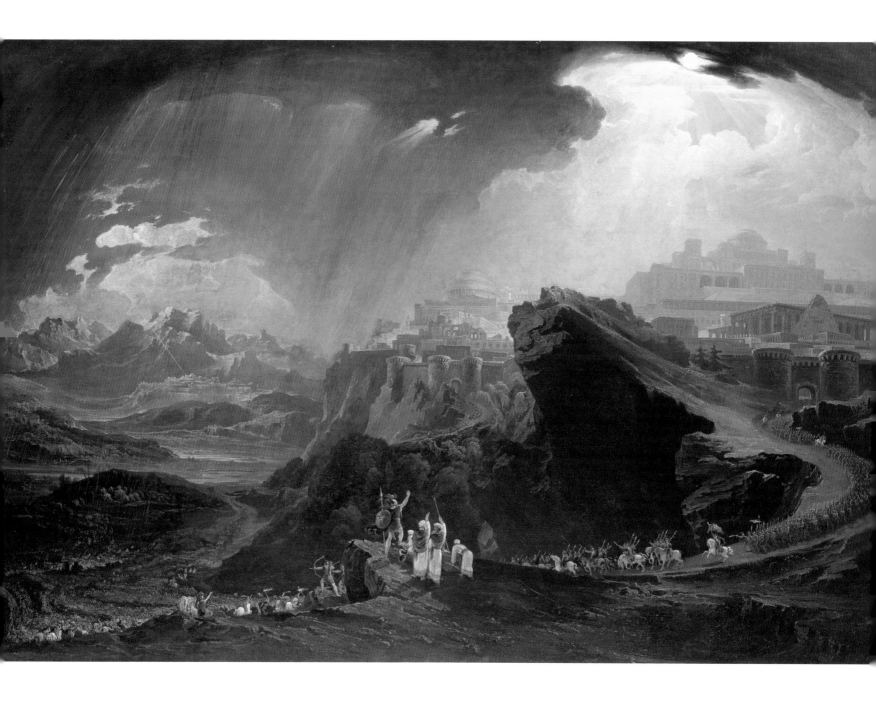

**Previous page.** Charcoal and pencil on illustration board. 22″ x 17 ¾″. c.1930. Unrealized scene for *Creation* by Willis O'Brien and Byron Crabbe. A two-horned arsinotherium attacking adventurers on a log. Although the film was never made, the log scene was incorporated into *King Kong*.

**Above.** *Joshua Commanding the Sun to Stand Still upon Gideon*, 1816, by John Martin (1789–1854), private collection. Oil on canvas.

ALL OF US WHO ARE LUCKY ENOUGH TO HAVE worked in the arts owe a debt to those of our predecessors whose work first inspired us to embark upon an artistic career and then influenced the direction of that career. Ever since the cavemen, artists have been influenced by other artists and have built upon those influences to create something new. For example, the Roman sculpture *Laocoon*, based on the story of a Trojan priest who, with his two sons, was crushed to death by two great sea-serpents, itself based on a Greek original, was rediscovered during the Renaissance period and, along with other examples of classical sculpture, had a dramatic influence on contemporary Italian artists who abandoned the gothic style of the Middle Ages and now sought to re-create the style of their Greek and Roman ancestors. When it came to choosing their subject matter, though, many of them continued to be inspired by Christian themes, especially the story of the Virgin Mary, rather than by classical myth.

Influences can, of course, cross the boundaries between different art forms. Thus, although the cinema was to develop into one of the greatest art forms of the twentieth century, the main visual influences on the early film pioneers (directors, art directors and even cameramen) were paintings, sculpture, drawings and engravings. They seized upon the images that impressed them and translated the underlying ideas into the new medium of the moving image.

I have always acknowledged that I was deeply influenced by several artists whose work meant a lot to me, and this is especially true when it comes to my drawings and paintings. Indeed, I have never been happy with my own work in these fields because I wanted to be as good as the people I admired, and often despaired of achieving that goal. However, I never tried merely to emulate their work, because I knew I would be unable to do so. Instead, I studied the techniques they used to achieve depth in their pictures, their use of lighting and their compositions, and tried to apply the lessons I learned when creating visualizations of scenes that arose from my own imagination.

Since this book deals with my own art, I think it is important to declare my own influences up front. I will not bore you by listing all the artists whose work I admire, but will concentrate on those whose influence had a direct effect on my own creations, on paper, in clay and in latex, which were produced as part of the process of creating our films.

Gustave Doré (1832–83), it has always seemed to me, was a motion-picture art director born before his time. In the early days of film production his influence on many directors, and certainly on art directors, was immense. The director Cecil B. DeMille was so impressed by Doré's biblical images that he borrowed groupings from Doré's illustrations for use in several of his films; they feature in some of the more exotic scenes in *Male and Female* (1919) and *Samson and Delilah* (1949) as well as in both of his versions of *The Ten Commandments* (1923 and 1956).

Doré was born in Strasbourg and became one of the world's leading book illustrators, working in France for most of his career. Some of his most popular illustrations were for *Dante's Inferno* (1861), *Les Adventures du Baron Münchhausen* (1862), *Don Quixote* (1862), *Atala* (1864) and The Bible (1866). He had an enormous influence on Van Gogh (who based one of his painting on Doré's Newgate illustrations) and commercial illustrators, amongst them artists who visualized scenes from Jules Verne's novels. His imagination and his talent for dramatic composition is typified by his unique way of focusing light onto the centre of the picture, by creating a dark foreground and background and highlighting the central action. The effect is almost cinematic. He favoured the use of a dark foreground, medium plane and very light backgrounds to help create a sense of depth. Sometimes his pictures look almost like a single frame from an epic film.

I had seen some of Doré's work when I was young but it had not made any lasting impression on me. However, when I met Obie he changed all that. He explained what an influence Doré had had on his own work and how much that was reflected in the pre-production artwork for *Creation*, *King Kong* and subsequent work. This made me reassess Doré and recognize the trace images that appear in *Kong*, especially Skull Island, the island's interior (the fallen log was right out of *Atala*, 1864), the crossing of the swamp on the raft and Kong's lair. The pre-production artwork gave the film a unique depth and character, and above all a heightened sense of fantasy.

Once I discovered Doré's 'cinematic' eye, I started to collect books illustrated by him. This began before I went into the army, and continued when I was posted to New York. Whereas most of my colleagues were enjoying the entertainment benefits of the city, to me it was like an Aladdin's cave of antiquarian bookshops. It was there that I found

some of the rarer Doré editions – *The History of the Crusades* and *Roland the Furious*, both of which are beautifully illustrated and are seldom seen. Because nobody was really interested in those kind of books then, I managed to buy them for cents. Later, whilst I was filming in Spain, I came across a copy of his travels through Spain, again a rarity. All these volumes and many more have inspired my own work, specifically how I composed my key drawings, intended to impress the money men and sell the idea.

It was about the same time that I discovered Doré that I also became fascinated with the work of the English artist John Martin (1789–1854). His use of depth and lighting and also his imaginative and romantic visions not only attracted me because of their style but also engaged my imagination. Martin was a painter of spectacular and apocalyptic scenes and his work continued the tradition of Turner's historical paintings. Born in Northumberland, in north east England, he first exhibited at the Royal Academy when he was twenty-three, with the dramatic and powerful *Sadak in Search of the Waters of Oblivion* (1812), a painting I deeply admire. When he exhibited *Joshua Commanding the Sun to Stand Still* (1816) and *Belshazzar's Feast* (1821) they caused a sensation, making a huge impression on the public even though the critics were less than impressed (a reaction with which I am more than familiar). Other works included *The Destruction of Herculaneum* (1822), another of my favourites, and *The Seventh Plague* (1823). His later work *Last Judgement* was made up of three gigantic canvases, including *The Great Day of His Wrath* (1851–3), which was an incredible, visionary masterpiece, depicting catastrophe and conveying an overwhelming sense of destruction. In the middle of the nineteenth century (the painting continued to be exhibited throughout Britain and America for nearly twenty years after his death) the only way that such destruction could be visualized or explained was as a manifestation of the wrath of God – an apocalyptic warning. The painting is full of violent movement and dominated by the messengers of death – earthquake, rain and lightning – with mountains and cities being cast into the abyss. Like Doré's illustrations, it resembles a frame from a movie – this time, perhaps, a blockbuster disaster movie.

There is one other British nineteenth-century painter who has been an influence on my work. His name was Joseph Michael Gandy (1771–1843) and he trained as an architect and was awarded a Gold Medal at the Royal Academy School in 1790; although he was never really accepted by the Academy. In 1798 he was employed as a perspectivist in the offices of the great architect John Soane. His most famous picture, *Jupiter Pluvius*, was exhibited at the Academy in 1819. His drawings, watercolours and oil paintings were grand and architecturally spectacular, although they are little recognized today. His real fame rests upon his architectural designs, which ranged from cottages to a town residence for the Duke of Wellington.

Gandy rarely executed anything except upon a grand scale.

It was somewhat belatedly, in the middle of the 1960s, that I discovered Gandy. I had decided that I would like to try and purchase a John Martin painting and so I looked around London auction houses and galleries. Although there were some available at the time (remember that such paintings were not that popular in the swinging sixties) the prices were impossibly high. Reluctantly I dropped the idea. One day, however, a friend of ours who owned a gallery happened to mention that she had a large painting that she had hoped was a Martin but which she had been unable to sell because it was unsigned. After extensive research, she established that it must be by Gandy as the flagstones depicted in the picture were very typical of his work. I know it sounds incredible, but that's how it was identified. I loved the painting. Like his other work, it is spectacular; the subject is a huge, sprawling, ancient city, not in the process of destruction this time, but vibrantly alive, showing the everyday life of the civilization that dwelt there, as imagined by Gandy. The entire city is dominated by a colossal seated statue of Jupiter which influenced my own version of Hera's temple and how I wanted Olympus to look in *Clash of the Titans*.

These three artists have meant much to me, both as an art-lover and as a film-maker. However, it was another artist, perhaps not as internationally known as the others, who showed me how to look at animals, especially long-dead ones, and to study the way in which they moved. His name was Charles Robert Knight (1874–1953), a distinguished American artist who not only painted and drew contemporary animals but, most famously, put 'flesh' on the bones of prehistoric animals. He was responsible for producing 'reconstructions' that showed how these long-dead creatures might have looked, based on the fossilized bones that were being excavated around the world. His collaborator in this endeavour, Professor Henry Fairfield Osborn, was a close friend of Knight's and a leading palaeontologist who held a senior position at the American Museum of Natural History in New York. This museum, along with most other similar institutions, had acquired a great many fossil dinosaur bones, and some of them had been re-assembled into more or less complete skeletons, but up until then nobody had tried to visualize what the living creatures would have looked like in the flesh, complete with their muscles and skin. Working with Osborn, who wanted above all to bring the public into his museum to see these bones, Knight 'built up' an idea of what they might have looked like and began drawing, sculpting and painting interpretations. His depictions helped people to realize how magnificent these creatures had been and so established their place in the public's imagination, where they remain today.

Knight's dinosaur paintings and drawings had more than just a realistic surface quality about them; they very clearly exhibited that unique nobility of

inspiration and dedication that separates the true creator from the mere draughtsman. Knight was not only a pioneer in terms of his close collaboration with palaeontologists with the aim of achieving scientifically accurate anatomical reconstructions; his methods were novel too. He would meticulously model each animal in three-dimensional form before attempting to depict it on canvas. His long experience of drawing and painting live animals in zoos gave him insights into the ways in which anatomy influenced movement and his vivid, romantic style gave his prehistoric reconstructions a unique 'charisma'.

My first encounter with Knight was in the Natural History Museum of Los Angeles County where there was, and as far as I know still is, a beautifully executed mural by him, showing a prehistoric scene at La Brea tar pits (within the city limits of modern L.A.) peopled with creatures that had become mired in the tar, thinking the pits were filled with water. I was only a small boy with a more than vivid imagination and I found that mural truly awesome, so much so that the image has never left me. My mother, who must have realized how impressed I was with the painting, bought me a picture-book of Knight's work called *Before the Dawn of History*. It included many illustrations of both carnivorous and herbivore dinosaurs; the first category fascinated me far more than the second, as is the case with most young boys today.

While I was in the army in New York I found Knight's number in the phone book and decided to call him. He answered the phone and for a while I was somewhat tongue-tied as I tried to tell him who I was and why I was phoning, but in the end we had a long, wonderful chat; sadly I cannot remember all the details of our conversation but I do remember was that he was very easy to talk to and very responsive and it was extraordinarily heartening to find that a man whom I hero-worshipped seemed genuinely interested in my struggles to bring dinosaurs to the screen. During the course of later phone conversations we discussed *The Lost World* and, of course, *King Kong* and he told me several times that he had been impressed with them. Obie would have probably written to him when he was making *The Lost World* because there was so much of Knight in that film. I planned to meet Knight, who had an apartment on 59th Street, overlooking Central Park, but, like so many other things, I never got around to it. I have always regretted this because I would have loved to have met him and discussed his paintings and the pioneering days of visualizing prehistoric creatures. However, I am fortunate to know Rhoda, his wonderful granddaughter, who has in many ways made up for that missed opportunity.

Incidentally, I had a very similar thing happen to me with Stan Laurel. He lived down in Santa Monica in a little apartment and when Ray Bradbury and I got to know this we planned to go down and visit him but we kept delaying until the dear man passed away. I suppose we all put things off, but

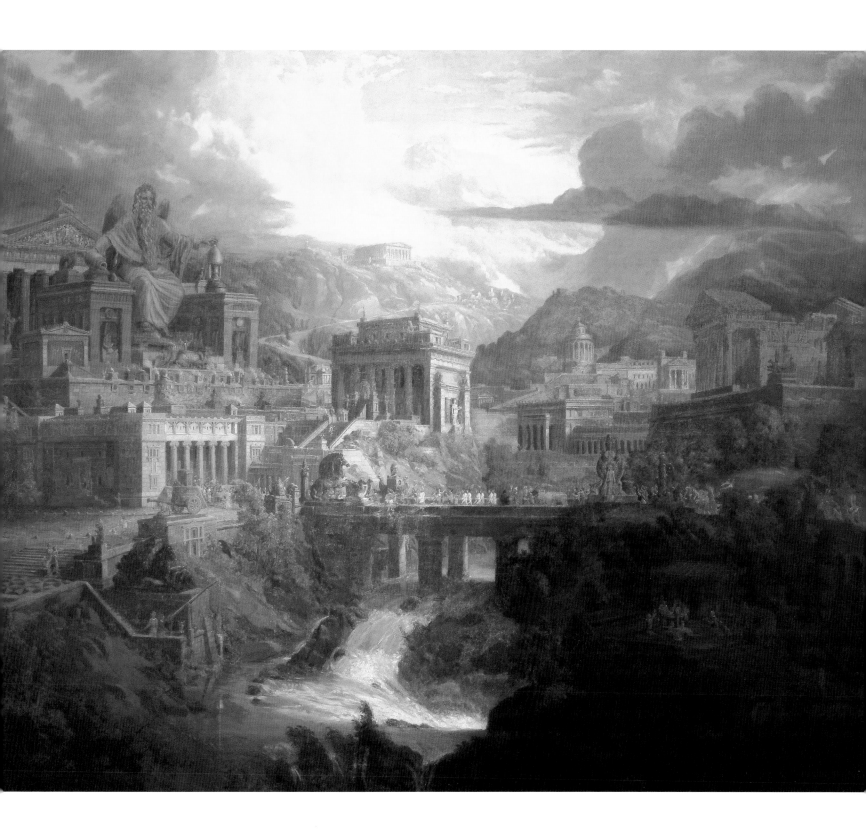

**Above.** *Jupiter Pluvius* by Joseph Michael Gandy (1771–1843).
Romanticized ancient city with a colossal seated statue of Jupiter.
Oil on canvas. 75" x 59". Gandy is a relatively unknown painter but
for sheer spectacle there are few others who come anywhere near
him. This painting is one of my most prized possessions and has
been a huge inspiration to me throughout my career, teaching me
to think big and give my inspiration free rein.

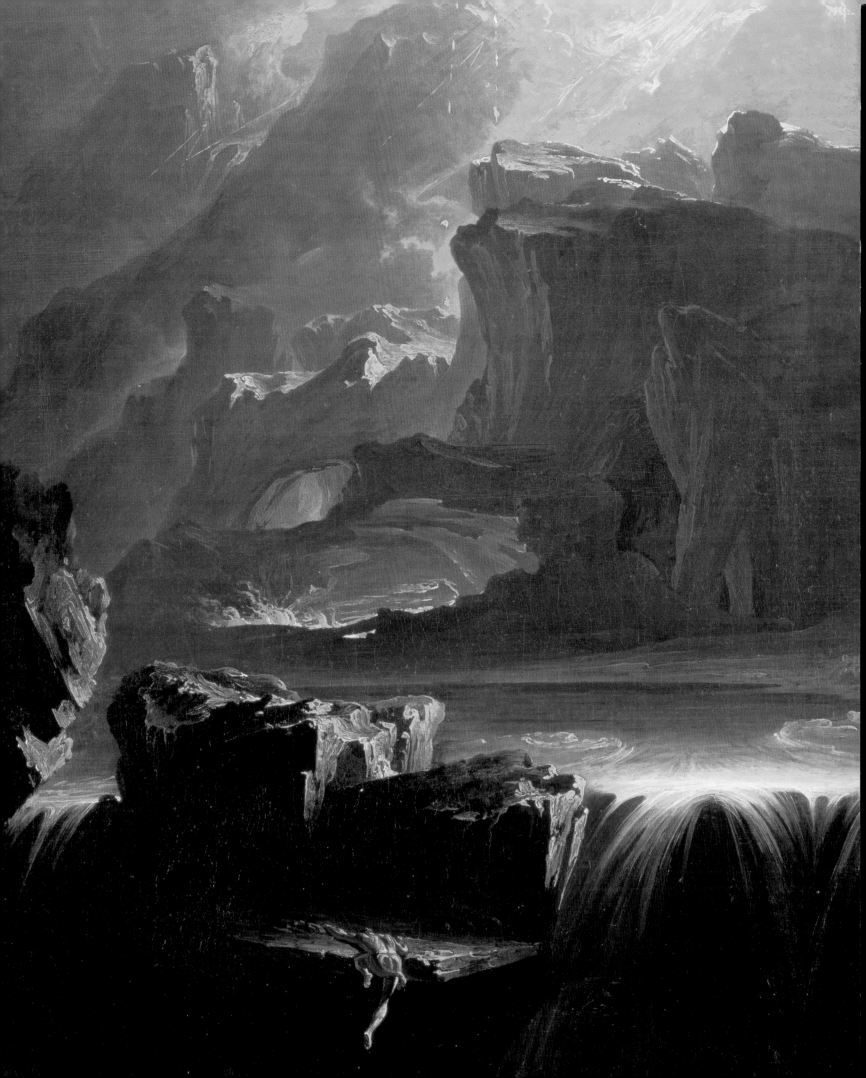

with people like Charles Knight and Stan Laurel, procrastination can lead to the loss of a potentially unique opportunity.

Charles Knight was the master of reconstruction in an artistic form. He brought dinosaurs and other prehistoric creatures to life in the public's imagination long before film could do so. For me, he is one of the most unjustly neglected of artists. His illustrations are rendered with such clarity and his attention to detail was so scrupulous – on the basis of the most up-to-date information available at the time – that it saddens me that he gets little or no recognition from the art world. Nor does he get the credit for having inspired, directly or indirectly, a whole range of movies.

While the drawings and paintings of Doré, Martin, Gandy and Knight showed me that, given the skills and the talent, it was possible to put on paper or canvas almost any scenario you could imagine, it was Willis O'Brien (1886–1962) who took things a step further and showed me that whatever I imagined, no matter how extraordinary, could be brought to life on screen. It was through his films that I discovered the art of stop-motion animation but Obie also impressed on me the importance of design and the way in which my creations were constructed. It is him that I have to thank for teaching me how to put into three

dimensions what I had only managed to do in two and so to bring 'alive' those creatures that inhabited my fantasy 'lost world'. Obie was multi-talented, an accomplished artist in all the relevant areas of film-making.

Before coming to films, he had many jobs, mostly unrelated to art. He started as an office boy but progressed to become a draughtsman working for a firm of architects. Utilizing his natural artistic talents, he then became a sports cartoonist for the *San Francisco Daily News*, which would have helped him to achieve speed and quality in his sketching. He also worked as a sculptor for the 1915 San Francisco World Fair, making statues and ornate carvings, which must have added to his talents.

It was Obie who first realized the theatrical potential of the dinosaur. Just as I did later, Obie had begun his career as an animator using dinosaurs because they were the obvious choice for stop-motion animation. As nobody had ever seen them alive, no one was in a position to dispute the way in which the animator chose to depict them – though, of course, their movements had to bear some resemblance to the audience's everyday experience of seeing other creatures going about their business. Obie called his process 'animation in depth', meaning three-dimensional model animation. His earliest models used a wooden armature

covered with modelling clay and the designs were based upon the advice of Dr Barnum Brown, a palaeontologist at the American Museum of Natural History in New York. Although crude, they did allow Obie to experiment with movement and to establish, by trial and error, in what increments an animator should move a model in order to convey a lifelike impression of fluidity. Obie's first commercial film, for which he animated an ape and a brontosaurus, was *The Dinosaur and the Missing Link* (1915), a short one-reeler. The two models were constructed using metal armatures covered with sections of rubber to give the creatures some texture. Then, in 1919, he made *The Ghost of Slumber Mountain*, a two-reeler featuring dinosaurs which was a huge commercial success. But it wasn't until 1925 that Obie took the final step and made a full-length feature film using his methods. This was, of course, *The Lost World*, based on Sir Arthur Conan Doyle's classic novel. This was also the first time that Obie drew sketches and made tests for the project to demonstrate what he intended to put on the screen. Along with model-maker Marcel Delgardo he constructed fifty or so models for the film, all based on Charles Knight's paintings at the American Museum of Natural History. All had steel armatures, around which was packed sponge to simulate muscles before they

 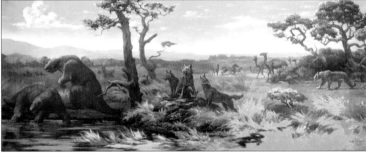

**Left.** Detail from *Sadak in Search of the Waters of Oblivion*, 1812 by John Martin, Southampton City Art Gallery. Oil on canvas.

**Above (both parts).** Charles R. Knight's mural for the *La Brea Tar Pits* (1925), Natural History Museum of Los Angeles County. This mural made an enormous impression on me as a child.

**Right.** Obie working on an oil painting for the unrealized project *Gwangi*. Obie painted the creatures and Jack Shaw rendered the backgrounds.

were covered in a layer of latex rubber. I saw *The Lost World* as a five-year-old and it inevitably left a huge impression on me.

In 1930 Obie began work with RKO on a project called *Creation* about a group of castaways marooned on an island inhabited by dinosaurs. He worked for over a year on pre-production drawings and tests but in the end the film was cancelled. However, the work wasn't wasted as a new project began to materialize, and one that would change Obie's career forever.

1933 saw the advent of *King Kong*, on which Obie not only worked with other animators completing the animation of Kong and the various other prehistoric inhabitants of Skull Island, but was also largely responsible for the pre-production artwork and other technical effects. Most of the films and projects with which Obie was involved over the years up until his death in 1962 were dominated by dinosaurs, which was, perhaps, the main reason why he didn't take three-dimensional stop-motion animation in other directions. That would be left to me.

Obie's artwork was immaculate in detail and execution. It had to be. When visualizing a scene in a movie for the producer and the front office, it is vital that all drawings and sketches convey the essence of a sequence instantly. Obie taught me that

they should always be exciting, even awe-inspiring, but also practical in terms of what could ultimately be achieved on the screen. He had a unique talent for achieving that combination, and he was able to inspire his fellow artists and designers to achieve it too. This latter point was important, for Obie didn't work alone on creating the large key sequence artwork for *Creation*, *King Kong* or his subsequent features. It would have been just too much for one man to visualize every scene, design it and then incorporate it into the complete picture. His assistants included other accomplished artists such as Byron L. Crabbe, Mario Larrinago, Ernest Smythe, Duncan Gleason, Leland Curtis and Jack Shaw.

On *Creation*, Mario Larrinago and Byron Crabbe assisted Obie in creating the artwork for key scenes showing prehistoric creatures amid ruined temples and jungle. Both these men also painted the backgrounds for the animation tests. Byron Crabbe was a set designer and effects artist whose outstanding career was brought to an abrupt and untimely end when he died in the mid-1930s. Mario Larrinago was born in Baja, California and began his professional career aged sixteen without any formal training. Apprenticed to his brother Juan, he painted sets for theatre productions at a scenic studio and then, in 1916, he was offered the job of technical artist at Universal Studios, eventually

going on to run the art effects department at Warner Bros. Between them these two artists shared the credit for drawing some of the most exciting key scenes. But it was Obie who was the guiding light. He would quickly execute a series of rough sketches, which were then used to draw the continuity artwork. Obie would usually draw the creatures and other artists would do the backgrounds and foregrounds, or sometimes Obie would create the composition and leave it to Byron Crabbe, or whoever he was working with, to produce the finished article. It was a team effort, but Obie was the leader.

*Creation* was never completed and when Obie suspected the project would be scrapped and that Merian C. Cooper, the producer, had the idea of making a gorilla picture, he, along with Crabbe, executed an oil painting of a huge, angry, drooling gorilla charging a hunter who was protecting a native girl. As legend has it, it was that picture that did the trick and so *Kong* became reality. When production began, Obie made many hundreds of small sketches and Larrinago and Crabbe then worked from them to produce many of the key drawings.

As I have already pointed out, the atmosphere of Skull Island in *King Kong* owed much to the influence of Doré, but it was Byron Crabbe and

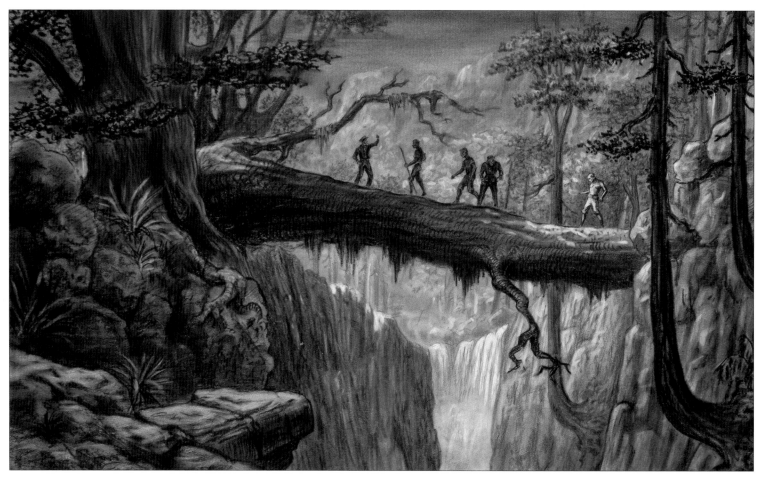

**Above.** Charcoal and pencil on illustration board. 17″ x 11″. c.1960. Log sequence for *Mysterious Island*. This is my homage to Doré, whose original is reproduced opposite.

**Right.** Illustration by Gustave Doré (1832–83) for *Atala* (1864).

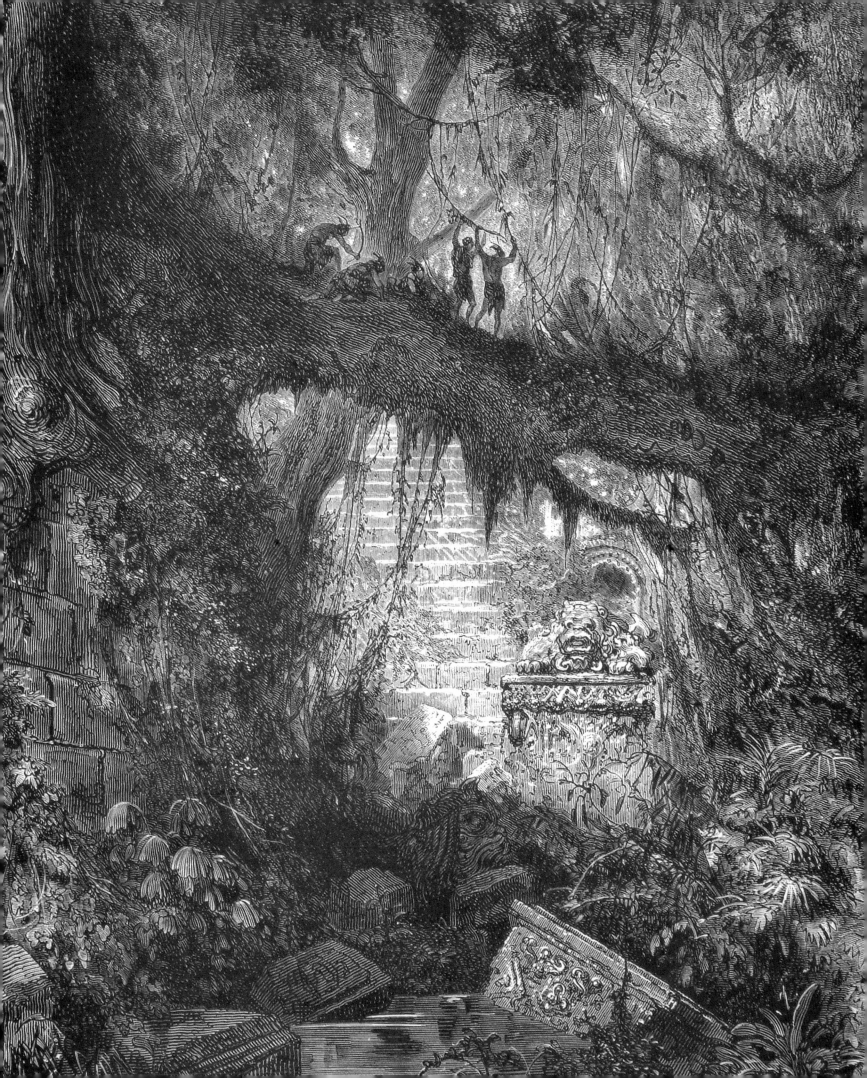

Mario Larrinago who painted all those spooky jungles that made the sequences on the island so original and powerfully mysterious. It was whilst preparing the early part of *Creation* that Obie first used Doré as the guideline for the effects he wanted to achieve. He once told me that to obtain the atmosphere of light and darkness in the picture, especially in the jungle scenes, he showed the production team Doré illustrations, including images from the Bible, *Atala*, *The Divine Comedy* and *Paradise Lost*. What also assisted in achieving this Doré-like depth was the use of sheets of glass on which the jungle was painted; these simulated a three-dimensional effect. I would say that Obie's technique was the first multi-plane camera (Disney's multi-plane camera was vertical, of course, whilst Obie's was horizontal). It enabled a scene to achieve depth by focusing the light on the action in the middle, but 'sandwiching' the jungle on layers of painted glass. However the painted jungle also had the advantage of preventing any movement that miniature foliage might suffer during animation, which was always an ongoing problem that all animators have to consider.

While working with Obie on *Mighty Joe Young* (1949) I was always amazed not only at his ability to visualize so perfectly what he wanted, but also at how quickly he could render a sketch or even a large drawing. His hand moved swiftly across the paper in confident strokes, creating a superb piece of art that I could only dream of rendering. It takes me so much longer. He was an extremely accomplished artist and if he had set his mind to it he could have made a separate living from drawing alone. But it was the movies that he loved and upon which he wanted to concentrate all his talents, though sadly the movies didn't always want Obie.

Considering the huge amount of artwork that Obie must have turned out, very few examples survive today. I am lucky to have some originals of his large drawings, watercolours and storyboards, which I treasure not only in his memory but as superb pieces of art in their own right.

Obie and *Kong* will be forever linked together. It was his greatest film and, after more than seventy years, it still stands as a masterpiece equal to any of the greatest fantasy films made today. There have been copies – the awful *Son of Kong*, which Obie hated, and *Mighty Joe Young* on which I worked with him – and there will, I suppose, always be attempts at remakes, the best of which will, I suspect, be Peter Jackson's forthcoming interpretation of the story.

Over the years I have often heard it said that I was so influenced by *King Kong* that most, if not all, of the ideas in my movies, are copied from *Kong*

and that I do not have an original idea in my head. I come back to what I said at the beginning. All artists need to be inspired. Of course, *Kong* was a huge influence on me and my career but I have never consciously copied ideas from it, only been inspired by it to create situations and drama that would inspire others as that film inspired me. In *Mysterious Island*, for example, the explorers use a fallen log to cross over a ravine. I freely admit this episode owed much to the similar sequence in *Kong*, indeed, was a conscious tribute to it, but don't forget that the sequence in the original was inspired by Doré. Nothing is new; we simply reinterpret a good idea.

It's always very gratifying when a director, producer, effects technician or makeup artist tells me how much our films have influenced him or her. People like George Lucas, John Landis, Peter Jackson, James Cameron, Steven Spielberg, Nick Park and many others have told me that it was a scene, a creature or an episode in one of our movies that inspired something in one of their own films or, in some cases, even set them on the path to their career in movie-making. That such people should suggest that my work played a part, in even the smallest way, in their success makes worthwhile all the hardship, frustration, pain and sometimes anger that accompanied the making of our films.

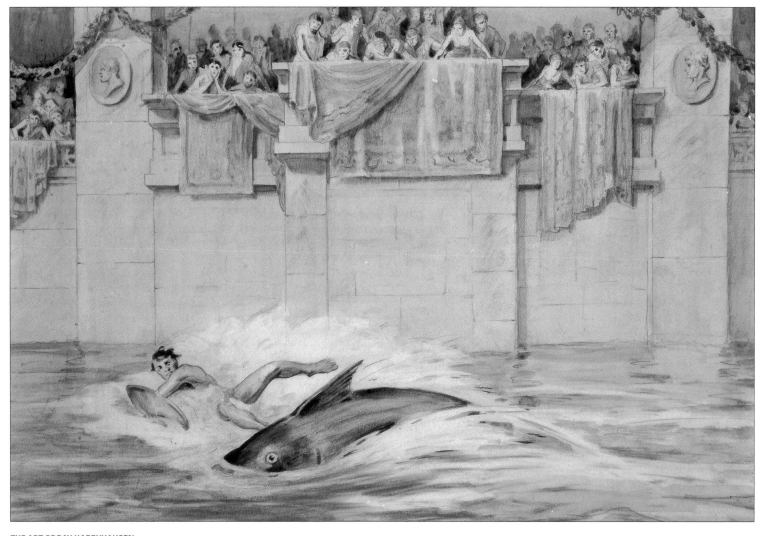

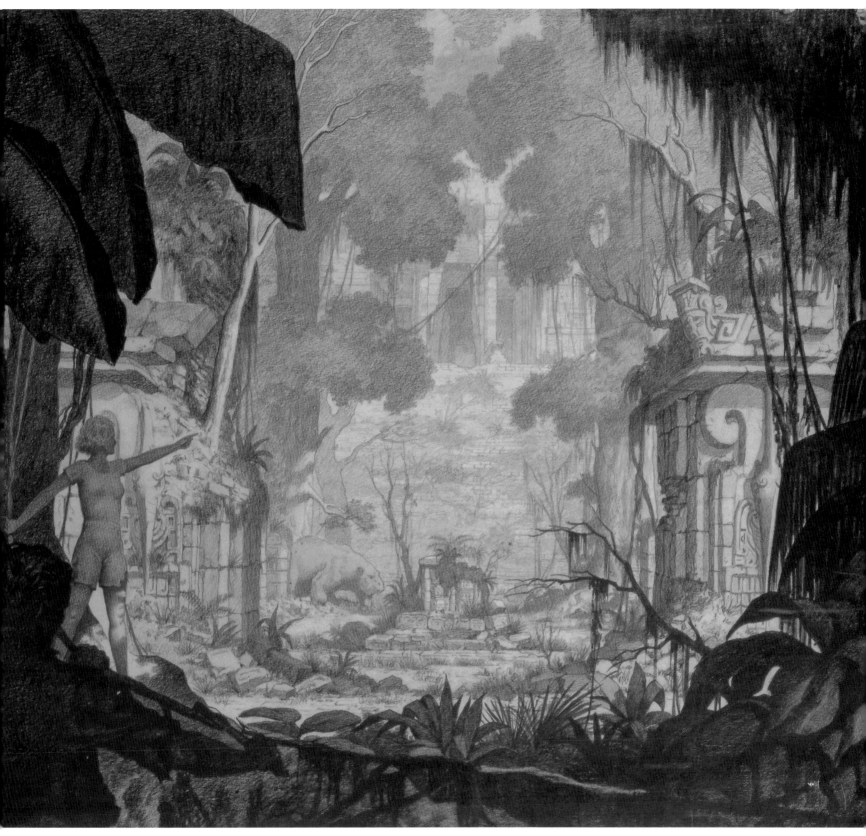

**Left.** Black and white ink wash. 20″ x 15″. c.1934. Concept for *The Last Days of Pompeii*. A very rare and beautiful drawing by Obie and Byron Crabbe. Originally the arena was to be flooded and the slaves pursued by swordfish, but Cooper and Schoedsack changed their minds (probably because of the cost) during the script development.

**Above.** Pencil on illustration board. 22″ x 17″. c.1930. Key drawing by Byron Crabbe for the unrealized *Creation*. In this drawing, based on Obie's designs, the adventurers are exploring a ruined city when a prehistoric giant sloth emerges from the background.

# CHAPTER 3    MASKS, MAYHEM & MONSTERS

*String puppets*

*Rubber masks*

*Paintings of ghouls*

So where did I begin? Well, my first genuine attempts to recreate *Kong* started at my junior high school, called Audubon (after John James Audubon, the ornithologist and bird illustrator), where my English teacher stimulated my interest in string puppets. She wanted one of the class to put together a puppet play, which she called 'Good English, Bad English' and, knowing of my talent for modelling, asked if I would undertake the task.

For my 'production' I made two puppets with heads, arms and legs of papier mâché and clad in outfits made by my mother. One character was a gentleman representing good and the other was the devil, representing bad. Putting modesty aside, I think I can claim that, although not a box-office smash, it was my first success. So much so that I was encouraged to construct other puppets for further productions, the next of which (and this will not come as a huge surprise) was a version of *King Kong*, complete with ape, brontosaurus and stegosaurus. I am not too sure how far humans featured in that story; perhaps I cut them out altogether in favour of the creatures, which were for me at the time the 'real' stars of the picture.

After that, although there was, of course, a strong human element in films like *Kong* and *The Lost World*, I reluctantly decided to steer clear for the time being of stories that included humans. So my next production was a small drama set in the La Brea Tar Pits in Los Angeles, with which I had become fascinated. It was based on Charles Knight's paintings and featured a number of prehistoric creatures including a sabre-toothed tiger and a mammoth which were seen disappearing into my stage version of a tar pit. I am pleased to report that it was quite dramatic and the performance I gave at school proved another great success, which encouraged me to take it 'out on the road', to private parties.

Encouraged by these early successes, I developed plays and puppets of a slightly more sophisticated nature, usually based on popular personalities of the time such as Mae West – this choice perhaps shows that I was 'growing up' – and Maurice Chevalier. I performed these little plays for my friends at home and in school and at parties. In 1939 I put together and performed two more string puppet plays, probably my last; one was a version of *Jack and the Beanstalk* and the other was a Halloween play featuring two skeleton string puppets. The latter, my first attempt at bringing skeletons to life, anticipated the animated skeleton in *The 7th Voyage of Sinbad* by about nineteen years.

These productions gave me a foretaste of the way I would work when developing film projects. They were virtually one-man shows. I wrote the script, sometimes with the help of a friend, sculpted the figures' heads and appendages out of papier mâché and made most of the backgrounds and all of the props. My mother, as always, made the costumes. Finally and perhaps most importantly, I operated the puppets. Thus I learned that, if I wanted to see my fantasies come to life, whether on a miniature stage or on screen, I would have to teach myself all the skills required. Although simplistic, these puppet dramas taught me a great deal about set construction, miniature props and what audiences liked. However, the limitations of string puppetry as a dramatic medium were obvious, and by this time I had learned all about stop-motion animation and knew that it was the way ahead.

In those years immediately before the war I tried out a whole variety of different forms of modelling and art, with no clear breaks between abandoning one medium or technique and taking up another. Working away in my hobby house studio, I experimented with models of all kinds, seeing which ideas worked for me, as well as improving my techniques in photography and animation.

One of the ideas I hit on during this period was making latex rubber masks, usually for fun. Like the string puppets, the masks taught me a lot and I also enjoyed making them. Most importantly, they allowed me to perfect methods of moulding latex rubber. They were very popular with my friends, one of whom, Forry Ackerman, asked me to make a mask of someone called 'Odd John', who was a character in a science-fiction novel (he, or it, had a high forehead and white hair and resembled the aliens in the film *This Island Earth*). Forry wanted the mask for a New York fantasy fair he was going to attend; it was very typical of Forry to go to such an event wearing something outrageous.

The mask, of course, had to fit the contours of his face, so he came over to my parents' house where I had him lie down on the lawn. To prevent him from suffocating I placed two straws up his nose and then covered his entire face in plaster of Paris in order to make a mould. I then intended to make a plaster bust onto which I would model the features of 'Odd John'. However, whilst the plaster was hardening on his face, Kong, my dog, decided he liked the look of Forry's feet (he had removed his shoes and socks) and started to lick them. Well, I can most definitely confirm that Forry is ticklish

**Previous page.** Watercolour on paper. 10"x 8". c.1937/8. One of my ghoulish little experiments.

**Left.** String puppets for a Halloween play. c.1939. These were my first skeletons, made from wood and plastic.

because when the mould was removed it had a kind of Mona Lisa smile on its lips. Sadly I wasn't able to finish that mask in time for the event in New York so Forry borrowed another that I had made previously; I think it was my version of Mr Hyde, which I later wore myself when attending a masked ball with my then girlfriend. I cut a fine but grotesque figure, wearing the mask as well as a top hat and cloak which I had rented for the evening.

I made many of these masks, all based on eccentric characters that had impressed me. I don't remember all of them, but I do remember making one that was based on Charles Laughton in *The Hunchback of Notre Dame* (1939) and another based on the character of She in the movie of the same name (the 1935 version, of course, when the poor lady had aged a few hundred years or so).

My late teens were definitely my eccentric period. Another activity I became involved in at that time, along with some friends, was drawing and painting what we called ghouls. This rather unusual pastime started out as a joke. My friends and I knew a lady who was very squeamish and, in an outburst of teenage cruelty and high spirits, we decided to show her a series of these ghoulish images, the idea being that the one that elicited the strongest reaction would be the winner. Sadly I don't recall if anyone did win but we had a lot of fun, each trying to outdo the others in producing the most garish and ghastly image. Looking back, I have half a notion that the lady in question was amusing herself by leading us on quite as much as we were enjoying the anticipation of her terrified responses. Perhaps by producing those paintings

my friends and I got some of our more delinquent tendencies out of our systems in a relatively harmless fashion. On the more positive side, the experience certainly helped me to enhance my design and watercolour techniques. Nothing is ever wasted!

As I explored the talents I discovered in myself, I found that my interest was becoming more and more directed towards stop-motion animation and eventually all these sidelines, whether or not they were fun, fell by the wayside and I concentrated all my efforts on new ventures in that field. It was now clear to me that stop-motion model animation offered me the best opportunities for making a name for myself and earning a living from the work that I most enjoyed.

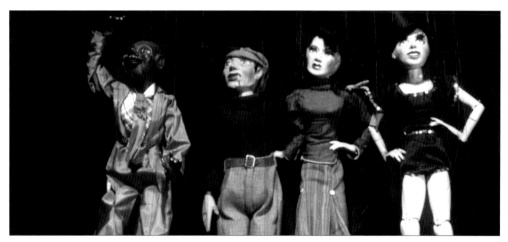  

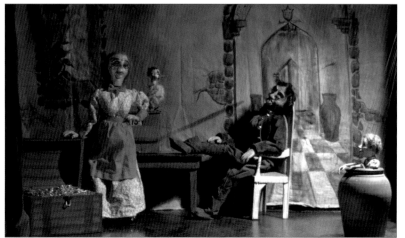

**This page.**
**Top left.** Wood and resin. Approximately 12″ high. c.1938. String puppets for a variety show.

**Top centre.** Wood and resin. Approximately 12″ high. c.1938. String puppet dancer for a variety show.

**Top right.** Wood and resin. Approximately 12″ high. c.1938. String puppet for a variety show.

**Centre and bottom.** Wood and resin. April 1939. Two scenes from my string puppet version of *Jack and the Beanstalk*.

**Opposite page.**
**Top left.** Mr Hyde mask. Latex rubber mask. c.1941. This was made for a Halloween Ball in 1941. The person wearing it is me at the ripe old age of 21 and the young lady was my girlfriend at the time.

**Top right.** Latex rubber mask based on Lon Chaney. c.1939.

**Centre right.** Latex rubber mask based on Charles Laughton in the role of the Hunchback of Notre Dame. c.1939.

**Bottom.** Watercolour on art paper. 10″ x 8″. c.1939. However much I try, I still can't see any hint of subsequent monsters in these paintings of ghouls.

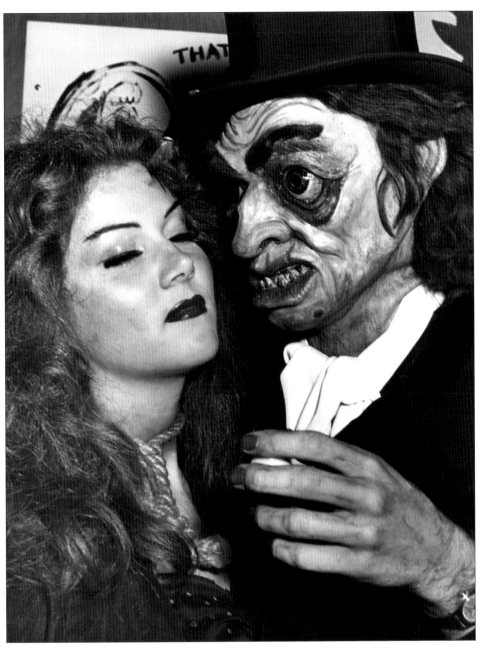

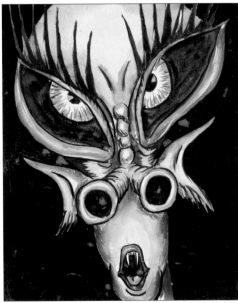

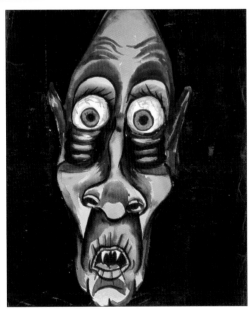

# CHAPTER 4    THE FORMATIVE YEARS

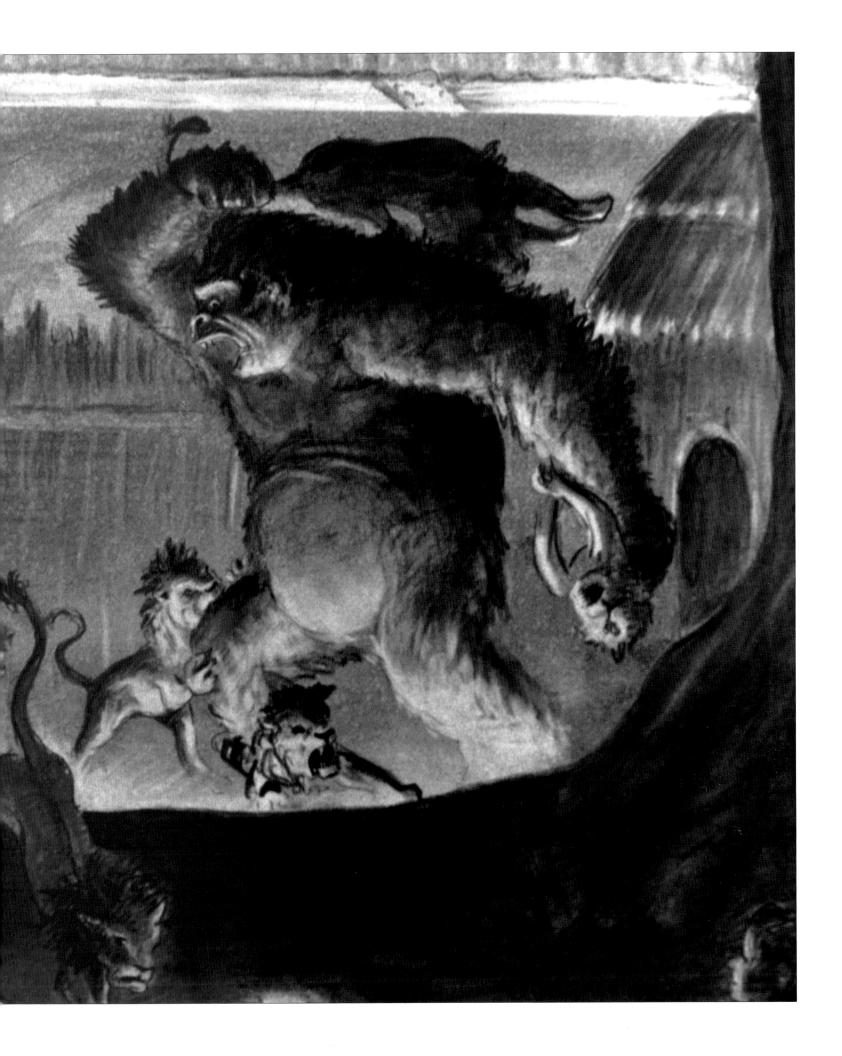

**Previous page.** Charcoal and pencil on illustration board. 14"x 11". c.1946. Joe Young attacked by lions while being exhibited at the club. I produced this drawing when Obie and I were working on the early design stages of *Mighty Joe Young,* long before the project had been commissioned by RKO. It was to a large extent influenced by a similar drawing by Obie and is very much in his style. However, it does contain some elements of what would become the Harryhausen style. Because I was always shy about my work I never showed it to him.

**Left.** Charcoal and pencil on illustration board. Original now lost. c.1938/9. Two carnivorous dinosaurs running over a rock bridge. This drawing was intended for an experimental project which would have been a '*Fantasia*-like' film interpreting the music of Ravel's *Daphnis et Chloe* in a cinematic form. I had pictured a section of the music accompanying a scene with two young dinosaurs running and playing in a prehistoric landscape.

ALL ARTISTS NEED TO EXPERIMENT; it helps them to define their own specific, and hopefully unique, talents. I experimented a great deal, as you will have already noted. By about 1938–9, I had decided that a career in stop-motion three-dimensional animation, and all the subsidiary trades it involved, was what I wanted. It seemed to encompass all that I wanted to do with my life – provided, of course, that I could make a living from it. But if I was going to be successful I had to try and attain some kind of professional standard, which meant that I needed to fine-tune my designs and models and to attain a fluidity of movement in animating my figures. It was therefore vital that I find projects which would both fire my imagination and allow me to hone my skills as an animator.

I worked on my ill-fated full-length animated dinosaur project, *Evolution of the World,* for some considerable time, building models, miniatures, props and vegetation, painting glass jungles and generally feeling my way to a more natural flow in animated movement. At the same time, I was always trying to find a good idea for a film. Inevitably, I came up with many stories that bore more than a passing resemblance to *King Kong,* featuring lost islands, ancient civilizations, ruined temples and those ever-present dinosaurs. There were, for example, versions of the legends of the destruction of Atlantis, or the discovery of the lost island of Lemuria, and then there was an idea involving a lost valley hidden deep in the sands of the Sahara desert, and occupied by descendants of the ancient Greeks who worshipped living dinosaurs. Another project involved a professor and his team who discovered a land beneath the ocean after descending into a Pacific abyss where, after abandoning their bathysphere, they discover a land of dinosaurs. None of these ideas ever came to fruition but the search for my own version of *Kong* remained a lifelong ambition, though, in the event, my biggest successes have been with mythological subjects. But more of that later.

There were other projects, though, that reflected a more practical approach to my goals of promoting the use of model animation, gaining a reputation and making some money from it. The first two were made during the war and were intended to show the military 'powers that be' that model animation, as well as cartoon animation, could be utilized in making training films. The first, *How to Build a Bridge,* was made just after America entered the war and the other, *Guadalcanal,* a year or two later.

Despite my efforts, the military was not persuaded and I began the war as an assistant cameraman.

However, I was lucky because I was reassigned to work on various effects and other optical tricks for the Frank Capra orientation film series, *Why We Fight,* which is seen today as a landmark in wartime film-making. It was also at that time that I was commissioned to make several plaster statues; the earliest were a series of models of the SNAFU character. These were produced for Major Ted Giesel, who used them as guides for the cartoon production developers working on the wartime information series featuring this comically incompetent soldier. I also made a plaster statue of the composer Dimitri Tiomkin for presentation to its subject by the team who had been involved in the production *Negro Soldier.* It was the producer, Carlton Moss, who asked me to make it, basing it on a drawing by Phil Eastman, who was also at that time working on preparing the SNAFU cartoons, and on photos of Dimitri that were surreptitiously acquired from his wife. I made a clay statue which I had cast in plaster of Paris; I then painted the cast and it was duly presented to 'Dimi'. I later found out that he had been delighted with it.

When I left the army I experimented in two areas that had the potential to provide me with a living. One was my Fairy Tales, which I will cover in the next chapter, but before embarking on those I tried my hand at commercials. Television was booming in the post-war years and I thought that it would be a good idea to use model animation to promote products. So I made a film of Lucky Strike cigarettes dancing out of a packet and back in again to the strains of 'Surrey With the Fringe On Top'. I felt it was rather good, but it caused me a lot of pain when the idea was 'borrowed' without my permission. Following that I worked on two short subjects. One, commissioned by a financial firm, featured an animated, fragmented dollar coin, the other, for a Christian organization, had a model set containing three crosses on a hill. Neither of these made me very much in the way of money nor did they lead to further work. However, there was one commercial that did make me a small amount of money, but sadly little prestige. It was a television campaign to promote the Lakewood real estate project in Los Angeles. In other words, it was made to sell houses.

It came about when I was introduced to an elderly gentleman called Mr Weinguart, the head of the Lakewood project. I went over to his office and showed him examples of my animation and

suggested that it would provide a basis for novel and commercially effective advertising. He obviously liked what he saw and referred me to the campaign's agency with a recommendation. I met with them and was commissioned to execute a series of adverts with a character called Kenny Key. I began by designing Kenny and drawing a number of storyboards more or less following the agency's instructions. There was, however, one potential problem. I wanted to do it all with a voice-over but the agency wanted the character to literally talk, which meant that I would have to animate the model to recorded dialogue. I carefully explained to them that the time and cost of making all the different heads that would be needed if I was to synch the animation to the recording would be prohibitive. Cost was the persuasive element, and they decided on the much simpler voiceover. In all, the animation took me approximately eight weeks to complete.

I made the model of the Kenny Key character in clay and from that I made a plaster mould from which I cast the latex rubber model. There was only one armatured model; the other models, some house keys (in the commercial they become Kenny) and the animated lettering were made of plaster. To achieve the various expressions on Kenny's face I made a series of heads that ranged from a happy face to one with puckered lips, which allowed him to smoke his cigar, and a normal face I did an eight-frame dissolve from one expression to another, a trick I would later use for the Fairy Tale characters.

In the end, with no further offers of jobs from the advertising sector, I decided that commercials were not what I wanted to do. I wanted to work in features. I wanted to make a successor to *King Kong*, and I was about to get my chance.

I had been in contact with Obie all through the war, so when I came out of the army we naturally continued our friendship. It was Obie who gave me the chance to prove myself when he asked me whether I would like to work with him on a new feature about a large ape, to be called *Mighty Joe Young*. He didn't need to ask twice.

Although it was my first potential feature film and I was working with Obie, it was also a tough time for both of us because it was over a year before we definitely knew that the project was going to go into production. During the twelve months of pre-production there were just the two of us and it was my job to sharpen his pencils and then, more often than not, sit and watch him producing a continuity board or the key drawing for a sequence. He could produce twenty continuity sketches in a day, drawn on the backs of old exposed photographic paper (used because it was extremely smooth). He would sketch out a basic idea of what he had in mind then cover the paper with powered charcoal and pick

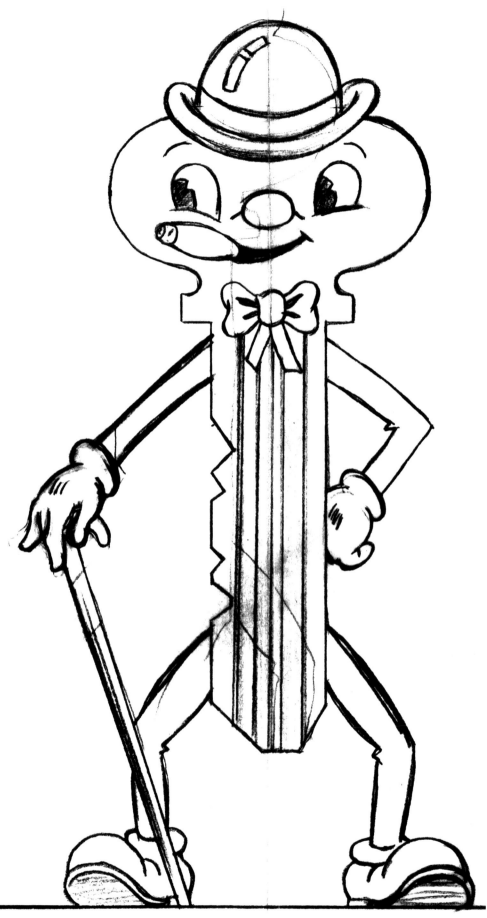

**Left.** Charcoal and pencil on illustration board. Original now lost. c.1939. A dinosaur attacks an ancient temple. Although I can't remember exactly why I produced this drawing, it may well have been related to a project I wanted to do on the legends of Atlantis or Lemuria. Of course, I had included the inevitable dinosaurs in my picture to liven things up a bit.

**This page.**
**Top left.** Painted plaster. 12½″ (h) x 4½″ (d) x 5½″ (w). c.1943. A model of the composer Dimitri Tiomkin. I was asked to do this for 'Dimi' soon after he had written the excellent score for the documentary *Negro Soldier* (1944), which was one of the WWII Frank Capra films on which I worked. It shows the composer ready to begin conducting, watched by a young black American boy. The statue was presented to Dimi as a tribute to his score and because all the crew liked him so much.

**Above and right.** Kenny Key illustration and armature diagram. Pencil and pen on tracing paper. 10½″ x 8″. c.1946. Rough sketch for the *Kenny Key* commercial. This shows exactly how the model would look and was drawn at actual size. A design for the armature of the model is shown above.

KENNY KEY

SCRIPT OF ONE MINUTE
KENNY KEY    T-V SPOT
FOR LAKEWOOD                          SERIES # 3

(Whirling key stops)
"Folks, here's the key to
your future....

..Lakewood.. the
future city, as new
as tomorrow
(Key dissolves into figure)

(curtain opens)
AND ..no down payment
for veterans....

(1st burst slides out
"Everything INCLUDED
no assessments of ANY
kind! (key EXITS LEFT

(enter right)..value
packed features, in
cluding Waste-king
Garbage disposer units..

(turns page of book)
..and beautiful ornamental
street Electroliers!

(turns page)
And an optional choice of
these appliances with no
down payment.....

(range pops oN PAGE)
..and only a nomINAL
increase in monThly
payment!

(book disappears)
..and a wonderful
variety of 2 & 3 bedroom

(dissolve) "Drive out manchester
and Firestone to Lakewood blvd.
(DoTs follow BLvD.)

..watch for the tower..
and the model homes
floodlighted 'til 10

(letters pop up)To MVS
the key to yovR
future."
(key pops up)

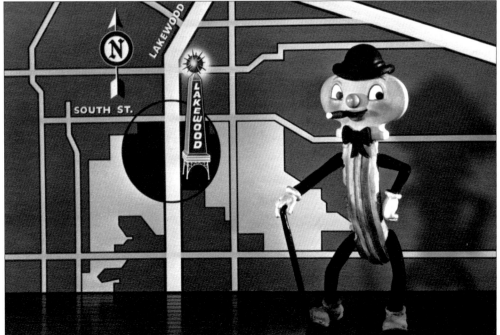

**Top.** Pencil on paper. 10½" x 8". c.1946. Part of rough storyboard for the *Kenny Key* commercial. This was my first-stage storyboard for the one-minute TV commercial for Lakewood. Later I constructed a very elaborate set of storyboards to present to the agency. These measured 20" x 15" with each illustration drawn on photographic paper.

**Bottom.** Still of Kenny Key as the model appeared in the final commercial. c.1946. This shows the full model, which is 10" (h) x 2" (d) x 3½" (w), making his one and only television appearance.

**Right.** Charcoal and pencil on illustration board. 16" x 12". c.1947/8. Drawing by Willis O'Brien for an unrealized arena scene in *Mighty Joe Young*. A typically beautiful drawing by Obie. There were many such scenes which were proposed but failed to reach the screen. In this one we see what would eventually become the club scene in the final picture, with crowds egging Joe on to attack the tigers.

out the highlights with an eraser, allowing the colour of the paper to come through. (Later, when I began on my own features, for example *It Came From Beneath the Sea* and *20 Million Miles to Earth*, I would briefly adopt the same technique of using photographic paper.) Finally, he would take a dark Wolf pencil and sketch in the dark outlines. He would also be able to do two elaborate key drawings a day, using the same technique, but on large card – in all he must have done ten or twelve of them. He was so brilliant at producing wonderfully exciting and visual pieces of artwork that I found myself mesmerized, and, boy, did I envy him his talent. Such a talent is something you are born with. You don't learn to draw that good and that quickly by reading books and attending classes.

When Obie had finished the continuity sketches, it was my job to mount them on cardboard and label them. He would then put them under his arm and go off to a story conference where he would talk them over with Merian Cooper (the producer), Ernest Schoedsack (the director) and other members of the production team. Inevitably, when Obie returned he would sigh and tell me that everything had changed and he would settle down to start all over again. One of the things I remember is that Obie loved horses. He rode them and he could also sketch and draw them in beautiful detail. He was in fact always drawing horses, which is why there are horses and roping sequences in both *Gwangi* and *Mighty Joe Young*.

If I had not had the experience of watching and learning from Obie, it would have probably taken me longer to learn how to produce and present visual material that would help me to 'sell' my ideas. Although my art is different in style from Obie's, he taught me an enormous amount about the process of translating the products of my imagination on to paper and presenting them in a way that would impress those who saw them.

There was, however, one area in which, by the time we made *Mighty Joe Young*, I believe I had managed to overtake Obie. When it was time to start the animation photography, my animation had achieved a higher standard of fluidity than his. For this reason, and also because Obie, as technical supervisor, was always planning the next set-up and rarely had time to animate, I ended up by animating most of the picture. After I had completed a few scenes, it seemed to be assumed that I was to do the animation although nobody said anything and nobody praised what I was doing, apart from John Ford, who congratulated me on the work I had done on the lion's cage sequence at the beginning of the film.

My model of Joe, which I affectionately called Jennifer, was a complex armatured 'build-up' construction with a cladding produced by Marcel

Delgardo. He had additional wires built into his mouth and face that allowed the animator to produce a limited number of expressions. When I was animating the drunk sequence, in which Joe is in his cage, I needed him to be able to purse his lips to get them around the lip of the bottle and to push out his lower lip when he was trying to get the last drop of liquor from the upturned bottle. The wires in the mouth wouldn't allow me to achieve this extreme expression, so I built up plasticine extensions of the lips for each frame of film. It was a solution that I improvised on the animation table, I hadn't planned it. It helped to provide him with an extra human characteristic and, although laborious, it was worth it. I sometimes wonder if people realize how much effort went into achieving the effect –

but that is something I often ask myself.

I was lucky because, as things turned out, *Mighty Joe Young* was the last picture of its kind. It was the end of an era for such expensive effects features and, as it turned out, the end of an era for dear old Obie. He could never quite see that he had to abandon the methods he had used in those pictures – methods he had, to a large extent, developed for himself. He could also never see that he had to reassess the type of pictures that stop motion-animation could be applied to. Times had changed and studios were no longer willing to commit a huge budget to such projects. Obie never wanted to work on low-budget productions but, in the end, because he couldn't get other employment, he was forced to work on low-budget projects and I think the disappoint-

ment may have contributed to his rather early demise.

To give just one example of the way in which Obie's methods become too expensive, for *Mighty Joe Young*, as with *King Kong*, he used layers of painted glass for the jungle backgrounds, thus giving 'depth' to the scene. Those sheets of glass were eight feet by ten (sometimes twelve) and the animation tables were placed between them, hidden by painting on the glass. It created a wonderful effect but the cost in time was prohibitive, as three or four matte artists were required to create each set. I knew, when I left Obie's side, that I had to find a way of producing screen adventures in a more practical and affordable manner.

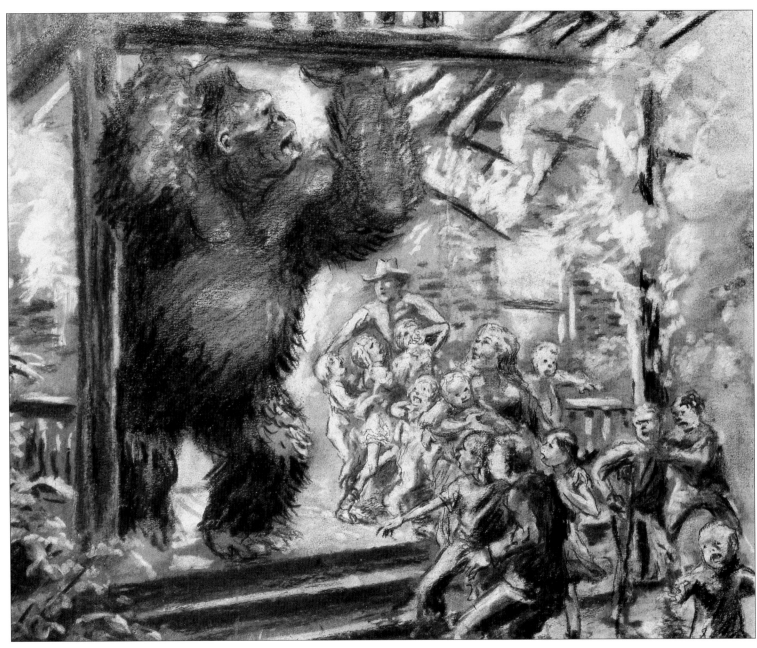

**Above.** Charcoal and pencil on illustration board. 16" x 12". c.1947. Drawing by Willis O'Brien of Joe holding up the doorway as the orphans escape the burning building. This is a charming drawing which Obie completed in a matter of two hours or so.

**Above.** Watercolour and pencil on illustration board. 16" x 12".
c.1946. Watercolour by Willis O'Brien for an scene in *Mighty Joe
Young*. This is one of my favourites and shows Joe dunking one
of the unfortunate lions in a tank of sharks. It illustrates Obie's
wonderful, if sometimes bizarre, sense of humour. In the end the
scene was dropped, presumably because the producers thought
its apparent cruelty might cause offence, even though the lions
would have been models.

**Right.** Watercolour and pencil on illustration board. 13" x 9½".
c.1946. Watercolour by Willis O'Brien for an unrealized bullring
scene in *Mighty Joe Young*. Yet another scene that never saw the
light of day. Obie always wanted to get a bullring scene into the
picture because he liked the idea of an ape fighting massive bulls.

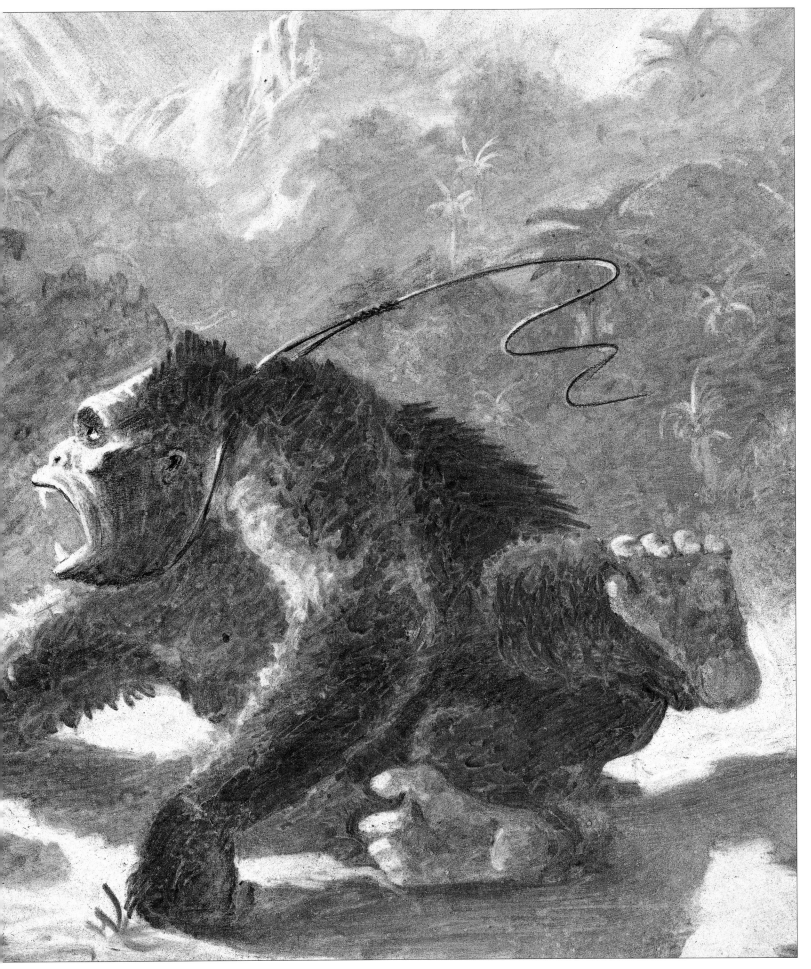

# CHAPTER 5 FAIRY TALES – MY TEETHING RINGS

**Previous page**. Watercolour on art paper. 13½" x 11". c.1951. Watercolour of the witch from *The Story of Hansel and Gretel*. For almost all of my Fairy Tales I would draw or paint the character I wanted in the film straight off. Only very rarely did I need to produce any rough, preliminary sketches.

**Left**. Scene from the 'Queen of Hearts' section of *The Mother Goose Stories*. One of my little jokes. I made a miniature film camera and crane and took stills featuring them in some of the scenes. The camera and crane model, which I still have, is approximately 15" long and can be raised to 12". The holes in the floor were used to fix the models during the animation.

As WE SAW IN THE LAST CHAPTER, I TRIED WORKING ON COMMERCIALS BUT THEY DIDN'T INSPIRE ME, probably because I quickly realized that television wasn't the media I wanted to work in. One of the other areas I thought I should try my hand at was making short films, but shorts need to be succinct and compact. It was difficult to find a series of subjects that lent themselves to animation and had commercial potential – although my parents had been generous in their support, I couldn't expect them to keep me all my life. After the war, and soon after I arrived back from a trip to Mexico where I discovered the charms of Mayan pyramids and lost cities, I coincidentally acquired from the Navy junk pile a can containing one thousand feet of outdated 16mm Kodachrome colour stock. What could I use this free film for? The answer was education. After much research I decided to make a number of shorts based on traditional fairy tales.

These films became my teething rings. They taught me an immense amount. In making them I continued to improve my techniques, especially the fluidity of animated movement. They also enabled me to develop two film-making skills that would prove invaluable when it came to giving my films a personal 'touch': firstly, how to film a subject with a beginning, middle and an end, in other words how to tell a story; secondly, and even more importantly, how to instil individual character traits into my animated models. Each story contained several different 'personalities', each of which had to have a charm and individuality of its own. This gave me the opportunity to express myself and to project the behavioural quirks that I had observed in people and animals into the models. Each short film was a progression, revealing development and experimentation as I not only 'breathed' life into the models, but gave them personalities all their own – from Mother Hubbard and her dog in the early *Mother Goose Stories* to the greedy King and Dark Stranger in *King Midas*. This very special art of characterization is even evident in the three minutes or so I shot for *The Tortoise and the Hare* in 1952, with its arrogant hare and bemused tortoise. It was these little nuances that gave the characters a timeless charm and brought them alive to young and adult audiences, which is perhaps why they still seem to work today.

Although I always use the generic title 'fairy tales', it was in fact with nursery rhymes that I began to develop the series. I had intended that these films should be about two or three minutes in duration, so I focused on the nursery rhymes *Little Miss Muffet, Old Mother Hubbard, The Queen of Hearts* and *Humpty Dumpty*. On completion, I decided to 'lump' them together by shooting an introduction and finale, with the Mother Goose character setting up a projector and introducing each story. So they became known as the *The Mother Goose Stories* and they were distributed around schools at the height of the fashion for visual education in the late 1940s and early '50s.

After finishing *The Mother Goose Stories* I decided to change tack slightly and concentrate on the real fairy tales, choosing the classic *Little Red Riding Hood* as my next subject followed by *Hansel and Gretel* and *Rapunzel*. These proved so successful that I later changed tack again and filmed a version of *King Midas*, based on the story from Greek mythology but altered to a medieval setting. Finally, in 1952, I began *The Tortoise and the Hare*, based on one of Aesop's fables, but again updated. For this I only shot about three minutes and then abandoned it, as my feature film career was taking off and I no longer had time to make these enjoyable little pieces. In 2002, however, it was completed by two other animators, Mark Caballero and Seamus Walsh, following my designs and style, with the occasional animated scene executed by me. The film probably set a world record for the time taken from inception to completion – fifty years!

The great thing about these films was that I felt I had all the time in the world to make them. There were no schedules to restrict my freedom to explore and innovate. They were not only enjoyable to develop and animate, but also allowed me the luxury of experimenting with effects that would be impossible to attempt in a feature because I would have been apprehensive that they might not work – and besides, I wouldn't have had the time. The five shorts thus allowed me to develop novel techniques which I could later put to use in my features with confidence, because I knew that they would work. For example, I achieved the appearance and disappearance of the mysterious stranger in *King Midas* by means of a matte smoke effect which I used again in several scenes for *Jason and the Argonauts*.

Nothing I learned whilst making these little films was ever wasted. But they also benefited from ideas and techniques that would have been impossible to translate to the world of feature films because of time constraints. An example was the rather elaborate metal camera crane, made by my father from

various automobile parts, that I used to film tracking shots for King Midas. For *Evolution of the World* and again for *The Story of Little Red Riding Hood* I used wooden ramps. Much as I would have liked to have had the time to incorporate such techniques and shots in a feature, time and money prohibited it.

I designed the armatures and sets and my father and I built them between us. My dear mother made all of the clothes and the fabric items, curtains, for example, and tablecloths and bed clothes. Sometimes she based these on my designs but at other times she would design and make them herself once she knew what the story was. Sometimes I would have to make the miniature props, like Old Mother Hubbard's rocking chair and King Midas' throne, but there were other items of set dressing that I bought in. These I would purchase in a shop on Olvera Street, a Mexican area in an old part of Los Angeles which sold miniature

flowers, pictures, vases and furniture which I would paint so that they matched the sets and the other props I had made and painted myself.

I constructed some of the models using the build-up method, for example the wolf in *The Story of Little Red Riding Hood*, which I then covered in a fur that I had bought at the local taxidermist. On occasions I experimented with casting the models – another example of the way in which the making of these films allowed me to learn new techniques. But however the bodies were constructed, all the heads were built of plaster. I sculpted them in clay or wax and then made a mould from which I made the finished heads. To obtain the full range of expressions I usually had to make between five and twelve heads. Initially I made a clay model of the head with a natural or normal expression and then cast the required number of heads all from the same mould – the heads had to be basically the same, otherwise the face would change too much when I

dissolved from one to the other. I then took each of the heads in turn, carved into it one of the expressions I needed for that character and finished it by moulding new plaster around the mouth and face. I would then paint all the alternative heads in the same range of colours and, when it came to animation, I changed one head for another by means of a dissolve within eight frames in the camera.

I would have very much liked to have made more Fairy Tales and, indeed, planned a number of others. Like *The Tortoise and the Hare*, sadly, they all fell by the wayside as features became the focus of my career. Some were planned in rough storyboard form as two- or three-minute subjects to be compiled into a 'Mother Goose-style' ten-minute film. Others were planned as complete eight- or ten-minute stories. The stories were varied as I always tried to find new subjects, not just fairy tales but nursery rhymes like *Jack and Jill* and *Hickory Dickory Dock*, *Jack Sprat*, *Wee Willie Winkie* and

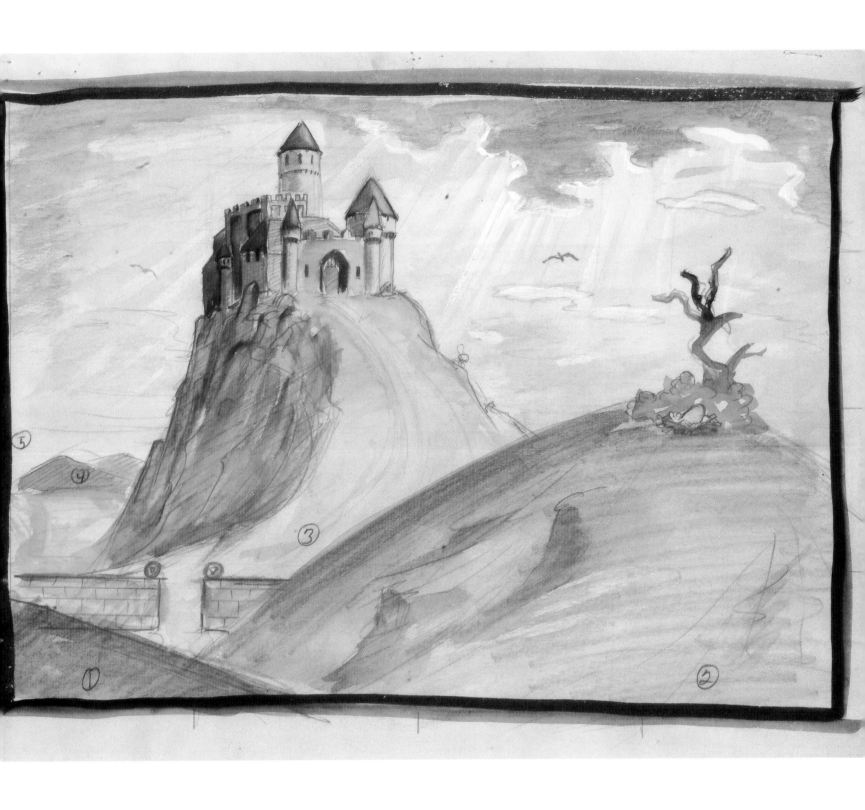

**Left.** Pencil and pen on paper. 12½" x 10". c.1945. Detailed sketch of how I intended to film 'Humpty Dumpty' for *The Mother Goose Stories*. This drawing shows how much planning I would sometimes put into shots; experience had taught me to be cautious and to plan well in advance.

**Above.** Watercolour and pencil on art paper. 12½" x 8½". c.1945. Painting for the backdrop of the 'Humpty Dumpty' section of *The Mother Goose Stories*. I painted not only the characters but also the backdrops that I wanted for each scene.

*Simple Simon*. However, the most interesting were the longer, more versatile subjects. Two of these were *The Night Before Christmas* and *Daniel in the Lion's Den*; the first was storyboarded in the fall of 1946 and would have been fun because it would have given me the chance to animate Santa Claus. The other was based on the story from the Old Testament. Sadly all that remains of these ideas are the rough pencil storyboards.

I am extremely proud of my Fairy Tales, not just for the reasons given above but also because they have stood the cruel test of time. Over the years very many teachers, children and adults who saw them as children have told me what an impression the films made on them. Each tale was designed to tell a story but also to have a moral and, crucially, to be enjoyable.

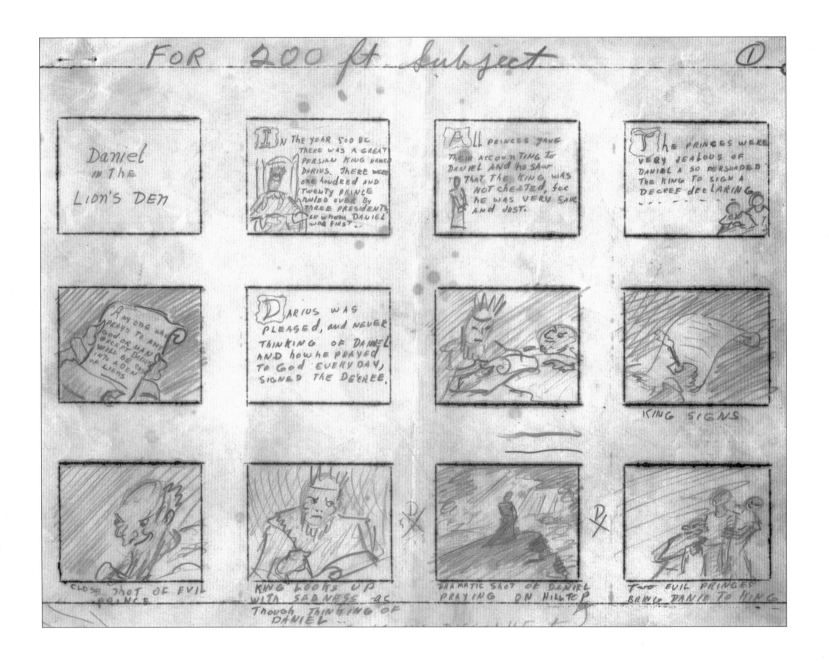

**Above.** Pencil and colour pencil on paper. 10½" x 8". c.1950/51. Storyboard for *Daniel in the Lion's Den*. One page of the storyboard for an unrealized Fairy Tale to be called *Daniel in the Lion's Den*. This is the first page of a six-page storyboard for the project. Although not a fairy tale, of course, it would have featured as one of the series.

**Right.** A selection of sketches for *The Story of Little Red Riding Hood*. c.1949. These were just a few of the sketches I made on photographic paper for this story; they were meant to be individual scene references rather than a storyboard. Sadly, few survive as most were destroyed in a flood some years ago.

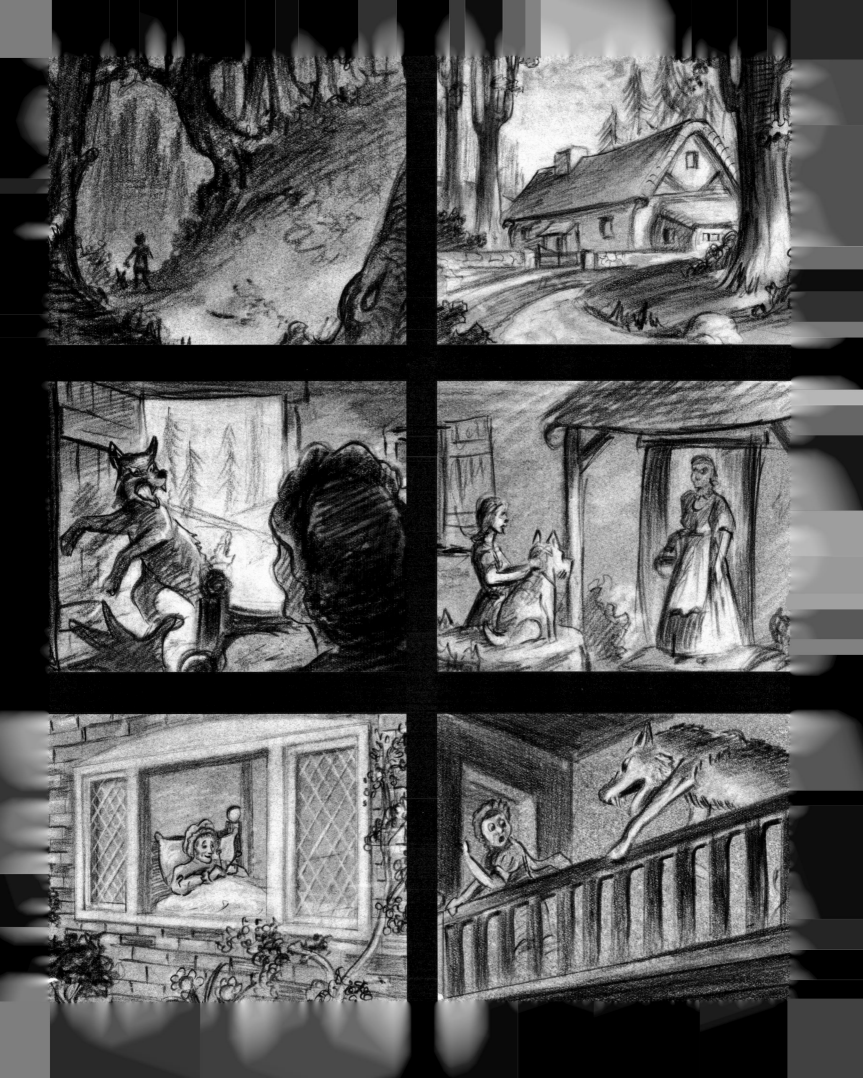

**Top.** Watercolour on art paper. 13″ x 11″. 1949.
Painting of Little Red Riding Hood.

**Bottom.** Pen and pencil on paper. 10½″ x 8″. c.1949.
The armature design for Little Red Riding Hood.

**Top.** Watercolour on art paper. 13½" x 11". 1949. Painting for Little Red Riding Hood's mother in *The Story of Little Red Riding Hood.*

**Bottom.** Watercolour on art paper. 13½" x 11". c.1951. Painting of Hansel and Gretel for *The Story of Hansel and Gretel.* This was a very early concept for the two children. I had thought to give the story a Dutch setting, hence their costumes.

**Above.** Watercolour on art paper. 13½" x 11". 1949. The design for
Grandma for *The Story of Little Red Riding Hood.*

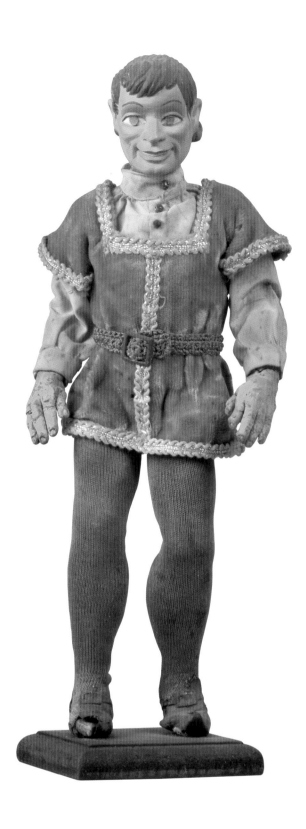

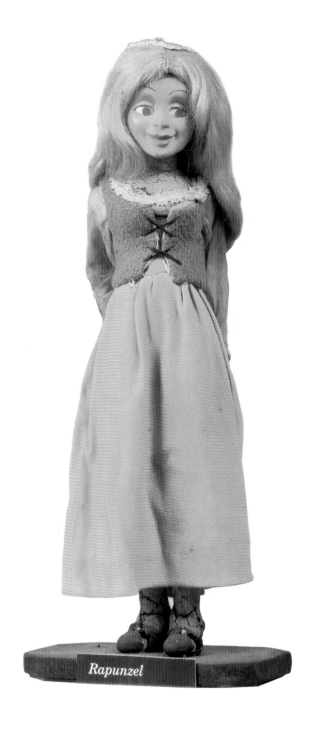

**Above.** Latex body with internal metal armature and plaster head. 10½″ (h) x 2″ (d) x 4″ (w). c.1952. Model of the Prince in *The Story of Rapunzel*.

**Above.** Latex body with internal metal armature and plaster head. 10″ (h) x 2″ (d) x 2″ (w). c.1952. Model of Rapunzel for *The Story of Rapunzel*. As with all my Fairy Tale models, my mother made the clothes.

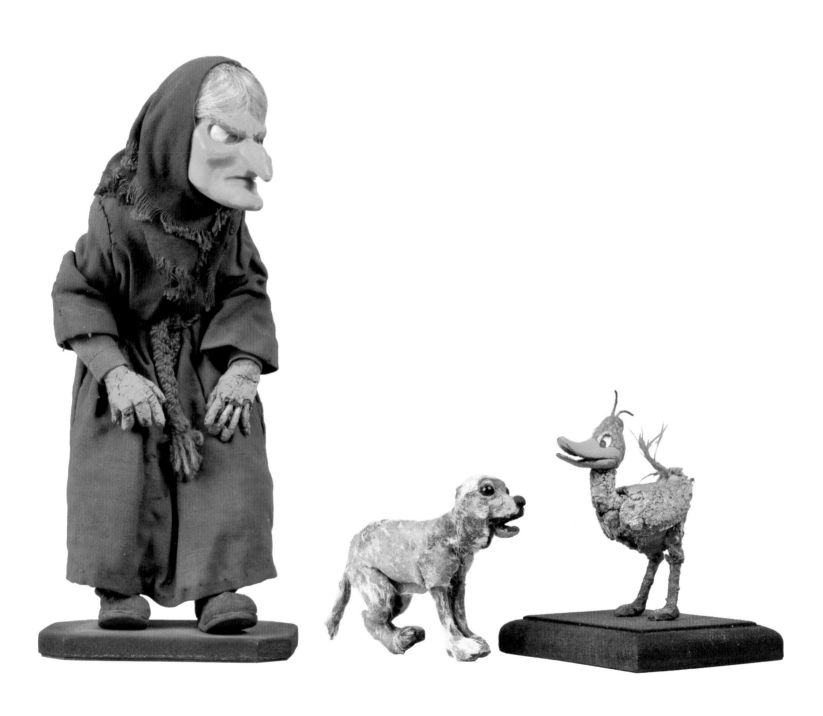

**Left.** Latex body with internal metal armature and plaster head. 9" (h) x 3½" (d) x 3" (w). c.1952. Model of the witch for *The Story of Rapunzel*. I did love my witches! This is the same witch who had appeared in *The Story of Hansel and Gretel* the previous year.

**Middle and right.** Latex body with internal metal armature and plaster head. Little dog: 2½" (h) x 3½" (d) x ¾" (w). Goony bird: 3" (h) x 2" (d) x 1" (w). c.1950. I really can't remember what I made the dog for. Sadly his fur is now almost gone, giving him a very mangy look. The goony bird featured in *The Story of Hansel and Gretel* where he is seen picking up the pieces of bread left by the children.

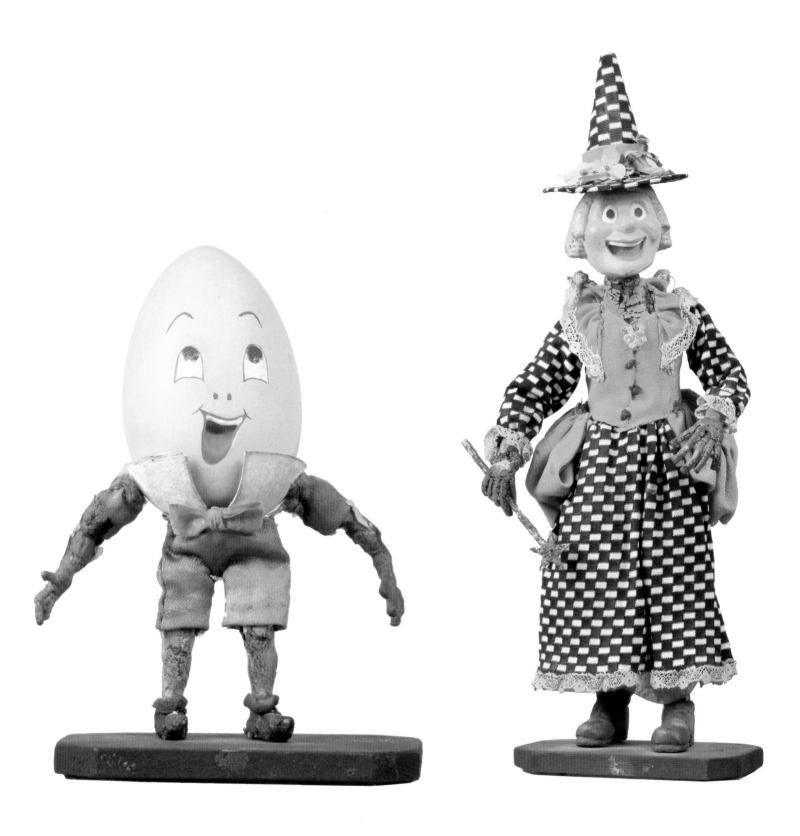

**Above.** Latex body with internal metal armature and plaster head. 6″ (h) x 2″ (d) x 4″ (w). c.1946. A model of Humpty Dumpty for *The Mother Goose Stories*. I always liked poor Humpty Dumpty.

**Above.** Latex body with internal metal armature and plaster head. 12″ (h) x 3½″ (d) x 4½″ (w). c.1946. Model of Mother Goose for *The Mother Goose Stories*. Her wand is looking a bit tarnished these days; after all, she is over sixty years old.

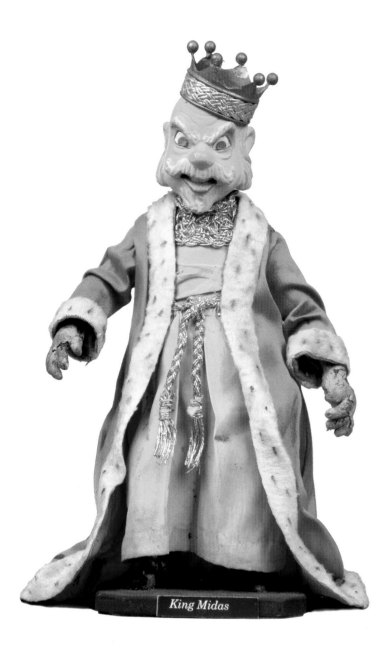

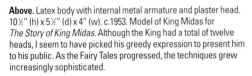

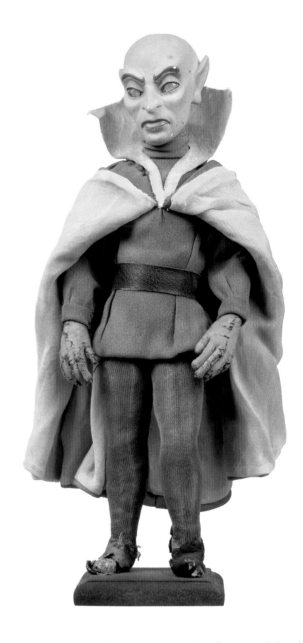

**Above.** Latex body with internal metal armature and plaster head. 10½" (h) x 5½" (d) x 4" (w). c.1953. Model of King Midas for *The Story of King Midas*. Although the King had a total of twelve heads, I seem to have picked his greedy expression to present him to his public. As the Fairy Tales progressed, the techniques grew increasingly sophisticated.

**Below.** Plaster. Each head is 2½" (h) x 1¾" (d) x 2" (w). c.1953. Set of eleven heads for King Midas for *The Story of King Midas*. This shows all the expressions I wanted to give the King. These models were used for what I called the replacement head process, which involved exchanging heads with different expressions for each other and fading from the first expression to the next over eight frames or so.

**Above.** Latex body with internal metal armature and plaster head. 11½" (h) x 4½" (d) x 3" (w). c.1953. The Dark Stranger from *The Story of King Midas* was based on Conrad Veidt in the role of evil Vizier in *The Thief of Bagdad* (1940). In my version of the story of Midas the Dark Stranger is the benevolent figure who grants Midas his wish to turn all things to gold.

**Below.** Plaster. Each head is 1½" (h) x 1½" (d) x 1" (w). c.1946. Set of six heads for Old Mother Hubbard's dog for *The Mother Goose Stories*. These are the heads for the cheeky dog in the nursery rhyme 'Old Mother Hubbard'. I cast a total of seven heads (one seems to be missing) and then carved out different expressions on each. I added the pipe and tongue in plaster and then painted them.

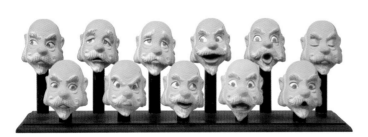

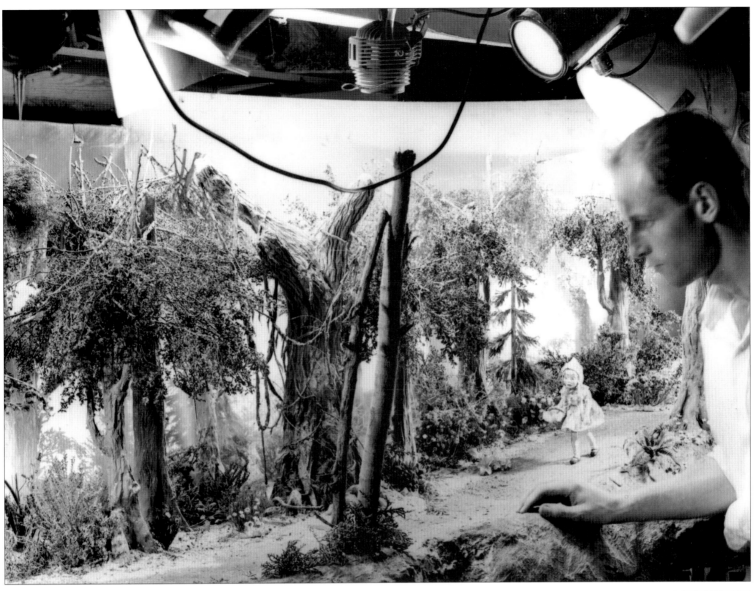

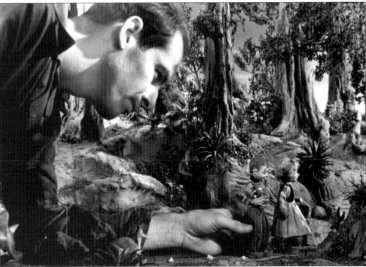

**Above left.** Latex body with internal metal armature. Item is now lost. c.1949. Model of the wolf for *The Story of Little Red Riding Hood*. The poor old wolf, minus his fur, sitting on the wall of my parents' garden.

**Above right.** Me at work on the forest scene for *The Story of Little Red Riding Hood*.

**Above.** Me again, this time at work on the two models for *The Story of Hansel and Gretel*.

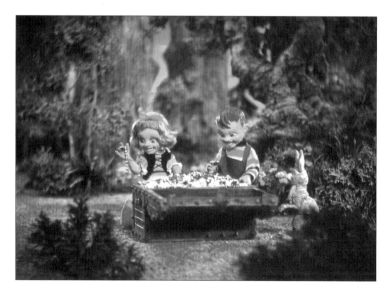

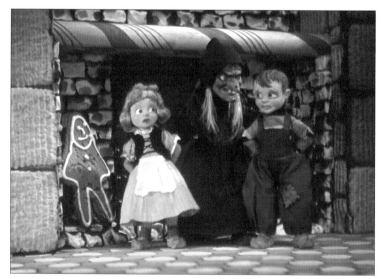

**Both pages.** A selection of rare colour stills from (left to right) *The Story of King Midas, The Story of Hansel and Gretel* and *The Story of Rapunzel.* The final still shows part of the miniature set for *Hansel and Gretel* with the witch.

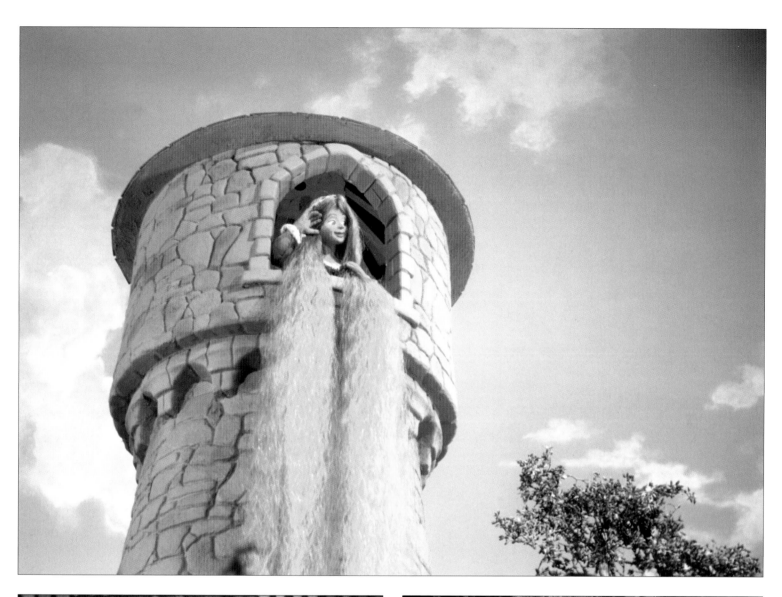

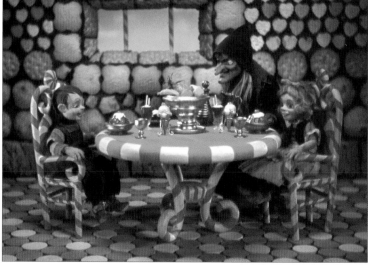

**Top.** Pen and pencil on tracing paper. 11" x 8¾". c.2001. A rough sketch for *The Story of the Tortoise and the Hare*. This changed somewhat when the film was finally made. The windmill, seen here in the distance, would not only be closer but would also feature more prominently in the story.

**Above.** Pencil on art paper. 11" x 8¾". c.2001. Key drawing for *The Story of the Tortoise and the Hare*. This was also changed in the final film.

**Above.** The Hare and his heads. The model hare was made of latex over a metal armature 11″ (h) x 4″ (d) x 2″ (w)) and the plaster heads were each 4″ (h) x 2″ (d) x 2½″ (w).

# CHAPTER 6  ALLO-REX

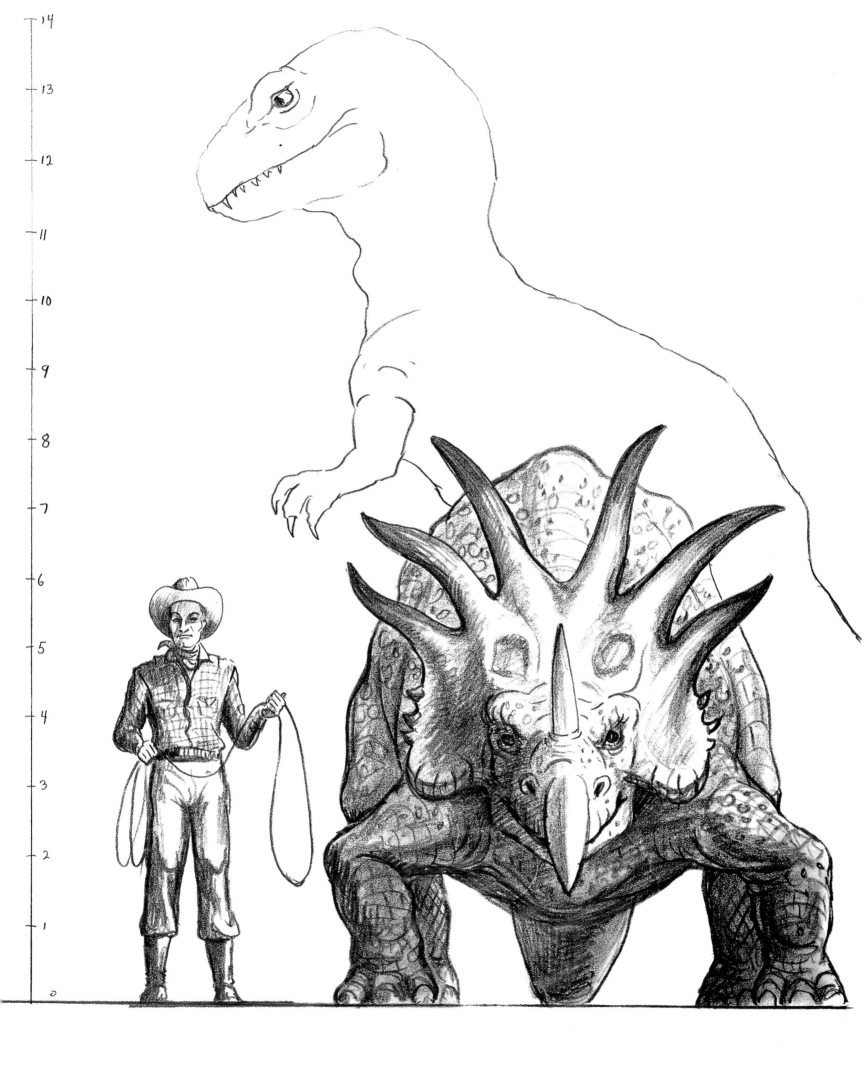

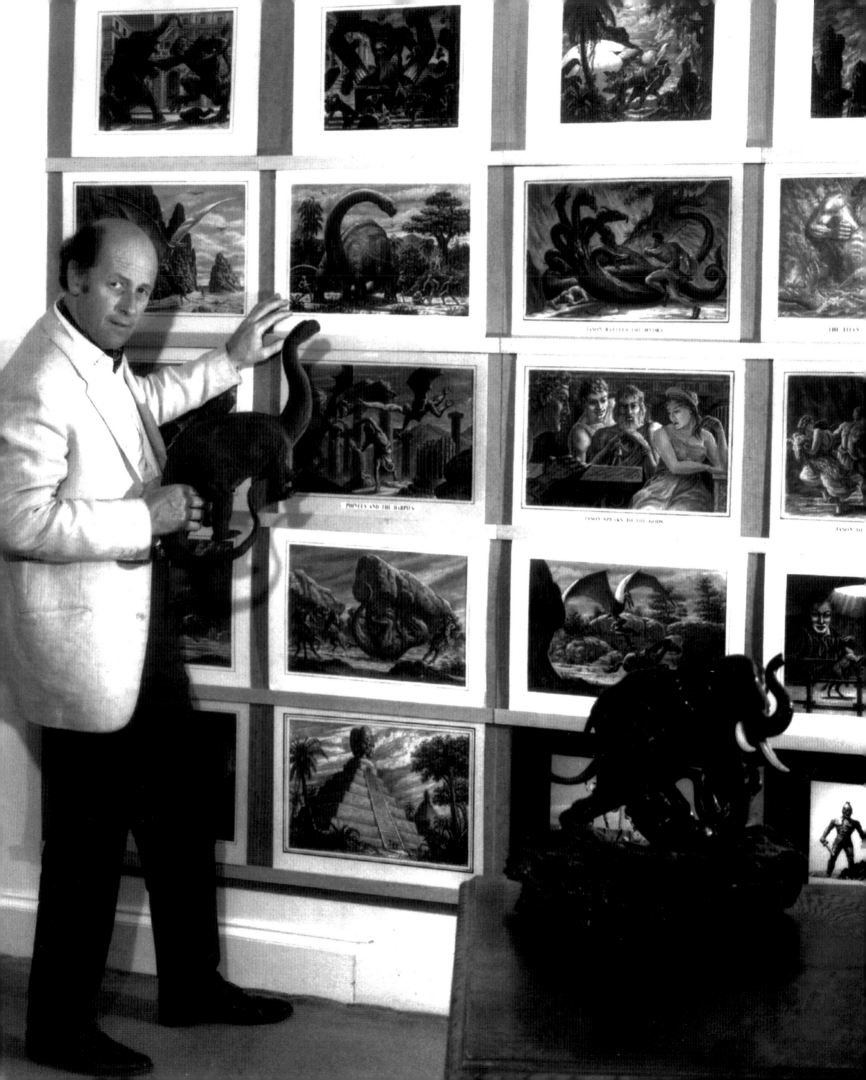

**Previous page.** Pencil on paper. 21" x 15". c.1967/8. Perspective drawing for *Gwangi*. This is a good example of how I establish the size of my creatures relative to the human actors with whom they will share the screen. It features a scale marked off in increments of one foot. It is immediately clear that Gwangi will appear to be fourteen feet high while the styracosaurus will measure eight feet. This simple device helps me, and the actors, during live-action filming, allowing us to judge just how tall each creature will appear to be. It also helps me to make my 'monster stick', which will stand-in for the creature during the live-action shoot.

**Left.** A publicity photograph taken in my office. I am holding (by his tail, rather disrespectfully) the latex model of the brontosaurus from *One Million Years BC* and pointing to a drawing for a sequence featuring the brontosaurus which was proposed but never filmed. This is part of a montage of original charcoal drawings showing some of my creations. Incidentally, the bronze at bottom right, showing an elephant being attacked by tigers, is not one of mine. It is a Japanese piece that I bought some years ago because I loved the composition and the vigorous portrayal of the animals' actions.

IT STILL SURPRISES ME HOW CLOSELY MANY PEOPLE ASSOCIATE ME WITH DINOSAURS ALTHOUGH, in fact, they only featured in five of the sixteen films I completed. However, I readily acknowledge that I do owe great debt to those wonderfully exotic creatures that dominated the Earth for about 183 million years during the Mesozoic era, because they provided me with the foundations of my career. The dinosaurs, especially the carnivorous ones, intrigued and inspired me in my youth, and continue to do so today; part of the attraction is that, unlike many of the other beings that I brought to the screen, they are not a product of the human imagination – they actually lived and breathed and ruled this planet long before we humans came on the scene. It is extraordinary to me that those bizarre and ungainly beasts, with their tail spikes, fins, enormous teeth and tremendous size could have lasted for so long only to be destroyed by what palaeontologists now believe was a stray asteroid. All this makes them both real and unreal. The stuff of fantasy.

Moreover, although fossil remains can give us an idea of the size and shape of the various dinosaur species, nobody can really can say for certain what they looked like: how their skin was textured, what colour they were, or even how they moved. This means that anybody who wants to recreate these creatures has plenty of scope to use their imagination.

I was about five years old when I had my first taste of dinosaurs. My parents took me to see the movie of Sir Arthur Conan Doyle's *The Lost World* (1925) in which an intrepid group of explorers, led by the fearless Professor Challenger, discover a dinosaur-infested plateau in the South American jungle. I had never dreamt that such huge and terrifying creatures might exist and they captured my imagination immediately, setting me on the path to a career in animation. At the time, of course, I had no reason to suppose that the dinosaurs I had seen on the screen were any less real than the human actors, and I asked my mother and father if we could go and see them for ourselves. They patiently tried to explain to me that the creatures no longer existed, except in movies and books; but, of course, I did not believe them. However, it was clear to me that, for the moment at least, the only way in which I could expand my experience of dinosaurs was to try and create models of them in papier mâché. In this undertaking my mother was an inspiration to me. I would build the torsos of creatures and humans and then sit and watch her as she shaped the heads for them. Slowly I learned the technique.

My obvious interest encouraged my mother to take me to a school in a nearby park where I learned the finer arts of sculpting in papier mâché and, later, in clay. After that I didn't look back. I instinctively knew that I wanted to be a modeller or sculptor. At grammar school I constructed models of Californian missions out of clay, whilst at home I was making prehistoric dioramas, dreaming all the while of discovering real-life dinosaurs on my own plateau somewhere in the jungles of South America or deepest Africa. I really wanted dinosaurs to exist and numerous trips, sometimes with my parents sometimes on my own, to see the dinosaur skeletons and reconstructions at the Los Angeles Natural History Museum reassured me that, since they had clearly once existed, some might still be around, somewhere.

This hope was further reinforced when, at age fourteen, I witnessed a tyrannosaurus rex, a ptero-dactyl, a stegosaurus and a brontosaurus living, fighting and, this time, making suitably savage noises as well, on Skull Island in the film *King Kong* (1933). Of course, Kong was the focus of my fascination, how could he not be? But those prehistoric creatures came a close second. Now I knew that I wanted to find the place, be it a plateau or an island, where, surely, the makers of *King Kong* had travelled to film such creatures.

Sadly, as I read everything there was to read on the making of *King Kong*, I found no indication that the film-makers had travelled to Africa, South America or, indeed, stepped outside Hollywood to shoot any of the footage for *Kong*. There were some articles that claimed that Kong was a man in a gorilla-suit but I could not believe such a thing. So where did they find Kong and those dinosaurs, and how could I find them? Of course, I was still too young to set off on an expedition to undiscovered parts of the globe, so to satisfy my enthusiasm I continued to recreate the creatures I had seen in *The Lost World* and *Kong*, this time aiming, if possible, to bring them *alive*.

As I have already mentioned in a previous chapter, I went through many stages in my efforts to bring movement to inanimate models. My first attempts involved string puppets. The process of making the puppets, and even performing with them, improved my construction skills; and at the same time I also continued to model animal forms and prehistoric beasts, setting them in miniature dioramas. Although crude, this process taught me not just how to build a basic dinosaur but also how to make miniature sets, complete with palm trees and other flora.

I developed my drawing and modelling skills by going to art school and I sketched and reproduced various Doré illustrations as well as scenes from *King Kong*, the latter were taken from 10 x 8 inch black and white stills that my friend Forry Ackerman (a fellow *King Kong* and fantasy fan) had made for me. Then I discovered three drawings of dinosaurs in an art store. Somehow I knew that they were from *Kong*, or maybe some similar film. They turned out to be scenes for *Creation* drawn by Obie and Byron Crabbe. They were out of my price range but the shop owner agreed to exchange them for some Remington-like plaster statues that I made. Throughout my career those three drawings continued to be a huge influence and inspiration.

Meanwhile I continued to devour everything I could find that would cast light on how *The Lost World* and *King Kong* had been made. Eventually, I discovered that they had been created by technicians using something called stop-motion animation. What was stop-motion animation? Well, once I had heard the term I made it my business to find out, although there were few books and magazine articles available on the subject at that time. I quickly learned that the dinosaurs in both films were certainly not living creatures but models that had been laboriously moved and photographed, one frame at a time, to create the illusion of life and movement. Needless to say, I wanted some of that and I renewed my experiments in design and animation with the passion of a fourteen-year-old Frankenstein.

As well as trying to imagine what dinosaurs would have looked like in the flesh, I faced the challenge of constructing models that could be manipulated in front of a camera. The obvious starting point was to try and recreate the creatures that had appeared in *The Lost World* and *King Kong* but I was also eager to obtain information about other dinosaurs.

This is where the great Charles R. Knight came into my life, big time. Although I have talked about him in a previous chapter it is worth stressing once more just how vital he was to my development as a designer and animator of dinosaurs. Knight had a true genius for visualizing long-vanished creatures. In his paintings, he not only put the flesh on dinosaur skeletons but created scenarios that brought the whole prehistoric world to life in the viewer's imagination As I have mentioned, the exhibits at the Los Angeles County Museum and the La Brea Tar Pits – tar-soaked skeletal remains of sabre-toothed tigers, woolly mammoths, giant ground sloths, dire wolves and even camels – regularly served to stimulate my ever-active imagination. I can still vividly remember a beautifully painted mural by Knight at one end of the display hall at the County Museum; it was a reconstruction of a scene at the La Brea pits thousands of years ago and I often stood looking at it, sometimes for hours on end, transported in my imagination back to the world in which those creatures had lived and died.

To make sure that he got all the detail correctly, Knight began by drawing his subjects before sculpting them in clay and then using the sculptures as models for his finished paintings. This helped him to depict the creatures in a three-dimensional way and allowed the museum to display their skeletons in action poses based on the paintings.

To help me in the construction of my own dinosaurs, I first of all made plaster models. They were usually about 12 inches long by 7 or 8 inches high and painted. Making these models helped me to visualize each creature before I committed myself to the time-consuming task of building an armatured version. I made several of these plaster models, although only two of them have survived. The first, which I made in the late 1930s when I was still a teenager, was of a stegosaurus, a creature that particularly appealed to me. It was a distinctive and formidable looking beast, though exclusively herbivorous, with a huge back, scales, spikes and a small head, and I made several versions of this model, all based on Charles Knight's painting in the Field Museum of Natural History in Chicago. Although I later made an armatured version of the beast for *Evolution of the World*, I was never able to slip him into any of my later features – there was one in *Animal World*, but that doesn't count. The other surviving plaster model, of an arsinoitherium, was made in the mid-40s, whilst I was still in the army in New York, and was again based on a Charles Knight painting, this time in The American Museum of Natural History in New York, which showed the magnificent creature defending itself against a pack of pterodon. As with the stegosaurus, I always hoped to get the creature a role in one of my films, but although I did draw him into various situations, he was always dropped.

By now I had at my fingertips most, if not all, the facts about stop-motion animation and the rest, as they say, is history. I bought a 16mm camera with a stop-frame facility and experimented in my dad's garage. These experiments were a matter of trial and error. As soon as I started to dabble in animation I realized that I needed to visualize the scenes I intended to film by producing two-dimensional sketches. I was lucky in that all my spare time had previously been dedicated to modelling and construction and, modesty aside, the artistic abilities I possessed seemed to be ideally suited to reproducing, on paper and in model form, what I saw in my imagination. I improved these abilities by attending art classes where I not only took drawing and painting lessons but also studied sculpture. These classes radically improved my skills and so helped me to refine my models and sets, which in turn led to an improvement in the quality of the material I was getting on film.

Rather surprisingly, the first armatured model I built was not one of the classic dinosaurs but an eryops, or giant salamander. This was a semi-aquatic creature, resembling a huge frog or a plump crocodile, that could grow up to six feet long and lived in the late Carboniferous period. I created a rubber model of it with a wooden armature inside. As this was before my first experiments with a borrowed camera, the model was never filmed – which was

**Top.** Two tyrannosaurus by Charles R. Knight from *Life Through the Ages.* c.1946. The movement in this, as in all Knight's work, is so exciting and powerful!

**Above.** Allosaurus biting a type of plesiosaur by Charles R. Knight. The action of these two creatures is again portrayed very dramatically and Knight's work hugely influenced the way in which I depicted aggressive creatures in my own key drawings.

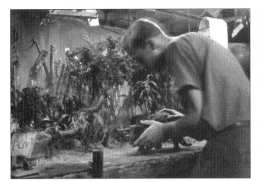

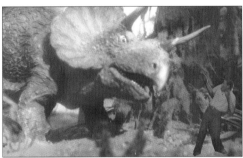

**Top.** A very young Harryhausen – with hair! – animating the triceratops for *Evolution of the World* (1938 – 40) in my hobby-house studio.

**Second from top, left.** Latex rubber. 18" high. c.1936. My very first attempt at an allosaurus /tyrannosaurus, which was made for my earliest experiments in animation. I always preferred to combine the best features of each species.

**Second from top, right.** Solid latex rubber. 12" long. c.1935. My model of a dimetrodon. This was not armatured but was made of hard latex and cotton. I had intended to make an armatured version of this model but, as with so many dinosaurs, I never got around to it.

**Second from bottom.** A hand coloured photograph of my triceratops 'performing' for *Evolution of the World*. The frightened young man in the bottom right-hand corner is me. This picture was taken to define scale – and also for fun.

**Bottom.** Metal armature. Approximately 30" long and 15" high. c.1938. A rare shot of my second brontosaurus armature, which was made with my father's help. It was extremely complex and enabled me to manoeuvre the large amount of latex rubber with relative ease during animation.

probably a good thing. But the experiment did teach me how to construct a rubber or latex model that could be used for animation purposes. The main lesson was that, while the rubber must be sufficiently flexible to allow the model's head, tail and limbs to be moved, it was also important that the model should be capable of 'holding a pose' in front of the camera. I built this first creature using too much rubber and it was therefore too elastic for the wooden armature to hold its body in position.

After that early attempt came a dimetrodon, a reptilian creature that had had a huge fin or 'sail' on its back. This was far more successful although, because I was still learning about musculature, it didn't quite look like a dimetrodon. Then came the cave bear, covered in my mother's fur coat, followed by my first model brontosaurus, with a solid inner body and wooden armature, covered in pieces of my mother's old silk stockings which were in turn covered in a film of latex. The whole thing was about five feet long. The good old brontosaurus was another of my favourite creatures. I think that it was the neck that intrigued me because it gave it the ability to get into places that other creatures couldn't. I was later reminded of this possibility when I acquired a book of photographs of drawings made by Obie and Crabbe for *Creation*. One of the photos showed a brontosaurus sticking its head over a ledge and confronting a terrified group of humans. It was an idea that I would later propose for a possible sequence in *One Million Years BC* that remained unfilmed.

I had already obtained those three large original drawings showing key sequences for *Creation* by Obie and Byron Crabbe, but the acquisition of the book of sepia photographs, containing a complete set of key drawings for the proposed film, was an incredible find. The book was given to me by a very generous cameraman while I was working on the George Pal *Puppetoons*. One day we had got talking about movies I admired (no prizes for guessing which ones) and he mentioned that he had been one of the technicians hired to work on the proposed *Creation*. Because he was a cameraman he was given the book to illustrate the kind of special effects that would be required for the picture. I asked him if I could see them and next day he brought the book to work and, because of my enthusiasm, insisted on giving it to me. Today, the book is one of my most prized possessions.

I first met Obie in 1939 when I visited him at the MGM studios while he was working on what would turn out to be another unrealized project, *War Eagles*, which was to be about a lost world, again inhabited by dinosaurs, in the Antarctic. I had called him on the phone and told him of my interest in prehistoric creatures and animation and mentioned that I had made some models, and he said, 'Bring some over.' I think I was there the next day. When I arrived he showed me the room where the models were being constructed by Marcel Delgado and George Lofgen and he told me that they were busy shooting the test reel although I never got to see that

as the set-up was on another stage. However, what impressed me most was a huge wall of over 200 large drawings, mostly by Duncan Gleason and Obie, and some oil paintings, all for *War Eagles*. There was so much that I couldn't take it all in; but I do remember an enormous painting of the Statue of Liberty with eagles perched on the spikes of her crown, and other eagles flying around the dirigible that was to appear at the climax of the story. They were all magnificent but what became of the majority of them, I don't know. Obie's wife, Darlyne, had a few watercolour drawings but they did not depict scenes of fantasy and I have one oil painting done by an artist who went on an expedition to the North Pole, Obie had hired him to do some backgrounds for the glass shots to be used in the film. When I was working with Miklos Rozsa, the composer on *The Golden Voyage of Sinbad*, he told me that when MGM was closed down all of his original scores were thrown in the furnace. That may also have been the fate of the *War Eagles* paintings and drawings.

Eventually I showed Obie my prized stegosaurus, with which I had won second prize at the Los Angeles Museum, he turned it around in his hands and eventually said, 'The legs look like wrinkled sausages. You've got to put more character into it and study anatomy to learn where the muscles connect to the bones.' To an eighteen-year-old lad this comment was both damning and soul-destroying, especially as it came from my hero, but it was one of the best pieces of advice I ever received. After that I regularly called him on the phone and made many visits to wherever he was living at the time (Obie was always moving from one house to another), and each time we would sit and talk about animation, art, model construction, Charles Knight and of course *Kong*. When I had grown to know him and Darlyne much better my parents would sometimes accompany me, and it was on one such occasion that I brought my projector along and showed Obie my ongoing 16mm tests for *Evolution* (see below) and other projects. On none of these visits did I ever show Obie any of my artwork, only my models. This was because I was never confident about my drawings and, even today, I cringe when I see some of my work. Just before I went into the army Obie invited me to visit him at RKO, at the time he was preparing *Gwangi*, and he showed me the drawings and the armatured, raw rubber, eighteen-inch-high model of the allosaurus that Marcel Delgardo had made. It was very detailed with wonderful skin texture. The skin was modelled in clay and then cast separately for the model. There were also glass paintings for the film rendered by the extremely talented Jack Shaw as well as little dioramas, or cardboard cut-outs, of various scenes that would be in the film. I did hear some time later that some kids in Culver City were selling the Obie/Byron Crabbe drawings along with their home-made lemonade, although I don't know how true that is. Either way, they are presumably lost to us now.

When I showed Obie my models he helped enormously by showing me how to look at anatomy

and also how the whole body is involved in coordinating single muscular movements. Armed with this advice my artwork and models improved steadily over the next few years.

By the end of the 1930s I began work on designing an extremely ambitious project, perhaps too ambitious for an eighteen-year-old, called *Evolution of the World*. I had envisaged a film that would show how the dinosaurs evolved and then died around 65 million years ago. To be honest, I only really touched the surface of the project with my artwork and concentrated mostly on making sketches of scenes and filming them. Off and on, over two years, I laboured at this enormous story until one day I went to the cinema (I still had time to enjoy myself) to see Walt Disney's *Fantasia*. In it was a section devoted to Stravinsky's *Rite of Spring* in which Disney had interpreted the music to accompany images of the evolution and demise of the dinosaurs. Well, that was it. I didn't shoot another frame and it taught me a salutary lesson – not to think too big. At least not until I was established. In all I shot only about twenty minutes of colour footage that included a brontosaurus (there he is again) and an allosaurus. Other creatures I designed and built for this epic were a sabre-toothed tiger, a stegosaurus, a triceratops and a woolly mammoth.

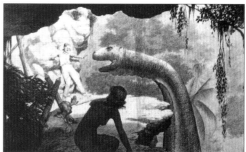

**Top left.** Sepia photographic print. 10" x 8". A beautiful drawing of a brontosaurus emerging from the mist by Obie, and perhaps Byron Crabbe, for the unrealized *Creation* (1930 – 31). The idea was subsequently used for *King Kong* in which a group of sailors are chased through a misty swamp by such a beast.

**Top right.** Sepia photographic print. 10" x 8". Another drawing for *Creation* by Obie and Byron Crabbe, again featuring a brontosaurus, but this time showing it attacking a group of people trying to hide in a cave. The depth and action in this is remarkable. The idea of a brontosaurus attacking people in a cave impressed me so much that I used the scenario as the basis for a sequence of drawings I did for *One Million Years BC*, but it was never used.

**Above left.** Charcoal and pencil on illustration card, 30" x 20". c.1930. This is a full-scale original drawing by Obie and Byron Crabbe for *Creation*, showing a pterodactyl swooping on a young girl and carrying her off in its claws. This scenario really made an impression on me and I later used the idea as a basis for scenes in *One Million Years BC* and again in *The Valley of Gwangi*. (Note the log bridging the chasm behind the action; this was an image inspired by Gustave Doré.)

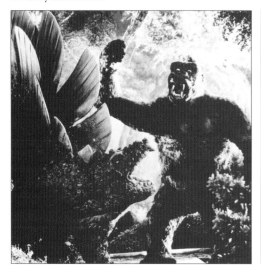

**Above left.** The model stegosaurus and Kong from *King Kong*. This was a posed photograph for a test, as they never appeared together in the final film. (KING KONG copyright RKO Pictures, Inc. Licensed by Warner Bros. Entertainment Inc. All rights reserved)

**Above right.** Copy of an original. c.1932. A key drawing by Obie for an unrealized scene for *King Kong*. At one time there was a plan to have Kong displayed in an arena, which was later replaced by a theatre.

**Right.** Watercolour on paper. 14" x 9". c.1937. A painting that I did based on Obie's drawing of Kong breaking his chains in the arena. Although somewhat cruder than Obie's drawing, this was an attempt to capture the drama of the scene and the movement of the creature.

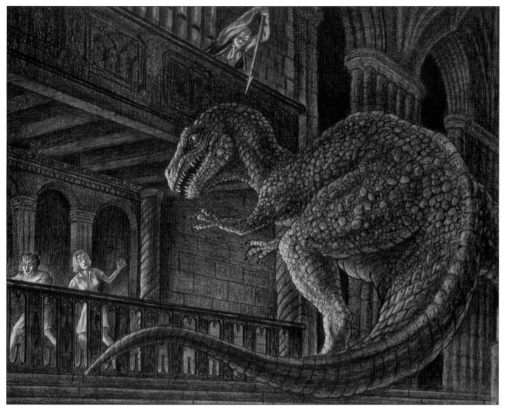

Although Obie took me under his wing and even offered me the job of chief animator on *Mighty Joe Young*, I still hadn't worked on a picture that included dinosaurs. However, following work on *Mighty Joe Young*, a project called *Valley of the Mist*, about a lost valley and an allosaurus, was proposed and we spent many months working on presentations; sadly the film was never realized, probably because of the high costs that had been incurred in creating the effects for *Mighty Joe Young*.

Another twelve years would pass before I returned to dinosaurs and this time it was to be my own dinosaur – not a 'real' creature but a kind of generic dinosaur of my own creation. In 1951 I was asked by producers Hal Chester and Jack Deitz at Mutual Films to design and animate a creature for their project *Monster From Under the Sea*, later *The Beast From 20,000 Fathoms*. Not surprisingly, neither producer had a clear idea of how the Beast should look on the screen, so the challenge for me was to find a creature that fitted the bill. It needed to be big (of course), able to survive underwater, as it had to travel by water from the North Pole to Manhattan, and, finally but most importantly, look credible. The process of finding that creature took several weeks whilst I spent some time 'feeling around' for the right image.

**Above.** Charcoal and pencil on illustration card. 20" x 14". c.1967. A key drawing for *The Valley of Gwangi*. It shows the attack of the creature inside the cathedral. This is one of my favourites and has hardly been seen before. I wanted to contrast the darkness of the cathedral interior with the dramatically lit confrontation between *Gwangi* and the humans, as Doré might have done it. I then 'framed' the lower section of the picture with Gwangi's tail.

**Right.** Pencil on paper. 20" x 12". c.1983. A very rough sketch for an unrealized key drawing for *People of the Mist* (1983). I wanted to show action in the foreground while focusing the viewer's attention on the pterodactyl-like creatures in the background.

The initial concepts included an octopus, a large shark and even a leviathan, but none of these images seemed right to me, so I experimented with other ideas, including a octopus-like alien creature and what looks today like a dragon, but in the end I knew that it had to be a dinosaur. But which one? I knew I didn't want a brontosaurus because that would seem like the end of *The Lost World* where a brontosaurus runs amok in London. I also didn't want it to be a tyrannosaurus because that was too 'normal', so it had to be something in between, and large enough to not be dwarfed by New York's buildings. The streets of Manhattan had to seem as though they were canyons where the Beast would feel at home. In the end I designed a four-legged dinosaur-like creature that was known in the picture as a rhedosaurus.

Rather unusually, even for that period, I didn't make any key drawings for the film, although I did sketch out some outlines of the Beast on tracing paper that included the rough idea for the armature; and much later, when we were discussing the screenplay, I sketched out a few rough storyboards. Instead of drawings I created the creature in clay and from that made an armatured model (based on my tracing designs) in latex, and presented that to Chester and Deitz. This first model had a round head and none of us, including myself, was happy with it because it looked too kind, too babyish. It wasn't menacing enough. When I returned to my

workshop I broke down the head and legs and remade the creature with a stronger, more reptilian head and thicker legs. This gave the rhedosaurus what I hoped was a more terrifying look. However, after some tests I made using the model, I realized that it still wasn't right, a conclusion with which Chester and Deitz concurred. Once again I rebuilt the creature, this time to what was eventually seen on the screen as the Beast. So the evolution of that Beast was long and hard and because I was new to the game I desparately wanted it to be right.

I was, in effect, a one-man band on this picture, as I would be, as far as effects were concerned, on most of my subsequent films. I not only designed, and to a large extent built, the models, but I also designed and supervised most of the miniatures that would be crucial to the animation. These included the lighthouse (which I still have), the harbour landing stage, the building that collapsed, the boat and sections of the Coney Island rollercoaster where the Beast was finally killed. Willis Cook constructed most of these and his work was exceptional. So much so that he subsequently worked on several of my other films.

The next two films I worked on concerned, respectively, a giant octopus and a creature from Venus. The octopus owed nothing to my dinosaur experience, but the Ymir was partly influenced by it. It was then another four years before dinosaurs re-entered my life when I worked on the Warner Bros

picture *The Animal World* (1956). It was a film on which I had little or nothing to do, other than to animate the dinosaurs. The only reason I took the job was to have the opportunity of working with Obie who was the supervising animator, which meant that he designed the armatures for the models and the set-ups. The film featured six species of dinosaur – ceratosaurus, triceratops, brontosaurus, tyrannosaurus rex, stegosaurus and a pteranodon – but the ceratosaurus and the tyrannosaurus were the same model with a horn added to the first. Using Obie's designs, the models had been built in the model shop in the Warner Bros studios, which was a very bad mistake. Irwin Allen, the producer, was overly conscious of costs and insisted that they be built in the studio and not by Obie or myself, to save money. The results were dull and lifeless and both Obie and myself were shocked and disappointed with them. The rubber skin looked just like, well, rubber skin. There was no texture or wrinkles, just plain, smooth skin. I know it sounds strange, but because they didn't have features they seemed unreal, and I found it difficult to instil character into them. There was one other person working on the preparations for the animation and that was Jack Shaw, a superb artist, who did many of the background landscapes for the table-top miniatures. Sadly Jack committed suicide right after working with us on *Animal World*. He was a very fine painter

**Above**. Pencil on paper. 20" x 12". c.1965. A drawing for the archelon for *One Million Years BC*. While creating fierce, carnivorous creatures and bringing them to life is always stimulating, I do sometimes like to 'take it easy' and focus on a slower, less violent prehistoric beast, even if it is not always from the same period. I like the archelon and its place in the film is, I think, perfect, since it prepares the audience for more formidable creatures.

**Right**. Pencil on paper. 18" x 11". c.1983. A very rough sketch for *People of the Mist* showing a creature watching travellers in a swamp. The dinosaur was probably meant to represent a hypsilophodon, which grew up to five feet long and climbed trees.

**Bottom left** . 10" (h) x 16" (d) x 4½" (w). c.1968. Hard rubber model of the styracosaurus featured in *The Valley of Gwangi*, used as a stand-in for lighting.

**Bottom right**. Plaster model of an arsinoitherium. 6½" (h) x 12½" (d) x 6½" (w). c.1946. I always wanted to find a place for the creature in a project but was never able to.

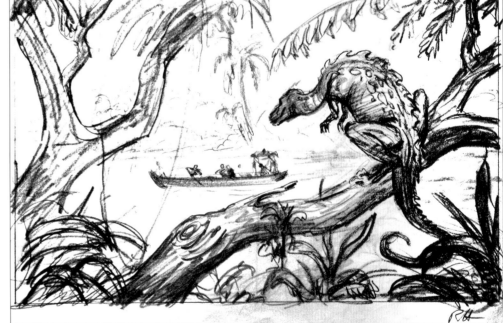

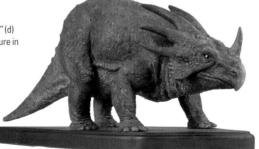

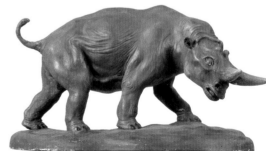

and all his work gave one a marvellous impression of depth.

Although I did all the animation, Obie would suggest the set-ups and I would interpret those in my own way, especially when it came to the fight sequences. In all Obie and I worked on the film for six weeks and our contracts with Allen and Warner Bros stipulated that we were not to do anything really complicated. We used two cameras to speed up the process and it was all table-top animation with painted backgrounds. Even though I was working with Obie it was, as far as input was concerned, one of the most unrewarding experiences of my life.

There was another long gap before I returned to prehistoric creatures. This time it was for *Mysterious Island* (1961). The original concept was a straight story of survivors on a desert island, just as in the original Jules Verne novel. However, when Columbia asked Charles and I to take over the project we knew we had to inject a number of special creatures into it, to liven things up. So we began by writing a narrative that would include dinosaurs. This in turn changed as the production developed and in the end all that was left in the picture are the phororhacos (what some people perceive as a giant chicken) and the nautiloid cephalopod, which attacks the divers underwater. The other creatures (the crab and the bee) are the results of Captain Nemo's efforts to create food for the world. The only other prehistoric

creature is one that exists only in a set of continuity drawings. It was a sea creature that was a figment of my imagination although it was probably based on a species of plesiosaur. In the drawings the divers are attacked by the creature, which is eventually destroyed by a torpedo, fired, it would later be revealed, from Nemo's submarine *Nautilus*. This scene was later dropped in a rewrite.

Another five years passed before I returned to my old friends when, in 1966, Hammer Films asked me to design and animate the creatures for their re-make of *One Million BC*, in the UK titled *Man and His Mate*, which they called *One Million Years BC*. In the original 1940 version the monsters consisted of lizards or, in the case of the allosaurus attack, a man in a rubber dinosaur suit, which, to be kind, was less than successful. Now Hammer wanted a line-up of creatures that would make the film a smash and take the basic story to another level. Working with producer Michael Carreras I came up with key drawings for a brontosaurus, an archelon, a fight between a ceratosaurus and a triceratops, a nest of pteranodons and a fight with a nasty allosaurus. I began by making a set of key drawings of these set pieces, along with perspective or comparative drawings of these and other creatures that were to appear. These, as always, helped to design sequences and were invaluable to the actors. In place of sketched storyboards I used a trick I had developed

for *Earth Vs The Flying Saucers*, which involved photographing various locations on Lanzarote (where the picture would largely be shot) and then making the storyboard for each sequence by drawing in the creatures over the relevant photograph.

Apropos *One Million Years BC*, I was once told by a five-year-old that I knew nothing about pteranodons or pterodactyls because they don't really have bat wings! Well, I know they don't. They should have had huge pieces of skin stretched from the top of their legs out beyond their claws. But what I had to think about was how these creatures of the air would work cinematically when I was animating them. If I had made my creatures with just skin for wings they would have looked improbable, even if they had been more accurate, so I used a certain amount of cinematic licence and gave them what I saw as more dramatic wings. In fact, I tried to make them look like umbrellas rather than bats. In effect, we tried to find a compromise between strict scientific accuracy and the need to achieve certain cinematic effects, and I believe we did the right thing. It gave them a fantasy element and after all we weren't making pictures for palaeontologists, although today filmmakers make all their creatures so real – too real for my tastes.

Over the next few years I would stay in touch with Hammer. We first discussed the possibility of remaking *King Kong* and then *When the Earth Cracked Open*. Neither project came to fruition and I

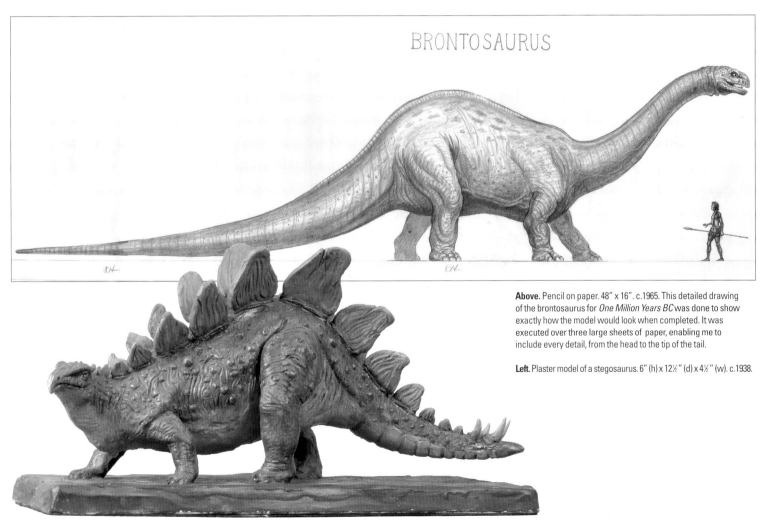

BRONTOSAURUS

**Above.** Pencil on paper. 48" x 16". c.1965. This detailed drawing of the brontosaurus for *One Million Years BC* was done to show exactly how the model would look when completed. It was executed over three large sheets of paper, enabling me to include every detail, from the head to the tip of the tail.

**Left.** Plaster model of a stegosaurus. 6" (h) x 12½" (d) x 4½" (w). c.1938.

am not too sad about *Kong*, but the second idea did have some possibilities. It was to be a return to the caveman-and-dinosaurs theme that Hammer had exploited so successfully, but on a much more ambitious scale. I did rough out some basic ideas as storyboards of giant ants, dinosaurs and a tentacled beast but that's as far as it went.

Around 1967/8, before Charles and I hit on the idea of making *Gwangi*, we considered making a Sinbad movie featuring dinosaurs instead of mythological creatures. The premise was good but from what I remember we couldn't quite come up with the story to flesh out the basic idea.

All those years before, when I had visited Obie whilst he was trying to set up his *Gwangi* project at RKO Studios, I had been more than impressed with his designs, storyboards and models for the film. Now, riding on the back of the success of *One Million Years BC*, Charles and I decided to try our hand at a dinosaur movie and what better choice than resurrecting *Gwangi*, with its cowboys, love interest and lost valley. This was not only a return to my roots, in other words *King Kong*, but, in my mind at least, it was also to be a tribute to Obie's imagination.

Whilst the writers worked on the screenplay I went back to Obie's original storyboards, which I still had in my possession. These had been crucial to the original story but they were now superseded by a more up-to-date storyline. I began by sketching some of the key sequences and then worked on a set of key drawings along with smaller sketches of other key scenes (done in ink on paper) and size comparison drawings showing the creatures in relation to the humans. As with similar drawings I had made for *One Million Years BC*, this was a vital aspect of model design, helping the actor to relate to what he should be looking at, and, of course, helping me to calculate size when on location shooting the rear-projection plates. After the storyline had been agreed, I finally executed the storyboards, which illustrated the complete sequences and showed the effects I would have to do in each shot.

*Gwangi* was not given the publicity it deserved and so was not a success and perhaps because of that it was the last dinosaur feature that I would be able to bring to the screen. However, I did work on two more projects that were never filmed. The first, which I have mentioned, was *When the Earth Cracked Open* in 1970 and the second, in 1983, was the ill-fated *People of the Mist*. This latter project really appealed to me and I worked on it for some considerable time, visualizing a large variety of ideas, including a pterodactyl, huge prehistoric vulture-like birds (a version of Obie's *War Eagle* birds), a stegosaurus being attacked by two nasty dryptosaurus and finally a number of evil-looking plesiosaurs and mesosaurus in a large man-made lake into which sacrificial victims are cast from a huge statue.

Although I have discussed the general principles involved in designing and constructing models, there are some features that apply only to dinosaurs. Perhaps the most important is the skin and colour. Skin texture plays a vital part in making any creature,

whether completely imaginary or not, look realistic and not rubbery. The best examples of how not to make models of dinosaurs would be the ones the studio created for *Animal World*. I spent a great deal of time, or at least as much time as I was able, in making sure the texture and (in the case of dinosaurs) scales were suitable and as realistic as the camera will permit. I based a lot of the textures on Charles Knight's illustrations, making some additions of my own to take account of cinematic considerations. I gave my dinosaurs lizard-like scales, bumps, wart-like features and folds of flesh around their legs, stomach and head, all of which helped to make them more interesting. I also liked to give my carnivores tails with layered scales, as a continuation of their spinal scales, which suggested easier movement of these appendages. The realism of the tail was vital in establishing its importance and so enabling me to instil character into these beasts.

Now to the question of colour, which is slightly controversial. Today's reconstructionists and filmmakers often make their dinosaurs vividly coloured, and perhaps this is correct if we accept the current theory that dinosaurs were the ancestors of the birds we see around us today. However, Knight's colourings for dinosaurs were more subtle, reflecting the colour of lizards. After all, very few lizards are brilliantly coloured. The average lizard is usually grey or grey/green. The use of subtle colours was therefore something that I adopted and I think, as far as their appearance on screen is concerned, this has been the right decision. The same applies to the issue of whether the tails should be up or down. Knight always had the tails down, as did I, and I think our creations looked considerably more elegant than some more modern reconstructions that show the tails sticking up into the air. Using the analogy of lizards again, most of them tend to drag their tails, but today's palaeontologists say that there has never been any evidence in finds to suggest that dinosaurs dragged their tails. Whatever the truth of the matter, I believe that the tails look better down.

The other important factors in making these creatures seem real were the teeth and eyes. The teeth I usually modelled in plastic, after which I would 'cook' them in the oven and then fix them to the skull of the armature before it was covered in latex. Sometimes I would be very technical and use toothpicks, which I then painted. The eyes were usually glass animal eyes from a taxidermist. They came in various sizes so I would select the ones that would suit the size of model and for dinosaurs I used lizard eyes, although I did use ones featuring round irises when I could not find the correct lizard-like glass eyes. Hopefully, nobody noticed.

As I have suggested, the way the dinosaurs moved was a vital factor in bringing them 'alive' and providing them with that all-important element, character. Of course, movement was always dictated by the physiognomy of the creature. A four-legged animal would certainly move differently to a two-legged one. It wasn't enough to have a creature walk on stage left, wag its tail and walk off again stage

right. I had to make that walk something that people would remember. So I utilized what advantages they had. Some had more than others. Some were more passive than others but all had tails, claws and heads that I could utilize to furnish them with character. I would always find something to 'latch onto' in order to put some distinctive traits into their actions. It may surprise some people that, although I did have some basic ideas as to what they were going to do when I was planning a sequence, their movements, by and large, originated on the animation table. One pose led to another. It was all spontaneous. Of course their action does have to depend on what is on the background plate, in other words, what the live actors are doing. If an actor recoils, you have to make the animal's jaws snap ahead of that action. But basically all movements were from my imagination and how I saw the creatures concerned. They were pure Ray Harryhausen.

Over the years my dinosaurs, and the way I depicted them, developed and matured. When I first began my experiments I wasn't as critical, but as the years went by I became more particular as to how they would look on the screen. There were new influences and on other occasions I would see that the muscle structure or movement should be stronger. When I look at the fight between the tyrannosaurus and the triceratops for *Evolution of the World* I notice that the legs of the triceratops moved incorrectly. The two left legs moved together and then the two right ones. Well of course, all four-legged animals move their legs diagonally. It was always a learning curve, an evolution.

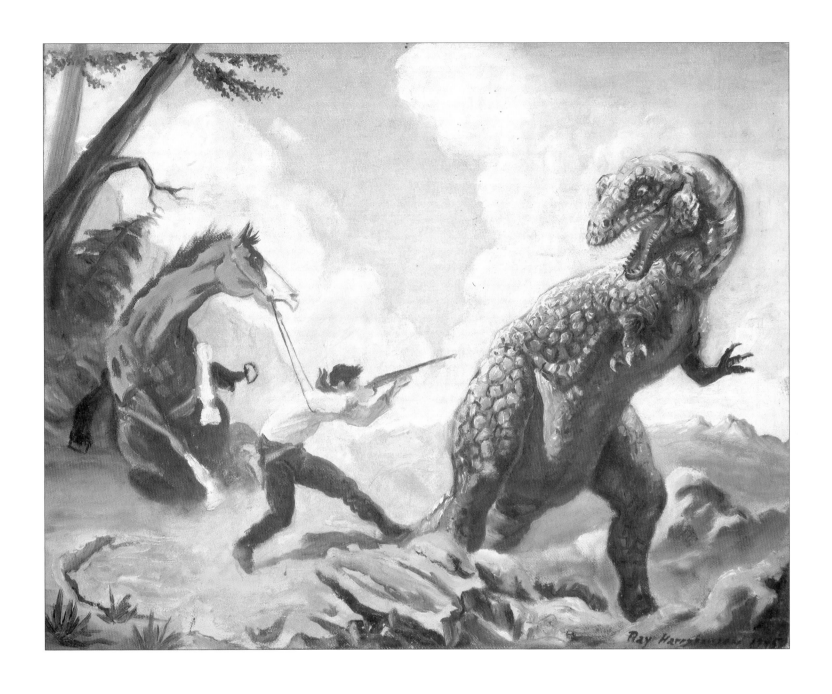

**Above.** Oil on canvas board. 20" x 12". c.1938/9. One of my rare oil paintings, in this case from the late 1930s. It shows a scenario of an allosaurus attacking a cowboy that I was toying with and Tony refers to it as my 'Remington-like dinosaur piece'. It may well have been inspired by Obie's *Gwangi*.

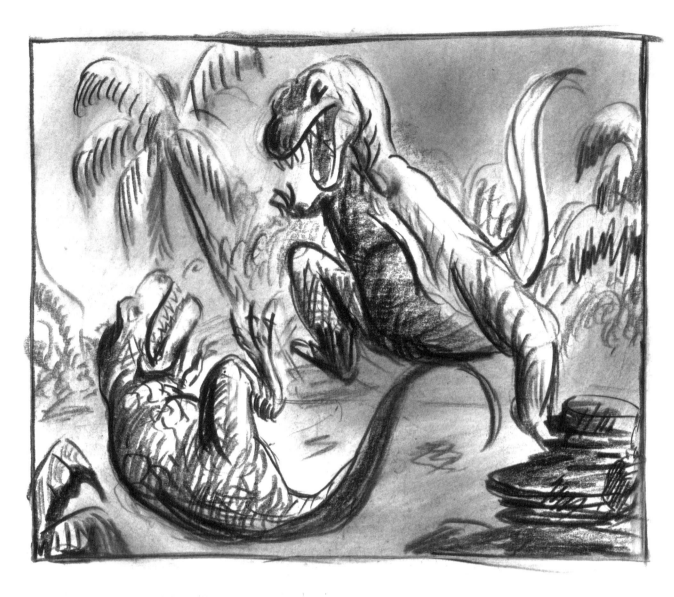

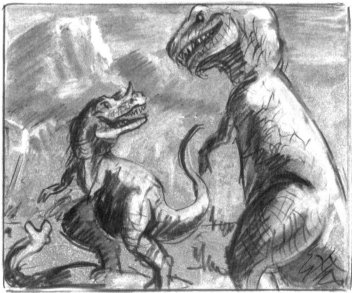

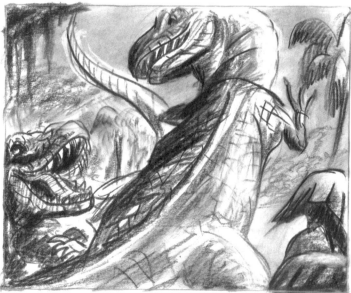

**Above.** Charcoal on photographic paper. Each 4" x 4". c.1938–40.
Three rough sketches for *Evolution of the World*. These action
sketches were for a proposed fight scene between two allosaurus /
tyrannosaurus rex.

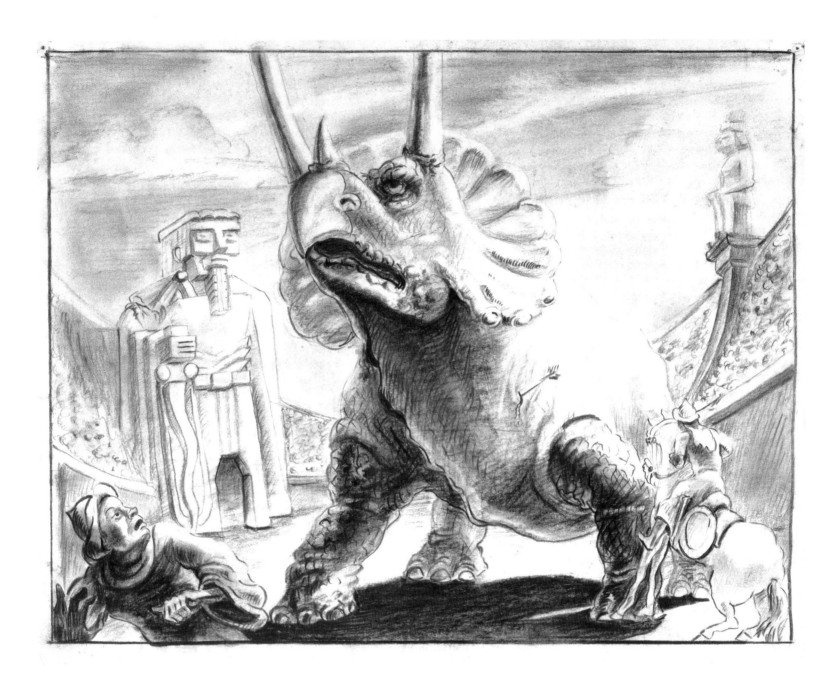

**Above.** Charcoal and pencil on paper. 10" x 8". c.1939/40. A quick sketch for a proposed early idea. I was always trying to get those dinosaurs into a story. I really don't remember what this sketch was for, but it was obviously set in an ancient civilization and featured a triceratops confronting gladiators in an arena.

**Following pages.** Pencil on art paper. 11" x 8". c.1968. Part of storyboard for *The Valley of Gwangi*. These two pages show my storyboard for the end of one scene (the fight between Gwangi and the styracosaurus) and the chase to the exit of the valley. On the second page, there is a sequence that never appeared in the completed film, showing Gwangi chasing the cowboys over a deep ravine, or ditch. This was an idea we borrowed from the original *Gwangi*.

MED. SHOT: Tuck releases
Carlos's horse as Carlos mounts.
They ride out left. 421A

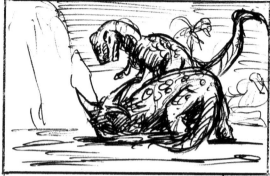

FULL SHOT: (Dyn) Both are
down, rolling over. Pulling apart
they leap to their feet. Gwangi sinks
his teeth into the Sty. shoulder. 424

MED. SHOT: Trapped between
the fire and the fighting monsters,
the group see the Prof. and Lope
ride up. 425

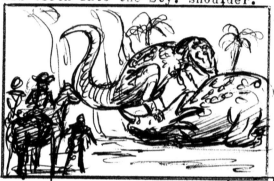

MED. LONG SHOT: (Dyn-TM) The
group move into scene and pause
to try to get past the fighting beasts. 425A

CLOSE SHOT: The group, as
their horses rear and prance in
fright. They charge off right. 425B

LONG SHOT: (Dyn)Led by Tuck,
they ride out past and behind the
struggling monsters. Gwangi has
the Sty. down and is crunching his
razor sharp teeth into its flesh. 426

MED CLOSE: (Dyn) As the
remainder of the group ride
by in b.g. Gwangi looks up. 427

MED. CLOSE: Moving with the
group as they race toward the
exit. 428

MED. SHOT GROUP — GWANGI (Dyn) `430`
They dash through the mushroom
buttes changing direction in f.g.

Gwangi appears in b.g. `430 CONT.`
dashing off left after them.

MED. SHOT: T.J.-PROF.-LOPE `432`
T.J. leaps her horse over a nest of
rocks. Prof. B. pulls back to avoid
them, circling rocks.

MED. FULL SHOT: CARLOS-BEAN `433`
ROWDY; Bean, Rowdy bear down ditch.
Rowdy's horse tumbles, scrambles
to feet, Rowdy on...exit.

FULL SHOT: TUCK (DYN) `434`
Carlos scrambles up the side as
Tuck, in b.g. slides down ditch,
disappears, then up and out f.g. Gwangi
appears across the ditch.

WIDER ANGLE TUCK &GWANGI- `435`
(Dyn) As he scrambles out of the
ditch and rides off Gwangi comes
to it, hesitates, then leaps it.

MED. SHOT; Interior end of `437`
fissure. The riders drive their
horses in bunching up at the opening.

INT. FISSURE : (Dyn) T.J. `438`
and group ride through
narrowing fissure.

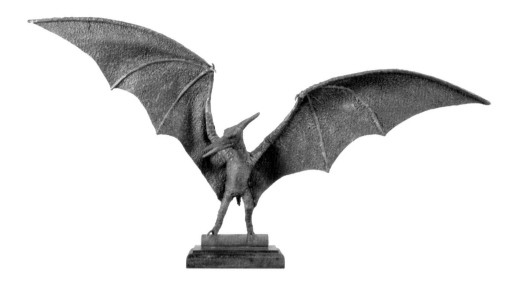

**Top.** Rubber latex over a metal armature. 9½" (h) x 4" (d) x 18½" (w). c.1965. The model of one of the pterodactyls that appeared in *One Million Years BC*. I recently had to restore him as his wings and legs were beginning to disintegrate. Although I know that pterodactyls did not really possess bat-like wings, I always felt that they looked more convincing airborne that way.

**Above.** Pencil on paper, 20" x 12", late1965. An early, rough sketch for a poster design for *One Million Years BC*. The way in which my films were promoted has always been important to me and I have taken a keen interest in how all of them were presented to the public, so I would occasionally sketch a poster design and show it

to the producer; however, this one was never presented to Michael Carreras. In the end Hammer decided this picture would be sold best by concentrating on Raquel Welch's assets rather than those of dinosaurs.

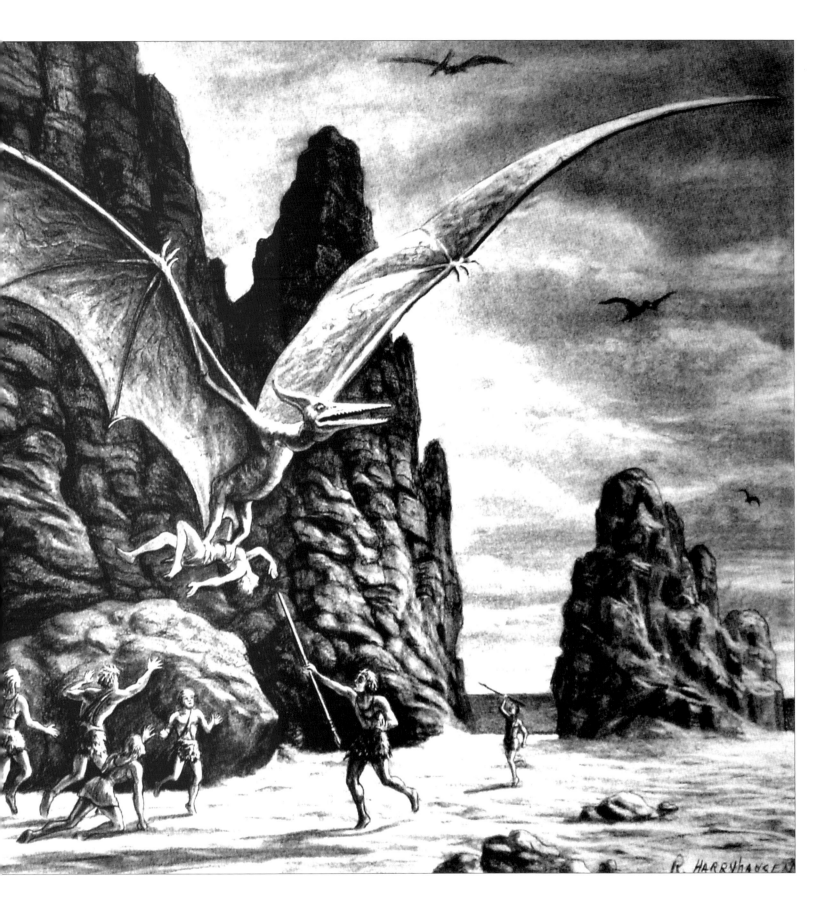

**Above.** Charcoal and pencil on illustration board. 20" x 14". c.1965.
A key drawing for the pterodactyl sequence in *One Million Years BC*
which shows the girl being carried off by the creature. The idea
was loosely based on a drawing by Obie and Byron Crabbe of a
similar sequence for *Creation*.

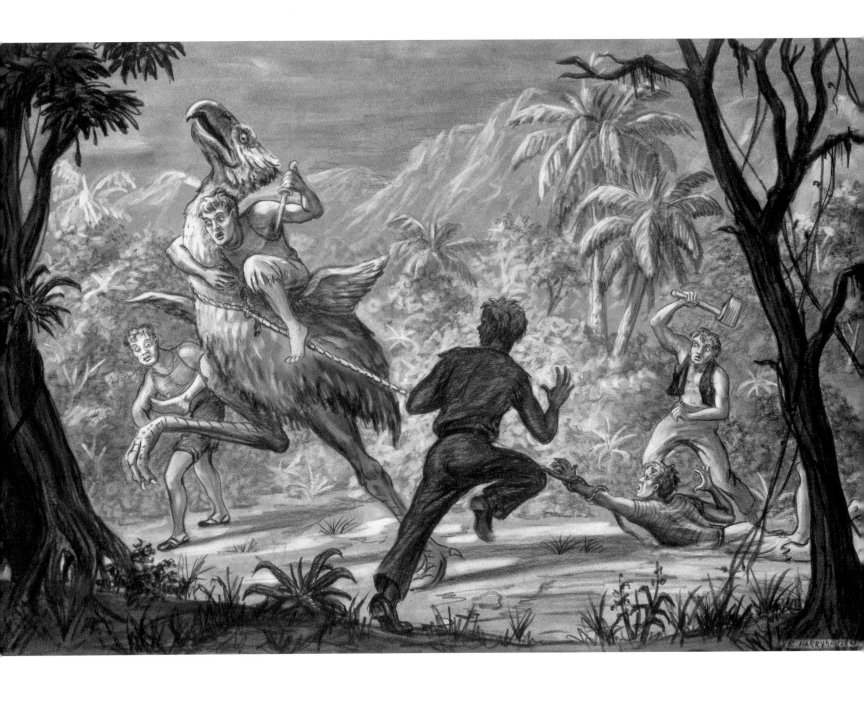

**Above.** Charcoal and pencil on illustration board. 17" x 11½". c.1960.
The key drawing for the attack of the phororhacos in
*Mysterious Island.*

# ALLOSAURUS

**Above.** Pencil on paper. 30" x 14". c.1965. A comparison drawing for the allosaurus in *One Million Years BC*. It not only allowed me to show how big this creature (he was meant to be a young allosaurus) would be compared with a human, but also to design detail into him for the key drawings and also for the final latex model. The ridged tail is reminiscent of a crocodile, which was intentional.

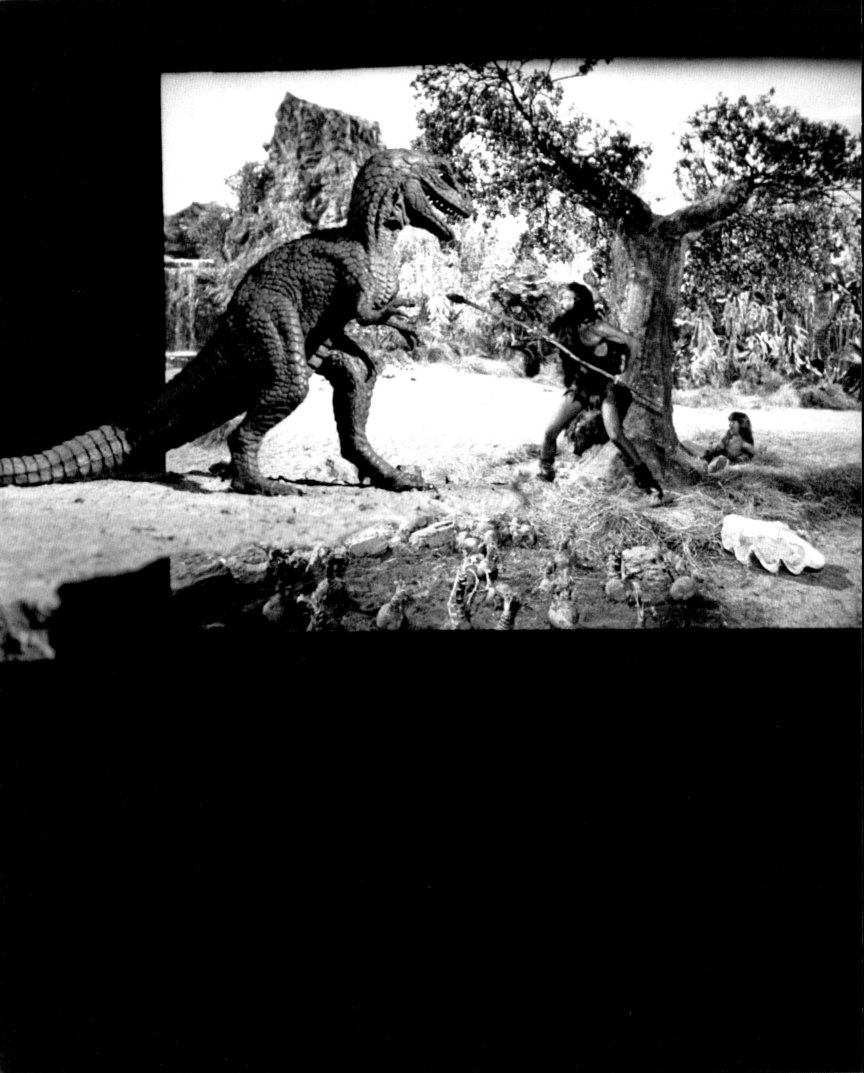

**Left.** 120mm film negative. c.1965. A very rare still showing how I coordinated the movements of the animated allosaurus with the live action on the rear projection plate for *One Million Years BC*. The caveman, played by John Richardson, is on the rear projection plate, as are the studio set with the tree and the natural features in both the background and the foreground. The model of the allosaurus was placed on a miniature v-shaped platform with a surface that matched the terrain shown on the rear plate. I then coordinated the movements of the model with those of John Richardson, with whom I had worked out the 'choreography' of the fight during the filming of the live action.

**Above.** Latex rubber over metal armature, 13" (h) x 20" (d) x 8" (w). c.1965. The allosaurus from *One Million Years BC*. Now almost forty years old, he is beginning to show his age. The tail and feet, which are often the parts subjected to the most manipulation by me during animation, are disintegrating, revealing the metal armature within. However, considering his age, he isn't doing badly.

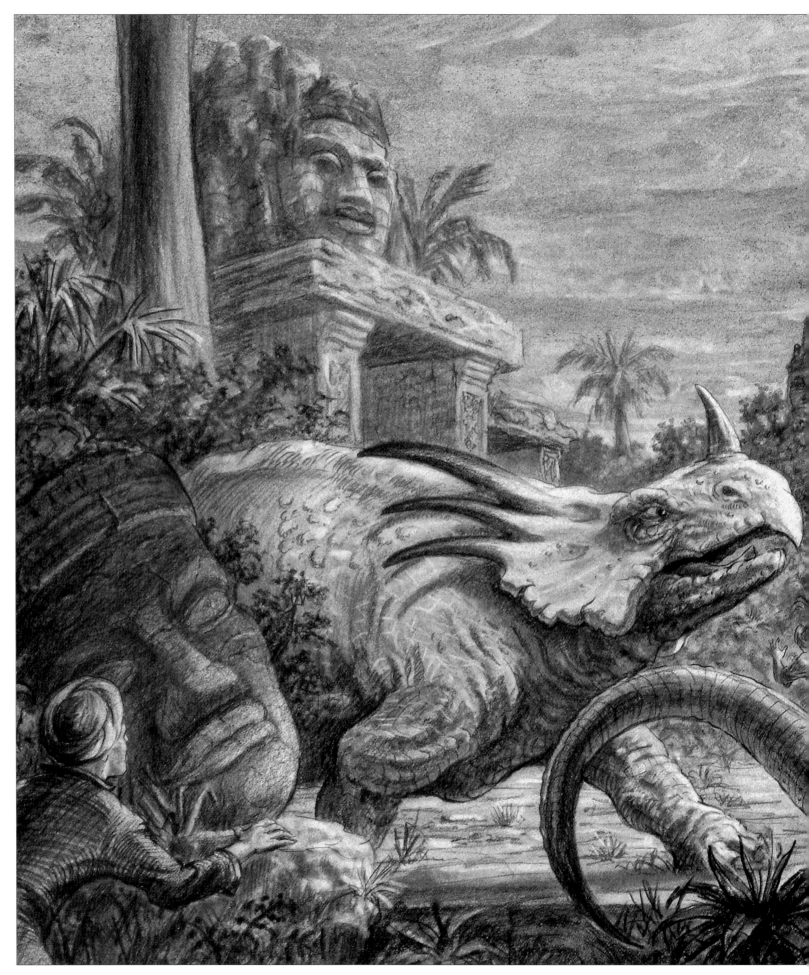

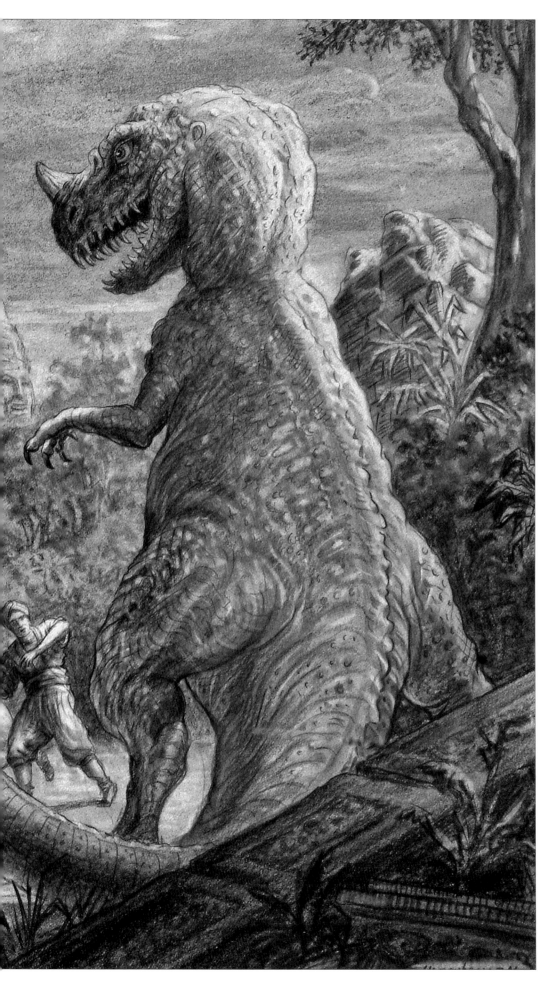

**Left.** Charcoal and pencil on illustration board. 19" x 13". c.1969/70. This is one of two or three key drawings I did for an unmade project called *King of the Geniis*, an idea for a film that would feature both Sinbad and dinosaurs. Aside from the syracosaurus and ceratosaurus / tyrannosaurus rex, the temples are both Mayan and Eastern in influence. Perhaps because of the poor reception for *The Valley of Gwangi*, Charles and I decided to drop the idea and whatever ideas were left over went into what would become *The Golden Voyage of Sinbad*.

**Right.** Charcoal, pencil and watercolour on illustration board. 22½" x 16½". One of my most dramatic drawings for my unrealized and ambitious *Evolution of the World*. It shows a triceratops defending itself against two dryptosaurs. This was hugely influenced by the Charles Knight painting showing two dryptosaurs attacking each other.

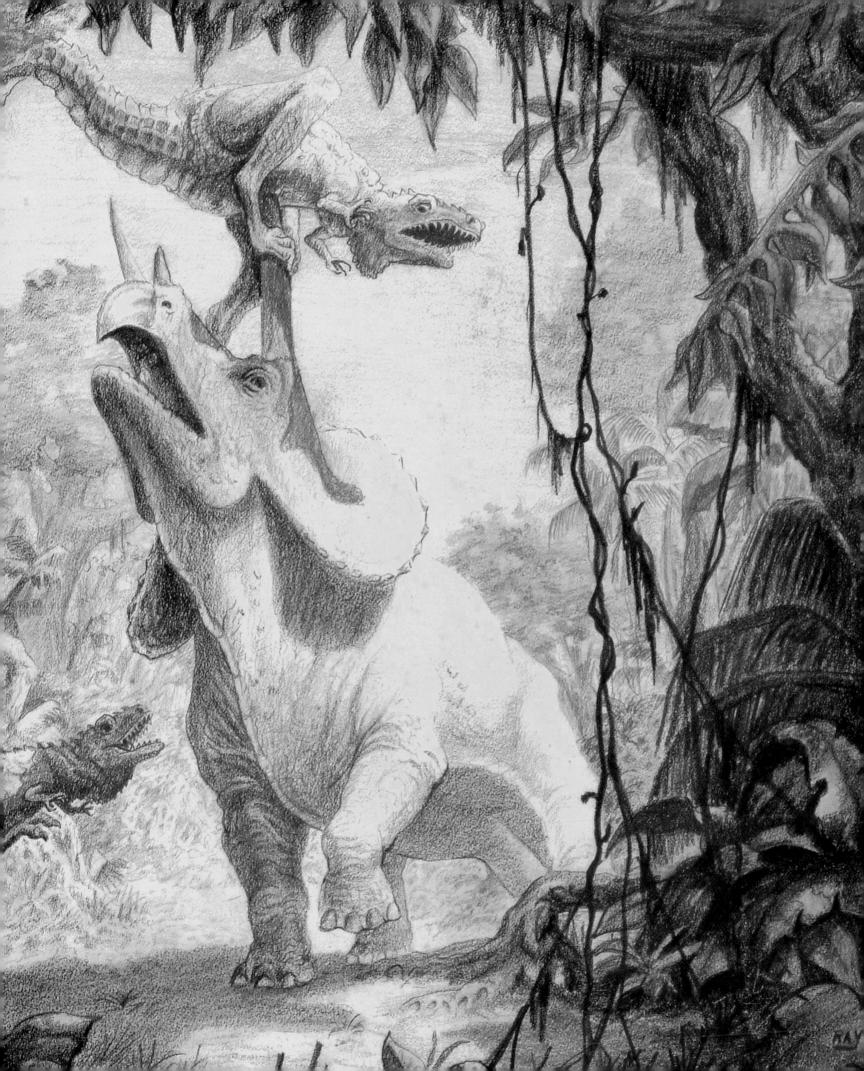

# TRICERATOPS

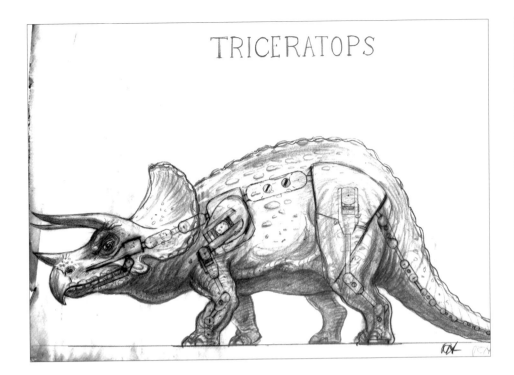

**Top.** Pencil on tracing paper. 22" x 14". c.1965. A preliminary drawing of the triceratops for *One Million Years BC*. Over the drawing I have laid a design on tracing paper showing how it will relate to the model.

**Above.** Charcoal and pencil on illustration board. 20" x 12". c.1965. Key drawing for the brontosaurus scene. This was my version of the brontosaurus being attacked, or attacking the cavemen, for *One Million Years BC*. Sadly the scene was dropped from the final picture.

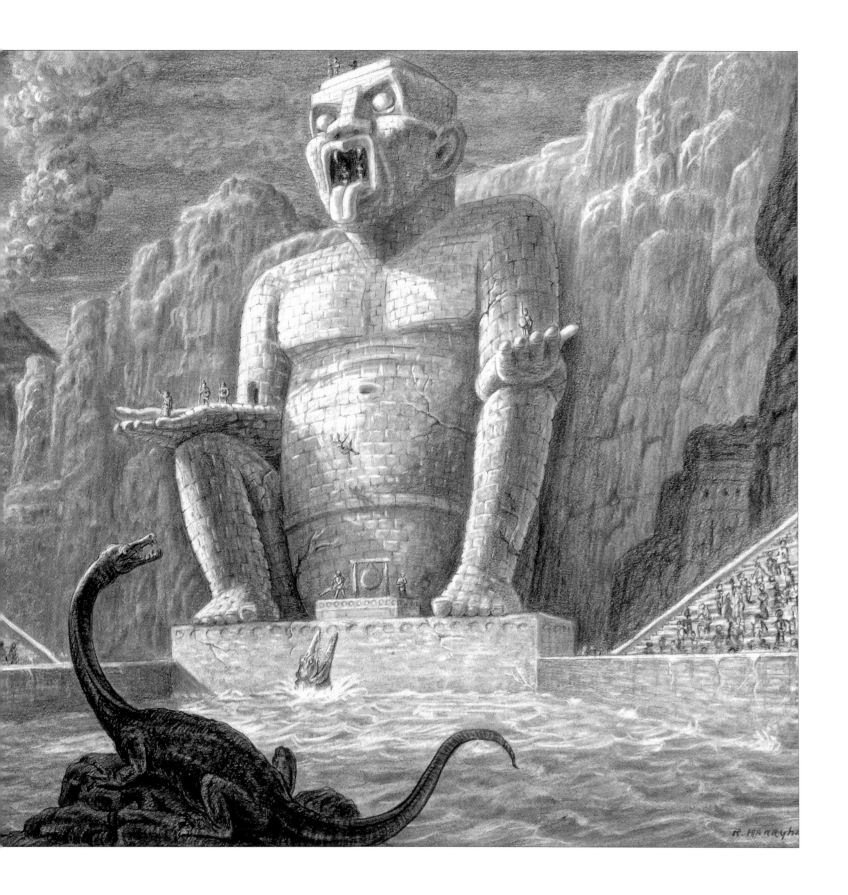

**Above.** Charcoal and pencil on illustration board, 16" x 10". c.1983. A key drawing showing a planned scene for the unrealized *People of the Mist.* Although Michael Winner wrote the screenplay, and was due to produce and direct the film, the idea of sacrificing young ladies to prehistoric water creatures was primarily mine. I had always wanted to create a massive statue, and the idea of pushing the virgins out of its mouth to meet their deaths in the water below seemed very unusual, although not too good for the virgins. In the watery 'arena', awaiting their lunch, are, in the foreground, a type of plesiosaur and, behind, a mesosaurus. Note the gong – shades of *Kong.*

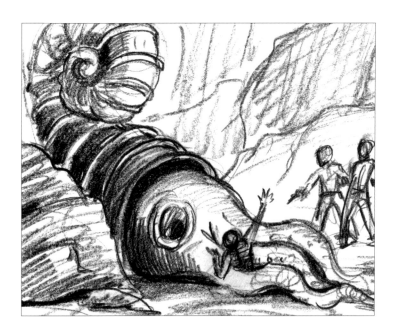

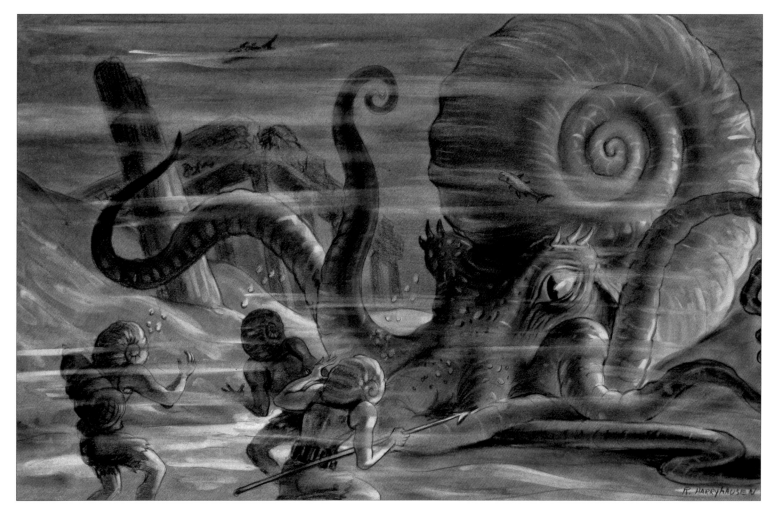

**Top left.** Pencil on art paper, 10" x 8". c.1951. A very rough sketch showing an early version of the prehistoric nautiloid cephalopod. This one looks as though I may have envisaged him stranded on dry land and he also appears disappointingly unthreatening – indeed, he looks as if he might be about to nod off.

**Top right.** Charcoal and pencil on paper, 7" x 4". c.1960. A drawing for *Mysterious Island* of a rather interesting scene that never appeared in the final film. The monster shown here is a form of mesosaurus, a marine carnivorous creature, and, according to the storyboard, the divers were going to use explosives to destroy him.

**Above.** Charcoal and pencil on illustration card. 20" x 14". c.1960. A key drawing of the nautiloid cephalopod for *Mysterious Island* (1961). This time I have shown him attacking underwater. The creature and his shell are satisfactorily dramatic.

**Top.** Pencil on paper. 10" x 8". c.1951. A design for *The Beast from 20, 000 Fathoms*. This is one of the many designs I tried for the Beast, a kind of triceratops. Eventually I turned to a more carnivorous interpretation for the final design.

**Above left.** Charcoal on paper. 10" x 8". c.1951. An intermediate design for the Beast. In this I had seen the creature as quite dinosaur-like but with a type of beak. I still had a long way to go.

**Above right.** Charcoal on paper, 13" x 9". c.1952. Another design for The Beast. The legs were still too long and ungainly and the face was unbelievable but the back and tail were beginning to reveal what would become the Beast.

# CHAPTER 7 ZEUS COMPLEX

TODAY, WHEN PEOPLE MENTION MY FILMS, they usually talk about *Jason and the Argonauts*, or *Clash of the Titans*, and I suppose that, if I was forced to choose my favourite of all the pictures I made, it would have to be *Jason and the Argonauts* because it is the most complete in terms of both story and animation. But the choice would not be an easy one because, apart from *The Animal World*, every one of the films I worked on seemed to me to be original and to present a unique challenge.

Although Greek mythology has always been a rich source for fantasy projects, and therefore stop-motion model animation, few films before *Jason* had realized the full potential of both the human characters and the mythical creatures that provide the basis of these wonderful stories. There are few other sources where you could find so many adventures, bizarre creatures and larger-than-life heroes. Most films in the genre, including the Italian sword-and-sandal epics of the '50s and '60s, had concentrated on the heroes, heroines and villains while more or less ignoring the creatures and the manipulative machinations of the gods. So I asked myself: what if we made a film that featured the creatures and the gods and used the humans to link the story? That was how *Jason and the Argonauts* was born.

However, when we considered the quests of Jason and Perseus, we soon realized that the storylines needed some modification if we were to translate them to the cinema screen. The basic premise might be usable, but there were episodes and characters that were clearly not suitable for our audience. The ancient Greeks obviously relished plenty of gore and sex and we were not in the horror or porn businesses. Both of the stories therefore had to be judiciously edited so that the heroic themes were retained while the more extreme elements were left out. Of course, if the films were being made today everything would probably have been left in, much, I fear, to the detriment of the cinematic story.

The addition of mythological subjects to our portfolio of fantasy films gave me the opportunity to conjure up a whole new range of exciting creatures. Sometimes we may have played a bit fast and loose with the plots, or introduced creatures from one story into another, but that is the great thing about these tales: you can keep to the spirit of the original without slavishly following it. For a film-maker, that is what makes them so entertaining. I suspect that the ancient Greeks would have been pleased with what we did – even if the academics have not always been quite so impressed.

So I was able to let my imagination run riot. It seemed as if a new door had been opened, giving me access for the first time to the whole fantastic bestiary of the ancient world. These productions had to be approached in a completely different way from a monster-on-the-rampage movie or even a Sinbad story. When I designed them I had to consider what Cerberus and Dioskilos, or a hydra, a harpie, or indeed a Kraken might look like. How should I depict the gigantic Talos and dream up a climax worthy of his stature? Few solo technicians, before or since, have been granted such freedom to devise a whole range of monsters and then been allowed to bring them to life. Of course, as well as looking right on the screen they also had to be practical from the animator's point of view. That was the trick.

I made my first attempt at translating mythology on to the screen in 1946. It was a project called *The Satyr*, embarked upon because I had been so inspired by the ruins of the Mayan sites during my 'sabbatical' in Yucatan, Mexico. My wonder at the pyramids, the grotesque carvings, the sheer spectacle of this lost civilization was further enhanced by the mystery of the jungle setting. On my return to Los Angeles I started to look for ways to fit it all into a storyline. I know what you are saying: the Mayan civilization was not in any way connected with that of the Greeks. But that was part of my idea. I wanted to combine Greek mythology with Mayan, or even Egyptian settings as I felt that there were so many similarities. For a start, both the Mayan and Egyptian civilizations had built pyramids; what other parallels might be found?

My story for *The Satyr* told of a group of travellers who discover the entrance to the mythological underworld beneath a Mayan pyramid. There, among other creatures, they encounter a sphinx, a griffin, the cyclops, Medusa and a satyr. In my story the satyr, who ruled over all the creatures of the underworld, was the personification of evil. In the original Greek legend a satyr or Sat'yri was a demigod, usually depicted as a man with the legs and feet of a goat, short horns in his skull and covered in thick body hair. Like the cyclops, the one-eyed giant of Greek mythology, the satyr lent himself very conveniently to model animation. Finding that perfect subject for the animation table was always very important.

For *The Satyr* I got as far as completing a rough tracing and a very rough key drawing of the

**Previous page.** Charcoal and pencil on illustration board. 13" x 12". c.1978. My design for the Kraken, one of the Titans. There was very little experimentation involved, the Kraken was one of those creatures that materialized very easily. The fact that he was an aquatic creature made the tail and tentacles a natural choice.

**Left.** Latex body with internal metal armature. 17" (h) x 25" (d) x 10"(w). c.1979. Even after twenty-four years, Medusa has stood the test of time although I have had to make a few running repairs. She was built to be photographed in close-up.

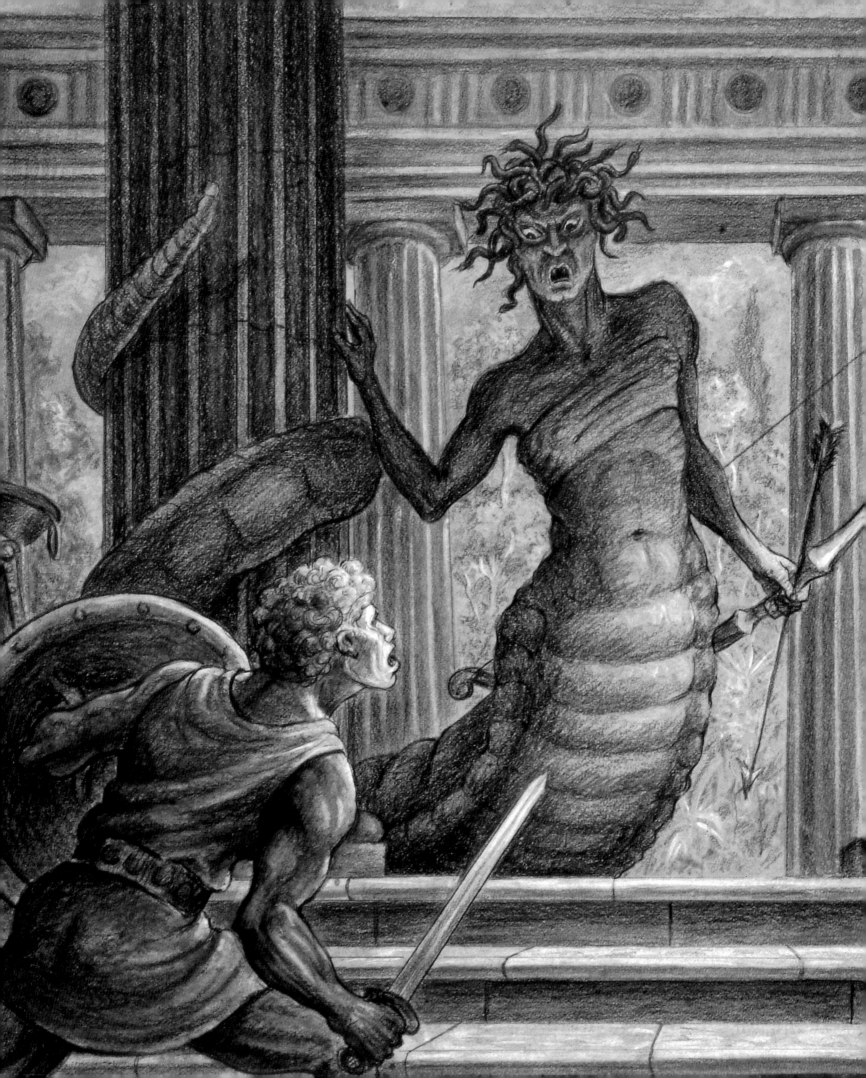

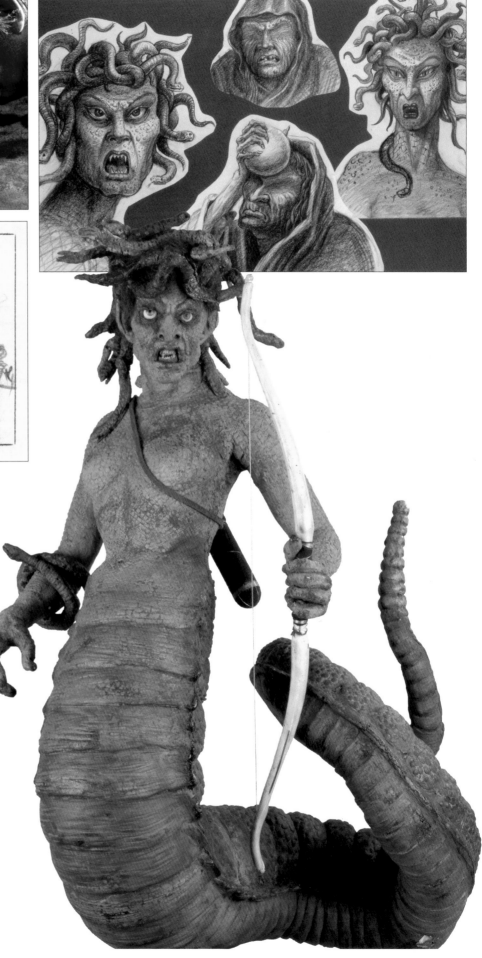

**Left.** Charcoal and pencil on illustration board. 18½" x 12". c.1977. Detail from a key drawing for the Medusa sequence. One of the presentation pieces that sold the picture to MGM. Apart from the addition of a 'boob-tube', this is almost exactly how she appeared in the film.

**Top left.** Me working on the Medusa model during filming for *Clash of the Titans*.

**Top right.** Charcoal and pencil on art paper mounted on illustration board. 21½" x 16". c.1978. Concept drawings of Medusa and two of the Stygian witches.

**Above.** Pencil on yellow tinted paper. 5" x 4". c.1946. Very early rough sketch of Medusa for *The Satyr*.

**Right.** Latex body with internal metal armature. 17" (h) x 25" (d) x 10" (w). c.1979. Medusa in all her glory. After the skeletons, she is probably the most popular of my creations and one of those I am most proud of.

creature emerging from a cave and looking down at two men, one holding a gun. Sadly, that is as far as the project progressed. It does, however, show that, as early as my late twenties, I had realized that mythology offered possible subjects for stop-motion model animation and had recognized the potential of these creatures in terms of screen interpretation. Sadly it would be years before I was able to bring my ideas to fruition.

In 1950 I again resurrected the 'underworld' idea, but without any of the Mayan or Egyptian influences. This project, called *The Lost City*, was to have been based purely on Greek mythology. The basic story told of an archaeologist who discovers an ancient statue of a centaur, half man, half horse. The writing on the statue guides him to a temple carved from living rock, hidden beneath, or near, another ancient city (perhaps Mycenae, the city ruled over by Agamemnon) and only revealed after a

sudden and convenient earthquake. On the exterior of the temple is a huge carving of a man on a horse rearing up to challenge a cyclops, and hidden in the temple the archaeologist unearths a passage leading to caves containing enormous statues of various mythological creatures, among which Medusa features prominently. At the end of the caves is a bottomless pit, which turns out, as before, to be the entrance to an underworld inhabited by the gods and creatures of mythology. In this version, the protagonist was to have been a cyclops who escapes from the underworld and causes havoc. The idea of bringing a cyclops to 'life' never left me and eventually I did manage to incorporate him into *The 7th Voyage of Sinbad*. Regrettably, I only completed one basic storyboard for *The Lost City*: it shows the opening scenes when the temple is discovered along with the entry into the caves of the underworld.

Apart from the cyclops, which popped up in

*The 7th Voyage of Sinbad* in 1958, it wasn't until the early 1960s that I was able to bring the essence of Greek mythology to the screen. *Jason and the Argonauts* fulfilled a dream that I had harboured since my late teens. In fact, the popularity of *The 7th Voyage of Sinbad* encouraged me to resurrect the idea of developing a mythological theme and to talk it over with my colleague, Charles Schneer. The idea of using the Jason story first arose during the filming of *Mysterious Island,* when I made some notes for a story in which the Argonauts, in the course of their quest for the golden fleece, encounter walking skeletons, a griffin, harpies and Medusa. The skeletons and harpies did eventually appear in *Jason,* the other ideas I saved for use in later adventures. Few if any of my ideas were ever completely discarded. Once I had pictured a creature in my mind's eye, it rarely left me until I had realized it on paper or celluloid. Even today there are still a horde

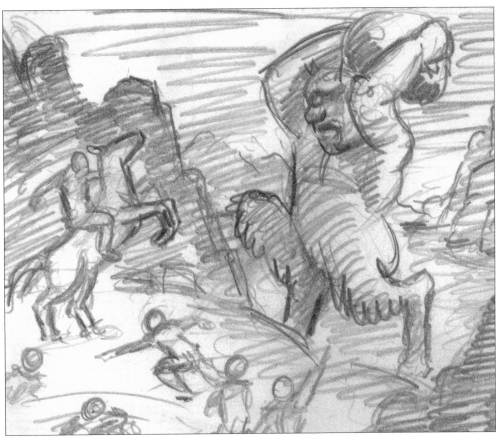

**Top left.** Pencil on art paper. 5" x 3¾". c.1950. Rough sketch of a cyclops attack for *The Lost City*.

**Top right.** Pencil on art paper. 5" x 3½". c.1946. Rough sketch for *The Satyr*. This was an idea I had for the earliest version of *The Satyr*. It shows the creature looming behind a Mayan pyramid.

**Above.** Pencil on art paper. 5" x 3¾". c.1950. Rough sketch of a cyclops fighting a griffin.

**Left.** Pencil on art paper. 5" x 3¾". 1950. Rough sketch of a cyclops fighting a dragon. Believe it or not, this was for *The Satyr*, not *The 7th Voyage of Sinbad*, and suggests that the images of these two creatures had been with me for a number of years.

**Above.** Charcoal and pencil on paper, mounted on illustration board. 20" x 15". c.1950. Storyboard for *The Lost City*. Re-using some of my ideas for *The Satyr*, I took this project a stage further by executing this single storyboard, showing how the explorers penetrate the underworld.

of such images swirling around in my head which, sadly, will never make their way onto the screen.

For *Jason and the Argonauts* I produced key drawings for twelve set pieces. Those that ultimately made their way into the film were: the meeting with the gods of Olympus; the encounter with Talos; Phineas and the harpies; the clashing rocks and Triton; Jason battling the hydra; the attack of the skeleton warriors; and the fight between Jason and his men and the skeletons. The ones that did not make it were: the hall of Zeus (which was changed to the temple of Hera); the fight with Cerberus; the gateway to the gods on Mount Olympus; and the dead rising in Hades. This last drawing was reinterpreted as the rising of the skeleton warriors from the ground.

The skeleton sequence was the climax of the story, but the scenes which I most enjoyed bringing to the screen were those featuring my version of the Colossus of Rhodes. The Colossus was supposedly a huge statue that straddled and protected the entrance to the island harbour of Rhodes and which had been destroyed in an earthquake in ancient times. The idea of a huge statue towering above a harbour has always appealed to my taste for the spectacular and it was also a perfect subject for animation as, being made of metal, its movements could be slow and creaking.

Legend has it that the original Colossus was a male figure holding a torch that guided the ships into harbour. Fine for a harbour light, but not a suitable role for a destructive messenger of the gods. Talos had to be a warrior and I designed him on paper as a bearded Greek statue with a classical hairdo; but when it came to designing the model, I decided to change him to a Greek warrior with a helmet and sword, which was far more threatening. This was an example of the way in which things changed as my ideas progressed from initial sketches to completed model ready for the animation table. My original drawing was fine but when the time came to script the story in detail it became clear that it wasn't going to work; it just was not dramatic enough.

When Jason is sent to find the blind seer, Phineas, to ask how he gets to Colchis, he finds that the poor man is being plagued by two nasty little winged creatures called harpies. In mythology there were three harpies, who had women's faces, the bodies of vultures and vicious claws on their hands and feet. To save time and money, I went for two harpies – why go to the expense of making three when two will do the job? My concept of these monsters was loosely based on some of Gustave Doré's illustrations for *Dante's Inferno*. I initially drew them as evil-looking beasts with scaly skins, bat-wings, three-taloned feet and hands, short tails

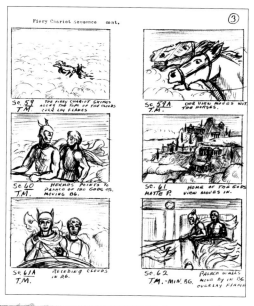

**Left.** Charcoal and pencil on art paper. 14" x 11". c.1946. Rough sketch of the satyr emerging from the entrance to the underworld.

**Above.** Photographic copies of original storyboards. 10" x 8". c.1962. Sadly the originals of these storyboards for a missing sequence for *Jason and the Argonauts* are lost. We originally planned a sequence in which Hermes would take Jason to Olympia in his fiery chariot.

**Right.** Pencil on art paper. 11" x 7½". c.1950. Rough sketch of a satyr fighting a dinosaur for *The Lost City*. Not only did I have a whole variety of mythological creatures inhabiting this underground realm, I also threw in dinosaurs for good measure.

**Right.** Charcoal and pencil on illustration board. 19" x 12½". c.1961. Key drawing of Talos for *Jason and the Argonauts*. Instead of facing out to sea, as the Colossus of Rhodes would have done, the huge statue of Talos turns inwards to prevent the *Argo* from leaving the island.

**Below.** Latex body over internal metal armature. 17"(h) x 4"(d) x 8½" (w). c.1962. Now forty-three years old, Talos still looks in reasonably good shape, although the latex body has shrunk and the metal armature is showing through in places.

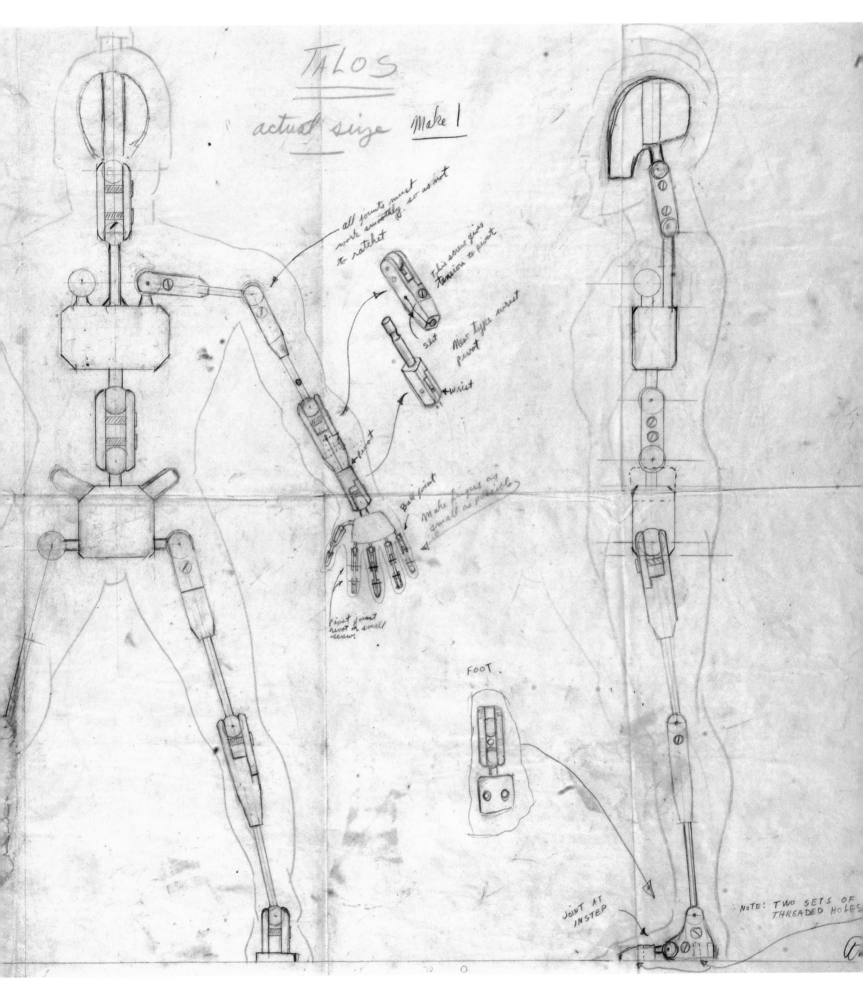

and horrifying faces. This time the original concept changed very little at the model-making stage, though I did, perhaps, soften their faces so that they looked a little more female.

The hydra was a wonderful creature to create for the screen. In mythology, it originally featured in the labours of Hercules, not the Jason story, and was described as a multi-headed creature which posed a real problem for Hercules because every time he cut off one head another grew in its place. We found the concept of a multi-headed beast was so powerful that we decided to 'borrow' the hydra to serve as the protector of the golden fleece. Of course, I did have to modify things a bit – the prospect of animating the process of one head being replaced by another was just too daunting, especially as there were already so many animation sequences in the picture. Seven is a mystical number and recurs many times in our pictures, so seven

heads it was, and none of them would be required to grow back.

There are few if any, graphic interpretations of the hydra so the design possibilities were limitless – just as long as I could make it work on screen. Although I was again influenced to a small extent by some of Doré's compositions, the overall design of the hydra is very much mine. One of my favourite basic designs involves creatures with snake-like torsos. The serpentine form is very adaptable and readily lends itself to model animation because the animator can keep it constantly moving and writhing, creating a threatening, eerie and gruesome effect. Tails are very useful, too. Many animals use their tails to express their emotional state: think of dogs wagging their tails or the softly swishing tail of a cat stalking its prey. And, if handled carefully by the animator, a tail can be used to convey a sense of a creature's character. In

the case of the hydra there are a number of serpentine elements: the curled, forked tail, the necks and, of course, the heads are all snake-like, with an added dash of dinosaur for good measure. I experimented with a range of designs until I felt that I had achieved a proper balance between the various elements. That's the fun of inventing such a creature.

The early screenplay featured Cerberus, the two-headed guardian of the underworld. In contrast to the hydra, he was a design nightmare and I was much relieved when Jason's journey into Hades, at whose gates he was to encounter the beast, was dropped. The first problem was that Cerberus was supposed to have three heads but when I sketched out a triple-headed version I simply couldn't make it look realistic and I knew that when the time came to animate it, it would look ridiculous. So I limited myself to two heads, a decision which, as with the

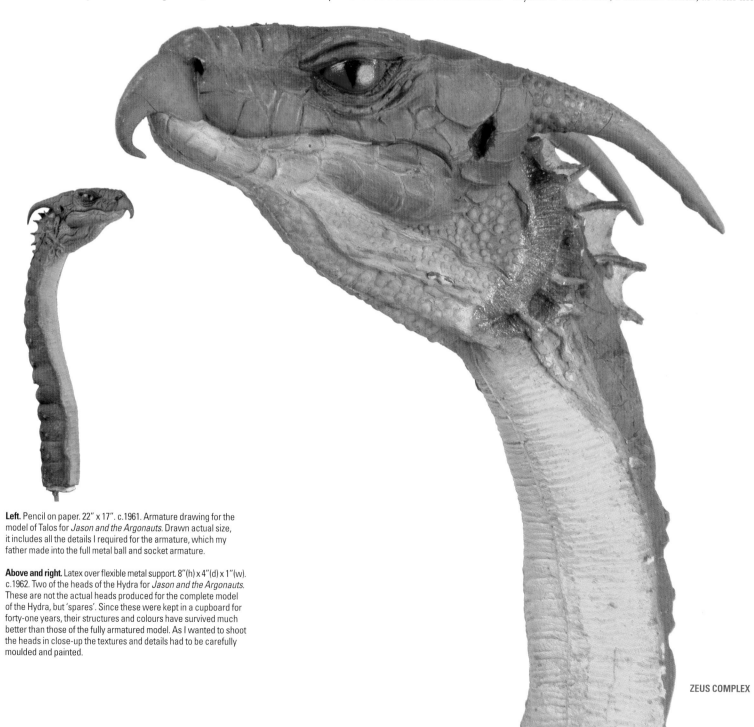

**Left.** Pencil on paper. 22″ x 17″. c.1961. Armature drawing for the model of Talos for *Jason and the Argonauts*. Drawn actual size, it includes all the details I required for the armature, which my father made into the full metal ball and socket armature.

**Above and right.** Latex over flexible metal support. 8″(h) x 4″(d) x 1″(w). c.1962. Two of the heads of the Hydra for *Jason and the Argonauts*. These are not the actual heads produced for the complete model of the Hydra, but 'spares'. Since these were kept in a cupboard for forty-one years, their structures and colours have survived much better than those of the fully armatured model. As I wanted to shoot the heads in close-up the textures and details had to be carefully moulded and painted.

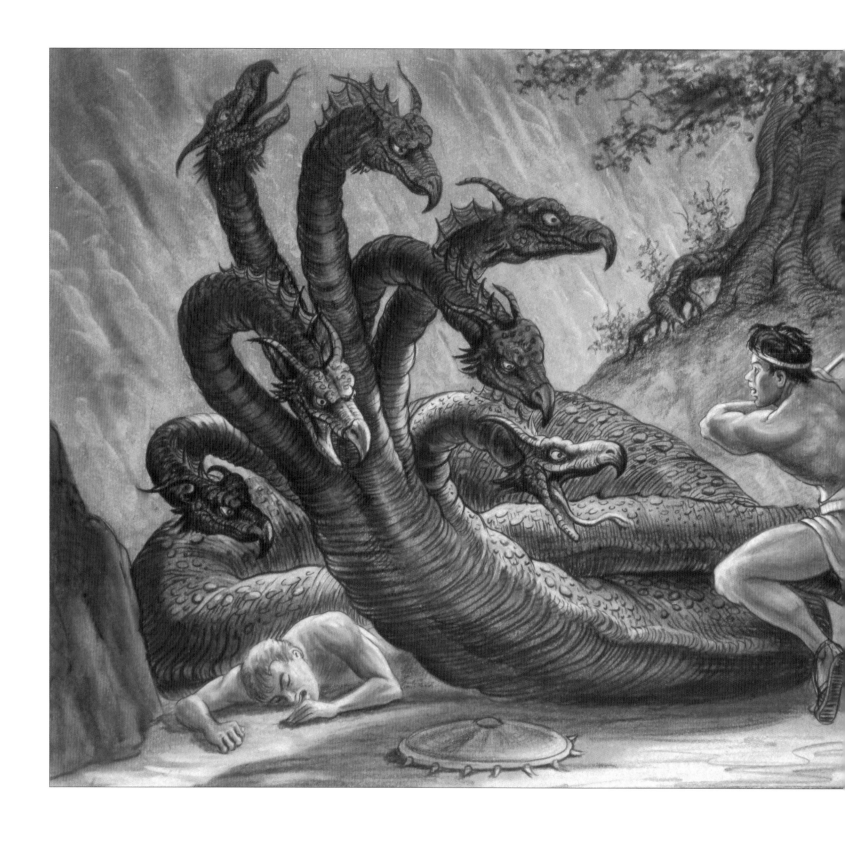

**Above.** Charcoal and pencil on illustration board. 19" x 12½". c.1961.
Key drawing for the Hydra sequence for *Jason and the Argonauts*.
This was one of the elements that sold the picture.

**Right.** Photographic copies of lost originals. c.1962. Storyboards for
part of the Hydra sequence for *Jason and the Argonauts*. It is sad
that none of my storyboards for *Jason* have survived. I must have
inadvertently thrown them out when the production was completed
– a most unusual action on my part. These copies came to light a
few years ago when Tony was digging around in my cellar.

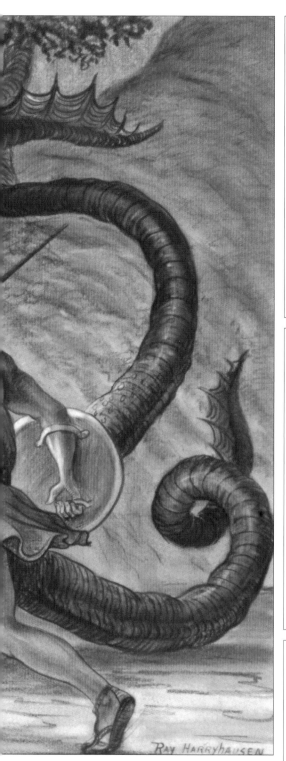

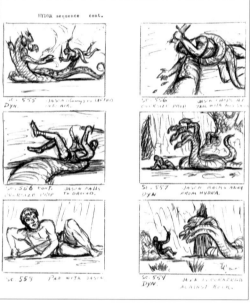

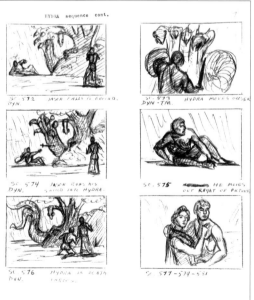

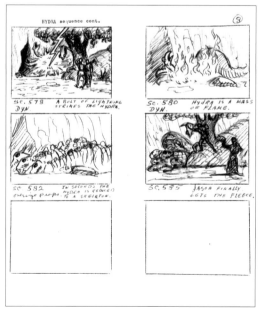

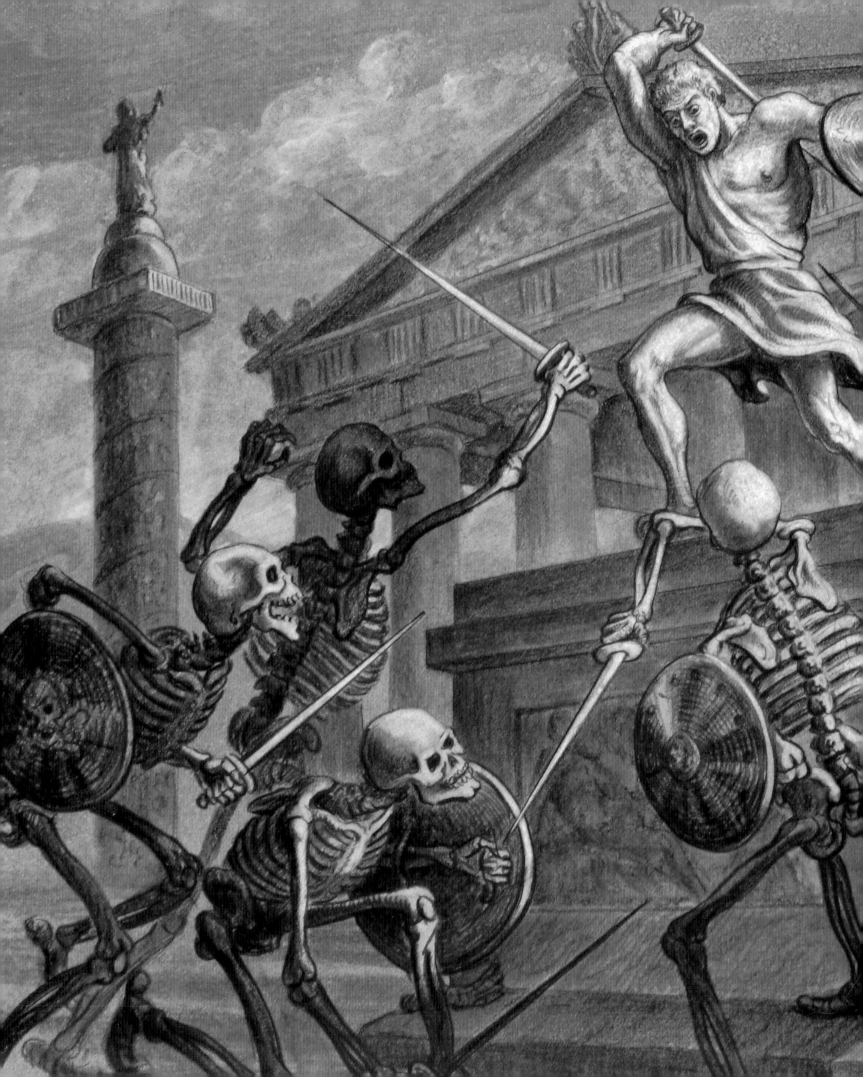

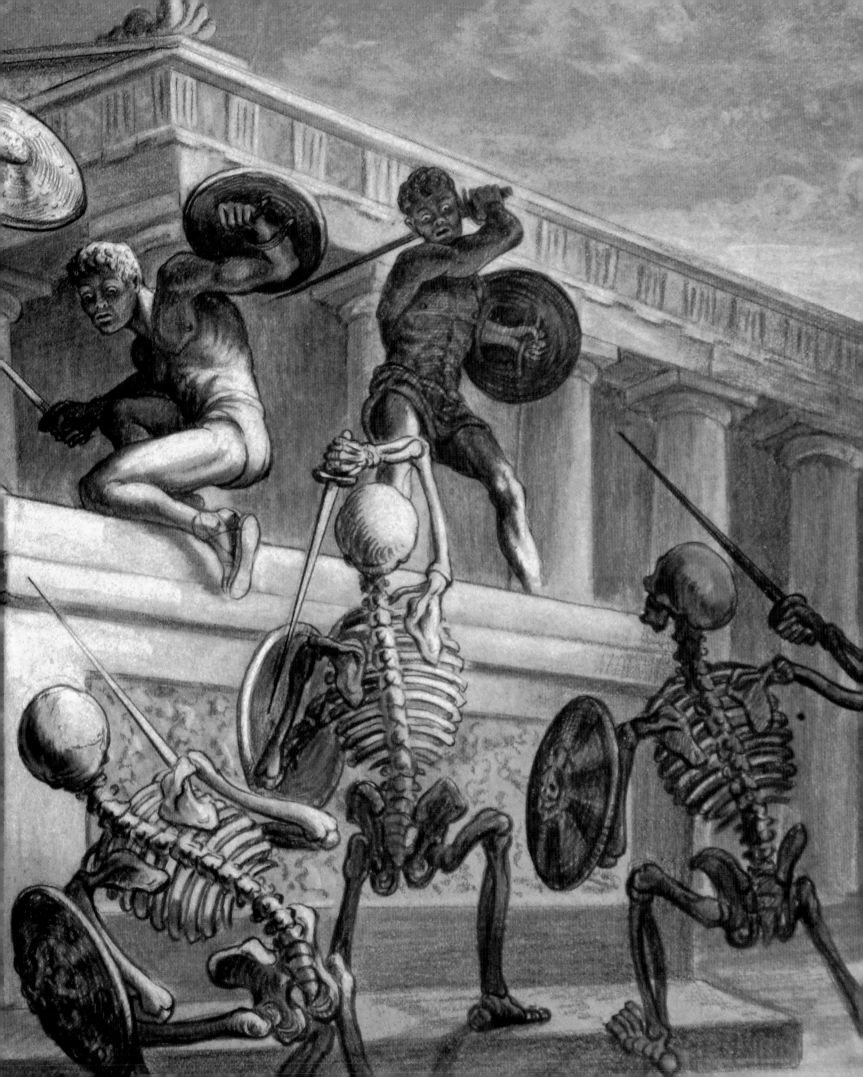

harpies, had the advantage of reducing the amount of animation required. My first drawing featured a chubby, feline creature, with jowls and whiskers; but the more I looked at it the more I realized that it was totally wrong. So in my next key drawing Cerberus appeared as a wolf-like creature with snarling, drooling mouths. In the end, although Cerberus was cut out of *Jason*, he was reincarnated, in the form of Dioskolos, in *Clash of the Titans*; another example of nothing being wasted.

Of course, the sequence that everyone remembers from *Jason* is the skeleton fight, which, like the skeleton in *The 7th Voyage of Sinbad*, was always intended to form the centrepiece of the story. In my key drawing for the fight scene I placed Jason and his two companions on a plinth, with the skeletons looking up at them, and this is in part the way the scene was filmed in the final picture. The effect of confining the human actors to the top of the huge block of stone, which they had to defend against the besieging skeletons below, was inherently dramatic. Moreover, by keeping the live action and the animated action on different levels, to some extent I made my own task easier.

In *Jason and the Argonauts* we were trying to do something unprecedented and this meant that my design input was greater than with most of the pictures I had worked on before. As with *The 7th Voyage of Sinbad*, many of the techniques were new, and I felt that it was very important to get everything right. I therefore spent much more time than I usually did on refining the concepts and ensuring that everything would work as I had visualized it. This didn't just apply to the key drawings and armature designs but to the storyboards as well. The shooting plan, a vital element in the making of any fantasy picture, was in this case extremely detailed because of the technical requirements of the effects and the implications for the editing of the Dynamation sequences.

Sadly, the film was not the box-office success we had hoped for on its initial release, and it was nearly twenty years before Charles and I felt confident enough to return to mythology. It's my guess that if *Jason* had been a big hit in 1963 we would have revisited ancient Greece much earlier; indeed we did leave open the possibility of a sequel by having Zeus suggest that he has other tasks for Jason. As things turned out, one of the reasons we returned to classical mythology when we did was that *Jason* had become a huge cult success in the intervening years and was now making a great deal of money for Columbia.

**Previous page.** Charcoal and pencil on illustration board. 18½" x 12". c.1961. Key drawing for the skeleton fight in *Jason and the Argonauts*. One of the most famous drawings I did for *Jason and the Argonauts*; in this case the scene in the film followed the drawing almost exactly, except for the temple in the background.

**Right.** Cotton and latex over metal armatures with resin skulls. Each one is 9½"(h) x 2"(d) x 2½"(w). c.1962. Three of the seven skeletons from *Jason and the Argonauts*. You would not want to meet this villainous group of individuals on a dark night! Although I am no longer certain, I believe the centre one is the original model skeleton from *The 7th Voyage of Sinbad*.

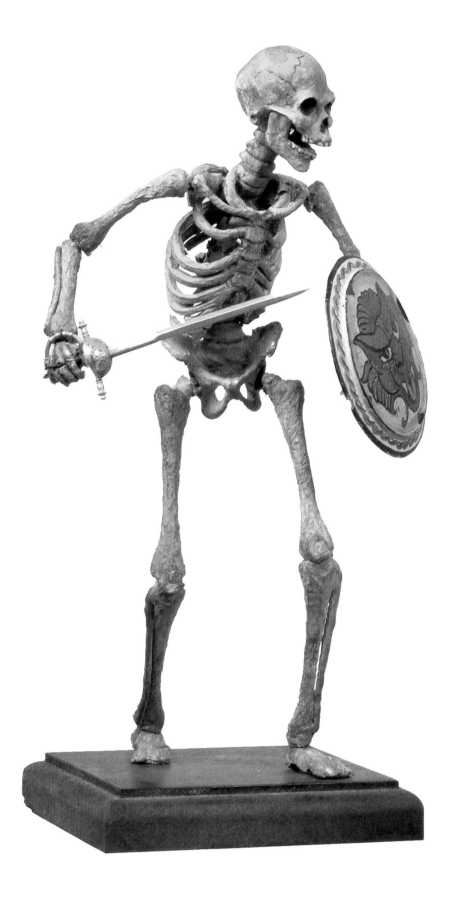

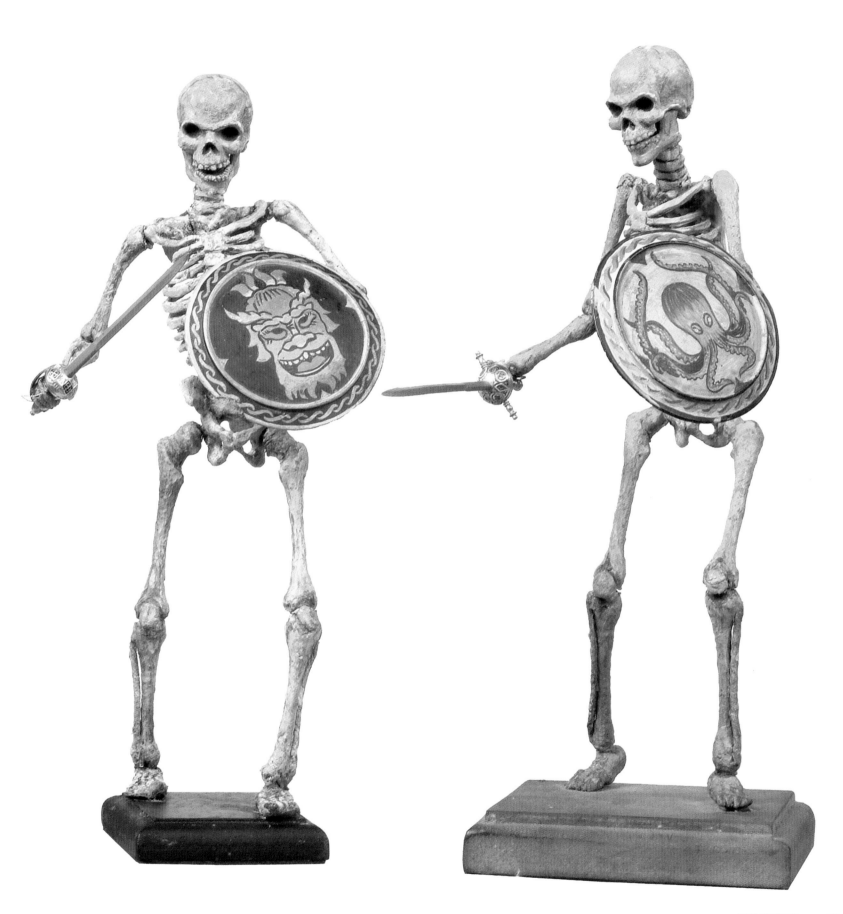

When the time did come for another mythological venture we chose a story that we had considered earlier, but then abandoned in favour of Jason and his quest for the golden fleece: the story of Perseus and Andromeda, which we called *Clash of the Titans*.

As with Jason, *Clash of the Titans* demanded a great deal of design work on my part. I was faced with designing an even larger number of creatures as well as a wide variety of special effects, includingthe destruction of the city of Argos. There was the Kraken, one of the Titans; Calibos, the son of Thetis; Pegasus, the winged horse; Bubo, the messenger of Athena; the giant vulture; Dioskilos, the two-headed dog; Medusa, who needs no introduction, and the scorpions that spring from her blood. When you consider that Jason had encountered only five creatures, the prospect of creating this range of beasts was daunting. But by the late

1970s audiences demanded a constant succession of thrills and MGM, the distributor, made sure the movie was packed with fantasy sequences.

Apart from a few initial sketches and drawings produced for the presentation to MGM, I designed all the creatures and other effects on paper within a period of eight weeks, beginning, as always, with rough sketches and then making more defined drawings from tracing paper. Unusually, and because of the huge volume of fantasy sequences, I produced only two key drawings. One was of Medusa, who was always going to be the 'star attraction' on which we would sell the project, and the other showed Perseus visiting the lair of the Stygian witches. There were another nine key or concept drawings but these were executed by art director John Stoll in 1976. I did, however, create a number of comparison drawings which showed the creatures side by side with human figures: one

or two sketches of Medusa, two of the Stygian witches and designs for Calibos and Bubo. In addition, I composed all the storyboards, including all the major effects sequences, whether they included creatures or not. Over and above these tasks, I was also kept busy supervising all the effects for the picture and completing the construction of the models themselves.

The first and last mythological creature to appear in the film is the Kraken, the Titan who is sent by Zeus to destroy Argos and to whom, at the end, Andromeda is sacrificed. The Kraken comes from Norwegian, not Greek, mythology but it was felt by Beverley Cross, the screenwriter, that, as a name for a sea monster, it was too good to miss. I designed him as half-man, half-fish, using the idea of fish-like jowls that I had employed so successfully in the designs for the Martians in what would have been my version of *War of the Worlds* and for

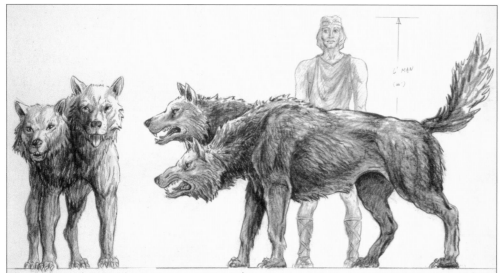

**Top.** Charcoal and pencil on illustration board. 19" x 12½". c.1961. First key drawing for Cerberus for *Jason and the Argonauts*. This design for the two-headed guardian of Hades looked somewhat tubby and rather too cat-like; I therefore discarded it.

**Left.** Charcoal and pencil on illustration board. 21½" x 15¾". c.1978. Comparison drawing for Dioskilos for *Clash of the Titans*. Nothing is ever wasted and my two-headed creature finally made it to the screen in the role of the guardian of Medusa's lair. This is a comparison drawing which helped me and the actors to gauge the size of the beast which would be added after the live-action photography had been completed.

**Right.** Charcoal and pencil on illustration board. 19" x 12". c.1961. Detail from the key drawing for Cerberus for *Jason and the Argonauts*. My final design for Cerberus was more wolf-like and ferocious than the first version. In the event the creature was dropped from the final script.

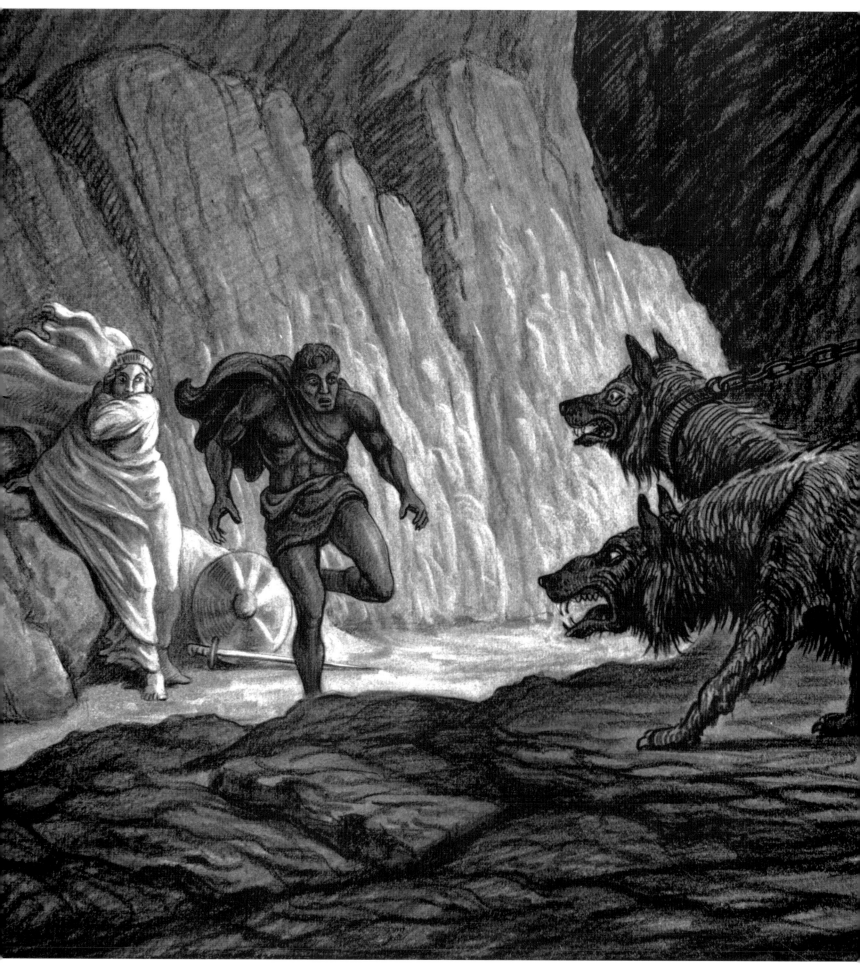

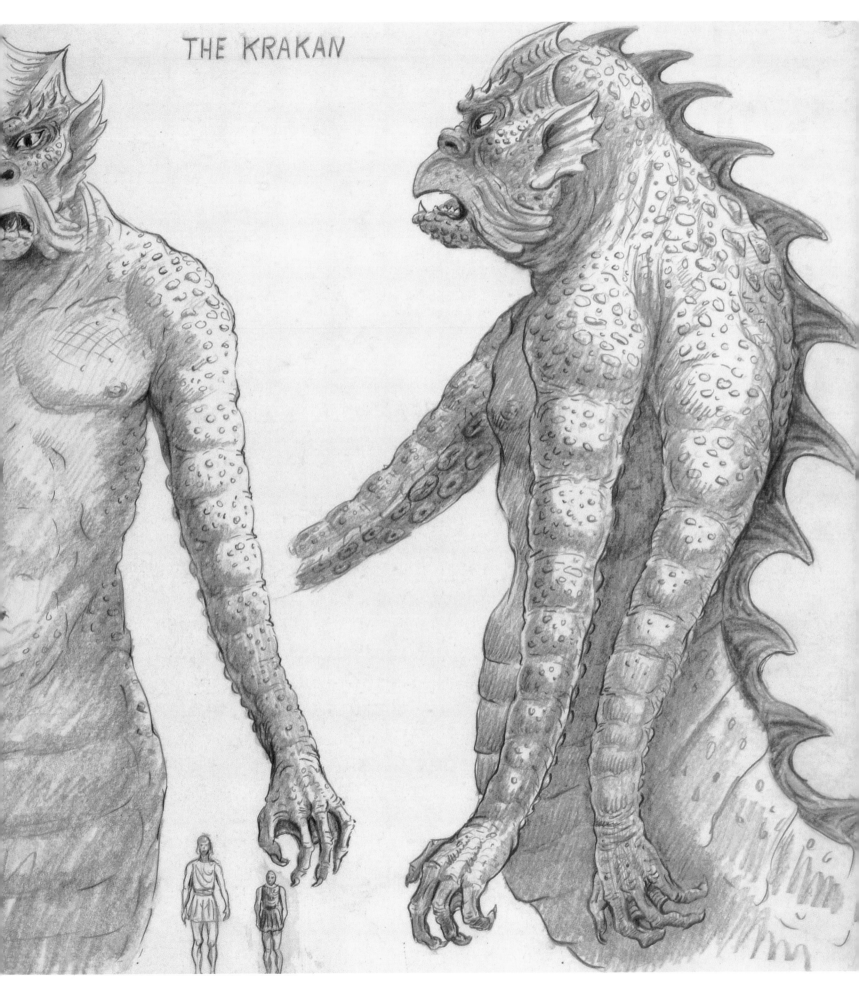

THE KRAKAN

the Ymir in *20 Million Miles to Earth*. It was another of those occasions where this feature seemed just right because the Kraken was, after all, supposed to live under water. To his human-like torso I added four arms, each ending in four digits, and a reptilian tail equipped with fins spaced out along its length, to strengthen the impression that this was a creature which could move through water at high speeds. I finished him off by giving him a textured green skin. There were two models, one about eighteen inches high and four feet long from nose to tail. The other was a huge half-torso model measuring about four feet high by three feet across, used for close-ups. Because the armature joints of the larger model had to be so tight to resist the thickness of the surrounding layers of latex rubber it was incredibly difficult to animate – so much so that animating just one small movement could leave your arms aching.

The villain of the story was of course poor old Calibos, who also owed nothing to Greek mythology, but was loosely based on Shakespeare's character Caliban ('a savage and deformed slave'). I always feel sorry for Calibos, who is the perfect example of how jealousy gets you nowhere. In the story he begins as a normal human being but Zeus turns him into a misshapen beast. He then becomes the enemy of Perseus because they are both in love with Andromeda. I visualized him as human but at the same time not human, so I began by giving him one normal human leg and a goat's hind leg. He also appears to be bent over, due largely to the tail I decided to give him because it contributes to his bestial quality. Finally I made his face as grotesque as I was able, giving him two short horns which emphasized the evil element. Right up to the shooting script we had planned on Calibos being mute but in the end we had to give him the

ability to speak. If I had animated the model to fit the dialogue then we would have been faced with months more work and the risk that he would look like an obvious puppet. In the end we decided to cast an actor (Neil McCarthy) to play the close-up shots and read the dialogue. Charles and I had a difficult job finding the right actor. The casting director first of all sent someone who looked like Peter Lorre so I showed the casting director my model and drawings and he came up with Neil, who had the right type of features and was also a big man, though even so he needed a lot of make-up. Although I had not been entirely happy with the use of an actor, in the end it turned out well.

Although the Kraken and Calibos were never part of the Perseus story, the next two creatures most certainly were. Ever since Conrad Veidt invited Miles Malleson to ride the mechanical flying horse in *The Thief of Bagdad* (1940) I had

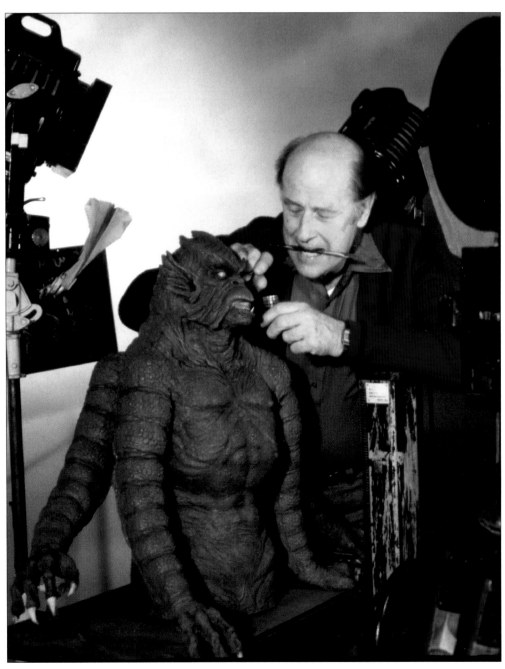

**Left**. Charcoal and pencil on illustration board. 21½" x 15¾". c.1978. Comparison drawing for the Kraken for *Clash of the Titans*. Another comparison drawing showing how huge the creature would appear to be in the film.

**Right**. Working on the largest armatured model of the Kraken. The combination of repeated movement and the heat of the lights can affect the condition of the models during animation and I often had to 'touch them up' to make sure that their appearance did not change.

**Right.** Charcoal and pencil on illustration board. 21½" x 15¾" c.1978. Comparison drawings for Pegasus for *Clash of the Titans*. Because I had two characters involved with this creature (one of course was a model of Harry Hamlin as Perseus) I had to make sure I had a reference for the flying horse's dimensions.

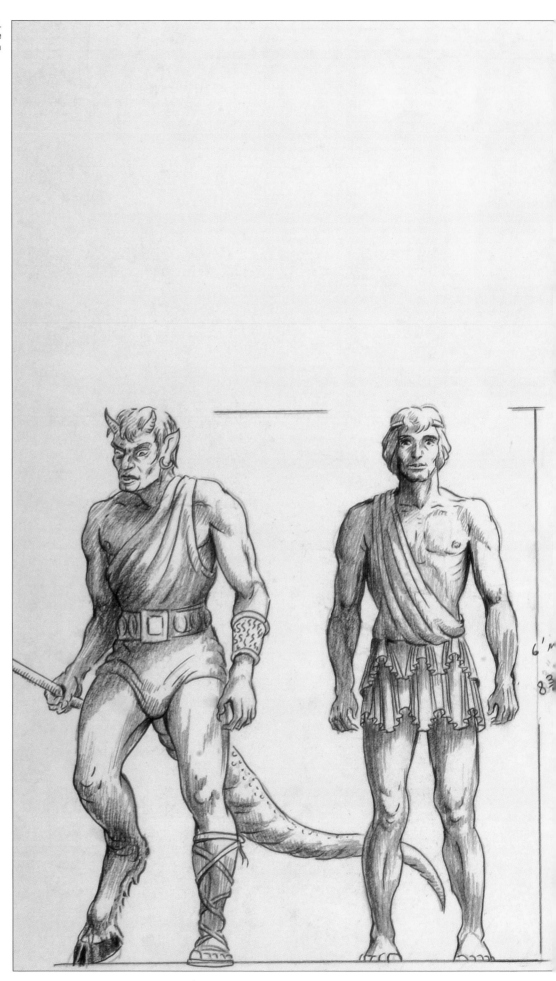

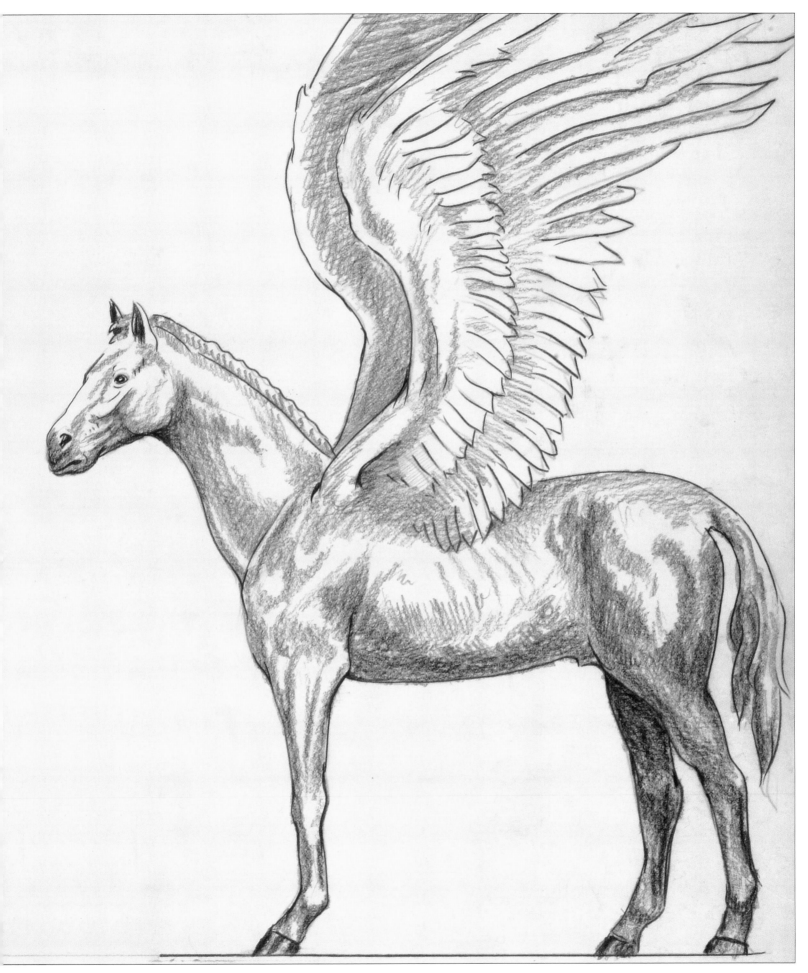

**Below.** Latex body with internal metal armature. Covered with baby goatskin and dove feathers set into latex for the wings. 14 ½ "(h) x 14 ½ " (w) x 16" (d). 1979. The feathers on this Pegasus model were slightly damaged by glycerine, which I had applied for the scene at the end of the picture when Pegasus emerges from the sea.

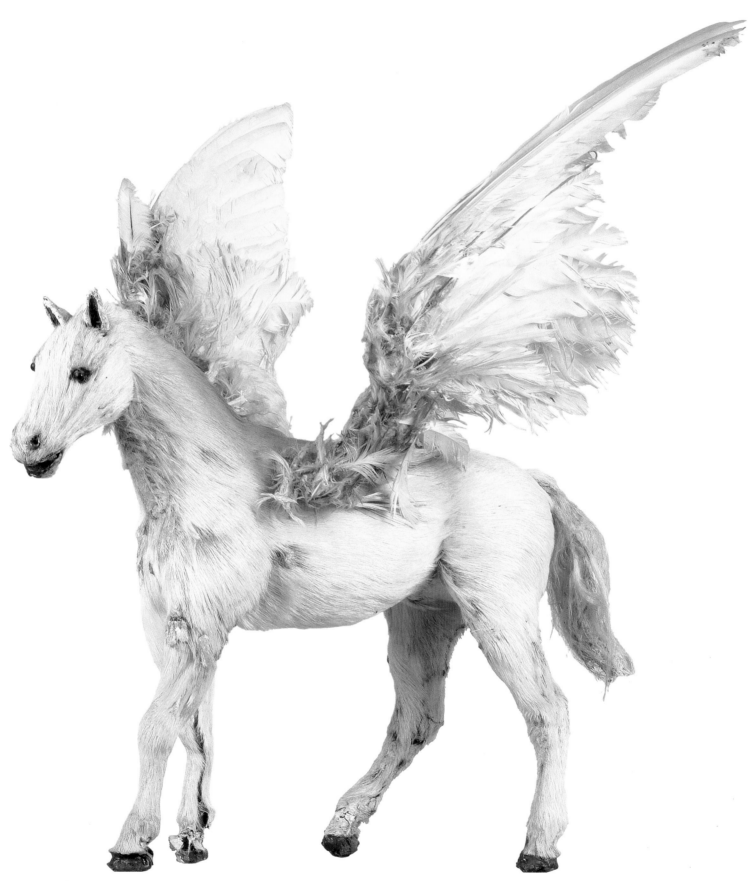

wanted to bring my own version to the screen. In the original tale, the flying horse Pegasus springs from the blood of Medusa but Beverley Cross changed the story to suggest that Calibos was changed by Zeus from a human into a monster as a punishment for killing all but one – Pegasus – of the herd of wild, winged horses. This meant that Pegasus was able to help Perseus earlier on in the narrative, and in our version it is the scorpions that spring from Medusa's evil blood. Deciding to include a flying horse in a story and creating one that looks realistic are two completely different things. The actual design was not so much of a problem; it was devising movements that would make it look like he was really flying that was difficult. In the end I made lots of rough sketches and decided that the wing span should be about double the length of the body. When it came to animating the flying sequences I decided, after extensive experiments and tests, that it looked more natural for him to gallop on air rather than using his wings to propel himself. This may sound obvious now, but at the time it really wasn't.

There were three Pegasus models (I built the armature for a fourth model but it was never covered) and I designed him with a white coat and wings, white being a symbol of goodness. The skin was that of an unborn white goat and the wings were white dove feathers. For the capture of Pegasus and Perseus' subsequent flight on his back,

I had to construct a model of the actor who was playing the part of Perseus, Harry Hamlin. This model was only used for long shots and was about ten inches high and armatured, although not as much as a normal model would have been.

Finally we come to Medusa. Her appearance and the claustrophobic chamber lit by flickering fires in which she appears all helped to make the sequence special and I believe it is one of the most impressive in any of the films I have worked on. She had long been a figure that I had wanted to bring alive by stop-motion animation and when it came to realizing her on paper I already had her clear in my mind's eye.

In mythology Medusa was one of the three Gorgons, who had begun life as beautiful women; but when she violated the sanctity of the temple of Athene, the goddess turned her hair to snakes and made her so ugly that she turned men to stone. Over the centuries, artists had depicted her many times, usually as a beautiful woman, normal but for the snakes on her head. This always seemed to me to be a contradiction, but because she could turn men to stone I felt she needed to be hideously ugly. What I went for was a face that was ugly but with perfect bone structure, thus giving her a threatening, mysterious quality, but at the same time a grotesque beauty. I also took the snake theme several stages further and gave her upper torso a scaly skin (this was always a good idea if you

wanted to make the human physique look repulsive) and then turning the lower part of her body into that of a snake, with a tip like that of a rattlesnake. I first portrayed Medusa in a key drawing I made in 1977, which shows her more or less as she appears in the final film (aside from a boob tube covering her breasts) in a temple with her snakelike lower body wrapped around a column. In the foreground is a man looking at her in horror and on the other side Perseus looking into his shield, ready to cut off her head. It was this image that helped to sell the picture to MGM, along with a bronze I had made of Perseus strangling the Gorgon while looking at her reflection in his shield.

In 1984, after I had worked on the *People of the Mist* project, Charles and I decided that we should try to bring another slice of mythology to the screen. Beverley Cross, the screenwriter of *Clash of the Titans*, had written a script based on Virgil's *Aeneid*, which relates the quest of Aeneas, prince of Troy, that led to the founding of Rome. It seemed perfect, especially when one considered the possibilities of the characters and creatures Aeneas might encounter in the course of his quest. Beverley's screenplay, which incorporated my ideas and those of everyone else involved, certainly didn't skimp on those aspects. Our version of the story included a colony of cyclopes, Furies, jackal-men, the Sphinx of Phyrgia, the goddess Hecate, Icarus

**Below.** Latex bodies with internal metal armatures. Large model – 16"(h) x 14"(d) x 9"(w). Small model – 8"(h) x 8¼"(l) x 4"(w). c.1979. The two models of Calibos I used for the animation. I put as much detail as possible into the large model, but as we had actor Neil McCarthy for the close-ups it wasn't really necessary.

**Below right.** Latex body with internal metal armature and covered with feathers from a variety of birds, including crows. 9½"(h) x 13"(l) x 8"(w). c.1979. Model of the vulture for *Clash of the Titans*.

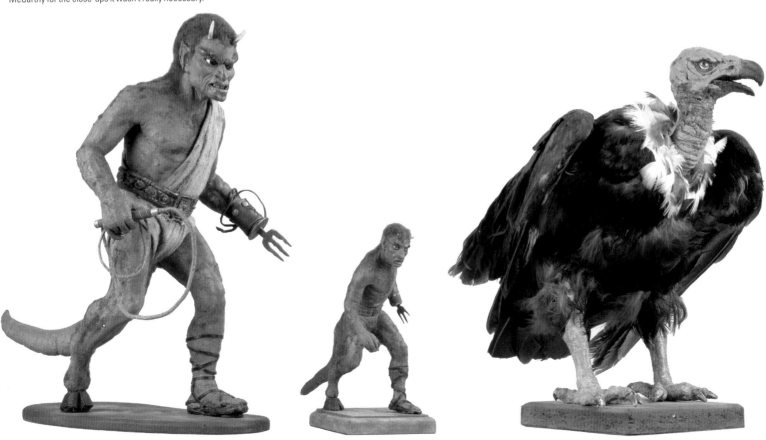

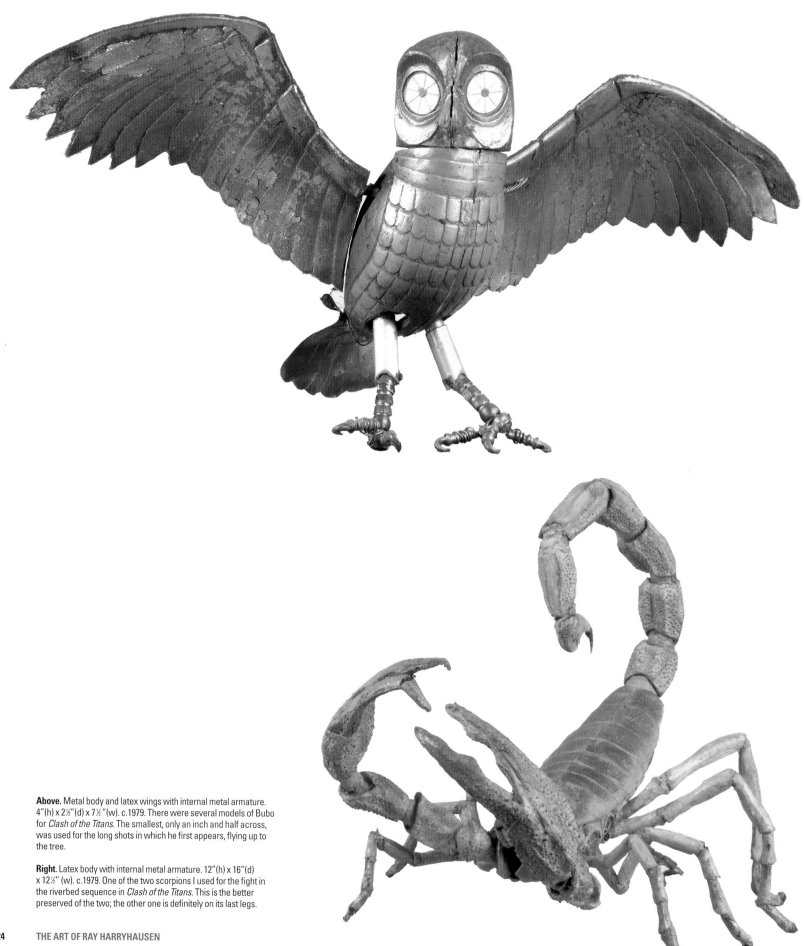

**Above.** Metal body and latex wings with internal metal armature. 4"(h) x 2½"(d) x 7½"(w). c.1979. There were several models of Bubo for *Clash of the Titans*. The smallest, only an inch and half across, was used for the long shots in which he first appears, flying up to the tree.

**Right.** Latex body with internal metal armature. 12"(h) x 16"(d) x 12½" (w). c.1979. One of the two scorpions I used for the fight in the riverbed sequence in *Clash of the Titans*. This is the better preserved of the two; the other one is definitely on its last legs.

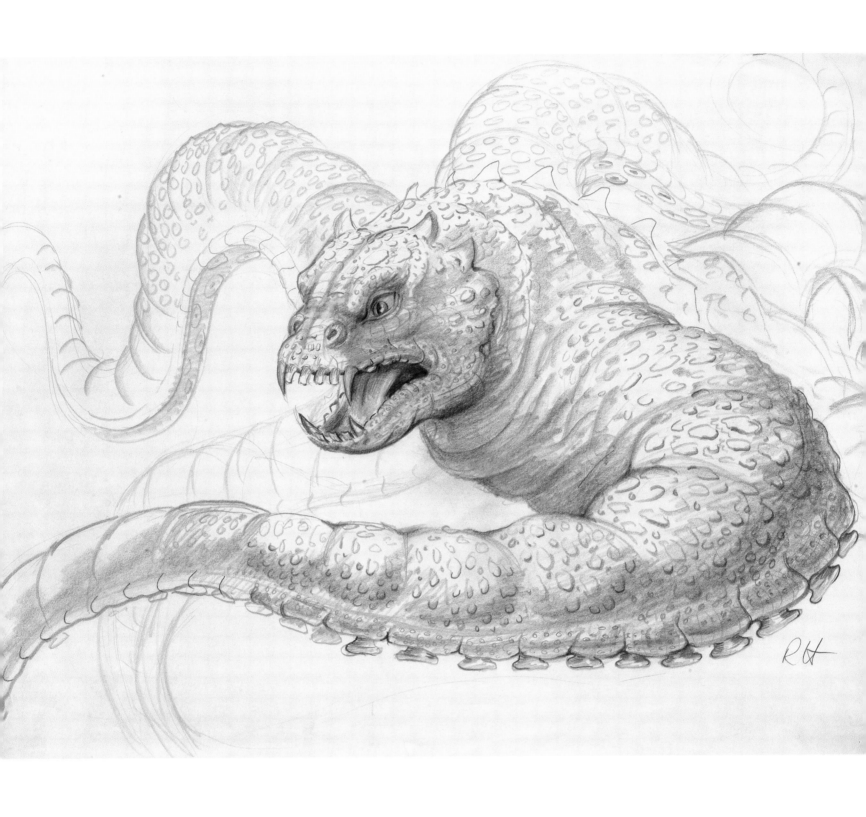

**Above.** Charcoal and pencil on art paper. 23½" x 16½". c.1984.
This was my first sketch for Charybdis for the unrealized *Force of the Trojans*.

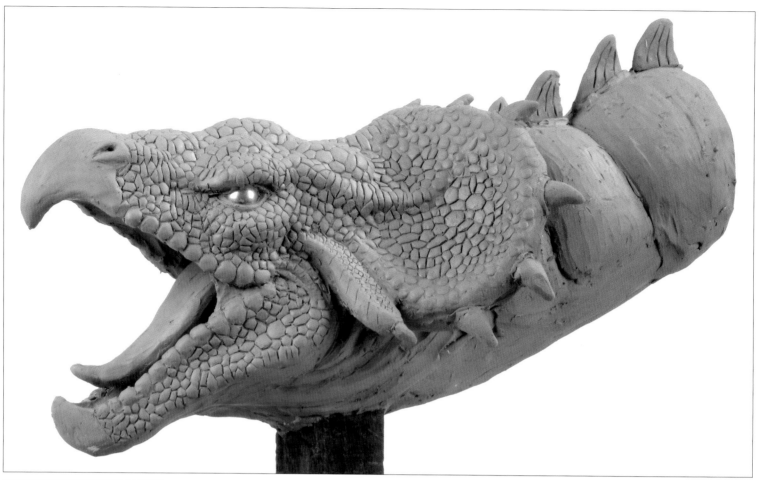

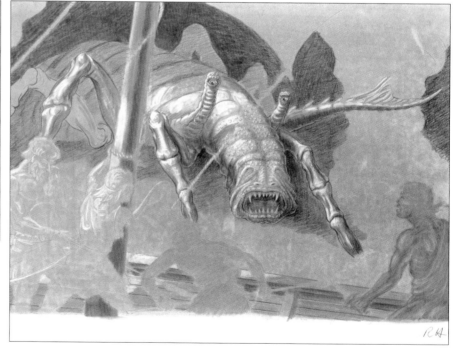

**Top.** Clay, mounted on a wooden cradle. 5½"(h) x 11¼" (d) x 5½"(w) . c.1997. This clay model of Scylla was based on my design for the version I hoped to use in *Force of the Trojans* but was actually sculpted for presentation to the producers of *The Story of Odysseus* – another project that was never realized.

**Above left.** Charcoal and pencil on art paper. 18" x 12". c.1970. Rough sketch of a centaur confronting an elephant. Just before embarking on *The Golden Voyage of Sinbad* I had an idea which involved using a mythological centaur as one of the protagonists.

**Above right.** Charcoal and pencil on art paper. 18½" x 12". c.1984. Unfinished key drawing of Scylla for the unrealized *Force of the Trojans*. The production was cancelled before I had a chance to complete my visualizations, which is unfortunate as it looks as if it could have been good.

and his ill-fated flight and, finally, the two figures we saw as the stars of the movie, Scylla and Charybdis. Although they were not part of the original Aeneas story, Beverley decided that these two ghastly creatures, who lured mariners to their death in the Straits of Gibraltar, would make wonderful adversaries. Homer's description of Charybdis in the Odyssey (*Divine Charybdis with a terrible roar swallows the waves of the bitter sea and three times each day she throws them up again*) gave me a great deal of leeway in my interpretation. She became an octopus-like creature with six tentacles, a scaly back and a hideous face with huge teeth. Scylla, on the other hand, was described as having 'six heads, each supplied with triple rows of teeth', which I thought was not interesting enough, so I gave her the body of a scorpion with a hint of carnivorous dinosaur and eyes on stalks.

The production sadly never progressed beyond the stage of an extensive recce to Egypt, Turkey and Italy and a few drawings and sketches which I produced. The drawings featured only Scylla and Charybdis, who would have provided the finale of the picture. However, I did also make a clay model of the Sphinx, which possessed a hideous face with an Egyptian head-dress, a naked torso with hanging breasts, four clawed legs, a pointed tail and bat-like wings. She would have been fun to animate but I would have been faced with a lot of problems because, in the final script, she had a large amount of dialogue.

My final exploit into mythology came in 1996 when I was asked by the British company Carrington and Cosgrove Hall Productions if I would work as a storyline and character development consultant on a project they were planning called *The Story of Odysseus*. I was, of course, delighted to be involved as they had an extremely good reputation in the field of animation. Moreover, as Charybdis and Scylla featured in the original story, I was able to resurrect some of my ideas. I didn't use the original designs that I had executed for *Force of the Trojans* but drew new ones based on them. Aside from some rough sketches and an incomplete key drawing, I also made a clay model of the head of Charybdis. Nearly ten years later we rediscovered this model and it appears in this chapter for the very first time. Putting modesty aside, I still feel it is a good interpretation of how I saw the beast, with its ribbed neck, scaly triceratops-like shield back of its head and a serpent/lizard face and beaked snout.

I have written here about some of the mythological creatures I was able to realize, but there are still a whole host of mythological figures, heroes, heroines, villains, gods and monsters waiting to be brought to the cinema screen. It just needs the right person, with the right imagination, to rediscover them and breath life into them My work has only scratched the surface.

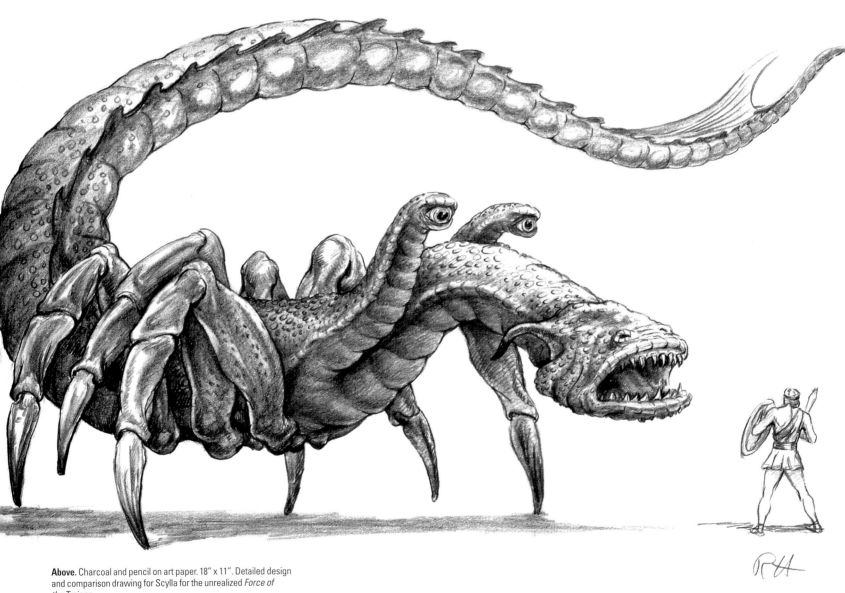

**Above**. Charcoal and pencil on art paper. 18″ x 11″. Detailed design and comparison drawing for Scylla for the unrealized *Force of the Trojans*.

# CHAPTER 8   EPITOME OF THE APOTOMY – ALIENS

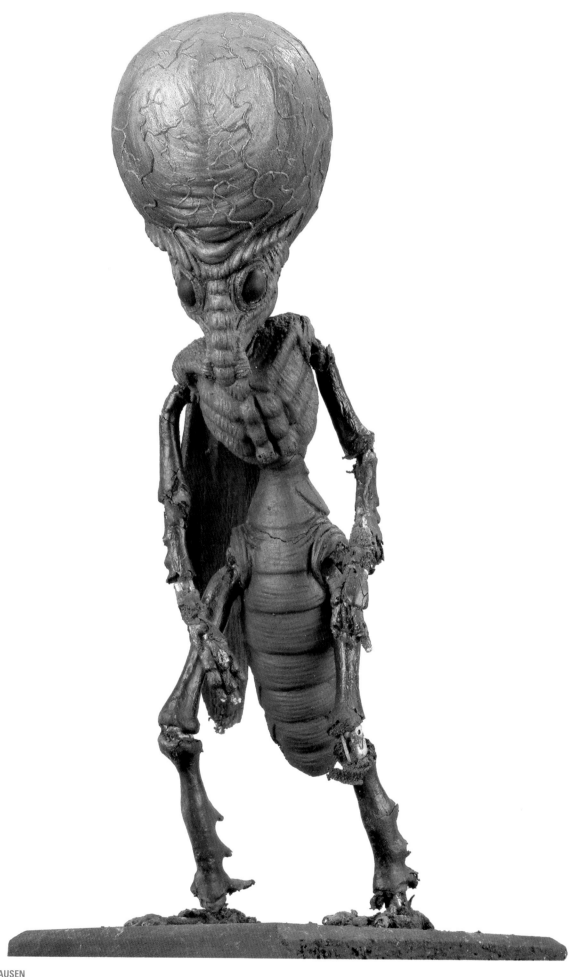

ALIEN BEINGS, LIKE DINOSAURS, LEND THEMSELVES PERFECTLY TO IMAGINATIVE DESIGN, and to stop-motion model animation. But any cinematic interpretation of aliens has to be good, otherwise audiences, rather than suspending their disbelief, simply start laughing. In this chapter I have concentrated on the design of the aliens themselves, rather than trying to discuss technological gimmicks, futuristic settings or science fiction plots. I should point out that I have made other films that might be categorized as science fiction, but since they do not feature aliens I have left them aside here and will return to them in chapter 10.

Although science fiction is not my favourite form of fantasy, I realized, when I started to look for subjects that I could develop as an amateur animator, that it offered a wide range of possibilities. My choice of subjects back then was largely influenced by comic strips such as *Flash Gordon* and *Buck Rogers*, but my real favourites were, and still are, the pioneers of the genre. I have enormous admiration for the wonderfully inventive minds of Jules Verne, H.G. Wells and, of course, Sir Arthur Conan Doyle, who wrote the Professor Challenger stories, which include *The Lost World*. The adventures they described were extraordinarily original and inventive, especially as they were mostly written in the late nineteenth century, long before space travel seemed even a remote possibility. But the idea of filming a Verne or a Wells story in my small hobby-house studio was not exactly realistic. Only when I found a major studio to provide the finance could I even contemplate that sort of project.

Although a whole variety of aliens had appeared on the screen by the time I began making my own features, most of them looked a lot like men, or, at best, men in rubber suits. Examples that come to mind are Robert Wise's *The Day the Earth Stood Still* (1951) and Howard Hawk's *The Thing* (1951). In contrast, by applying the versatility of stop-motion and armatured models I could make anything I wanted and was not in any way confined to human-like forms. I could give my aliens bug eyes, tentacles (one of my favourites), skeletal frames, huge heads, tails and even wings. I was prepared to consider anything so long as it didn't resemble a man in a rubber suit. Before anyone writes to remind me of the rubber environmental suits worn by the aliens in *Earth Vs the Flying Saucers* and the kids in rubber suits in *First Men in the Moon*, I would like to emphasize that these represented compromises made for reasons of

expediency, not out of choice.

There were of, course, limits to my freedom to devise outrageous alien forms. The beings I designed still had to be credible to the audience. For example, without hands, and in particular the evolution of the opposable thumb, it is obvious that human beings could never have developed technologically, culturally and artistically in the way that we have. So if one creates an alien with only a tentacle or a forked, pincer-like hand, audiences may legitimately ask how such creatures would be able to design and construct vehicles capable of transporting them to Earth or, indeed, anywhere else.

The whole point of making films about aliens is, of course, that they should be just that, alien and therefore as un-human as possible. In addition, most designers would agree, it certainly helps if they are both monstrous and frightening. I must confess I followed that policy myself when it came to most of my designs. In fact, the only two of my creations that were equipped with wholly credible hand-like appendages were the Selenites in *First Men in the Moon*, who had three digits, one of which looked like a thumb, and the human-like alien that would have appeared in *The People of the Mist*. However, I did always try to keep to the basic rule and incorporate some kind of hand logic when designing 'intelligent' beings. In the case of *The Jupitarian*, *The Elementals* and the Ymir in *20 Million Miles to Earth* it didn't really matter as they were alien creatures and not necessarily intelligent ones. The Martians in *War of the Worlds*, on the other hand, were obviously intelligent and had built vehicles to bring them to Earth. Nevertheless I did dispense with those digits because I followed Wells' description, perhaps a tad too closely.

My first real foray into the alien field was in 1937, when I built a model which I called the Jupitarian. It was designed and built for a test film and was loosely influenced by those *Buck Rogers* and *Flash Gordon* comics I had been so impressed with as a youngster. The test also featured a 1930s version of a rocket ship which lands on Jupiter and encounters my enormous Jupitarian. The creature was a wild design and I never truly felt it was very practical. The poor thing possessed four webbed arms, three claws for hands, tiny legs and an enormous head that was far too big for its body. All I wanted to do was to create something that had never been seen before but I really didn't realize when I completed my basic drawing that it was so physically imprac-

**Previous page.** Charcoal and pencil on illustration board. 15″ x 11½″. c.1949. Key drawing for the unrealized project *War of the Worlds*. In this drawing the Martian war machines are pursuing fleeing humans. Someone recently pointed out that almost in the centre of the picture there are what appear to be three crosses, something I had never noticed before and which certainly wasn't intentional.

**Left.** Latex and cotton body with internal metal armature. c.1963. 9½″ (h) x 3½″ (d) x 2¼″ (w). Model of the Grand Lunar for *First Men in the Moon*. Although the head Selenite, called the Grand Lunar, was modelled in detail, he is never clearly seen in the picture because his appearance is always distorted by a 'force field'. But here he is revealed in all his glory, showing all the detail including the veins in his oversized skull. I always think he looks as if he has water on the brain.

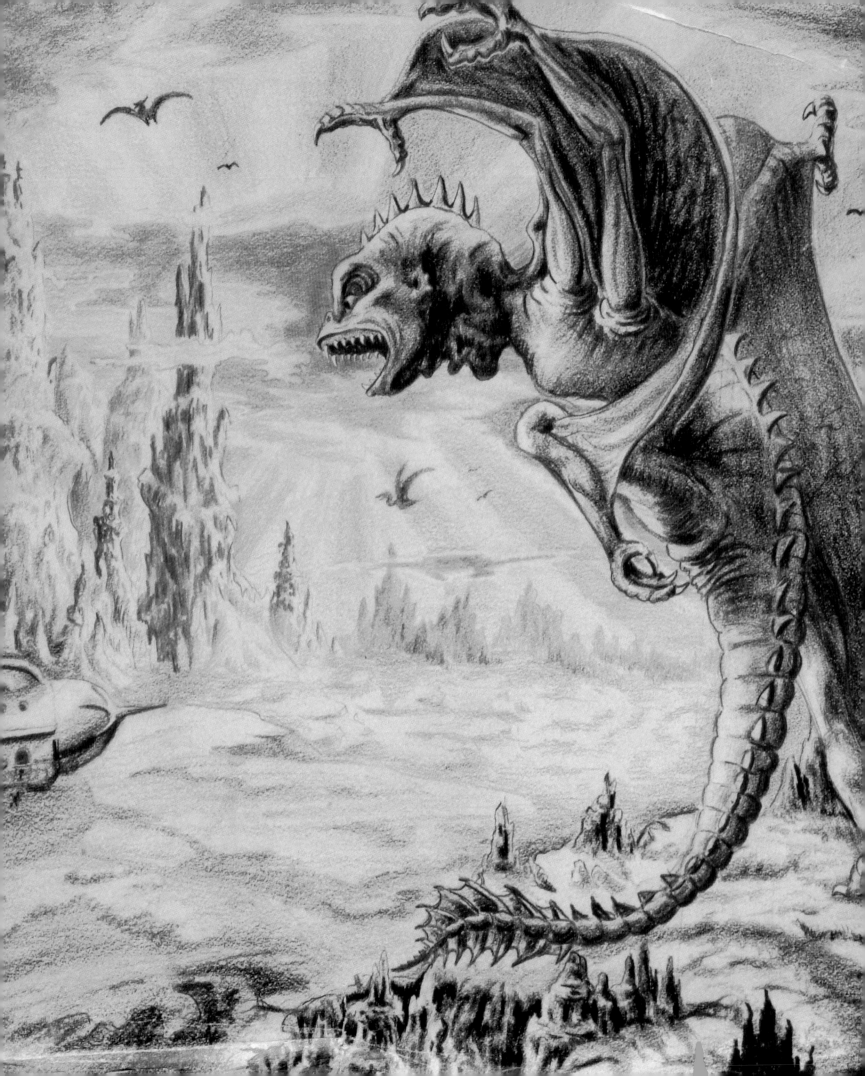

tical; it was only when I was building the model and animating it that I became aware of how wrong it all was. So many screen aliens seem to be designed just to be different and are, to me, totally illogical – like my Jupitarian. That model taught me to consider, at least to some degree, the practical aspects of a design – no matter whether it was a dinosaur, an alien or a mythological character. It was a valuable lesson and one that I wouldn't forget.

One story I had always wanted to film was Wells' *War of the Worlds*. It describes how the Martians arrive in southern England in cylinders and, once here, construct tripod-like war machines with three metallic legs. After decimating the human population they are eventually killed by God's smallest creatures – germs – against which they have no natural defences. My version was to have been set in America but the Martian designs were largely based on Wells' description of octopus-like creatures with

huge heads, bulging eyes, fish-like jowls (a design I was to use to more practical purposes in the Ymir and the Kraken) and six tentacles that terminated in two digits. Looking at it today, this creature is unimpressive and totally wrong – mainly because its two digits would never have allowed it to build the spacecraft let alone the war machines, but also because it would have been unacceptable as a terrifying alien invader because it wasn't scary enough.

From 1942 onwards I spent a great deal of time, spread over many years, trying to develop the project and interest people in making it into a feature film. To illustrate the project's potential I wrote a rough outline for the story as well as producing a number of tracings, sketches, key scene storyboards and large key drawings; for good measure I also made a 16mm colour test of an alien emerging from a capsule. These all helped illustrate the exciting key elements of the story such as the

aliens, the tripod war machines and, of course, the destruction of various famous sites in America. Sadly, all my hard work was to no avail and my version of Wells' magnificent story was never made.

*The Elementals* dates back to an idea I had when I was in my teens. However, although I did some rough sketches, it wasn't until my first box-office success with *The Beast From 20,000 Fathoms* that I resurrected it as a viable feature project, wrote a step outline of the story, and took it to Jack Deitz who had produced *The Beast*. He loved it and commissioned several writers to develop a script. My basic outline featured winged alien creatures (*The Elementals*) that had come to Earth, in chrysalis form, in a spacecraft. (It was never explained if they had built the craft or if some other kind of beings had launched them into space in order to get rid of them.) When their ship crashes they escape and hatch out into vicious flying creatures (based on

**Left.** Charcoal and pencil on tinted paper. 14″ x 11″. c.1937. Drawing for *The Jupitarian*. One of the few surviving early key drawings for this project shows an outrageous creature which is discovered on Jupiter. I did build a model and animate it for tests but the project never progressed further.

**Above.** Pencil on tracing paper. 8″ x 6½″. c.1952. Sketch for the unrealized *The Elementals*. This was a design that I had planned to transfer to a key drawing but the project never came to fruition. It shows an alien Elemental attacking people in a Parisian street.

**Top right.** Charcoal and pencil on art paper. 6″ x 6″. c.1952. Rough sketch for a possible incident in the unrealized *The Elementals*. This is an idea that I had to feature the Eiffel Tower in the story so that I could visit Paris.

**Bottom right.** Charcoal and pencil on art paper. 6″ x 6″. c.1952. Sketch for the unrealized *The Elementals*. This is my first sketch showing the creature attacking people on a Parisian street.

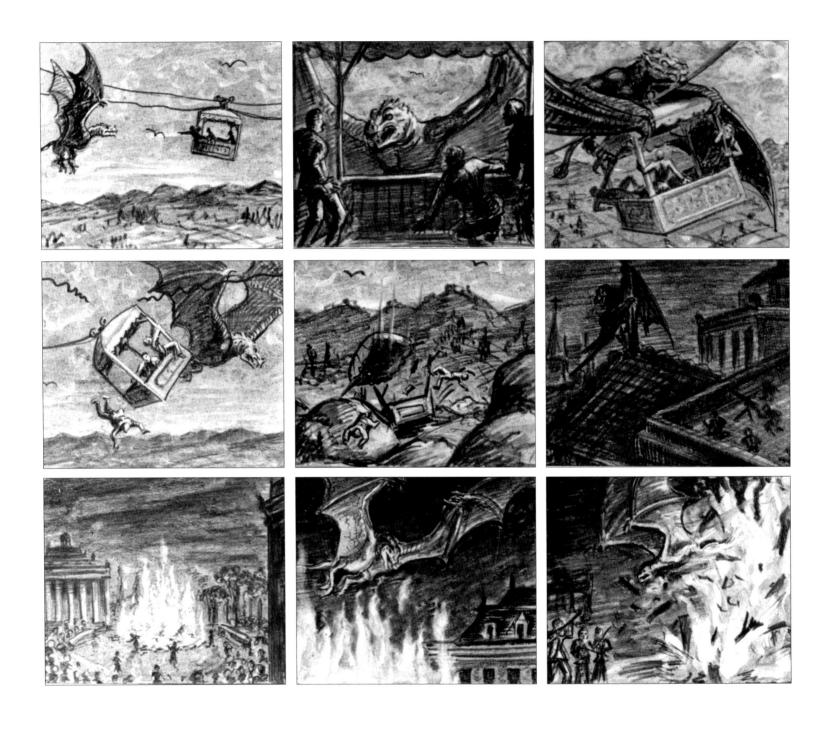

**Above.** Situation sketches for the unrealized *The Elementals*. c.1952. Originals are lost; these are photographic copies. Here we have the creatures attacking a cable car and being attracted into the flames.

**Right.** Pencil on art paper. 14 ½″ x 11″. c.1949. Rough design for a key sequence for the unrealized *War of the Worlds*. This shows a Martian war machine destroying an airship in a scene that resembles the 1937 disaster at Lakehurst Naval Air Station in New Jersey when the German airship *Hindenburg* was destroyed.

the Furies of mythology) that begin to terrorize Paris, where I had set the story.

Whilst the writers were working away on smoothing out my outline, I worked on the visualization. Again, I drew a number of designs for the creatures and armatures, continuity boards, tracings and key drawings based on scenes in my outline. For example, the creatures were shown nesting on the Eiffel Tower and attacking a cable car, a plane and a cart before meeting their end in a fireball on or near the Seine. In these original drawings the creatures were designed to appear huge (about six or seven feet high with a wing span of about twenty feet) and bat-like in appearance. Their faces owed a lot to mythology, featuring large canine teeth and horns. They had tails, two three-digit, clawed feet and pterodactyl-like claws on the edges of their wings from which they hung when they slept, in a bat-like fashion. They were alien in appearance but at the same time familiar.

As with *War of the Worlds* I made a test film in colour, which Deitz paid for me to shoot on 35mm stock. It showed one of the creatures attacking and carrying off an unfortunate victim. That victim was in fact me. By the time I came to make that test I had changed the appearance of the creature considerably. It still had bat-like wings, clawed feet and a tail, but it now had a head like a carnivorous dinosaur. Why I changed it I can't now remember but I suspect that, once again, it was because, when I came to build the model, I felt that the original concept would not work and that it needed to be much more reptilian and therefore more frightening.

The aliens in *Earth vs the Flying Saucers* (my first cinema project featuring aliens) appeared in a supporting role; it was the saucers themselves that were the real 'stars' of the film. But although the storyboards were mostly devoted to the saucers, the aliens did make several appearances. In our story they have travelled from a dying planet and are intent on conquering and colonizing Earth. However, once out of their saucers, they can survive in the Earth's atmosphere only with the protection of their 'environmental' suits and, with one very brief exception, we only see them in these suits. Originally, the audience was going to see more of the aliens, especially in the scenes inside the saucers, and they were to have been animated. However, not unusually, time and money were in short supply, so we had to settle for human actors in costume. Their suits were designed by me in considerable haste and subsequently I have always felt that they were something of an embarrassment. They were made of rubber with jointed arms and legs that allowed the actors inside to move, with a hood, or cowling, covering the head. There was no time to test them out and improve them, and as a result they seem

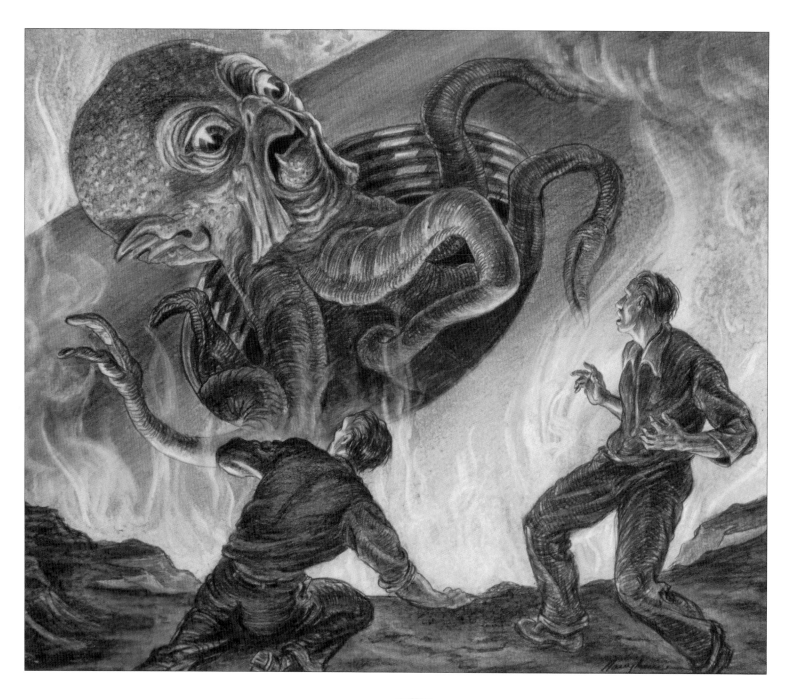

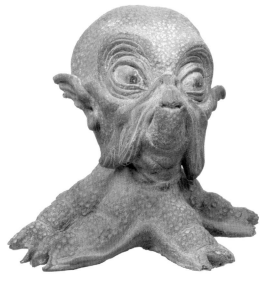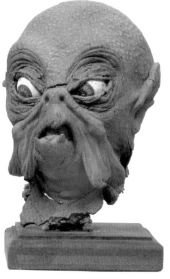

**Above.** Charcoal and pencil on illustration board. 14 ½" x 11½". c.1949. Drawing for a key sequence for the unrealized *War of the Worlds*. The opening key scene for the project shows the Martian emerging from the capsule. This was the scene I chose to film for my test for the project.

**Left.** Copy of the original. 5" (h) x 5½" (w); (R) Latex with internal metal armature 4½" (h) x 3½" (w). c.1949. Two Martian heads. The head on the right is the original I used for the test film. He is minus his tentacles because the armatures were used for a subsequent model. The model on the left was originally given to Forry Ackerman but was stolen from him. Years later he rediscovered it in an antique shop in Seattle.

**Above.** Charcoal and pencil on illustration board. 14½″ x 11½″.
c.1949. Drawing for a key sequence for the unrealized *War of the Worlds*. The Martians meet their end in New York. Earth's smallest creatures – germs – had achieved what man was unable to do.

**Above**. Charcoal and pencil on illustration board. 15″ x 11½″. c.1949.
Drawing for a key sequence for the unrealized *War of the Worlds*.
This depicts the scene soon after the Martian war machine
emerges from the crater where the spaceship had crashed.

awkward, wooden and therefore slightly comical.

The only time we see an alien 'in the flesh' is when one is shot in a wood and his cowling is removed. Before the creature disintegrates, we briefly see his face. Like the rest of the technical details of the film, the alien's face was designed by me and then cast in rubber by the studio. It depicts an 'ancient' face, heavily lined and wrinkled with two large eyes and a pointed mouth. Like the design of the saucers, these features were descriptions from people who claimed to have been 'kidnapped' by such creatures.

In the two alien features I previously worked on, I had produced very few, if any, large key drawings and I had either avoided drawing storyboards altogether, as was the case with *The Beast From 20,000 Fathoms*, or had limited myself to a bare minimum relating to the more important sequences, as happened with *It Came From Beneath the Sea*. In the case of *Earth vs the Flying Saucers*, because of the complex nature of the effects, I found it necessary to make a larger number; but I was able to speed things up with the help of the many photographs that I had taken, as usual, when we were recce-ing locations, in this case in Washington, DC. Usually I took such pictures simply for reference, but in this case they were incorporated into the storyboards. For example, in the sequences that show saucers 'crashing' through the column of the Washington Memorial and the large window in the Union Station, I used my photos of the Memorial and the station to provide the backgrounds and sketched in the saucers and the other effects I wanted to include in that sequence. Not having to draw backgrounds saved time and a great deal of money. It was a technique that I would use again, for exactly the same reasons, for *One Million Years BC*. On other occasions I sometimes used one or two recce photos to sketch in a specific scene but not as a complete storyboard; examples were the temples on the island of Lemuria in *The Golden Voyage of Sinbad* and the city of Charak in *Sinbad and the Eye of the Tiger*. It was a useful technique for conveying a quick visualization of a scene.

My next alien was the Ymir, who was the undoubted star of *20 Million Miles to Earth*. The poor thing is brought back to Earth as an 'egg' from the planet Venus, by a manned rocket expedition. The creature was originally conceived as a cyclops (at that time the project was called *The Giant Cyclops*), but as the story was developed I decided that the cyclops idea looked totally wrong. My next design was a huge scaly, tubby figure with jowls and spikes that began on his forehead and ran down his back. Looking at some of the drawings I made at the time, I notice that I gave this design five-digit

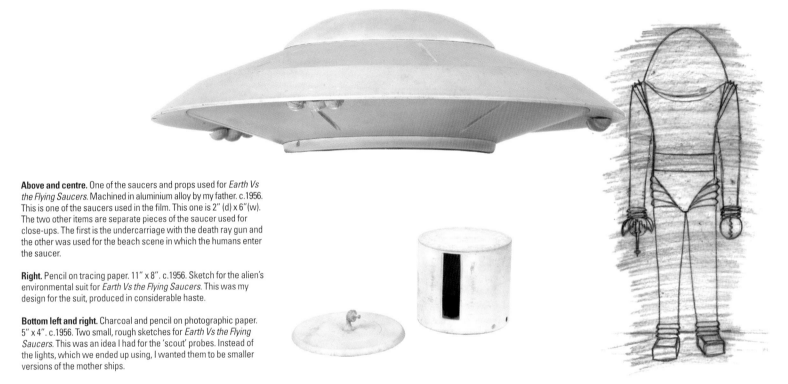

**Above and centre.** One of the saucers and props used for *Earth Vs the Flying Saucers*. Machined in aluminium alloy by my father. c.1956. This is one of the saucers used in the film. This one is 2″ (d) x 6″(w). The two other items are separate pieces of the saucer used for close-ups. The first is the undercarriage with the death ray gun and the other was used for the beach scene in which the humans enter the saucer.

**Right.** Pencil on tracing paper. 11″ x 8″. c.1956. Sketch for the alien's environmental suit for *Earth Vs the Flying Saucers*. This was my design for the suit, produced in considerable haste.

**Bottom left and right.** Charcoal and pencil on photographic paper. 5″ x 4″. c.1956. Two small, rough sketches for *Earth Vs the Flying Saucers*. This was an idea I had for the 'scout' probes. Instead of the lights, which we ended up using, I wanted them to be smaller versions of the mother ships.

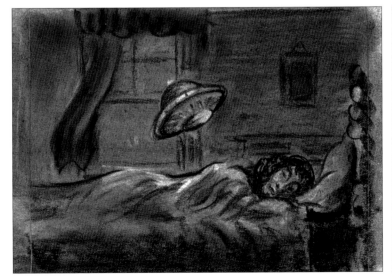

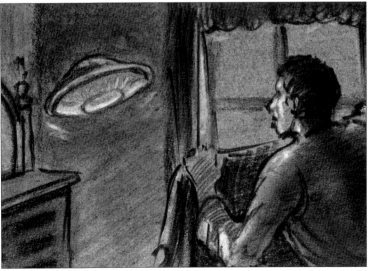

**This page.** Charcoal and pencil on tracing paper. 11" x 8". c. 1956. Rough sketch of a possible alien for *Earth Vs the Flying Saucers*. The early scripts demanded that the alien should be seen on screen and I sketched out lots of ideas for their appearance. It is interesting to see how my mind was working on every angle even if some of the creatures would have been impractical.

**Right.** Photographs mounted on illustration board. 20" x 14". c.1956. Storyboards for *Earth Vs the Flying Saucers*. This is an excellent example of the technique of using a combination of location photos and sketches to create a storyboard. It saved much time since the photographs provided all the background.

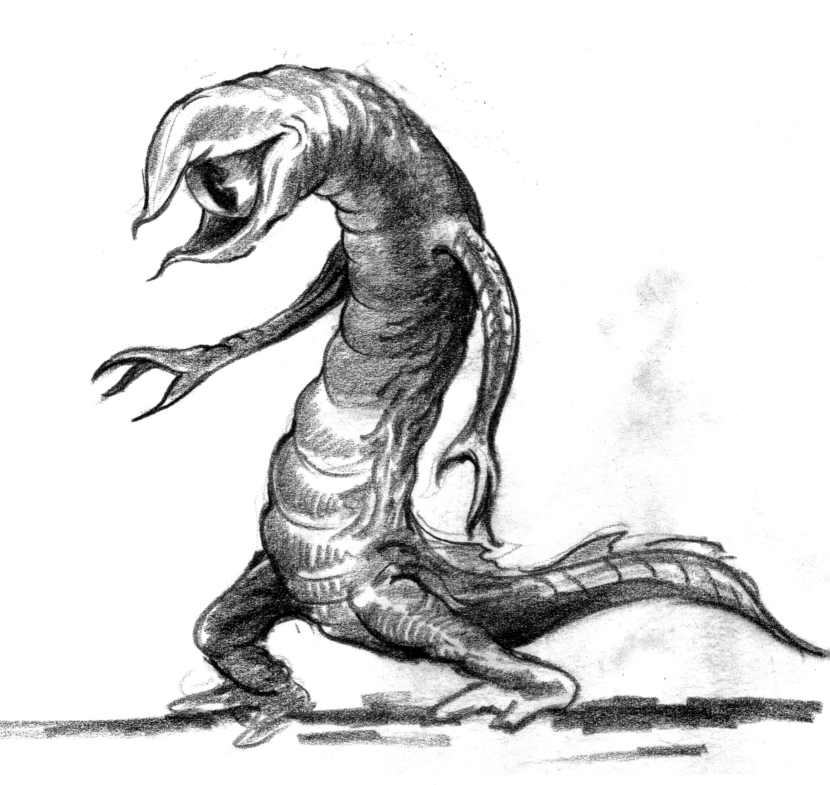

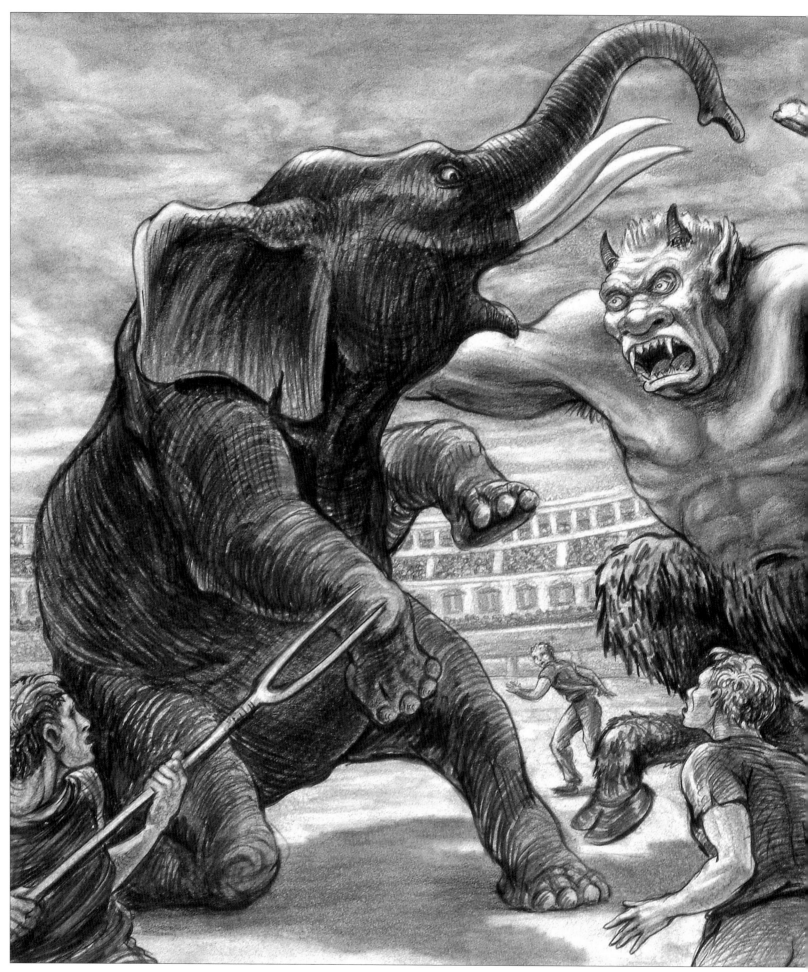

**Left.** Charcoal and pencil on illustration board. 15″ x 11½″. c.1954. Early drawing for what would become *20 Million Miles to Earth*. This was a very early concept for the original story, called *The Giant Cyclops*, that evolved into *20 Million Miles to Earth*. This of course was not a cyclops but it would become one as I developed the storyline through my illustrations.

**Above.** Charcoal and pencil on illustration board. 15″ x 11½″. c.1955. Key drawing for *20 Million Miles to Earth* showing the final design of the creature. The Ymir destroys some ancient columns in the Roman Forum.

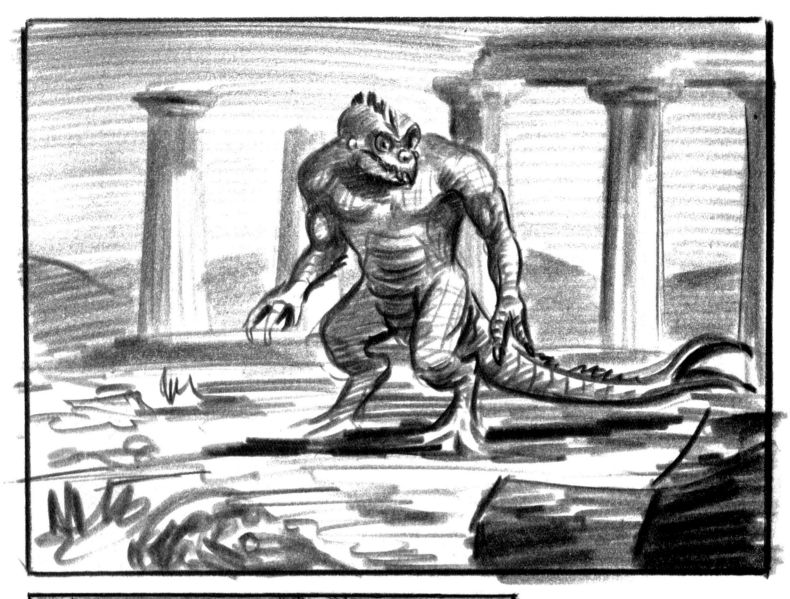

**Top.** Charcoal and pencil on art paper. 6½" x 4". c.1955. The Ymir stands in front of a Greek temple for what would become *20 Million Miles to Earth*. I must have originally imagined the Ymir running amok in Greece, although I can't remember anything about that. Alternatively, I may have been thinking of the Greek temple of Paestum in Southern Italy.

**Left.** Charcoal and pencil on photographic paper. 8" x 6½". c.1955. An early version of the Ymir trapped in ice in Chicago for what would become *20 Million Miles to Earth*. This was an early concept for the capture of the Ymir.

hands even though the creature wasn't conceived as an intelligent being. I began some basic continuity boards and tracings for key drawings using this design, but I again realized that the concept wasn't realistic enough. So I went back to drawing board and worked on a new design until I was satisfied that I had created something that worked. It is amazing that while a creature will sometimes spring fully formed out of my mind and on to the paper more or less the first time I sit down, on other occasions it will take a great deal of work to arrive at what I believe is the correct balance of realism, practicality and originality.

In the case of the Ymir, even after abandoning my first two ideas, it still took me a considerable amount of time to arrive at a final version. For this third attempt, I kept the fish-like jowls, which I had used previously for the Martians in my *War of the Worlds* as I felt these were perfect for a creature that had evolved in the hostile atmosphere of Venus, and the spiked spine. I then made him more upright and slimmer, creating a more human-like stance, and added a reptilian skin texture, clawed feet and a tail. It was also at this stage that I reduced the number of digits to three, thus, according to my theory, reducing his intellect. The humanoid element not only produced a more believable creature, it also allowed me to introduce characteristics on the animation table that helped the audience to identify and empathize with the creature.

It was another seven years before Charles Schneer, my producer, and I worked on another science-fiction adventure. But this time there were no flying saucers and no rampaging monsters on the loose in the city streets; instead, we turned to a period story by H.G. Wells. Of all the science-fiction films I worked on, *First Men in the Moon* is most certainly my favourite, a story of high adventure that contains action, humour and a strong message. Sadly it didn't go down well with audiences at the time, perhaps because the genre had by then lost its appeal.

My association with the story goes back to the late 1930s when I first read it and was sufficiently impressed to start visualizing how it might appear on screen. I drew a few very rough sketches of the men walking on the moon; according to Wells' novel, the sun heated up the moon's surface, giving it an atmosphere and revitalizing plants that then produced oxygen. Those sketches also included a version of the mooncalf, which, even then, I visualized as a caterpillar-like creature. When the project was commissioned by Columbia in 1963 I returned to those early concepts, retaining the caterpillar design for the mooncalf, but starting from scratch when it came to visualizing the moon and its interior and the indigenous creatures, which Wells called Selenites.

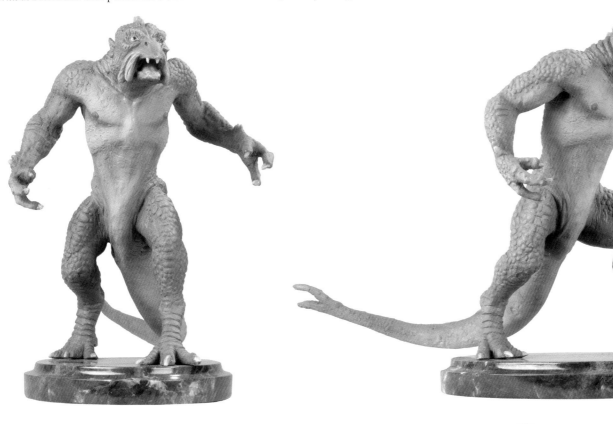

**Above and above right.** Resin casts. 9½″ (h) x 17½″ (d) x 11½″ (w). c.1956. Model of Giant Ymir for *20 Million Miles to Earth*. These casts were made much later from a mould made from the original plaster model.

**Right.** Resin Ymir skull with ball joint. 1½″ (h) x 2″ (d) x 3″ (w). c.1956. The Giant Ymir's head from *20 Million Miles to Earth*. All that remains of the poor Ymir. The rest of him was cannibalized to create the cyclops in *The 7th Voyage of Sinbad*.

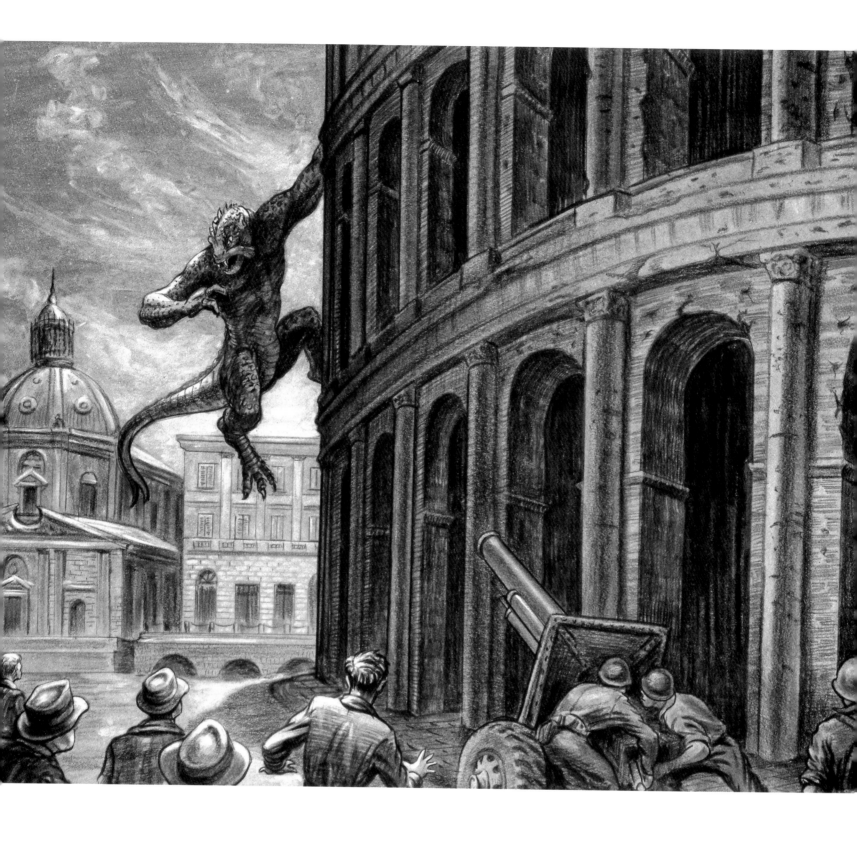

505A

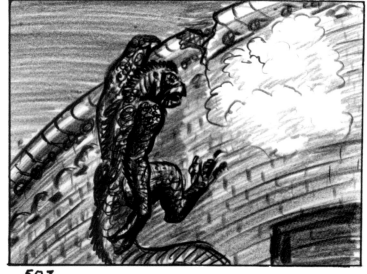

507

508

510 – 513

**Above.** Original lost. This is a photographic copy. c.1956. Sequence drawing of the death of the Ymir for *20 Million Miles to Earth*. To illustrate how I saw the death of the Ymir on the Coliseum, I drew these four images for the end of the film. They helped the screen-writer, actors and cameraman to envisage what I wanted.

The Selenites, together with the mooncalves, were the animation stars of *First Men in the Moon*. I designed them as ant-like creatures because they lived 'in' the moon harvesting their food from the huge caterpillar-like mooncalves. As I had begun with the concept of ant-like creatures, I designed the rest of their world, including the doors, tables, an x-ray machine and the hive (not used), in hexagonal forms. Keeping the interior sets simple, like a technological colony, made the story seem much more credible. Whenever I can, I do like to make consistent use of a single concept or theme throughout a film.

I didn't execute any key drawings for this film, only continuity boards, which over the years have suffered due to a flood I once had in my basement. The few that remain in reasonable condition have now been preserved and stored by Tony. Although they were not stored in the cellar, a similar fate seems to have befallen the Selenite models, which are also the worse for wear and beginning to disin-

tegrate, as the photographs in this chapter show. It is likely that this is the last time they will be seen. The continuity boards each contain between seven and twelve small drawings, illustrating a specific sequence in the film. Sometimes they include a large drawing at the top, followed by six or so smaller drawings that take the sequence on to its conclusion. These boards are not as detailed as a full storyboard and are produced only to help the screenwriter, director and actors.

Selenites were based on ants, and have elongated heads (aside from the Grand Lunar who has a bulbous head), short antennae, large bug-eyes, spindly legs and arms, folded wings (though they never actually flew) and a long insect-like lower body. Their design was intended to represent a body-form that suited a subterranean, colonial existence in tunnels and caverns. Once I had the concept clear in my mind I was able to render the Selenites on paper extremely quickly. Likewise the mooncalf, which basically appeared as I had origi-

nally conceived it, except that I made it more menacing by equipping it with vicious mandibles with which it attacked the Lunar adventurers.

*First Men in the Moon* was a satisfying film to design and work on. My admiration for Wells helped the project to come together relatively easily, apart from some problems with the anamorphic ratio (wide-screen). The end product was, I think, one of the best features Charles and I did and, gratifyingly, it has stood the all-important test of time, which can be the cruellest critic.

The final science-fiction film in which I was involved was to have been an adaptation of H. Rider Haggard's *People of the Mist*, a story that begins in Victorian England and ends on a plateau called the Land of the Mist, inhabited by natives, dinosaurs and other creatures, all of which are controlled by aliens. It could have been *King Kong* meets *The Lost World* meets *War Eagles* meets *Invaders From Mars*, and I thought it would work very well if the proper script could be written. But

**Left.** Latex and cotton body with internal metal armature. Each 4½"(h) x 1½" (d) x 1" (w). c.1963. Models of four Selenites for *First Men in the Moon*. The poor Selenites are not standing the test of time well. As can be seen here, their lower legs and arms are crumbling so this may be their last public appearance.

**Above.** Charcoal and pencil on art paper. Bottom five drawings are all on yellow tinted art paper. All are mounted on illustration board. 22" x 16". c.1963. Storyboard for a sequence in *First Men in the Moon*. It shows the two astronauts discovering the lens cover. All my drawings for this film were designed to fit the widescreen Panavision ratio.

**Following pages.** Charcoal and pencil on yellow tinted art paper. All mounted on illustration board. 22" x 16". c.1963. Storyboard sequence drawing for *First Men in the Moon*. For this film I made a number of these separate, short storyboards rather than producing a full storyboard. The first sequence shows part of the unrealized hive sequence and the second details what would become the X-ray machine, and the questioning of Cavor about Cavorite.

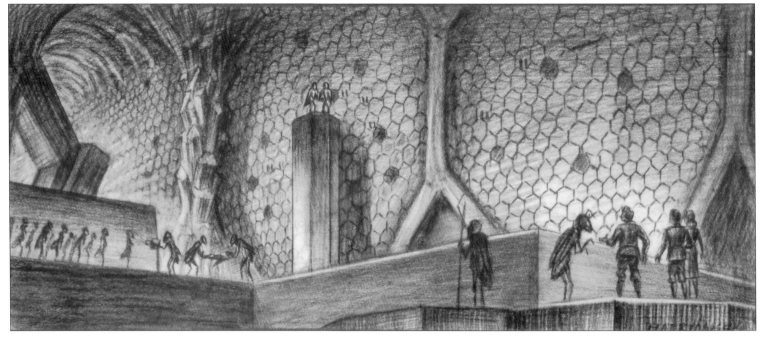

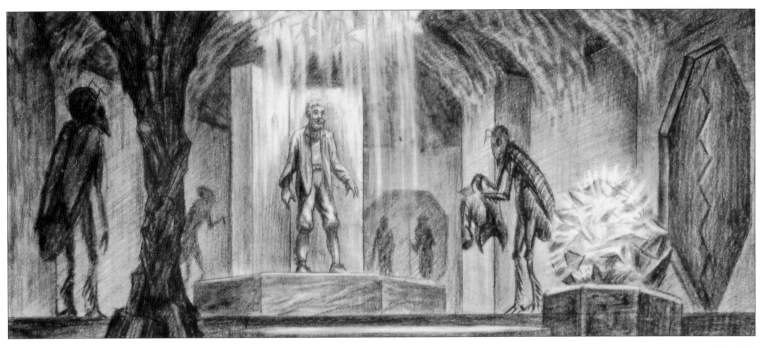

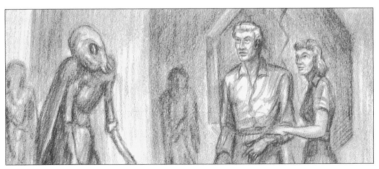

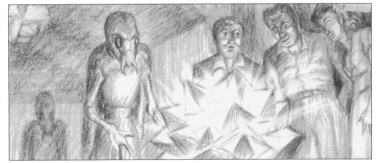

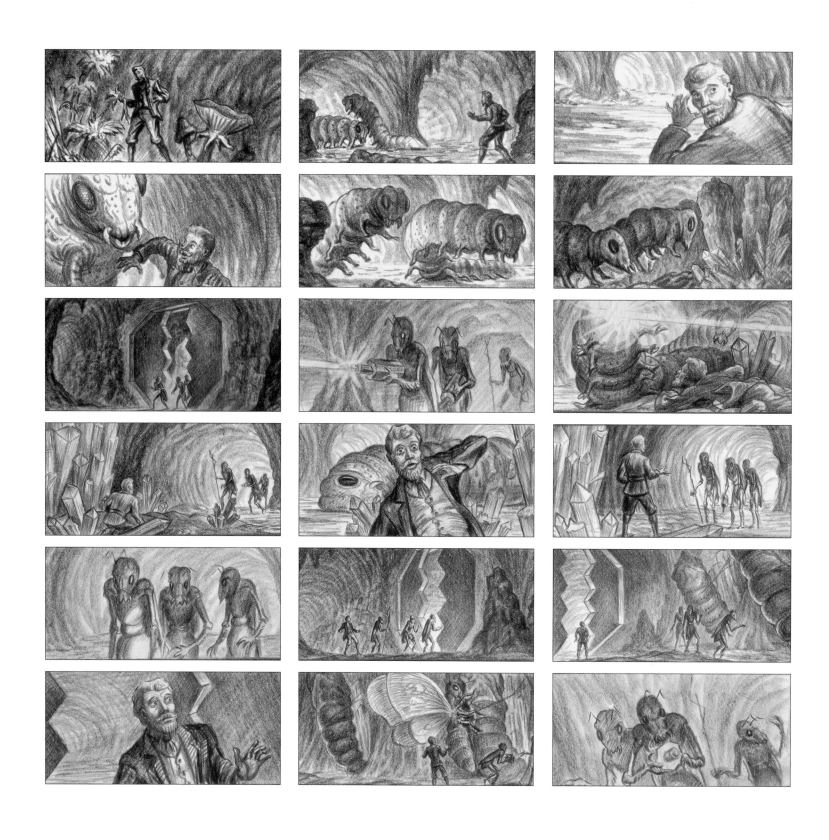

**Above.** Charcoal and pencil on yellow tinted art paper. All mounted on illustration board. 22" x 16". c.1963. Storyboard sequence drawing for *First Men in the Moon*. A set of drawings for another unrealized sequence which would have shown the discovery of the moon-calves and a cocoon chamber where they transmogrify into moths.

**Right.** Latex and cotton body with internal metal armature. Each 8½" (h) x 3"(w) x 2"(d). c.1963. Three more Selenites for *First Men in the Moon*. These high-level Selenites are slightly larger than those earlier in this chapter and in marginally better condition.

**Following pages.** Charcoal and pencil on illustration board. 19" x 12". c.1983. Key drawing featuring the humanoid alien which was to have featured in *People of the Mist*. I suspect that I would not have animated him as he was too humanoid.

sadly, once again due to script difficulties, the project never came to fruition.

I worked for some time trying to come up with good and believable designs and sequences for the project and made a number of sketches, tracings, key drawings, posters and plaster models. Amongst them are drawings of an ancient Mayan-like city with flying creatures (a cross between a vulture and pterodactyl) influenced by *War Eagles*; two adventurers being attacked by a real ptero-dactyl; a stegosaurus being attacked by two smaller dryptosaurus; a giant sacrificial statue with marine dinosaurs waiting for their lunch; a plaster model of the same sacrificial statue and another of a reptilian creature, which I don't think I had intended to be alien. Finally, I made a key drawing of one of the aliens, portraying it as a heavily bearded, humanoid being of perhaps twelve or thirteen feet in height, standing in the mouth of a cave facing two humans. This scene would have revealed that everything in this strange world was controlled by the aliens. In combination, these images suggest a very exciting and original project and I am sure that one day someone else will rediscover the story and convert it successfully into a film.

Between 1937 and 1983 I designed a whole range of creatures from other worlds and, even though aliens were not my métier, had managed to come up with some reasonably spectacular results, most of which I believe to be original and cinematically exciting.

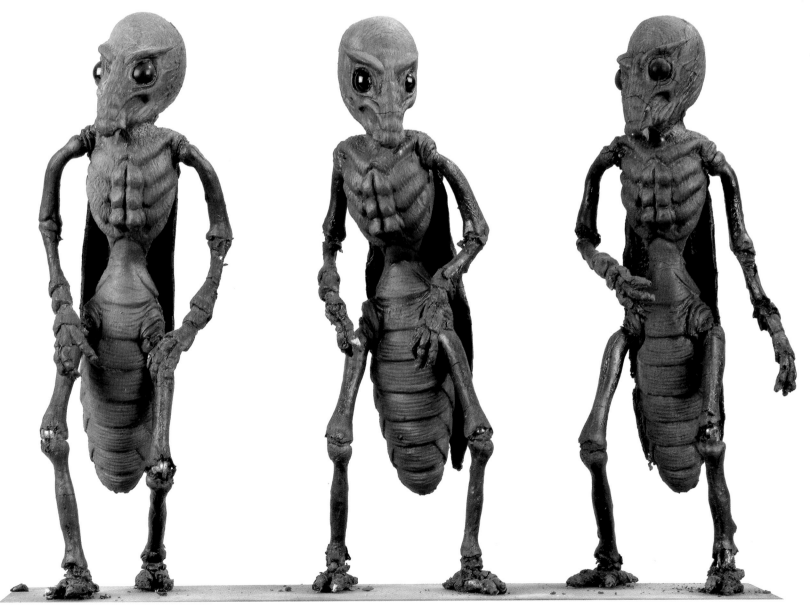

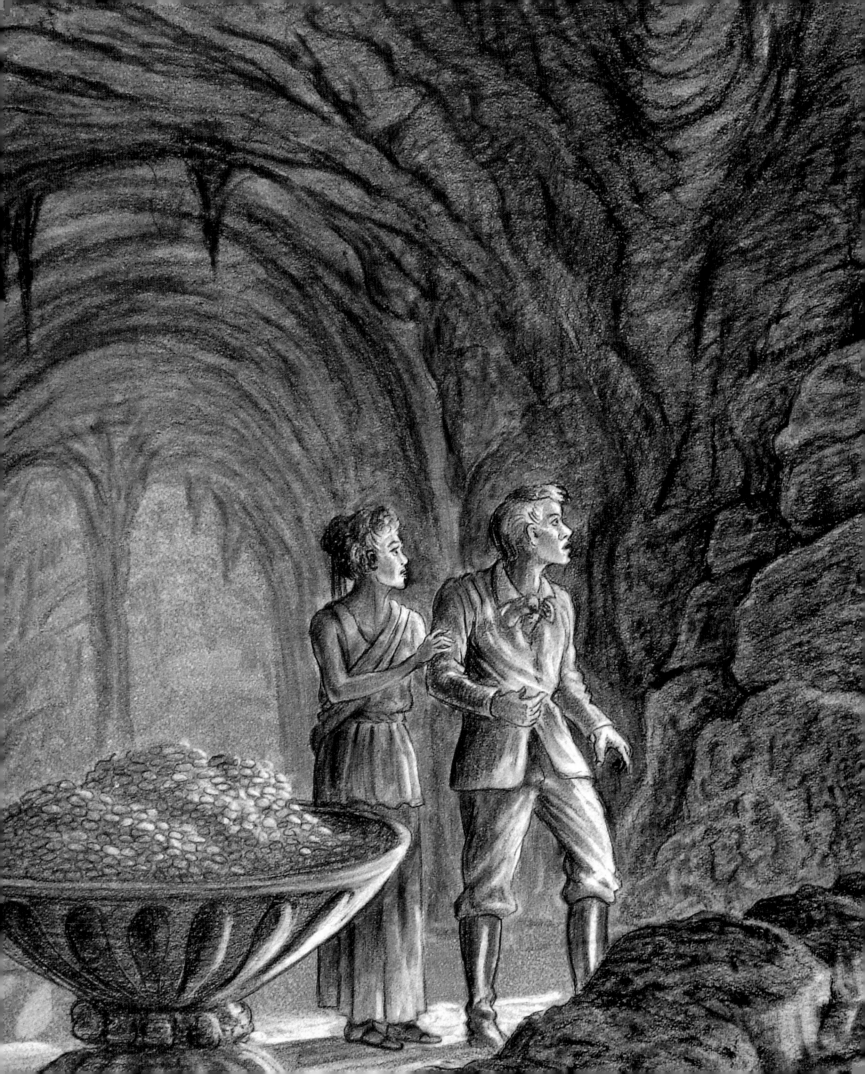

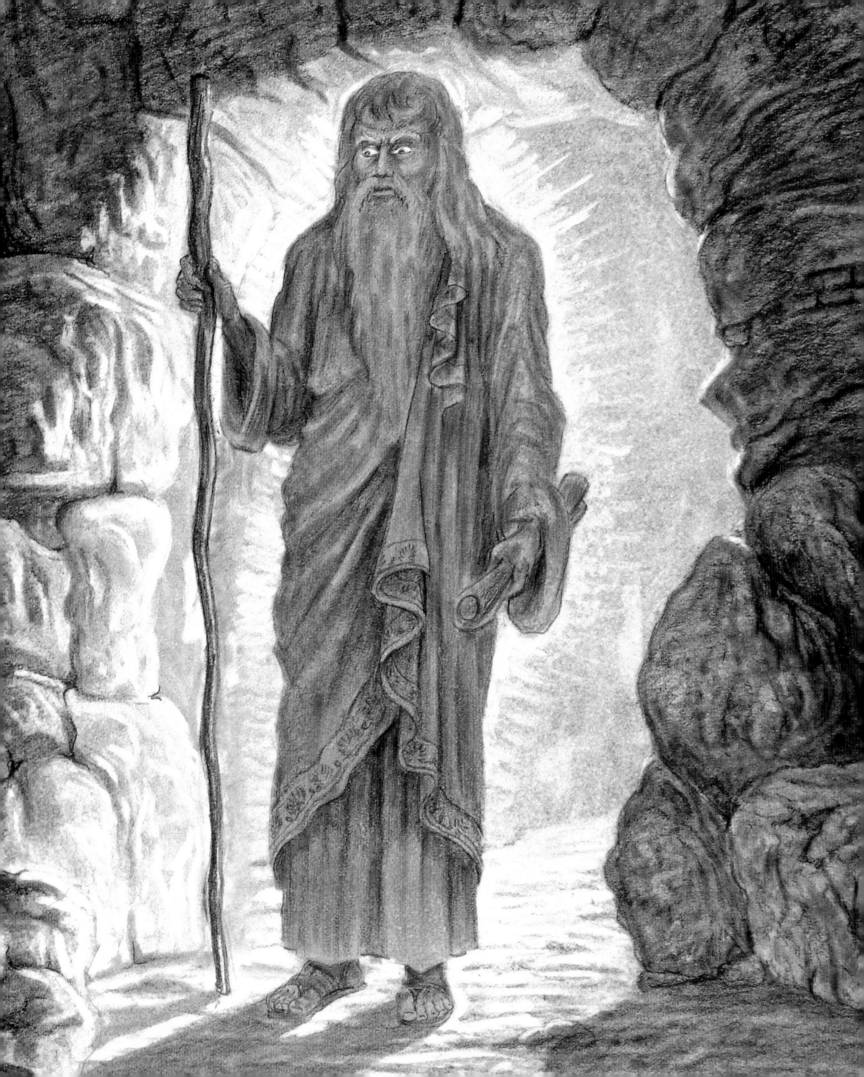

# CHAPTER 9  LEGENDS

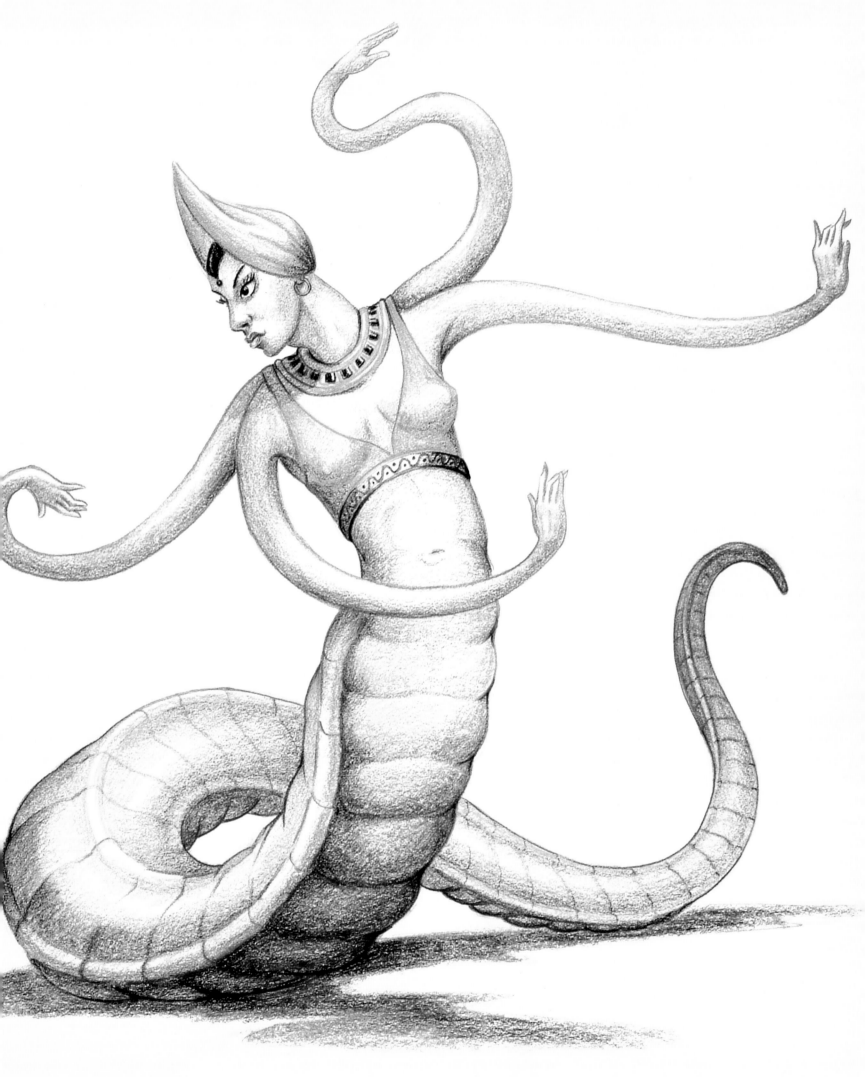

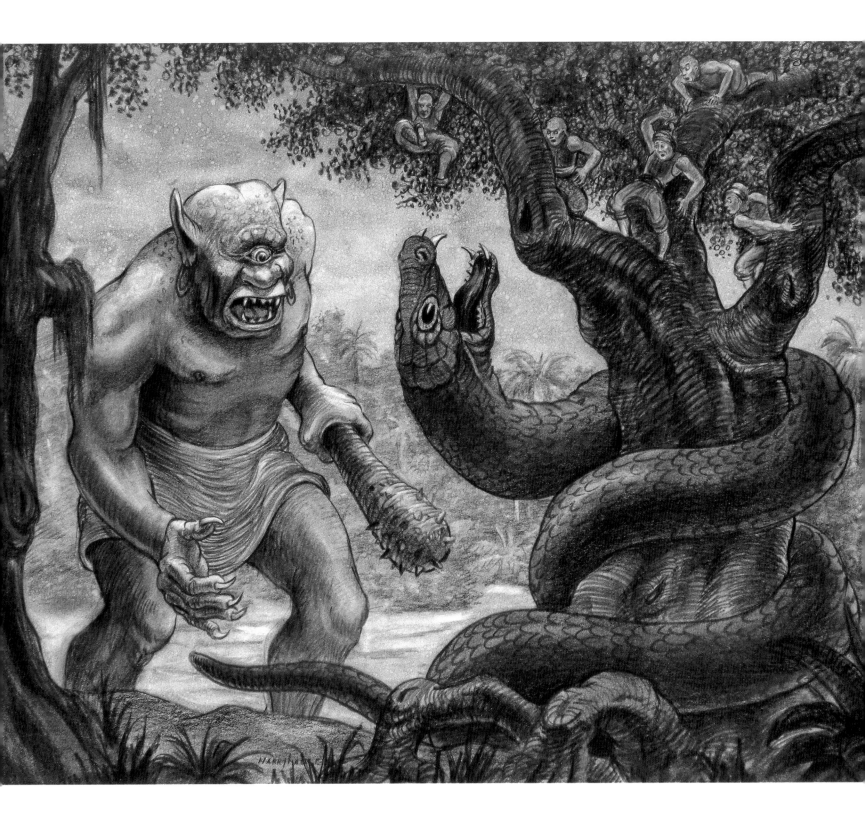

**Previous page.** Pencil and watercolour on illustration board. 19" x 14". c.1957. Watercolour of the snakewoman for *The 7th Voyage of Sinbad*. This was my first and only design for the exotic snake-woman.

**Above.** Charcoal and pencil on illustration board. c.1957. Key drawing for *The 7th Voyage of Sinbad*. An unrealized sequence for the film which would, I think, have been very dramatic. I suspect it was dropped because of Charles Schneer's aversion to snakes.

*The Abominable Snowman (1946)*

*The 7th Voyage of Sinbad (1958)*

*The Golden Voyage of Sinbad (1973)*

*Sinbad and the Eye of the Tiger (1977)*

BEFORE WE MADE *THE 7TH VOYAGE OF SINBAD* film-makers had largely ignored legends (as opposed to classical and biblical mythology) as a source of stories; or, if they tackled them, generally down-played the fantasy elements, concentrating on the human stories and producing movies that were either simple love stories or what could best be described as cops and robbers escapades in baggy pants. At best, they might include a fleeting reference to a creature like the roc, but nothing would be shown of it. There was, of course, one exception to this rule and that was Alexander Korda's *The Thief of Bagdad* (1940). This was, and still is, a classic film. It does include the usual love story and a typical villain, but it also shows, to great effect, how exciting fantastical creatures could be when transferred on to the screen. It featured a genie, a flying horse, a six-armed mechanical statue and a flying carpet (this last, I must admit, was something I never attempted to replicate). *The Thief of Bagdad* was always the example I quoted to show just how exciting legends could become if the audience could actually see the fantasy creatures, and it was the yardstick against which I judged my own work when I set about putting the creatures back into legend by using my imagination and the wonders of Dynamation.

The most exciting and colourful hero for me was, of course, Sinbad the Sailor. Although he isn't in the truest sense a legendary figure but a hero from the Arabian classic *The Thousand and One Nights*, his adventures were very much in the tradition of the genre. I owe a great deal to Sinbad, not least the opportunity to change the direction of my career in feature film-making. Up until 1958 I had been almost exclusively involved with so-called monster-on-the-rampage movies and was looking not only for a way out, but also for new inspiration and, as always, for new subjects to which I could apply the techniques of stop-motion animation. The turning point was a key or concept drawing of Sinbad fighting a skeleton on the top of a ruined spiral staircase. Initially, the choice of Sinbad was almost incidental: it was the skeleton that I wanted to animate. But after considering other potential heroes, it occurred to me that Sinbad would be its best adversary. In this way I fortuitously lit upon an idea that would change my career and enable me to demonstrate that three-dimensional stop-motion animation could be much more versatile than some in the industry had imagined.

However, although my discovery of Sinbad was to be a turning point, he was not the subject of my first venture into the territory of legends. That was the Abominable Snowman, otherwise known as the yeti, which is reputed to roam the isolated wilderness of the Himalayas. The idea of using the yeti as a subject for stop-motion animation occurred to me soon after the war, when, for a time, the creature featured quite prominently in the press. Once I had decided that the subject was suitable I began trying to develop a story around it. That proved difficult, and after a while the project floundered and I filed it away in my story morgue, possibly for reconsideration another day.

That day came in 1952, just after making *The Beast From 20,000 Fathoms*, when I resurrected the idea to see if, with one feature now under my belt, I could develop the storyline and sell the concept. Conceiving even a basic outline was never easy for me but, after much trial and error, I came up with a combination of *The Lost World* and *Lost Horizon*. Set in the early 1950s, the story follows the adventures of an intrepid professor who, along with a small rag-tag group of scientists and adventurers, sets out to find the elusive Abominable Snowman, said to inhabit the remote regions of the Himalayas. One night they encounter the huge beast and manage to wound it and then track it to a huge hidden valley in Tibet. This perfectly sheltered, tropical valley, a bit like Shangri-la, is heated by vents from a volcano, and is the home not only of the yeti but also of dinosaurs and a race of mystical humanoids who are the last survivors of a lost race that ruled the Earth at the time of the dinosaurs. These beings store all the secrets of the world, holding them in trust until humans are capable of using the knowledge properly. Like so many of my storylines it doesn't have an ending; I always thought that a minor problem that could be worked out later by the writers. However, I suspect that the valley, the yeti, the dinosaurs and all the wonders hidden there would have been destroyed by the volcano.

Although I had sketched out some rough ideas for the yeti when I had first thought of the idea (unfortunately none survive), I hadn't produced any key drawings. As far as we are aware nobody knows what the creature looks like (although according to legend it is half-man, half-ape or -bear), and this allowed me free rein when I set about visualizing its appearance. I drew only one rough sketch, which shows the beast swinging one of the unfortunate explorers around his head like a club. The creature is humanoid but with an ape-like

**Right.** Charcoal and pencil on illustration board. 14½" x 11½". c.1957. Key drawing for *The 7th Voyage of Sinbad*. Another unrealized scene which shows two cyclops fighting over a group of caged and potentially tasty sailors.

or Neanderthal face and a hair-covered body. This seemed feasible as thick body hair would enable the yeti to survive the extreme cold of the region. Sadly, this one image and the basic story are all that survive of the project, as it progressed no further. It wasn't until 1976 that I again tried to incorporate a yeti into a plot, this time the story for *Sinbad and the Eye of the Tiger*. It seemed a good concept to have a yeti encounter Sinbad and his crew on the ice, but it was not to be – in the course of script conferences the yeti was replaced by a giant walrus.

My first successful attempt to recreate a legend therefore came about as a result of my ambition to animate a skeleton and my decision that the best adversary for this unusual villain would be Sinbad. I chose Sinbad not just because he was an exemplary hero but also because his adventures often brought him into contact with sorcery and mysticism. That one drawing, and the brief outline I had written, became the basis of *The 7th Voyage of Sinbad*, which would eventually lead on to two further cinematic adventures. But, of course, a single

sequence is hardly the basis for an entire film. As a result of other ideas of mine, and concepts developed during production meetings, the final film contained a menagerie of beings, some drawn from legend and some 'borrowed' from world mythology.

The first creature encountered by the audience is the cyclops, which is seen chasing Sokourah, the evil magician, on the island of Colossa. The sequence was always intended to be dramatic; the audience would be amazed to see such a creature emerging from the mouth of a cave and striding across the beach – nothing like this had been shown on the screen before and, as with *Kong*, people simply didn't know how it was done. All these years later, even though there have been so many wonderful cinematic special effects sequences, the appearance of the cyclops still has the capacity to leave audiences astonished. The vicious, one-eyed giant was, of course, lifted from the story of Odysseus in Greek mythology, but I wanted to take him a stage further. In particular, I did not want the audience to think that the creature was a man in costume, but I

also had to ensure that it would be practical as an animation model. I therefore gave my cyclops the traditional attributes of the Greek original, but with the additions of a goat-like lower torso and legs that ended in cloven hooves, features were 'borrowed' from another character in Greek mythology, the Satyr.

Arriving at a final version of the cyclops/Satyr design was no easy process. Inevitably, the image that ended up on the screen was not the one that I began with. When I made my initial sketches and drawings for the cyclops I felt that they looked fairly ordinary – if a giant cyclops can be described as ordinary. The only unusual characteristics he possessed at that stage were his single eye, pointed ears, a ridge of spikes over his head and his size. It wasn't until I came to making the model that I changed the design to give him the satyr features: a furry lower torso and cloven hooves as well as – for good measure – scaly, wart-covered skin and, his crowning glory, the horn. Amongst my charcoal key drawings of sequences that would include cyclops were the spit-roasting of the sailor over the

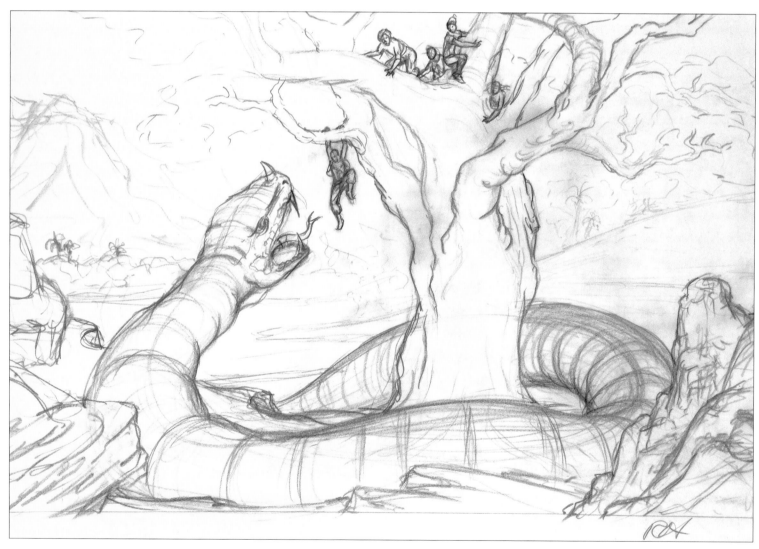

**Above.** Pencil on art paper. 20″ x 12″. c.1970. A rough sketch that shows that I never let a good idea go. I had first hoped to find a place for this scenario, a snake attacking a group of men hiding in a tree, in *The 7th Voyage of Sinbad* but I produced this when I was feeling my way through various ideas for *The Golden Voyage of Sinbad*.

**Right.** Charcoal and pencil on tinted photographic paper. 8½″ x 7″. c.1946. A very rough sketch for *The Abominable Snowman* project. Although crude, this is a good design for the creature. I must have picked up the idea of the man being swung around his head from Obie who depicted *Mighty Joe Young* swinging a lion around his head.

fire, the uprooting of the tree, the rescue of the sailors from a huge snake and a fight between two cyclopes over who would get to eat some sailors imprisoned in a cage; these last two scenes never appeared in the final film. I am pleased to say that the cyclops seems to be one of those creatures who has continued to appeal to fans and film-makers alike. To me, he now comes over as a formidable but likeable fellow.

The snakewoman is one of my favourite characters in the film. I had always wanted to add a character at that point in the story who was not only completely different from the dancing girls with diamonds in their navels that feature in most costume adventures, but who would also show the magical powers of Sokourah. The snakewoman is conjured up by the sorcerer to perform a dance of death when he 'combines' Princess Parisa's hand-maiden with a serpent. Her upper torso is that of a human female with the addition of an extra pair of arms, but the remainder of her body is that of a snake. I decided to give her four arms so that I

could elaborate the snakewoman's dance; with just two arms the creature might have seemed a bit mundane, but the extra pair of arms enabled me to give her whole body an allure and a flow that worked wonderfully with the music. When I animated the model I used the music from the film *Salome* (1953), loaned by Columbia's music library, as a guide that provided a beat; later, of course, the great composer Bernard Herrmann wrote a wonderful new score that fitted perfectly with my animation.

The dance movements were to be modelled on those of a belly dancer and before I began work on the sequence I decided I needed to 'study' belly dancers in order to capture the essence of their art. This arduous piece of research involved me slogging round all the Los Angeles nightclubs I could find that were featuring belly dancers. Sometimes animators have to suffer for their art! Some years later, when I was on a holiday with my wife Diana in the Lebanon, we were walking down a Beirut street when I noticed a nightclub with a famous belly dancer (I can't remember her name)

appearing for one night only. So in we went and sat down to watch the act. She was extremely good (I was of course now an expert) but halfway through her performance smoke started to emerge from my jacket and I thought I was on fire. I turned around and discovered that a gentleman sitting behind me was smoking a hookah and that the smoke was travelling up the back of my jacket. As you can see, such research can sometimes be dangerous!

The roc is a gigantic two-headed bird, which we originally intended to introduce in a scene which would see it try to sink Sinbad's ship by dropping huge rocks on it. Later this idea was abandoned and replaced by a sequence in which Sinbad and his men fight the adult roc as she tries to take revenge for the killing of her chick after it has hatched from the egg. The creature was yet another irresistible subject; how could anyone resist creating and animating such a bird? I executed only one drawing for the sequence, which showed the chick being forcibly pulled from its egg by the sailors.

One of the first creatures I designed for the

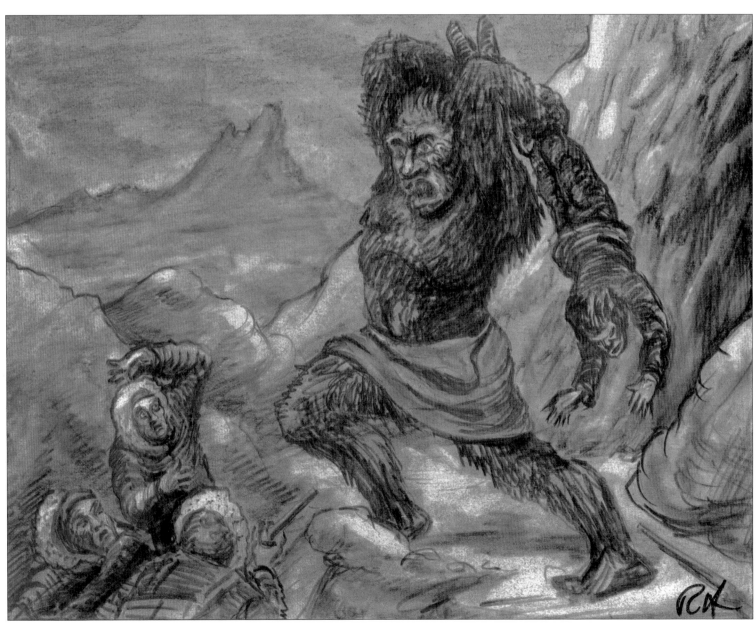

**Right.** Charcoal and pencil on illustration board. 14½" x 11½". c.1957. Key drawing for *The 7th Voyage of Sinbad*. Although this scene did reach the screen it was set on a mountainside not in a jungle as I depicted it here. The drawing, with its dark foreground, well lighted central action and dark, highlighted background, clearly shows the influence of Doré.

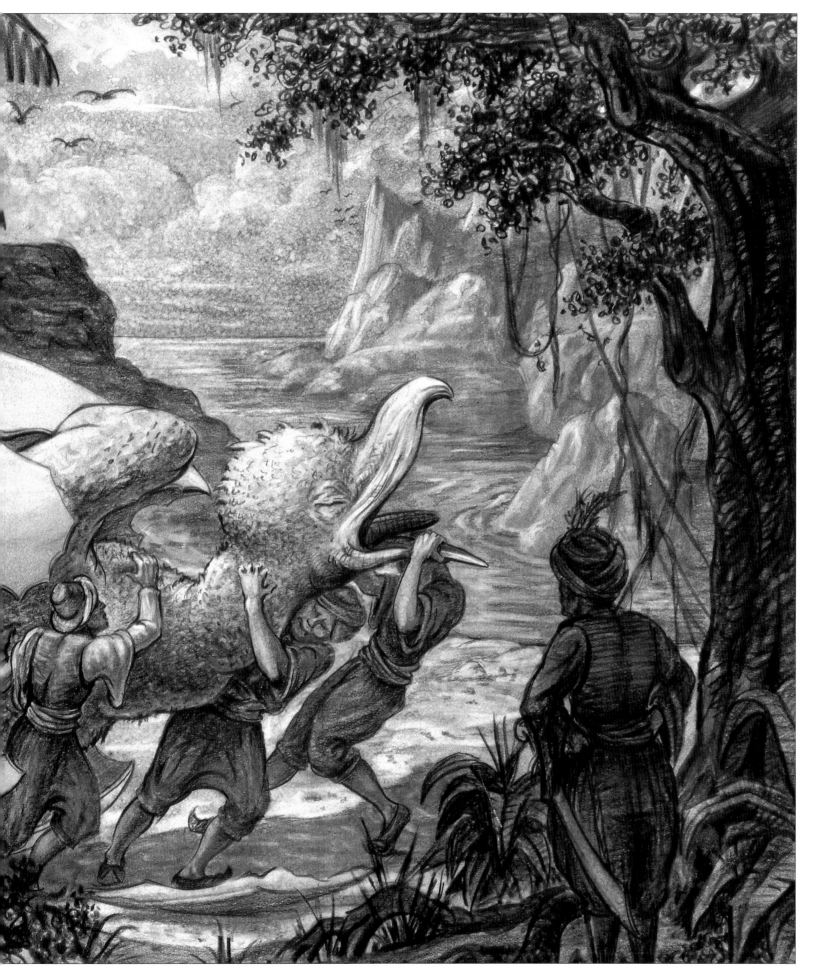

picture was a dragon, the guardian of Sokourah's castle. I had always wanted to animate a dragon, fiery breath and all. My key drawing of him shows the creature being slain by Sinbad, outside a huge cavern. Although it certainly owed something to Doré, my design for the dragon was also based on Far Eastern legends. He is primarily reptilian, with a touch of dinosaur (of course), twisted horns and a forked tongue. I gave him a scaly, reptilian skin and fire-breathing abilities, although I kept his use of this weapon to a minimum because it took time to matte in the fire. The only traditional dragon feature that he lacked was the ability to fly, which I decided was unnecessary because it would require too many changes to the story. Having him ground-based didn't diminish his power but did give him enough vulnerability to allow Sinbad to slay him.

Cinema history records that *The 7th Voyage of Sinbad* was a huge worldwide box-office success.

We had offered the public something so original that they flocked to it and, rather gratifyingly, it has stood the all-important test of time. Looking back now, it seems strange that sixteen years would elapse before we tackled the stories of Sinbad again.

Partly as a result of the lack of success of *The Valley of Gwangi* in the late 1960s, Charles and I considered that we had reached a point where it was perhaps time to return to Sinbad. What would become *The Golden Voyage of Sinbad* began life in 1971 as a rough step outline written by myself. It was from that outline, along with ideas contributed by the rest of the production team, that screenwriter Brian Clemens later developed the final script. Along the way however, as with all productions, there were many twists and turns as I conceived and rejected various different ideas before eventually arriving at a storyline that incorporated the right balance of situations and creatures.

Credit should go to Brian, and to all the other screenwriters we worked with, for bringing together all the various ideas that contributed to our complex fantasy productions. It is important to recognize that none of our pictures was intended to be merely a device for stringing together a series of effects sequences. The effects were important, of course, but we always attached equal importance to having a strong and coherent story. Because I would be developing effects ideas and the screenwriter would be trying to integrate them into the screenplay, it was imperative that we worked closely together, overseen by Charles, and sometimes the director. That's why a good screenwriter was so vital to our pictures. In this case Brian managed to deliver a script that was both credible and logical.

However, before I even began working on that first step outline I had already conceived an idea, which I called *King of the Geniis*, that manifested

**Above left.** Me with the original model of the baby roc for *The 7th Voyage of Sinbad*. c.1957.

**Above right.** Charcoal on art paper. 9″ x 6½″. c.1957. Sketch for the entrance to the centre of Colossa for *The 7th Voyage of Sinbad*.

**Left.** Charcoal and pencil on blue tinted paper. 9″ x 6¼″ c.1957. Sketch for Sokourah's underground castle for *The 7th Voyage of Sinbad*. As the concept of an *Arabian Nights* story was so original I wanted to make sure that I designed everything even though the miniatures were made in the studio. Note the spiral staircase on top of one of the towers; I presumably intended the skeleton fight to be higher up.

**Above right.** Animating the dragon on miniature set. Here I am working on the dragon during the filming of a sequence that showed him in his underground lair.

**Below right.** Sketch for the Dragon. Charcoal and pencil on art paper. 6″ x 4″. c.1957. Rough sketch for the dragon for *7th Voyage of Sinbad*.

**Following pages.** Charcoal and pencil on illustration board. 7″ x 11½″. c.1970. Key drawing for *King of the Geniis*. This scene would have been wonderful to animate with the snake twisting itself around a carnivorous dinosaur.

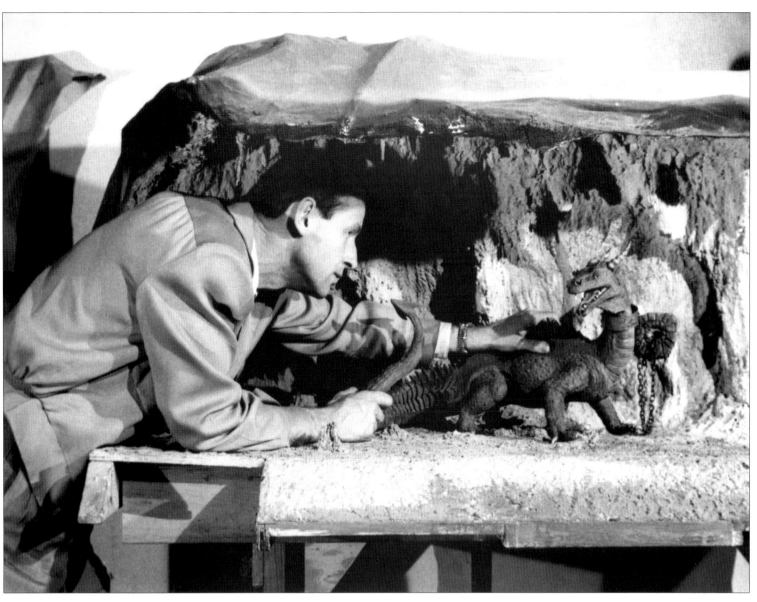

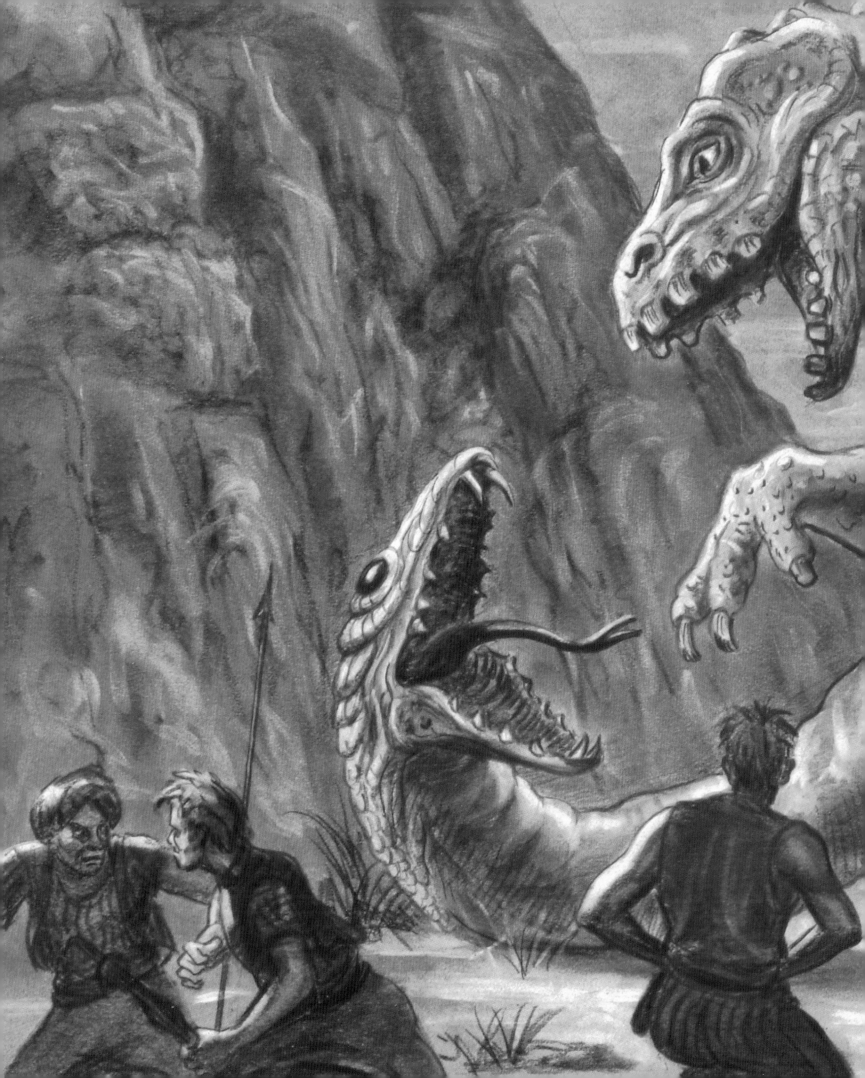

itself in a number of large key drawings. They were all charcoal and pencil renditions, the first of which was a 'poster' for *King of the Geniis*, which I hoped would provide a visual summary of the overall concept, which involved genies, centaurs and, not surprisingly, dinosaurs. This 'poster', although rather old-fashioned by today's standards (it was produced thirty-two years ago), features a hero and heroine, a bald-headed, Spock-eared genie, a centaur and a charging styracosaurus. To accompany it, and to promote the idea of a movie incorporating both Sinbad and dinosaurs, I made three other large key drawings. These would suggest that Sinbad was to have found a lost continent (probably Lemuria), inhabited by dinosaurs and a bestiary of weird, mythological creatures. One of these drawings showed a styracosaurus again, this time facing off against a ceratosaurus against a background which featured temples based upon Indian and/or

Cambodian models – they certainly owed something to the ruins of Angkor Wat in north-western Cambodia (see Chapter 6). Another showed the styracosaurus attacking an encampment; and the third showed a dinosaur-like creature fighting a huge snake which is wrapped around the dinosaur's body (this may have been set in an early version of what would become known as the Valley of the Vipers). This last dinosaur was not based on any known species; like the rhedosaurus in *The Beast From 20,000 Fathoms*, I made it up, so perhaps it should be called a 'harrysaurus'. As will have become clear to readers of this book, I was always keen, when working out new stories and concepts, to find a place for dinosaurs, and a Sinbad story about a journey to a lost continent seemed a perfect opportunity to create a 'lost world' where they could happily exist. But, perhaps because of the failure of *Gwangi*, or maybe because the story

never really came together in a way that could have included dinosaurs, the ideas contained in the four drawings never found their way into *The Golden Voyage of Sinbad*.

Whilst the screenplay was being developed I executed a further twelve key drawings of sequences for the project. These included the fight with Kali; Kali dancing; the creation of the homunculus; the fight between the gryphon and the centaur; the centaur attacking Sinbad; the Oracle of All Knowledge; and the Fountain of Destiny. In addition I executed designs for the vizier's golden mask, the gryphon and the figurehead. There were, inevitably, other concept drawings that didn't find their way into the screenplay; these included a fight between a cyclops and a centaur; the Valley of the Vipers, and a giant fighting a cyclopean centaur (the giant fell out and I suspect he was reincarnated as Trog in *Sinbad and the Eye of the Tiger*). Finally,

**Above.** Charcoal and pencil on illustration board. 19" x 13". c.1970. Drawing for a poster for unrealized project *King of the Geniis*. On occasions I would draw a possible poster (none were ever actually used as posters) in order to try and distil the essence of the concept for a film. In this case the project concerned was an early idea for

what would eventually become *The Golden Voyage of Sinbad*, but without the genie and the dinosaurs, which left me with almost nothing to work with so far as the poster was concerned.

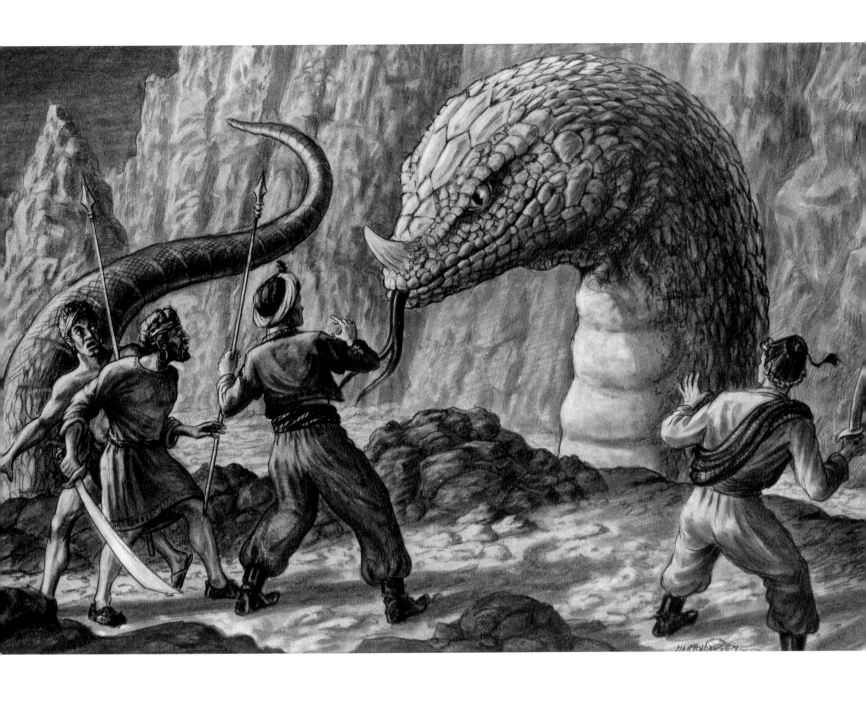

**Above.** Charcoal and pencil on illustration board. 19" x 12 ½". c.1971. Key drawing of The Valley of the Vipers for *The Golden Voyage of Sinbad*. This drawing is very much influenced by Doré. It shows a scene that was dropped from the screenplay just before production.

**Following pages.** Charcoal and pencil on illustration board. 18½" x 12". c.1971. Key drawing of the Fountain of Destiny for *The Golden Voyage of Sinbad*. The concept for the Fountain of Destiny sequence remained very much as I had depicted it in this drawing. Various influences are evident, including those of Doré and John Martin.

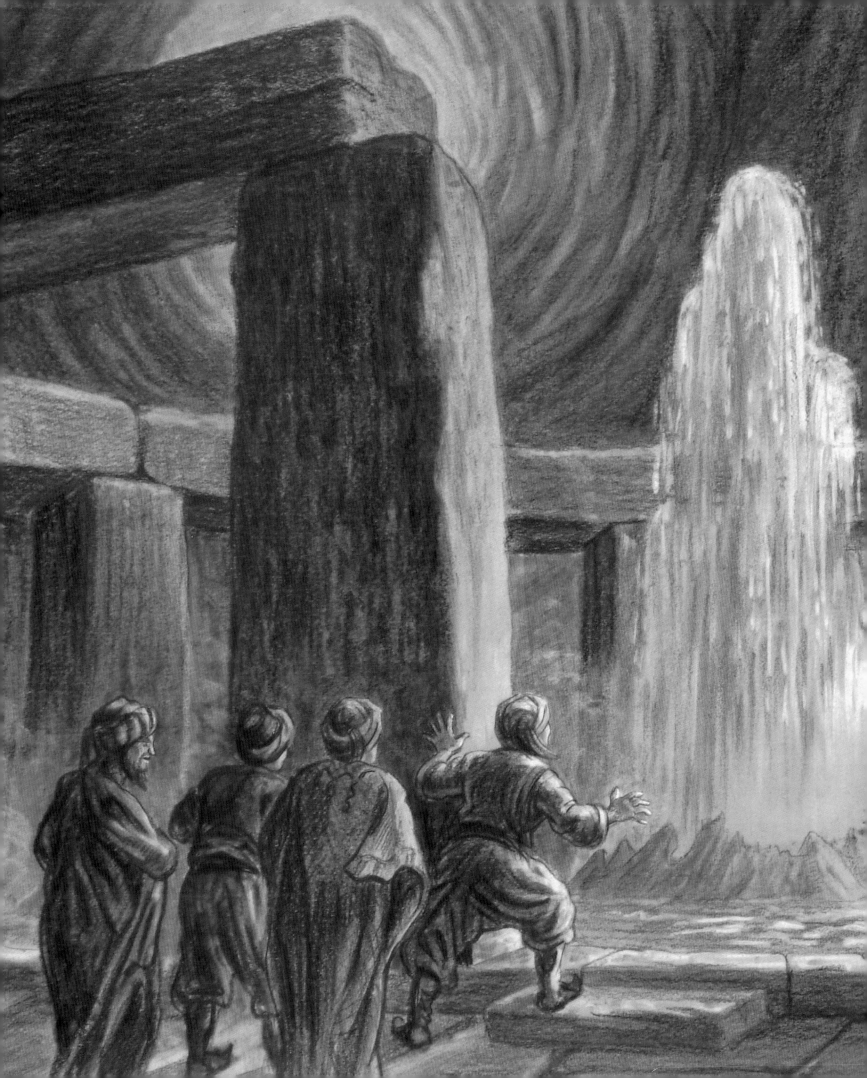

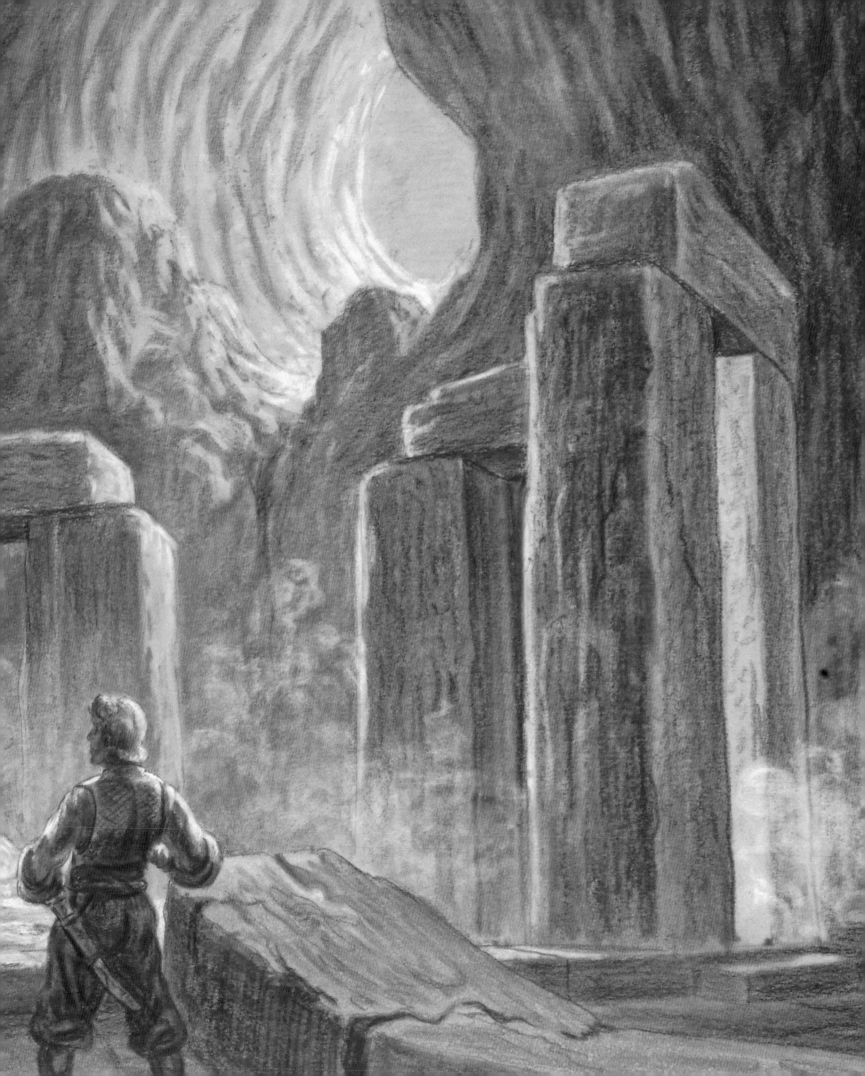

**Right.** Charcoal, pencil and watercolour on illustration board. 19" x 12½". c.1971. Key drawing for cyclops for *The Golden Voyage of Sinbad*. This was an early idea for the beast that lived below the temple of the Green Men. Originally I had envisioned him as a cyclops but he looked too much like a man in a rubber suit. Later of course he was changed to a cyclopean centaur.

**Following pages.** Charcoal, pencil and watercolour on illustration board. 19" x 12½". c.1971. Key drawing for an attack by the cyclopean centaur for *The Golden Voyage of Sinbad*; the scene was never incorporated into the film.

there was also a watercolour drawing of a cyclops (when he was a plain old cyclops) in the mouth of a cave. Because we thought he was too much like the cyclops in *The 7th Voyage*, and also resembled a Greek wrestler in costume, I changed him to the more exotic cyclopean centaur. When the screenplay was finalized I then sketched and compiled a number of storyboards that detailed the complex effects for each key sequence.

I have a favourite in every film, and in *The Golden Voyage of Sinbad* it was the homunculus. I was taken by the idea that a magician could make a being to do his bidding, and had always wanted to animate such a creature. Indeed, I had tried to have a homunculus included in *The Three Worlds of Gulliver*, though for some reason it fell by the wayside during script conferences. But the idea of a tiny being created by a magician to serve as his eyes and ears seemed to fit into the storyline

for *The Golden Voyage of Sinbad* extremely well, certainly better than the clichéd crystal ball. So I resurrected the original *Gulliver* drawing and made a new one, this time redesigning the creature so that he became even more grotesque, with a humanoid torso and head, a reptilian or dinosaur-like tail, three-digit hands and feet and bat wings. Once again, when it came to constructing the actual model, I changed him by giving him a shorter tail and a pointed skull and ears, which I believe adds to his fiendish appearance.

The first of Koura's homunculi in the film is destroyed by Sinbad in the vizier's vault. His successor (it was of course exactly the same model) is shown being brought to life by the magician and this sequence is one of my favourites. It turned out to be very enjoyable to animate: there is a particular irony because it shows the creation of an artificial life by a magician, but, of course, behind the hand

of the magician is the hand of the animator. The homunculus wasn't really evil in himself, just the tool of Koura, and I couldn't help feeling sorry for him, as I did for *King Kong*. I always see Kong as the true twentieth-century homunculus because he was created artificially, although not in his case by occult means but by stop-motion photography.

In my career I have brought to life a number of inanimate creations: there were the cigarettes in the Lucky Strike commercial, Kenny Key, Talos in *Jason*, the Minaton in *Sinbad and the Eye of the Tiger* and another two in *The Golden Voyage of Sinbad*. The first was the ship's figurehead, or siren, and the second was the statue of Kali. The figurehead was a late addition to the film, and something of an anachronism; an Arabian ship would not have had a figurehead, but we created her as a device to allow Koura to steal the map to the island of Lemuria. She was designed to appear as a

**Above.** Charcoal and pencil on illustration board. 19″ x 13″. c.1971. Key drawing of a fight between a neanderthal man and a cyclopean centaur for *The Golden Voyage of Sinbad*. The scene was never included in the film and I suspect I resurrected the neanderthal man for *Sinbad and the Eye of the Tiger*.

**Right.** Pencil on art paper. 20″ x 12″. c.1971. Unfinished sketch of a snake creature for *The Golden Voyage of Sinbad*. I can't remember why I thought him up but he might have had something to do with the unrealized Valley of the Vipers.

kneeling figurehead, pointing ahead of the ship's prow but situated on the deck to allow her easy access to fight the sailors. The pose, I felt, was very dramatic and when she comes to life, the dropping of the arm is very frightening. Her 'hair' stood up almost vertically (loosely based on Elsa Lancaster's make-up in *The Bride of Frankenstein*) to emphasize her fierce features. I must confess that I don't believe I would have boarded a ship which had her on its bow.

We had originally planned to film most of the picture in India, but later dropped the idea for a number of reasons, mainly financial. But as I had already planned and constructed sets for Lemuria that included Indian architecture and temples, we decided not to change the setting. The exterior and interior of the Temple of the Green Men, including the statue of Kali, are almost purely Indian in origin. Kali is yet another of those creations that I

had wanted to 'bring to life' because a statue that possessed multiple arms, all holding lethal swords, was both a perfect stop-motion character and a worthy opponent for Sinbad. In Indian legend Kali, the wife of the god Siva, is the goddess of destruction. I combined her with another terrifying Indian deity, Durga, who is traditionally portrayed with eight or ten arms. In the end I dressed my Kali in a traditional Indian costume, with head-dress, Indian kilt and a row of skulls around her waist, and I reduced her eight or ten arms to six.

There are two other creatures in the film: the cyclopean centaur and the gryphon, the first of which represented evil and the second good. Originally, as I have mentioned, I had come up with the idea of a club-wielding cyclops but this seemed mundane, so I decided to combine him with a centaur (a mythological creature with the head, arms, and torso of a man joined to the body

and legs of a horse), giving me a cyclopean centaur. It gave me the best of both worlds and it also sounded good. The griffin, or gryphon as I choose to call him, is the guardian of the Fountain of Destiny and his traditional incarnation, with a lion's body and an eagle's head and wings, is a heraldic symbol of strength and vigilance. Originally in the script he was to have come to life from a statue but there was not time to animate all that, so he just appears, which to me is extremely disappointing – having him come to life to defend the side of good would have been so much more dramatic in cinematic terms. I designed and constructed the gryphon to be as realistic a beast as possible, with wings in proportion to his body that could credibly have supported his weight in flight. But when it came to the animation I decided he would stay on the ground for two reasons: firstly because no matter how I modified the design he still looked

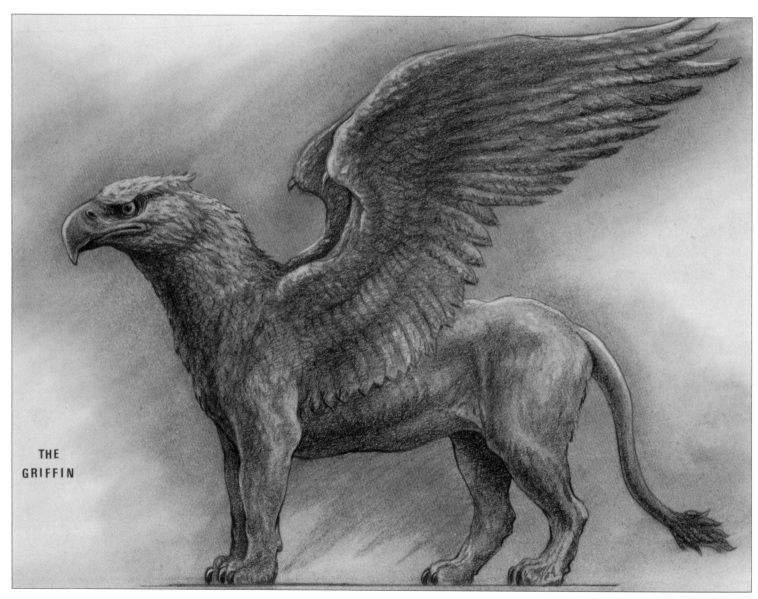

THE GRIFFIN

**Above.** Charcoal and pencil on illustration board. 19" x 12½". c.1972. Concept drawing for the gryphon, or griffin, for *The Golden Voyage of Sinbad*. I was always very pleased with this creation but sadly his appearance in the film was all too short.

**Right.** Latex body with an internal metal armature. 13½" (h) x 3" (d) x 6" (w). c.1972. Original figurehead, model for *The Golden Voyage of Sinbad*. The figurehead or siren, was a very easy design.

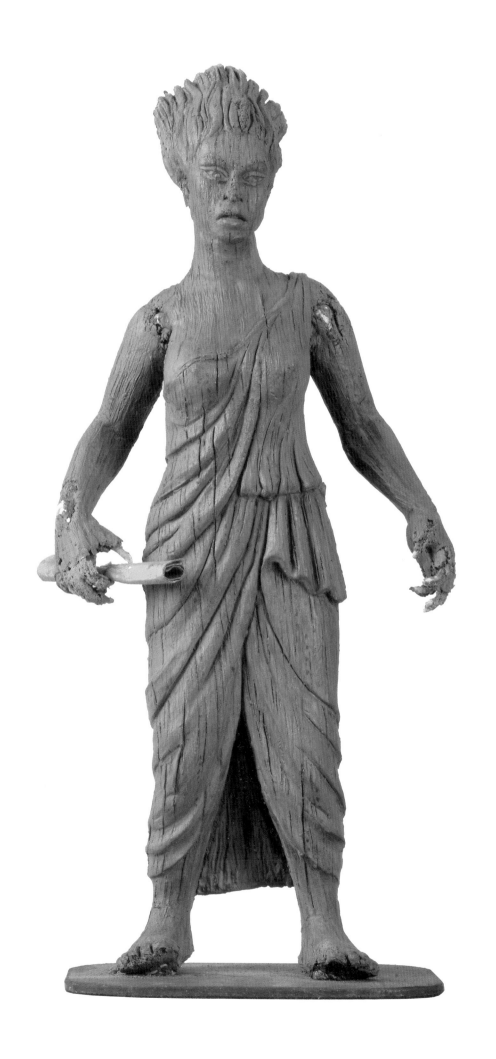

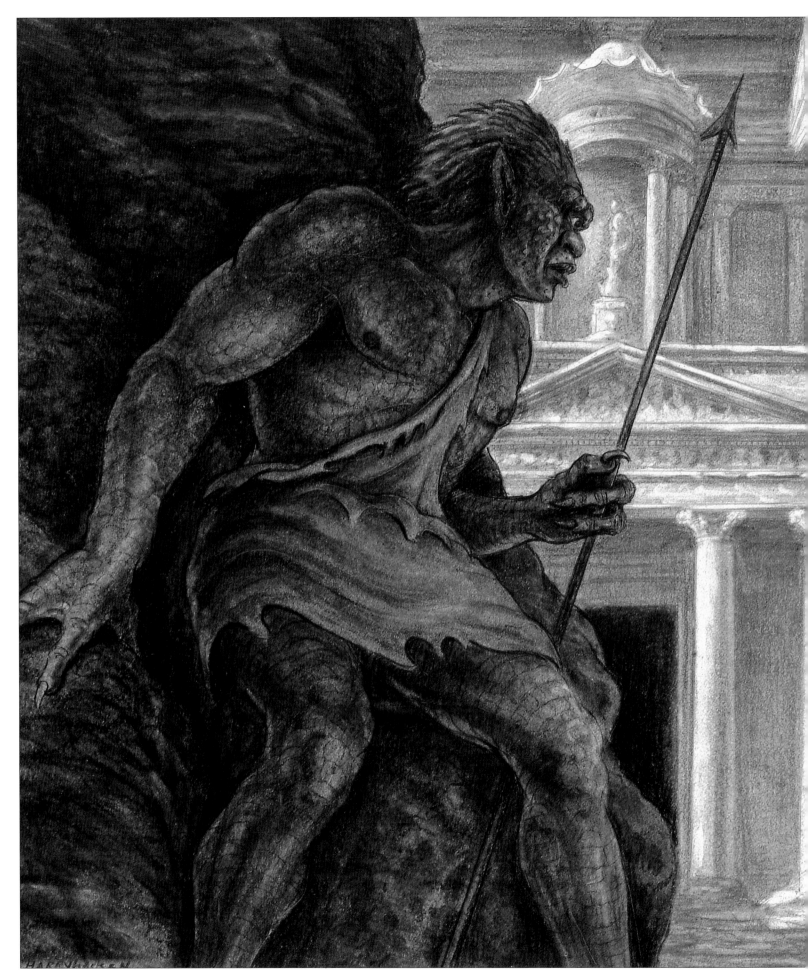

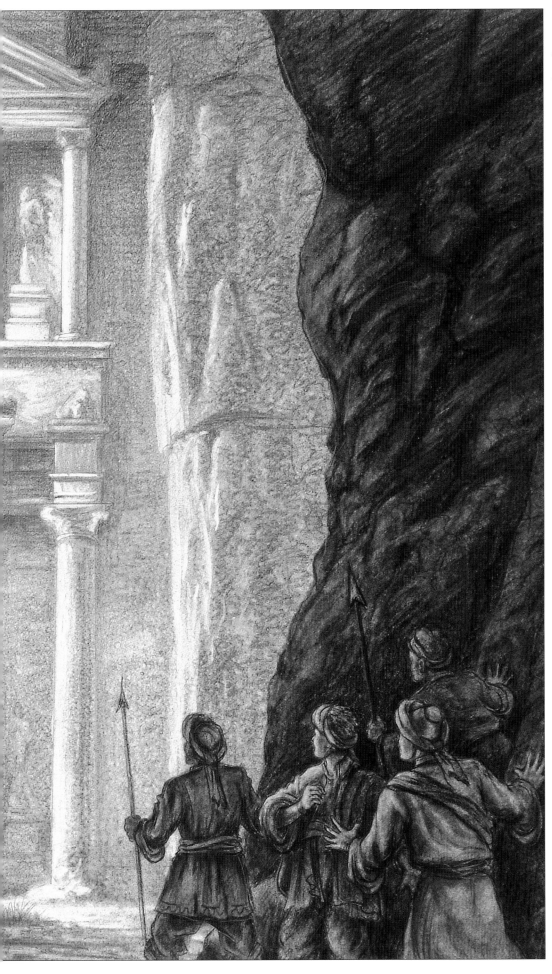

**Left.** Charcoal and pencil on illustration board. 19" x 12". c.1974. Key drawing of Trog for *Sinbad and the Eye of the Tiger*. Sadly, this scene, in which Trog would have guarded the secrets of what we know as the ancient city of Petra, does not appear in the final film. The influence of Doré is again very strong, especially in the contrast between the shadowed foreground and the highlighted temple in the background.

lumpy and awkward in the air, and secondly because it would save on animation time.

*The Golden Voyage of Sinbad* re-established our credibility at the box-office and it was another of those landmarks in my career when all the concepts and lots of hard work come together to make a good fantasy adventure. Although it was never meant to be a sequel to *The 7th Voyage of Sinbad* it was a worthy successor to the film that had begun it all.

Sometimes, no matter how good the effects, or how much planning, preparation and originality you try to put into them, the rest of the film is not up to scratch, and ends up seeming tired and uninspiring. Sadly, this was the case with our next Sinbad excursion.

In the light of the success of *The Golden Voyage of Sinbad*, it was decided to make another Sinbad adventure called *Sinbad and the Eye of the Tiger*, incorporating some of the unused ideas from my step outline. The picture had several faults, many of which were a consequence of the fact that it was put together too quickly; even so, from my own point of view I am generally proud of the designs and creatures it contains.

In order to differentiate the new movie from *Golden Voyage*, we started by making the adversary an evil witch instead of a wizard or sorcerer. On the effects front, I did manage to come up with a number of interesting and original creations, including three ghouls, an intelligent baboon, a minaton (mechanical man), a giant walrus, a giant troglodyte and a sabre-toothed tiger. Creatures and sequences dropped from the final script were the Valley of Vipers (again), a worm creature and a prehistoric arsinotherium. Because of the tight schedule I didn't make many key drawings, only enough to sell the picture to Columbia. These drawings included the gateway to Hyperborea, an early design for the pyramid, which was half-Indian, half-Mayan, the troglodyte at the entrance to Petra, and a complete set of storyboards for the effects sequences.

Originally, the troglodyte, or Trog as he became known, was to have been a Neanderthal man. To my regret there are no sketches or drawings, but what has just come to light in the darkest recesses of my cellar is a solid latex model of a Neanderthal, fully clothed in a fur costume and painted. I must confess that although my original outline mentions him I had forgotten that I had gone as far as making a mould and model of him. But there he stands in all his glory for the first time. I think he must be the only one of my models – albeit a solid latex one – that has never been seen before. Why he was replaced by Trog I can't really remember, but my vague recollection is that I felt that he was not unusual or dramatic enough, and that audiences might assume he was simply an actor in a monkey suit. In fact, there was a point during the early stages of production – presumably before the Neanderthal came on the scene – when we actually did consider using a man in heavy make-up. In the end we decided that the creature had to be an animated model because animation gives a creature the strange quality we are always striving for, the fantasy effect that the first *King Kong* had.

In any event I changed him into a troglodyte man, and gave him a more brutish appearance with an added extra in the form of a horn in the centre of his head. Because I wanted the Trog model to be used for close-ups I gave him a more complex armature and facial wires, which allowed me to animate his facial reactions to the actors, and a very finely detailed skin texture. I achieved the latter effect by making a separate skin, detailing folds and blemishes and even veins in the hands, all of which gave him a rather ancient look. I then made a mould of the skin and from that cast the latex skin, which I stretched it over the armatured model. This prevented him from looking like a rubber doll, which can sometimes happen if the models are cast straight from the mould.

The three nasty ghouls, created by Zenobia's sorcery and summoned from hell by her at the beginning

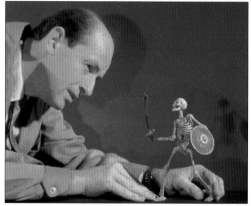

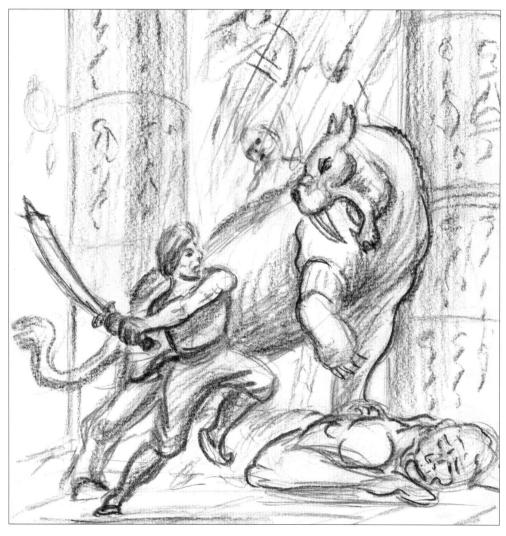

**Above.** Me with the original skeleton model seen in *The 7th Voyage of Sinbad.* c.1957.

**Left.** Charcoal and pencil on art paper. 10" x 8". c.1974. Rough sketch of Sinbad attacking the tiger after he has killed Trog for *Sinbad and the Eye of the Tiger*. This was a very rough sketch for the end sequence where Sinbad kills the tiger but in the end it was changed so that he killed the beast with a spear.

**Left.** Pen on tinted paper. 11" x 8¼". c.1974. Three pages of story boards for *Sinbad and the Eye of the Tiger*. The top storyboard shows the conjuring of the zomboids from the fire by Zenobia. The bottom two show the unrealized sequence showing a Neanderthal man as he struggles in a tar pit.

**Below.** Latex body with an internal metal armature. 16" (h) x 4" (d) x 9" (w). c.1975. Original model of the minaton for *Sinbad and the Eye of the Tiger*.

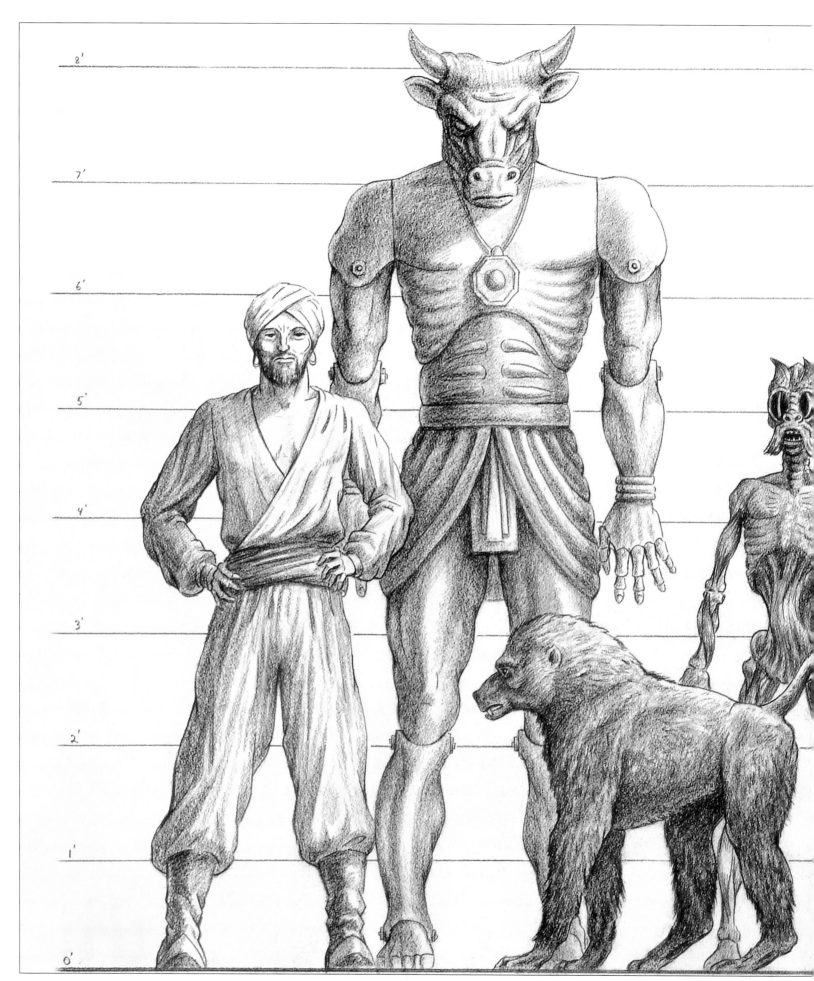

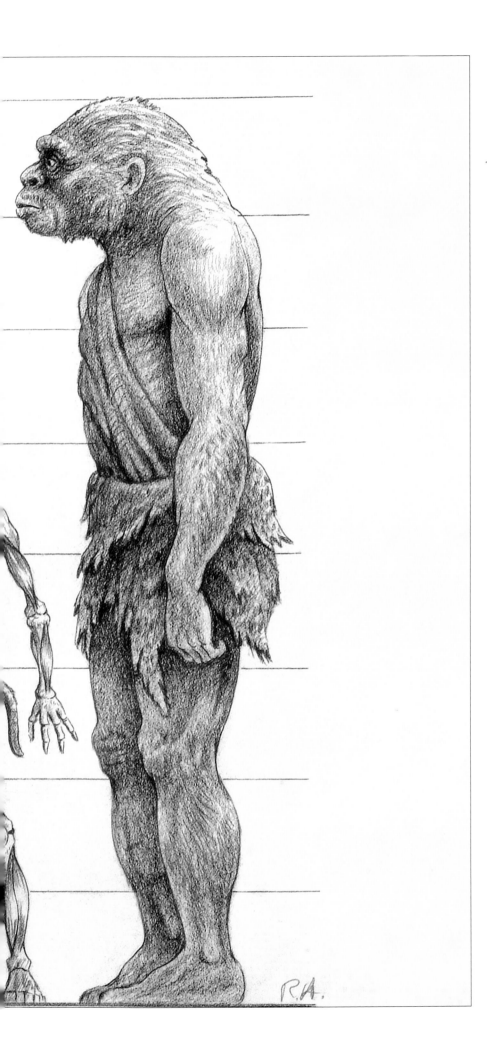

**Left**. Charcoal and pencil on illustration board. 23" x 19". 1975. A detailed comparison drawing of all the creatures that would appear in *Sinbad and the Eye of the Tiger*. It was always useful to design it like a 'usual suspects' line-up, as this made it easy to compare the heights.

R.A.

of the picture, were based on an illustration of a human body with its skin removed, revealing the muscles beneath. I decided that this would make a wonderful basis for these half-dead, half-living beings. To give them an even more evil look I added horns (an old favourite of mine when depicting evil) and bug eyes, which also made them look as if their skin had been peeled back from their eyes.

When *Sinbad and the Eye of the Tiger* was released it was a financial success but it lacked the quality of *Golden Voyage*, and looking at it now I have to say that it remains the least satisfying of the three Sinbad movies.

That isn't quite the end of the Sinbad saga, as there were plans to make two other Sinbad movies. Both had possibilities, but the first project, which had a working title of *Sinbad Goes to Mars*, floundered because we were unable to come up with a credible screenplay for the second half of the proposed story. In fact, looking back now, it occurs to me that the idea was our way of trying to take advantage of the resurgence of interest in science-fiction films. Perhaps if it had been made we would have had to make compromises, diluting our concept of fantasy films based on legend in order to achieve box-office success. The other idea, which

held much greater promise, was tentatively called *Sinbad and the Seven Wonders of the World*. It would have required no compromises on our part and would have seen Sinbad make another voyage, seeking out clues to the whereabouts of a fabulous treasure in the seven wonders of the ancient world. Sadly, it was not to be.

**Left.** Latex body with an internal metal armature. 10″ (h) x 2″ (d) x 4″ (w). c. 1975. Two of the three ghouls that appeared in *Sinbad and the Eye of the Tiger.* In close up they look even more ghoulish!

**Right.** Hard latex body. 15″(h) x 9½″(w). c.1975. Model of Neanderthal man originally intended for *Sinbad and the Eye of the Tiger.* This was the predecessor of Trog. There was never an armatured model. This is simply a hard latex model painted and 'dressed'. In the end I decided he just wasn't imaginative enough.

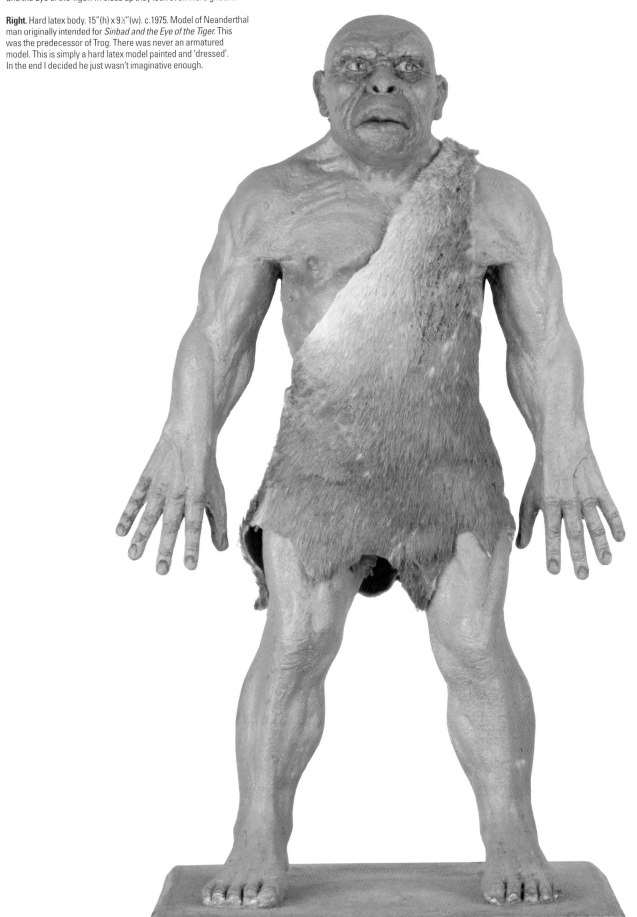

# CHAPTER 10　OTHER ADVENTURES

**Previous page.** Charcoal and pencil on illustration board. 17½" x 11½". c.1960. Key drawing of the discovery of the damaged submarine *Nautilus* for *Mysterious Island*.

**Above.** Oil on canvas. 16" x 12". c.1948. I painted two pictures for my unrealized project *The Adventures of Baron Munchausen*. In this one the Baron, who is riding a penny farthing in a lunar landscape, is being pursued by a three-headed eagle. The other picture depicted the Baron standing on a lunar hill and looking up at the huge silhouette of the Earth.

WHEN WE DECIDED THAT THE CHAPTERS IN THIS BOOK SHOULD REFLECT THE THEMES OF MY WORK, we knew that not everything would fit easily under the headings we had chosen. We naturally wanted to include all the films that I worked on and as many of the unrealized projects as we could, to make this book a true representation of my work. In the event we had seven titles left over, three of which matured into completed features and four of which were, to my regret, never made.

Baron Munchausen and Gulliver's Travels are wonderful flights of literary fantasy, both coincidentally based on eighteenth-century novels. *R.U.R.*, *Food of the Gods* and *It Came From Beneath the Sea* would have certainly fallen into the science-fiction category had we not decided to restrict that chapter to alien beings rather than the entire science-fiction genre. Similarly, although our version of *Mysterious Island* certainly featured dinosaurs, it also trespassed into other genres such as castaway adventures and period science fiction, and so did not qualify for inclusion in Chapter 6. Finally, the 1933 film *Deluge*, which I tried to remake, didn't fit into any of our chosen categories, and this remains the only true disaster film I ever considered.

I first became aware of Baron Munchausen in 1937, when I saw Gustave Doré's atmospheric illustrations for the tales. Although there was a real Baron who was reputed to have been somewhat outrageous with his storytelling, the stories as we know them were committed to paper by Rudolph Erich Raspe in 1792. When I read them I found that they appealed to me, partly because Raspe's Munchausen was such a great prevaricator and fantasist, but also because the adventures he described were so outrageous that I felt they would be a perfect subject for stop-motion model animation. But at that point in my career I didn't pursue the possibilities and it wasn't until 1949-50 that I decided to try to make them work as a series of shorts for animation and set about producing step outlines for what I called *The Adventures of Baron Munchausen*. Movies based on the stories had been made in the past, most notably the 1943 German version with Hans Alber in the title role, but, as with mythology, legends and other fantasy fiction, much had been made of the man and his antics, but little of the fantasy.

The first of my proposed series was to have been based on the Baron's trip to the moon. To begin with I made a plaster model of the character, based on Doré's conception of him as a rather arrogant fellow, dressed in eighteenth-century costume and holding a long cane. This model helped me refine the design for the animated model and construct a suitable set of storyboards. In addition I also executed two oil paintings of the Baron on the moon. I can't remember why I used oils but it was probably another instance of my experimentation with different illustrative mediums. One painting shows the Baron standing on a cliff overlooking the lunar landscape with the huge globe of the Earth in the background. The other shows the Baron being chased on a penny-farthing bike across the lunar landscape, by a three-headed eagle silhouetted against the backdrop of the Earth.

One of the first things I had to consider was sound and how the stories would be narrated. I realized that I would not be able to use captions or dialogue title cards as I had done with *The Mother Goose Stories* as they simply were not sophisticated enough, and I also felt that a voice-over wouldn't work either. This film needed proper dialogue, allowing the characters to speak to each other. Having decided that, I then had to decide how I was going to make it work. I first of all considered using the replacement head technique (a separate head is made for each expression or lip movement) which I had used for the George Pal *Puppetoon* series in 1940-42, but I never liked the process as it always looked unnatural and mechanical. In the end I decided that I would experiment with making models with faces that could be animated in stop-motion to simulate speech. The task of animating two models talking to each other, especially when I had minimum resources, was an extremely ambitious enterprise; but I tried and, to an extent, succeeded.

I designed a scene for a test to be shot on 16mm colour stock. It showed the Baron being discovered in a cheese by the giant in a 'Moon Cheese Factory' and the ensuing conversation between the two of them. Using the build-up method, I constructed an armatured model of the Baron and another one of the giant's face and upper torso, which was far more elaborate than the first. The head was about six inches high but when it was rear projected (in this case, animated footage would be shot and then projected on a screen at the rear of the animation table) the image was enlarged so that it appeared many times bigger than the Baron in the foreground. It was constructed over a very complex arrangement of armatures, levers and wires, which were controlled from the back of the head (which was missing and never seen by the camera). This

arrangement allowed me to move his face slightly, hold that position and then shoot a frame of film. There was no recorded dialogue; I just animated the features to simulate the movements associated with speech. The Baron Munchausen model, which has its back to the camera all the time, was about six inches high. This was placed and animated in front of the image of the giant's head on the rear projection screen but at that stage it was only meant to react to the giant, not to speak with him. It was the giant that was the experiment. To say that it was laborious work would be an understatement, and although the test proved that the technique was feasible, I realized when I finished the weeks of work necessary to complete a single scene that the idea was impractical. I had to remind myself that I was looking for ways to make model stop-motion animation more viable, not more expensive. Sadly I don't know what happened to the giant's head. It

must have rotted and been thrown away. Such was the fate of so many of my actors.

Between 1945 and 1947, I spent a lot of time dreaming up ideas and designing backgrounds for a project based on the 1921 play *R.U.R.* (or Russom's Universal Robots) by the famous Czech author Karel Capek. My interest began just after the war, when I discovered a book about the play in the New York Public Library which led me to do some further research into Capek and the idea of robots. Capek coined the word 'robot' specially for the play, which is set in the future in a society where an entrepreneur called Russom is producing robots to replace human workers in a range of menial tasks. As in many of the later robot stories, Russom's machines develop minds of their own and rebel against their master, ultimately destroying him and human society. It was of course the concept of a mechanical humanoid creation that interested me,

for, as I would demonstrate with Talos, Kali and the Minaton, a 'mechanical man' could be an ideal subject for stop-motion animation.

I set about producing a drawing and a part storyboard and began writing a rough outline for the project. The outline doesn't exist today but the drawing and sketches do. The unfinished charcoal drawing shows lines of male robots waiting to be completed by their inventor, who is about to fit a robotic arm on to the first in line. The storyboards take the story on to the beginning of the rebellion, when the robots begin to methodically destroy their human masters. I believe the concept would have made a good film at that time, though now the basic storyline has become something of a cliché.

As I have already mentioned, I am a huge fan of the novels of H.G. Wells. Aside from his wonderful vision of a *War of the Worlds*, a subject that would haunt me throughout my professional career, I also

**Left.** Charcoal on art paper. 11" x 9". c.1945. A very rough sketch for the robots for *R.U.R.* showing the height I had originally imagined for them. I must have soon decided they were just too large, but the idea would resurrect itself again for Talos in *Jason and the Argonauts.*

**Above.** Charcoal and pencil on illustration board. 14" x 11". c.1945.
An unfinished key drawing for the unrealized *R.U.R.* This drawing
was finally 'fixed' – i.e. liquid sealant was applied to prevent the
charcoal or pencil from smudging – after years unfixed.

considered Wells's 1903 story *Food of the Gods*. This is a Utopian tale about a strange substance that causes whoever, or whatever, eats it to grow to an enormous size – an idea that I found irresistible and which set me to thinking about the possibilities of giant wasps, rats and farmyard animals as well as human beings.

The idea of making it into a film first came up in 1950 (at about the same time as *Valley of the Mist*) when Merian C. Cooper, the producer of *King Kong*, bought an option on the story from the Wells estate and asked Obie to head the technical effects for the project. Obie in turn asked me to work with him as his assistant. Whether Obie made any drawings I really don't know, but at the time I made a very crude sketch of a giant wasp with a group of military men pointing a gun at it. In the end nothing came of Cooper's project, but much later, in the early 1960s, I suggested to my producer,

Charles Schneer, that we might revive the idea and showed him my second piece of artwork for the original project. This is a watercolour charcoal drawing of giant chickens (and, if you look closely, one chick), towering above buildings in a very English village. Sadly, like so many other good ideas, the project progressed no further, in this case because someone else had acquired the rights from the Wells estate.

It was in 1954 that I was introduced to Charles Schneer and made my first film with him. He had the idea of making a feature about a giant octopus attacking San Francisco and, after seeing *The Beast From 20,000 Fathoms*, believed I was the man to create and deliver the special effects. The resulting film became known as *It Came From Beneath the Sea* and marked another of those turning points in my life and career, for Charles and I went on to make twelve pictures together. Overall, ours was a

good and constructive working relationship; Charles understood what I was capable of delivering and how I needed to work.

The story of *It Came From Beneath the Sea* was pure science fiction, featuring an octopus that somehow grows to an enormous size after a US undersea nuclear explosion. The major set pieces showed the creature pulling itself up the Golden Gate Bridge, wrapping itself around the Embarcadero building and generally causing mayhem by destroying much of the city and killing many of its unfortunate inhabitants. Although I didn't make any large key drawings for the production I did produce a large number of very rough effects sequence storyboards, or continuity drawings, sketches on photographic paper, a large drawing of the octopus and, using location stills of the Golden Gate, drawings showing how I planned to have the octopus pull itself up the piers of the bridge.

**Above.** Charcoal, pencil and watercolour on illustration board. 19" x 12½". 1961. I always hoped that Charles and I could have made a film of H.G. Wells' story *The Food of the Gods* but it was not to be. Notice the little, or not so little, chick wedged between the church and the next building.

**Right.** Both painted on photographs of locations. c.1954. Each 7" x 5". Two sketches of the octopus attacking the Golden Gate Bridge and running rampant in the streets of San Francisco for *It Came From Beneath the Sea*. These are good example of using location photographs as the basis for storyboard frames.

When Charles and I went to see Columbia executive producer Sam Katzman, to get approval for the production, I showed him the large drawing of the octopus, along with some of the continuity boards. I recall Katzman telling me that my drawing of the octopus was all wrong. I was surprised at this, since I had spent many hours at the Long Beach Aquarium, studying these strange creatures and making sketches and drawings; but Katzman was the exec producer so I meekly asked what was wrong with it. He said that the sac was wrongly positioned: it should be standing up not lying back behind its eyes. I just looked at him and then suddenly realized where he had got this mistaken idea from – the octopus in some of the Popeye cartoon shorts always had the sac standing straight up. I quickly sketched out the cartoon octopus and diplomatically pointed out that it did not reflect the real creature.

There was one complete model of the creature – complete that is apart from the fact that it had only six tentacles (to cut down on animation time) and not the usual eight. To disguise this shortage of appendages, I designed the entire range of effects where the octopus is seen on screen so that the audience would only see a few of the tentacles at any one time. In addition to the main animation model there were three other, larger armatured tentacles of various sizes that were used for sequences such as when the octopus pushes one of its tentacles up through the bridge and the destruction of the Oakland Ferry Gate. Because I needed more detail in these close-up sequences I required larger and more finely textured models. Aside from the usual restrictions of time and money, the picture was a pleasure to work on and was, I am glad to say, a box-office success.

After Charles and I made *The 7th Voyage of*

*Sinbad*, Columbia recommended that we look at a script based on Jonathan Swift's *Gulliver's Travels* that had been brought into the studio by Jack Sher and Arthur Ross. The film based on this script, which became *The 3 Worlds of Gulliver*, was something of a departure for us. Because we had not developed the screenplay ourselves it meant that the effects were 'added on' to the storyline rather than being 'built in' as the project was developed. As a result, although we were able to add a few items of our own, *The 3 Worlds of Gulliver* was a film with just two animation sequences: the squirrel sequence and Gulliver's fight with the alligator. I made only one large key drawing for this project, which shows a magician creating a very devilish-looking homunculus to fight Gulliver. The idea was never used in the final film, although it did find its way, in part, into *The Golden Voyage of Sinbad*. In the end we replaced the sequence with

**Above.** Charcoal and pencil on art paper. 6″ x 5″. c.1954. This is one of a number of quick sketches I made to try to visualize the demise of the giant octopus. In the end it was never used and the creature dies at sea.

**Left.** Charcoal and pencil on art paper. 11″ x 8″. c.1954. Two rough sketches of the giant octopus attacking the men who survived the sinking of their vessel for *It Came From Beneath the Sea*. The scene was never realized in the final film.

**Above.** Wood and wire miniature. 14"(h) x 4"(d) x 23"(w). c.1954. The original miniature of the Oakland ferry gate, which is destroyed by the giant tentacle of the octopus. Two views of the miniature with the lower one (the back view) revealing how I animated the destruction of the gate. It is now restored to its original shape but you can still just make out the individual blocks, and in some cases the wires, which would be animated as the model tentacle pushes through the aperture.

**Above.** Charcoal and pencil on illustration board. 17" x 11.5". c.1958. Key drawing for an unrealized scene in *The 3 Worlds of Gulliver*. This was for a scene, later dropped, in which a nasty magician would have created a homunculus. The homunculus is much more diabolical than the one I would eventually create for *The Golden Voyage of Sinbad*.

**Left.** Pencil on paper. 16½" x 11". c.1958. Comparison drawing for *The 3 Worlds of Gulliver*. One of the few large drawings I did for this project, all of which are featured in this book. Here I sketched out Gulliver compared with a Lilliputian and with Glumdalclitch, a young Brobdingnagian girl. This kind of drawing was invaluable because of the large amount of perspective photography involved in the production.

**Right.** Charcoal and pen on tinted paper. 8" x 5½". c.1958. Rough sketch of Gulliver on the back of a giant rat for *The 3 Worlds of Gulliver*. This was an early idea for Gulliver's fight near the end of the film. In the final screenplay the rat became an alligator, I suspect because Charles had almost as great an aversion to rats as to snakes.

the one showing the fight between Gulliver and the vicious alligator. I also executed a series of small continuity sketches mounted on a board for the squirrel sequence. My other design duties included producing storyboards and sequences sketches for complex travelling matte sequences.

Following straight on from *The 3 Worlds of Gulliver*, our next venture was based on another famous novel, this time by Jules Verne. This was *Mysterious Island*, a sequel to his *Twenty Thousand Leagues Under the Sea*, about a group of refugees from the American Civil War who escape prison in a balloon and end up on a tropical island inhabited by strange creatures, pirates and Captain Nemo. In the same way as they had provided us with the screenplay for *The 3 Worlds of Gulliver*, Columbia now presented us with an old script that they had had for some years. Because we had made a respectable picture from the Gulliver project they

hoped that we could breath new life into this abandoned project by using Dynamation.

Although we kept the main premise of the story we had to inject more action and adventure, so I spent a great deal of time searching for new ideas that would differentiate this picture from other desert island movies and for Dynamation concepts that would complement Verne's original while still remaining affordable. A whole range of ideas was considered, including populating the island with dinosaurs and linking it with Atlantis or Lemuria. This explains some of the sequences that remain in the final picture.

I executed quite a number of key drawings for the effects sequences, as well as sketches and a full set of storyboards. The drawings covered a variety of subjects, including the attack of the phororhacos, a giant prehistoric bird; the balloon caught in the storm; the nautiloid cephalopod, a marine prehis-

toric creature; Granite House; a sunken city with Egyptian statues; the dormant volcano; the erupting volcano; the giant crab; a log sequence and the submarine *Nautilus* in the cave. As with most films a number of key sequences were eventually dropped from the storyline. These were the discovery of an ancient roadway into the sea; a prehistoric plesiosaur; a man-eating plant; a forest of mushrooms and an automated mechanical device that Nemo uses to recover phosphorus from the island's volcano.

*Mysterious Island* was one of the most enjoyable and colourful of the adventure stories that we made, beginning with a frightening ride in a balloon (enhanced by a wonderful Bernard Herrmann score) and ending with a volcanic eruption which destroys the island and Captain Nemo. Sadly, the picture was partially thrown away by being released as a second feature (in those days

Sc. 261               S.S.        F.G.    Studio

Sc. 265-269           T.M.        F.G.    Studio
                      P.S

Sc. 270-272      Out  T.M.        F.G.    Studio

(114)

B.G.   Location

Location   B.G.

B.G.   Location

**Left.** Pen and ink on green-tinted paper. 11" x 8". c.1958. One page of designs for travelling mattes for *The 3 Worlds of Gulliver*. I designed a whole book of these travelling matte sequences to enable me to be absolutely clear about what I was doing and to illustrate the process to the cameraman and actors. In the end this scene was not completed by means of travelling mattes but largely by means of perspective photography.

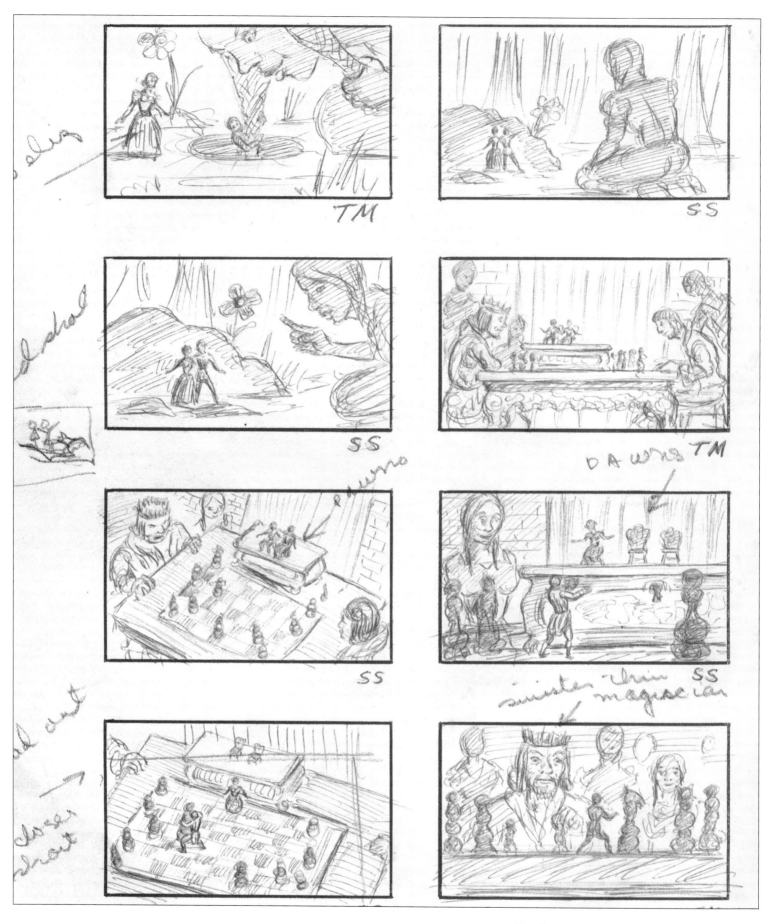

**Above.** Pencil on paper. 10" x 8". c.1958. Rough storyboard for the chess sequence between Gulliver and the King of Brobdingnag for *The 3 Worlds of Gulliver*.

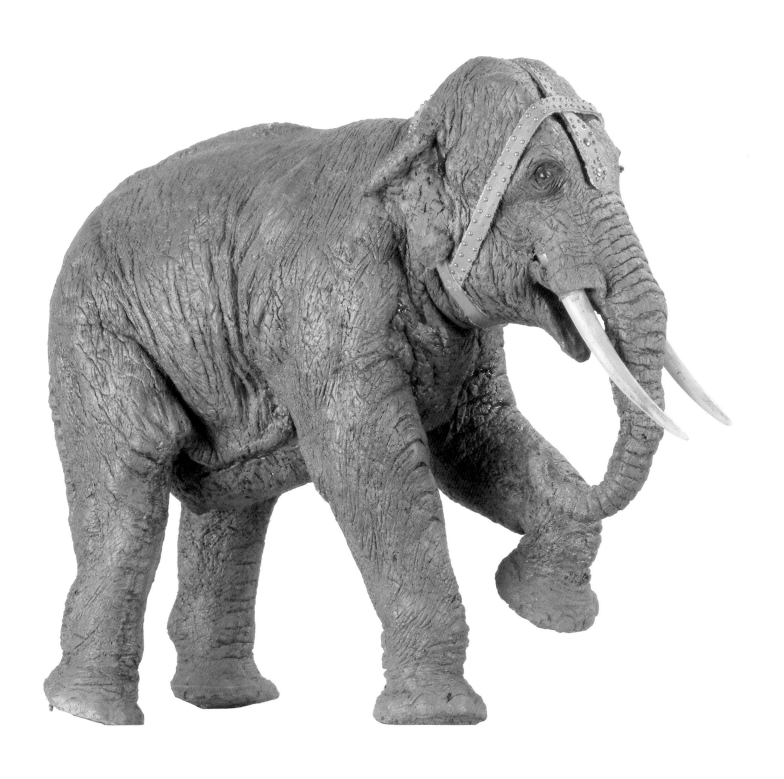

**Above.** Latex body with an internal metal armature. 11"(h) x 14"(d) x 6"(w). c.1968. The original model of the elephant in *The Valley of Gwangi*. I had to add him to the roster of models for the film when the real elephant proved too small. Sadly he doesn't appear in the picture for any great length of time so I thought he should make a reappearance here.

**Right.** Charcoal and pencil on illustration board. 7″ x 11½″. c.1960. Key drawing for the forest of giant mushrooms for *Mysterious Island*. One of the many scenes that never made it to the final screenplay. This was to have been the landscape through which the castaways passed on their way to a ruined ancient city.

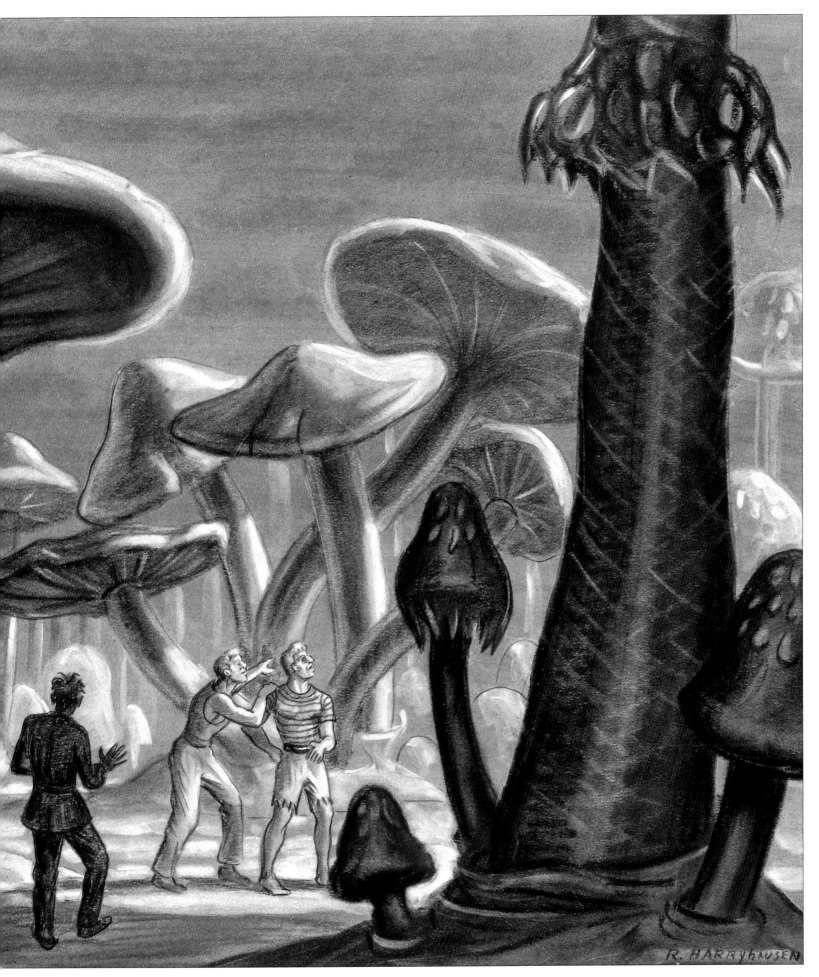

**Top.** Latex body with an internal metal armature. 6 ½″(h) x 11½″(d) x 8½″(w). c.1960. The original model of the bee for *Mysterious Island*. This one model played all three bees that appear in the film; I simply multiplied him by means of split screen. He is very delicate, and hasn't stood the test of time very well.

**Bottom.** Latex body with an internal metal armature. 7½″(h) x 7½″(d) x 6″(w). c.1975. The original model of the wasp that appears in *Sinbad and the Eye of the Tiger*. He is not so old, and time has so far been good to him.

**Right.** Wood and metal miniature. 23″(h) x 6½″(w). c.1952. Miniature lighthouse for *The Beast From 20,000 Fathoms*. Although I designed it, the actual miniature was not built by me. This was returned to me after some forty years by Forry Ackerman and I have had to make some repairs to its structure. If you look closely you will make out the reconstituted individual blocks that would have been animated as the creature pushes the structure over.

cinemas often showed two features in a package) although it remains a favourite of many fans, Tony included.

The final project in this chapter is called *Deluge*, or *The Deluge*. I had seen the original film some years after its initial release in 1933 (the same year as *King Kong*). It was a strange story that began with an eclipse of the sun, followed by an earthquake and a tidal wave (both still very impressive on the screen) that destroy civilization – or at least New York, which is all the audience sees. After that the story becomes rather mundane as it follows a group of survivors in a post-apocalyptic world. Of course, it was the effects that captured my imagination and I continued to believe that, with some

alterations and stop-motion 'additions', a remake of the film had great potential as a special effects project. I suggested the idea in early 1971 to Michael Carreras, the producer of *One Million Years BC* and one of the directors of Hammer Films, but he couldn't see the possibilities. I may also have talked with Charles about it, but in any event the project languished and finally died.

My idea was to set the story in London and to have the film climax with the destruction of the city and, indeed, the world by a deluge that would cleanse the Earth for a new beginning. This catastrophe would be preceded by a variety of ominous portents – an eclipse, the moon leaving its orbit, volcanic eruptions, a plague of terrifying beasts

(some would be dinosaurs, of course) emerging from the ground. To try to impress Michael I made one drawing, a poster design showing a huge tidal wave sweeping down the Thames and carrying away Westminster Bridge and Big Ben.

*Deluge* is perhaps a fitting topic with which to end this chapter. It was perhaps too ambitious, although it anticipated the advent of a whole cycle of 'disaster' movies, beginning with *The Poseidon Adventure*, by only a year or so. The fate of this project shows how difficult can be to get projects into production and why, although they did sometimes serve their purpose, so many of the drawings that I produced to help sell my ideas ended up in my morgue.

**Above.** Poster for *The Deluge*. Charcoal and pencil on illustration board. 19″ x 12″. c.1967. A poster I designed to try and sell the idea of remaking *The Deluge*. I put a lot of time into this poster design but neither Hammer Films nor Charles were interested.

**Above.** Pen on blue tinted paper. 11" x 8". c.1960. Two pages from the storyboard for the phororhacos sequence in *Mysterious Island*.

**Following pages.** Pencil on art paper. 23½" x 16½". c.1983. Comparison and design sketch with a front elevation, for the unrealized *People of the Mist*. This was a rough sketch for a creature (not a dinosaur or alien) that would have featured as a major adversary in the story.

# CHAPTER 11    "IT'S FINE STUFF, BUT IT WILL ROT IN TIME"

LIKE A PARENT PROTECTING HIS YOUNG, I have always tried to keep my 'creations' safe from harm, except, of course, when the storyline required that they be killed off. Sadly several had to be sacrificed when they were cannibalized in the name of time and budget, and those that survive are beginning, like their human contemporaries, to show their age. The problem with latex rubber is that it is liable to rot, and after forty-plus years some of the models are most definitely crumbling, just like the unfortunate queen in *She* (1933) after she stepped into the flame of eternal youth for a second time.

As the illustrations in this book demonstrate, some models have fared worse than others and it is not always easy to discover why this should be. Obviously, those creations that possess thin legs or spindly appendages are likely to show their age more quickly; the Selenites from *First Men in the Moon*, for instance, are almost unmoveable by now. However, in general the skeletons have survived the ravages of time fairly well; though I have occasionally been forced to carry out some surreptitious repair work on the cotton and latex rubber that forms their bones. Perhaps some of the damage is due to the way I baked them in my oven or the amount of time they spent under the hot lights – even though I used hard rubber stand-in models when I was testing light and colour balance. But that cannot always have been the case or the skeletons would be gone by now while the Selenites would be in fine shape. Whatever the root of the problem, the photographs in this book are perhaps the final record of how they look and although some are but a shadow of their once-great presence on screen, they should enable the reader to appreciate the finer points of their design.

I realized many years ago that my models would have this problem, and that the same fate awaited them as those made for *King Kong, Son of Kong* and *Mighty Joe Young*. It has to be said that RKO never looked after any of the models, which were just thrown into the basement. So, recollecting what Eva Moore said to Gloria Stuart whilst appreciating the smoothness of her skin in James Whale's *The Old Dark House* (1932) – "It's fine stuff, but it will rot in time" – I knew that I had to try and stop the 'rot'. Not by preserving the actual models because that would be next to impossible, but by recreating as many of them as I was able in a more enduring medium and for this I chose bronze.

In this chapter we have included images of the one extremely large bronze and nearly all the eleven smaller ones that I have designed. The only exclusions are two featuring the rhedosaurus from *The Beast From 20,000 Fathoms*. As the process of producing a bronze is extremely complex and the casting is not something I do myself, I shall describe only how they were designed and sculpted.

The starting point for making a bronze is basically the same as for a latex model. The difference, of course, is that the final product is made by a foundry and not in my kitchen oven. So the first step is to design the sculpture on paper and get a feel for what will work as a three-dimensional statue. Some figures did not need much effort because they were more or less straight replicas of the original model; the Talos from *Jason and the Argonauts* is a good example. However, most of my bronzes feature two or more figures engaged in a dramatic confrontation, sometimes modelled on a sequence from one of the films, for example the slaying of the dragon by *Sinbad* or the fight between Kong and the tyrannosaurus rex. These set-piece castings, which I think of as the three-dimensional equivalents of a single frame of film, require a vast amount of planning to ensure that each figure will look both realistic and dramatic from all possible viewpoints.

The next stage is to sculpt my model, or maquette, out of either clay or wax. I have no preferences for one or the other, but wax does allow for the reproduction of finer detail. This is the stage on which I spend most of my time. It took me several months, in my spare time, to sculpt. The Beast attacking the lighthouse, three weeks of which were devoted to the scales on the creature's body. If time is not spent on the details at this stage, the bronze can look distinctly lacklustre when it is cast.

When the finished product emerges from the mould, it still has to be cleaned up. At this point it looks rather a mess; there will, for instance, be projecting stubs where the molten metal was poured into the mould which have to be cut off and the surface polished. Finally, the separately cast sections have to be assembled and welded together. In the case of the *Kong* bronze, for example, Kong, the Fay Wray figure and the branch were all one cast from the same mould, whereas the tyrannosaurus rex was a separate casting.

At this stage the bronze also looks very bright and brassy. This is when the patina (the colour which, on an old bronze, would be the natural product of centuries of wear but which has to be applied to a new one) is added to provide a variety

of texture and tone. To do this the foundry has to apply solutions of various types of acids which are burned into the metal by means of a blowtorch, thus giving it a colour. In the case of the *King Kong* statue, for example, there are two different colours – the bronze colour of the Kong figure and the base, and the green hue of the tyrannosaurus rex. I often asked the foundry to apply different patinas because I wanted something to stand out or because I wanted a creature to have a different, or perhaps a more natural, colour.

The bronze that I call *Slaying of Medusa by Perseus* was the first one I ever made. Over a very short period of time, perhaps a month, I sculpted the wax model in Los Angeles, whilst staying in my mother's house and then had the bronze made there as well. Its purpose was to help raise the money to make the film *Clash of the Titans*, and as it was, of course, extremely heavy I had to find some way of carrying it to and from a succession of meetings. The solution I came up with, a bag carrier mounted on wheels, didn't look very classy and must have greatly puzzled people at MGM; but it served its purpose, as the bronze played a large part in gaining approval for production.

There are differences between the bronze and the scene as it finally appeared in the film. The most obvious one is that in the bronze Perseus is shown naked and strangling Medusa as he looks at her reflection in his shield. The idea of killing Medusa in this way was incorporated into early versions of the screenplay, but was later, quite rightly, abandoned in favour of having Perseus kill her with his sword. The bronze shield was intended to have been highly polished to reflect Medusa's face, but it proved difficult for the foundry to obtain a reasonable shine so the shield now has only a brighter patina.

The bronze *Sinbad and the Dragon* was based more on my key drawing for the sequence on the death of the dragon in *The 7th Voyage of Sinbad* than on the scene as it finally appeared in the film. Sinbad dominates the piece as he towers over the snarling dragon curled at his feet and prepares to strike the fatal blow with his sword. The dragon is much smaller than the one I portrayed in the film or the original drawing, for sculptural reasons. A large dragon in such a sculpture would have looked too cumbersome and out of place and I also wanted to stress the figure of Sinbad, rather than the creature.

The *King Kong and the tyrannosaurus rex* bronze was, of course, loosely based on the scene from the film where Fay Wray (who can be seen as a tiny figure on the base) is being fought over by the two creatures. My Kong is more gorilla-like than the original and he is seen with his left hand around the dinosaur's neck, while his right arm is poised to strike it. It is a dynamic and exciting piece, which

**Left.** *Kong fighting the plesiosaur.* Wax maquette mounted on a rough wooden base. 8" (h) x 9" (d) x 10½" (w). This striking pose, based on the sequence of Kong fighting the plesiosaur in the original *King Kong*, was never finished. It shows Kong poised to place one foot on the prehistoric beast ready to hold him down. The fur on Kong and the plesiosaur's scales are incomplete. The model was designed and sculpted for a huge piece that was to have been erected at the UFA Studio in Germany. Sadly the statue was never commissioned.

**Right.** *King Kong and the tyrannosaurus rex.* Bronze mounted on a red wooden base. 17" (h) x 11" (d) x 16" (w). This is my favourite scene from the original *King Kong* in which the giant ape is protecting the defenceless Fay Wray from the tyrannosaurus rex. The scene is in effect a boxing match between the two great beasts, which is illustrated in the pose I gave Kong with his arm held up to deliver a mortal blow. It is my tribute to the film.

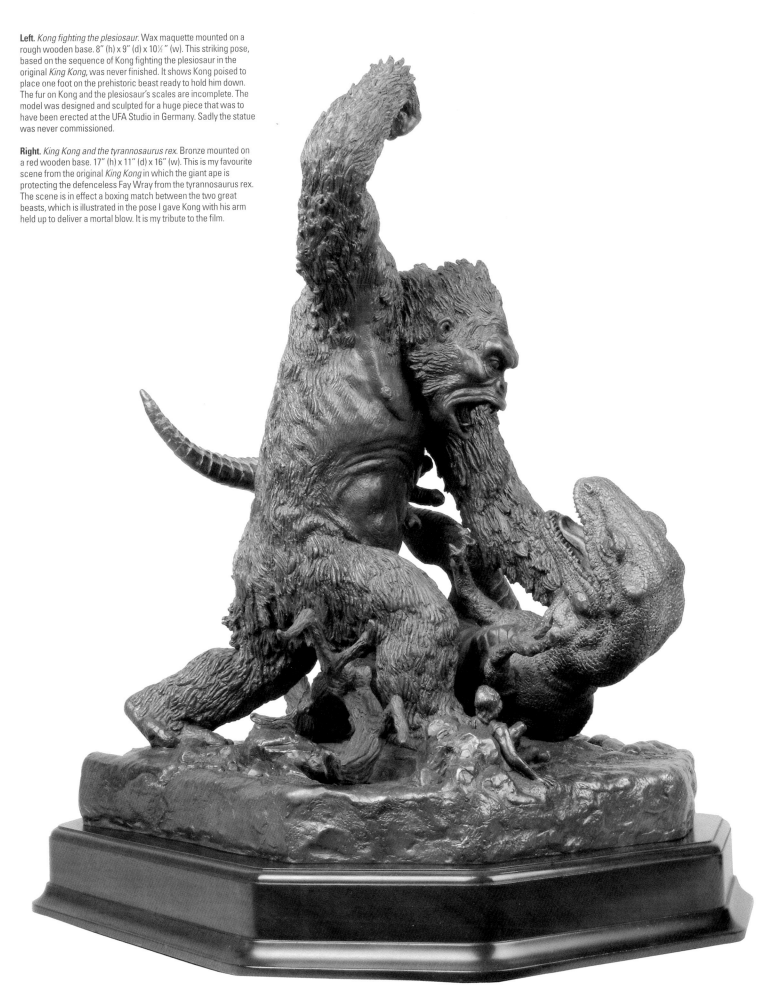

can be viewed from almost any angle. While we are on the subject of Kong I should mention a piece called *Kong fighting the Plesiosaur*. This only exists as an unfinished wax model because it was originally designed for a monument at the old UFA Studios in Germany, but the piece was never commissioned. If it had been made it would have been erected on a little island in the middle of a lake situated inside the studio complex and would have stood fifteen or twenty feet high. You will note that the process of sculpting the skin texture of the plesiosaur and Kong's fur was never completed.

Because the original model of the rhedosaurus featured in *The Beast From 20,000 Fathoms* is one of those that no longer exists (except for its skinless resin skull), it was an important candidate for preservation as a bronze. In fact there are two bronzes of this creature. The first is in the Sony Museum in Berlin, and is about twelve inches long and eight inches high; it shows the Beast rearing up on its hind legs, in a pose similar to that on the original poster for the film. The second and more dramatic of the two, was made many years later, and is based on a key scene in the film in which the creature attacks a lighthouse. It came about when an old friend, Forry Ackerman, kindly returned the original wooden miniature lighthouse to me. It stimulated my creative juices and I set about sculpting the Beast rearing up to destroy the lighthouse. The Beast was cast as one piece while the lighthouse was cast separately from the original miniature.

The cyclops featured in *The 7th Voyage of Sinbad* was another of my creations that had long departed this world (his armature, minus one leg, resides now in the Sony Museum). But he was very popular with fans and therefore another strong candidate for permanent preservation in bronze. I first sculpted him in clay with a more muscular upper torso and I had originally intended that he would be clutching a human figure in each hand, but in the end I decided to leave him with hands that were open but threatening.

The only other creation, apart from the rhedosaurus, of which I made two bronzes was Kali from *The Golden Voyage of Sinbad*. The original latex model does still survive – just. Her hands and legs are disintegrating so badly that we could not even take a photograph of her; each time she is moved large pieces of latex rubber come off in the hand. The first of two bronzes I made of her was a straightforward pose of the figure holding her six swords, called simply *Kali*; the second shows her fighting Sinbad, and is rather unoriginally called *Kali Fighting Sinbad*. Both were incredibly complicated to sculpt and cast. For Kali I first made a clay model of her without the swords and then made one model of a sword, which was cast six times;

**Left.** *Slaying of Medusa by Perseus.* Bronze mounted on a green marble base. 13½″ (h) x 9½″ (d) x 12½″ (w). This was the first ever bronze I created, in 1978–79. Based on the famous scene from mythology where the hero Perseus kills the evil gorgon Medusa, it shows Perseus strangling the creature with one hand as he looks at her reflection in his shield held in his other hand. Using the shield as a mirror enabled him to avoid her gaze, which would turn him to stone. Along with drawings of other scenes, it was this bronze that helped to sell the idea of *Clash of the Titans* to MGM.

**Above.** *The Cyclops.* Bronze mounted on a blue/black stepped base. 14″ (h) x 8½″ (d) x 14″ (w). An aggressive pose for the giant cyclops based on the creature in *The 7th Voyage of Sinbad.* This cyclops is slightly different from that seen in the film in as much as he has a more muscular physique.

**Right.** *Sinbad and the Dragon.* Bronze mounted on stepped black marble base. 8¼″ (h) x 8″ (d) x 8″ (w). Sinbad dominates this piece as he rises over the reptilian dragon in a suitably heroic pose. It is not closely based on either the sequence from *The 7th Voyage of Sinbad* (in which the dragon is killed by a giant crossbow bolt) nor on my initial key drawing for the sequence. However, the latter was the inspiration on which I built this new pose. Here the dragon is much smaller than in either the film or the drawing and he is more reptilian.

**Above.** *Prehistoric Challenge.* Wax maquette mounted on a rough wooden base. 5 ½ ″ (h) x 6 ½ ″ (d) x 9 ½ ″ (w). This was my original wax model, used to make a mould for the casting of the bronze. Sadly the young cavegirl is now missing.

**Above.** *Prehistoric Challenge*. Bronze mounted on a green marble base. 5½″ (h) x 6¼″ (d) x 9½″ (w). This is the final piece, which is not really based on a scene or sequence from *One Million Years BC*, but was a fantasy showing a caveman defending a cavegirl from a cerotosaurus.

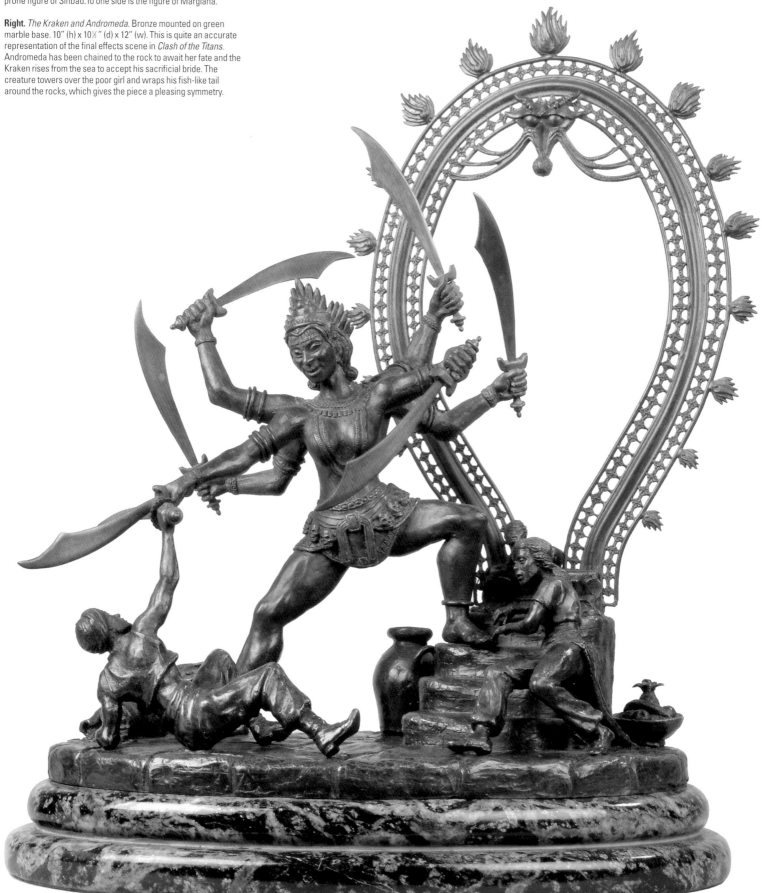

**Below.** *Kali fighting Sinbad.* Bronze mounted on a stepped green base. 14″ (h) x 7½″ (d) x 12″ (w). Based on the sequence from *The Golden Voyage of Sinbad*, Kali has just stepped down from her ornate Indian-style surround and is flourishing her swords at the prone figure of Sinbad. To one side is the figure of Margiana.

**Right.** *The Kraken and Andromeda.* Bronze mounted on green marble base. 10″ (h) x 10½″ (d) x 12″ (w). This is quite an accurate representation of the final effects scene in *Clash of the Titans*. Andromeda has been chained to the rock to await her fate and the Kraken rises from the sea to accept his sacrificial bride. The creature towers over the poor girl and wraps his fish-like tail around the rocks, which gives the piece a pleasing symmetry.

the foundry then assembled the complete figure. For the fighting bronze I made separate models of *Kali*, her arms, the swords, but the base includes the girl looking on in horror, Sinbad defending himself and the ornate Indian frame.

Although all my bronzes are precious to me, one of my favourites is *The Kraken and Andromeda*. Unlike many of the others it is almost completely green, including the base. This reflected the beast's colour in the film and the fact that he appears from the sea. The figure of the Kraken seems to be emerging from the base, all we see is the upper torso, complete with his four arms, one of which grasps the rock while the other three reach out for the tiny figure of Andromeda. Although we don't see the lower part of the creature's body we know he has a serpent or fish tail because part of it appears to be wrapped around the rock to which the poor girl is chained. I made this bronze to preserve the image not only of my Kraken model but also of the complete scene at the end of *Clash of the Titans*, on which it is very closely modelled. The image of a large, almost overwhelming, creature towering over a human has always captured my imagination, which will not come as a great surprise to anybody.

Unlike the Kraken, the bronze which I call *Prehistoric Challenge* was never meant to reflect any specific scene in the film to which it relates, in this case *One Million Years BC*. To begin with the dinosaur is a cerotosaurus and, although one appears in the film, he is not seen confronting a human. As with all other castings, I began by drawing this action scene on paper before making a three-dimensional version in wax. None of the figures resembles those in the film; the humans are more ape-like than the cave-people played by John Richardson and Raquel Welch and the cerotosaurus is smaller than the film version. The entire sculpture is in fact on quite a small scale so the use of wax was vital because it is a little more stable than clay and allows the sculptor to incorporate more detail. Although the prehistoric cave-girl is now missing from the wax model, I am pleased that the rest of it survives to show how closely the initial model resembles the final product.

The casting of Talos from *Jason and the Argonauts* was designed to preserve the form of the original armatured model because the original is now in very bad condition – so bad that the metal armature is showing through. Although the clay model from which the bronze was cast was made from the same mould as the latex original, I did enhance his physique somewhat.

The largest and most recent of the bronzes that I have designed and seen through the casting process is not based on any of my own creations; it still features a hero, but this time a real hero. My wife Diana is the great-granddaughter of the Scottish explorer and missionary David Livingstone. Long before I met and married Diana, Livingstone's story had inspired, enthralled and intrigued me. He was born in Blantyre, Lanarkshire, Scotland on 16 March 1813 and entered the brutal reality of working life in a local mill at the age of ten. Undeterred by the long hours and arduous work, the young Livingstone became interested in books and nature and his social conscience was aroused by an appeal to support missionary work in China. When he was old enough, he embarked upon medical studies at the Anderson College in Glasgow during the winter months, returning to work in the mills in the summer. As soon as he could, he applied to the London Missionary Society for service to China. However, following a lecture on Africa given by Dr Robert Moffat in 1840, Livingstone decided that his future lay in the vast, largely unexplored territory then known as the 'dark continent'. Africa captured his heart and mind.

Although I thought the man extraordinary in many respects, it was the famous incident of Livingstone being attacked by a lion that really impressed me. I have rarely heard a more dramatic narrative or finer example of true, old-fashioned heroism. To admire such a hero in today's anti-hero society may seem old fashioned to some, but to me such heroism is the essence of inspiration and a

timeless concept. At his first home in Mabosta, north of Kuruman, Livingstone opened a mission station and quickly earned the complete respect and loyalty of the people. When a man-eating lion began hunting around the mission, threatening the lives of the locals and preying upon their precious cattle, Livingstone decided to shoot the animal. After days of tracking, he finally encountered the beast, which sprang at him, though not before he was able to fire two shots. As Livingstone himself described it, 'he caught me by the shoulder as he sprang, and we both came to the ground together. Growling horribly close to my ear, he shook me as a terrier does a rat.' Distracted by the bearers, the wounded lion suddenly collapsed as the bullets finally took effect. The marks of the lion's teeth remained on Livingstone's shoulder throughout his life as a reminder of the incident, and he never regained the full use of his left arm.

I had always felt strongly that this moment of heroism should be depicted in bronze so that the entire world could see and appreciate Livingstone's courage, and this led me to make a small wax maquette of that defining moment in the great man's life, hoping one day it might be realized as a full bronze statue. When Mr Cunningham, the curator of Blantyre Park Museum, visited me I showed him my wax model. He was excited and promised to try to raise the funds to cast it; to begin with he was unsuccessful, but finally The National

Trust for Scotland took over the operation of the Park and managed to raise the necessary funds.

I knew I would be unable to undertake the task of producing a statue of that size on my own. At eighty-four years of age, I had to accept a director's role when it came to sculpting the full-size version. I recognized that if I were to fulfil this life-long ambition I would have to collaborate with an artist who shared my passion for the subject and was capable of realizing my conception; I wanted a sculptor who would capture the essence of Livingstone the hero and the scale of his adversary.

I first met Gareth Knowles many years earlier in the Atelier Foundry in Hartley Whitney, when he was working on a piece called *The Hawk and the Houbara*. The piece immediately impressed me. I saw that Gareth had not only mastered the intensely intricate forms of his subject but had brought them to life and captured everything the birds stood for. I knew that he would be just the man to realize my dream for the Livingstone bronze. Using my maquette as a model, he and I spent many hours in his studio in Donegal, Ireland, perfecting a gargantuan clay statue, called *Livingstone and the Lion*.

I am proud to say that the final bronze was unveiled in the park of the David Livingstone Museum at Blantyre, to much publicity on Wednesday 7 April 2004, at a ceremony attended by the Livingstone clan, my wife, my daughter, Vanessa, friends and

members of the National Trust for Scotland. I had tried for many days to think of something distinctive to say when the statue was revealed and at the moment of disclosure all I could think of was, 'And now the eighth wonder of the world.' Not exactly original, but, considering the size of the bronze, quite appropriate.

At the age of eighty-five, it is unlikely that I shall now find the time, or indeed the energy, to design and sculpt other bronzes. However, I feel that the pieces that I have managed to produce are a good representation of my creations and will preserve the memory of at least some of them As for the remaining creatures, even though I made my last picture nearly a quarter of a century ago, I can at least take comfort from the fact that they are preserved on celluloid, which is, perhaps, appropriate, as celluloid was the medium for which all my art was produced.

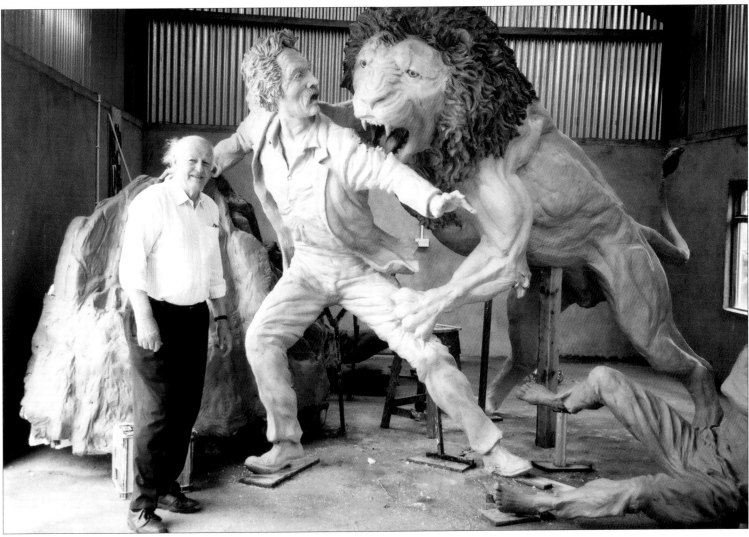

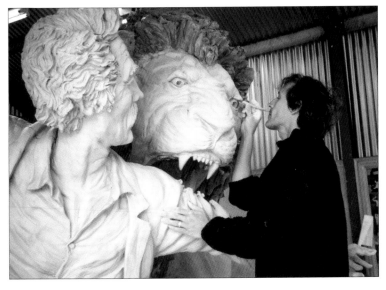

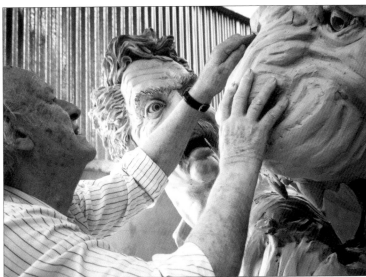

**Left.** *Livingstone and the Lion.* Wax maquette. c.1987. 13" (h) x 10" (d) x 18" (w). My interpretation of the attack on Livingstone by the lion.

**Top.** Posing with the one-and-a-half times lifesize clay statue in the studio. From this the full bronze will be cast.

**Above left.** Gareth at work on the clay model.

**Above right.** Me working on some of the finer details in Gareth's studio.

**Following pages.** *Livingstone and the Lion.* Bronze mounted on a round granite base. 11½' (h) x 19' (w). I like to think of this as my crowning achievement, although I think perhaps I might just have a few more projects up my sleeve. It is a giant bronze statue that shows the great missionary and explorer David Livingstone defending himself against a ferocious man-eating lion whilst two natives lie prone on either side. It is a rarity as it has the distinction of being the only one of my statues that is on permanent exhibition, in this case in the grounds of The David Livingstone Centre in Blantyre, Larnarkshire in Scotland.

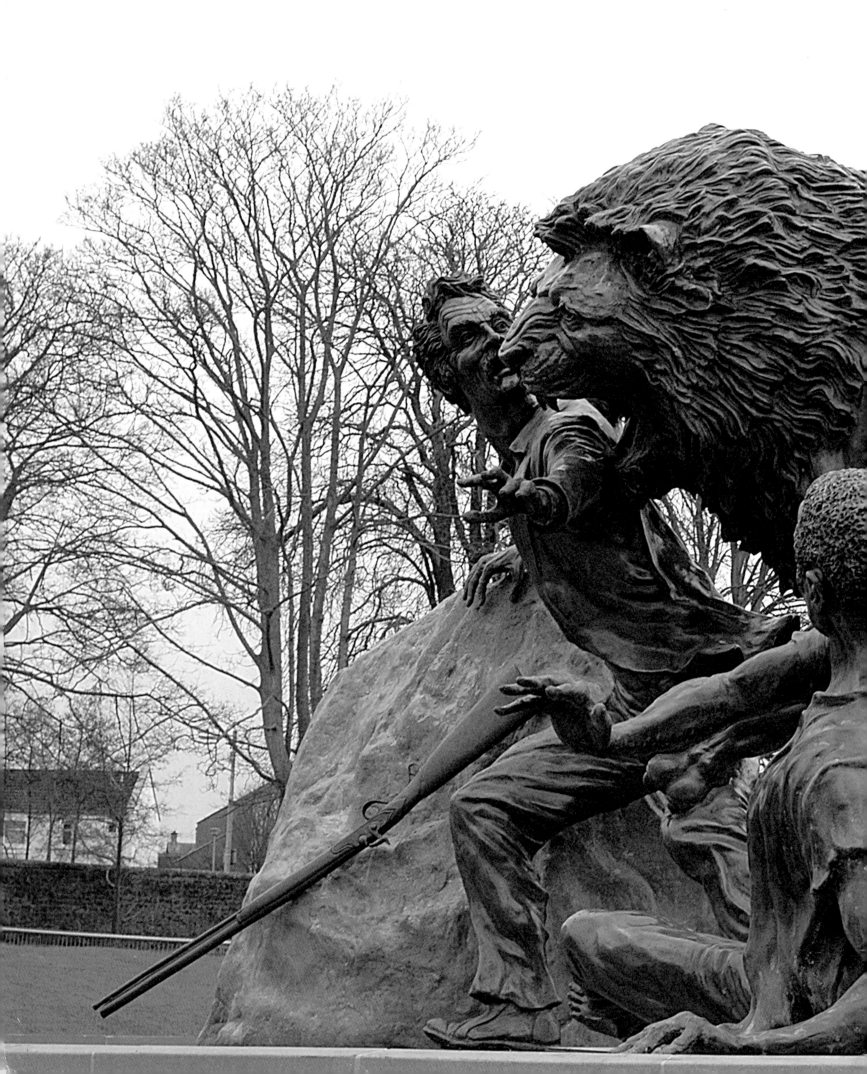

# Index

Numbers in **bold** refer to illustrations.